Light Writing &
Life Writing

Light Writing &

Life Writing

Photography in
Autobiography

Timothy Dow Adams

The
University
of North
Carolina
Press
Chapel Hill &
London

© 2000

The University of North Carolina Press

Set in Monotype Garamond
by Keystone Typesetting, Inc.
Manufactured in the United States of America
The paper in this book meets the guidelines for
permanence and durability of the Committee
on Production Guidelines for Book Longevity
of the Council on Library Resources.
Portions of this book have previously appeared
in "Life Writing and Light Writing: Autobiog-
raphy and Photography," *Modern Fiction Studies*
40, no. 3 (Fall 1994): 459–92. © 1994 Purdue
Research Foundation. Reprinted by permission
of the Johns Hopkins University Press.

Library of Congress
Cataloging-in-Publication Data
Adams, Timothy Dow.
Light writing and life writing: photography in
autobiography / Timothy Dow Adams.
 p. cm.
Includes bibliographical references and index.
ISBN 0-8078-2513-1 (cloth: alk. paper).—
ISBN 0-8078-4792-5 (pbk.: alk. paper)
1. American prose literature—20th century—
History and criticism. 2. Authors, American—
20th century—Biography—History and
criticism. 3. Authors, American—20th
century—Biography—Illustrations. 4.
American prose literature—20th century—
Illustrations. 5. Literature and photography—
United States. 6. Autobiography—Illustrations.
7. Autobiography. I. Title.
PS366.A88A33 2000
818'.50809492—dc21 99-21544
 CIP

04 03 02 01 00 5 4 3 2 1

For Paul Dow Adams,

our hope for the future

The photograph is first and last

an artifact, yet it has unique and

confusing peculiarities, less like those

of a ball bearing, nuclear warhead,

or bird's nest soup than those of a

woven rush mat, roof thatch or

vegetable soup.

—*Henry Holmes Smith*

Contents

Preface

Memory brings forth not reality itself, which is gone forever, but the words elicited by the representation of reality, which as it disappeared impressed traces upon the mind via the agency of the senses.

—*Augustine*

Although autobiography was once thought of as nonfiction, as a subgenre of biography—and is still often classified under biography in libraries, bookstores, and catalogs—in recent years scholars working with the genre have almost universally come to the realization that whatever else it is, autobiography is not simply nonfiction.

Beginning with Paul John Eakin's now standard *Fictions in Autobiography*, which argued that "the self that is the center of all autobiographical narrative is necessarily a fictive structure" and that "fictions and the fiction-making process are a central constituent of the truth of any life as it is lived and of any art devoted to the presentation of that life,"[1] most theorists have come to agree that the presence of fiction within autobiography is no more problematic than the presence of nonfiction within the novel.

Focusing more on the autobiographical act, including its fictive impulse, than on the historicity of the text, theorists have in recent years given their books on the genre such titles and subtitles as *Fabricating Lives* (Leibowitz), *Inventing the Truth* (Zinsser), *Figures in Autobiography* (Fleishman), *Constructions of Self-Representation* (Folkenflik), *Rewriting the Self* (Freeman), *Metaphors of Self* (Olney), *Marginality and the Fictions of Self-Representation* (Smith), and *Imagining a Self* (Spacks).

The argument would seem to be over. However, at the same time that the fictiveness of autobiography became a given, the forms in which autobiography manifested itself started to expand, taking in a number of related subgenres usually thought of as undeniably nonfiction; in addition to biography, memoir, and diary, literary scholars began to consider journal, letters, personal literary criticism, confession, oral history, daybook, documentary, travel writing, *testimonio*, film and television autobiographies, performance art, and as-told-to autobiography, as well as poetry. To make clear that the study of autobiographical texts includes all these types, many scholars now use the term "life writing" when they refer to personal narratives in general, despite the fact that life writing is just English for biography.

Substituting "life writing" for "autobiography" does not really solve the fiction/nonfiction question because, as numerous writers have noted, life is not necessarily nonfiction either. Avron Fleishman's assertion that "life—indeed the idea of a life—is already structured as a narrative" is echoed by Oliver Sacks: "It might be said that each of us constructs and lives a 'narrative,' and that this narrative *is* us, our identities . . . for each of us *is* a biography, a story."[2] Back in 1964 Alfred Kazin, struggling with the increasing instability of the genre, used the term "autobiography as narrative" to describe books such as Frank Conroy's *Stop-time* or Hemingway's *A Moveable Feast*. Many autobiography theorists since have avoided the fiction/nonfiction issue altogether by arguing, as Elizabeth Bruss did, that autobiography is "an act rather than a form" or by agreeing with Paul de Man's declaration that autobiography is not so much a genre as "a figure of reading or of understanding that occurs, to some degree, in all texts."[3] In his *Postmodernist Fiction*, Brian McHale argued that in comparing autobiography and fiction, "fiction is fatally compromised; it is the autobiographical fiction, not the 'straight' autobiography, that seems redundant here."[4] Autobiography's separation from nonfiction can be seen in a number of indexes, perhaps most symbolically in the creation of the Modern Language Association's Autobiography, Biography and Life Writing Division as a unit distinct from the Nonfiction Prose Division (now officially titled Nonfiction Prose Studies, Excluding Biography and Autobiography).

If it's not necessarily nonfiction, and not exactly fiction, then what is autobiography's referential status? A number of autobiography's theorists have spent the last decade attempting to answer that question by trying to isolate the fictional from the nonfictional, autobiography from the merely autobiographical, trying to distinguish what was once referred to as the autobiography proper from the autobiographical novel and the fictional autobiography (books such as Ernest Gaines's *The Autobiography of Miss Jane Pittman*). Even biography, once taken as even more clearly nonfictional than autobiography, has not been immune to blurring in the geography of genre, as demonstrated by Ira Bruce Nadel's theoretical study *Biography: Fiction, Fact, and Form* or such novels as Steven Millhauser's *Edwin Mullhouse: The Life and Death of an American Writer, 1943–1954, by Jeffrey Cartwright* or Updike's *Bech: A Book*. Adding to the confusion, novelists who once produced ambiguous texts, such as Roth's *My Life as a Man* or *The Counterlife* and Rosellen Brown's *Autobiography of My Mother* (the same

title as Jamaica Kincaid's 1996 novel)—or that odd trio of problematically subtitled memoirs: Frederick Exley's *A Fan's Notes: A Fictional Memoir*, Herbert Gold's *Fathers: A Novel in the Form of a Memoir*, and Gore Vidal's *Two Sisters: A Memoir in the Form of a Novel*—have recently turned to apparently straightforward autobiography as exemplified by Roth's *The Facts* and Updike's *Self-Consciousness*.[5] An exception to this turn from ambiguity is John Barth's *Once upon a Time*, which he describes as "a memoir bottled in a novel."

While the canon of autobiography was absorbing writing previously assumed to be nonfiction, as well as the life stories of those previously uncelebrated, scholars also began to expand to extraliterary autobiographical texts, as illustrated by *After Pomp and Circumstance*, Vered Vinitzky-Seroussi's study of high school reunions as autobiography, or *Getting a Life*, a collection of articles subtitled *Everyday Uses of Autobiography* edited by Sidonie Smith and Julia Watson. Smith and Watson's collection includes essays on such topics as the gaps between the spoken and signed "I" in the Deaf community; medical identity through DNA and medical data; genealogy as autobiography; twelve-step teleology; autoethnography in teen motherhood videos; survivor discourse; race, identity, culture, and kin in the transracial adoption process; the academic curriculum vitae; and autobiography in television talk shows and personal want ads.

All the scholarly work I have been discussing—the expansion of the empire of autobiography through colonization in the name of fiction of a number of smaller nations previously governed by nonfictional juntas—has recently produced some nagging worries, a few nonbelievers, a small backlash generated by a striking impasse: while autobiography theorists were busy establishing the idea that virtually everything was a fictive autobiographical text, poststructuralist theorists were at work challenging such terms as author, self, subject, agency, and representation, with the result that at times the emerging nation of autobiography, on the verge of achieving the status of a superpower, suddenly appeared to be collapsing. To paraphrase Donald Barthelme's "On Angels," the death of the author left the theorists of autobiography in a strange position. And having firmly established that the self is only a fictive construct, a number of poststructuralist theorists, including Alice Kaplan, Cathy Davidson, Jane Tompkins, Marianna Torgovnick, Henry Louis Gates Jr., Nancy K. Miller, Shirley Geok-lin Lim, Elisabeth Roudinesco, Frank Lentricchia, and Louis Althusser, have now adopted the paradoxical solution of writing their

own fairly traditional autobiographies.[6] At the same time Janet Varner Gunn, one of the earliest of autobiography's theorists, has recently published her own personal narrative, *Second Life: A West Bank Memoir*, as has novelist and autobiography scholar Helen Buss, author of *Mapping Our Selves: Canadian Women's Autobiography*, whose *Memoirs from Away* has recently been published with both her scholarly name and her novelist's pen name listed on the title page as joint authors.

The worry that autobiography was an endangered species appeared early in the history of recent autobiography criticism. Using speech act theory to construct a set of guidelines for autobiography, Elizabeth Bruss argued: "Autobiography as we know it is dependent on distinctions between fiction and non-fiction, between rhetorical and empirical first-person narrative. But these distinctions are cultural artifacts and might be differently drawn, as they indeed once were and might become again, leading to the obsolescence of autobiography or at least its radical reformulation."[7] Similarly, De Man declared, "Just as we seem to assert that all texts are autobiographical, we should say that, by the same token, none of them is or can be."[8] Michael Sprinker's essay "Fictions of the Self: The End of Autobiography," another of the early attempts to suggest that the genre was defining itself out of existence, was the final essay in James Olney's *Autobiography: Essays Theoretical and Critical* (1980), although the idea that autobiography was no longer possible had already surfaced in 1975 in *Roland Barthes by Roland Barthes*, in which the narrator asks the apparently rhetorical and riddling question: "Do I not know that, *in the field of the subject, there is no referent?*"[9] This self-canceling sentence occurs in a text whose back cover carries the label "a kind of autobiography," a book that begins with the sentence "it must all be considered as if spoken by a character in a novel" and includes a chronology of Barthes's life labeled "biography." *Roland Barthes* classifies itself, in the form of a chart under the heading "Phases," as an example of the genre of "morality," defined as "the precise opposite of ethics (it is the thinking of the body in a state of language)."[10]

Although Gerald Kennedy's "Roland Barthes, Autobiography, and the End of Writing" sees in Barthes's work another sign of the demise of autobiography, Paul John Eakin argues in his influential *Touching the World: Reference in Autobiography* that the "mismatch between theory and experience" demonstrated in the combination of *Roland Barthes by Roland Barthes* and *Camera Lucida* "suggests that it is time to reopen the file on reference in autobiography." "When the austere tenets of post-

structuralist theory about the subject came into conflict with the urgent demands of private experience," Eakin continues, "Barthes turned for solace . . . to photography," which was for him "the most referential of all the arts, testifying authoritatively to the existence of what it displays." Eakin continues, "In the field of the lens, we might say, there is always a referent, and Barthes beholds in photographs the truth that these referents have really existed: 'Every photograph is a certificate of presence.' "[11]

In analyzing *Roland Barthes* through the filter of *Camera Lucida*, taking both as autobiography, Eakin seems to have discovered a way out of the impasse, an irrefutable sign of how autobiography's representational aspects differ from fiction's. Because photographs are in a sense physical traces of actual objects, they somehow seem more referential than words, and as Eakin asserts, "autobiography is nothing if not a referential art."[12] Barthes is particularly straightforward about the physical link: "The photograph is literally an emanation of the referent."[13] Similarly, Susan Sontag refers to photographs as "something directly stenciled off the real, like a footprint or a death mask," and photography theorist Rosalind Krauss phrases the linkage this way: "Photography is an imprint or transfer off the real; it is a photochemically processed trace causally connected to that thing in the world to which it refers in a manner parallel to that of fingerprints or footprints or the rings of water that cold glasses leave on tables. . . . On the family tree of images it is closer to palm prints, death masks, the Shroud of Turin, or the tracks of gulls on beaches. . . . Technically and semiologically speaking, drawings and paintings are icons, while photographs are indexes."[14] Krauss's assertion is somewhat odd, given that C. S. Peirce, in applying his own terminology to photography, asserts that photographs are both iconic and indexical signs: "Photographs, especially instantaneous photographs, are very instructive, because we know that they are in certain respects exactly like the objects they represent. But this resemblance is due to the photographs having been produced under such circumstances that they were physically forced to correspond point by point to nature."[15]

At first there seems to be something irrefutable about the idea that the presence of photographs within a text constitutes a clear distinction between life writing and other genres. Novelists have frequently resorted to the visual for asserting a sort of fictive referentiality, examples including Faulkner's map in *The Sound and the Fury* or Anderson's in *Winesburg, Ohio*, or such devices as bibliographies of both real and

invented books in *Bech: A Book*, or the simulated coffee stains printed on the pages of William Gass's *Willie Masters' Lonesome Wife*, which was published as though it were a typescript rather than a printed novel. However, actual photographs of *authors* do not appear in fiction, though Richard Powers's novel *Three Farmers on Their Way to a Dance* fictionalizes a real August Sander photograph, and other novels, such as Paul Theroux's *Picture Palace*, Alice Munro's *Lives of Girls and Women*, Timothy Findlay's *The Telling of Lies*, Alison Moore's *Synonym for Love*, Sue Miller's *Family Pictures*, Ann Beattie's *Picturing Will*, Jamaica Kincaid's *Lucy* and *Annie John*, Katherine Harrison's *Exposure*, Maria Cardinal's *The Words to Say It*, and Lee Smith's *Oral History*, to name only a few, describe fictional photographs.[16]

Although photographs of authors within the text of a novel would seem to make no sense, photographs, especially of settings, though infrequently of fictional characters, have been published in novels since the nineteenth century, including the fiction of Dickens, Hardy, Scott, Hawthorne, and James. Recent examples of novels containing photographs include Lynn Sharon Schwartz's *The Fatigue Artist*, in which photographs are captioned with words that also appear within the text of the novel, and Carol Shields's Pulitzer Prize–winning *The Stone Diaries*, which includes eight pages of photographs in the middle of the text, images that Shields arranges as if in a family album.

Despite the examples I have listed of photography within fiction, there remains a sense, even in the age of digitally altered photography, that the specificity of photographs and their connection to the scene they depict make them as different from other forms of visual representation as autobiography is different from other literary genres. Because photography within narrative seems to operate on another plane than other forms of narration, a consideration of photography within life writing is a uniquely valuable way to look at the referential dilemma from another point of view. However, the history of referentiality in photography has run almost a parallel course to autobiography's, as I will detail in chapter 1.

Following the introductory chapter, which focuses on autobiography's and photography's vexed history of referentiality, the movement of *Light Writing and Life Writing* is from word to image. Chapter 2 concentrates on Paul Auster's *The Invention of Solitude*, a text within which only one photograph is reproduced, though the cover's image of the author's father in a trick photograph is emblematic of the son's attempt at filling in the empty family album by writing what he calls a

"Portrait of an Invisible Man." In chapter 3 I take up Maxine Hong Kingston's two autobiographical texts, *The Woman Warrior* and *China Men*, books in which no actual photographs are reproduced, although the idea of photography is central to Kingston's writing in terms of the unreliability of historical documentation for a childhood lived among "ghosts." Chapter 4 continues my initial emphasis on prose descriptions rather than actual photographs and provides a transition to the middle section of the book, in which words and images work together. In this chapter I analyze Sheila Ortiz Taylor's nine prose set pieces—chronologically arranged descriptions of family photographs at the heart of *Imaginary Parents: A Family Autobiography*—her collaboration with her sister, Sandra Ortiz Taylor, as well as Sandra's miniature installations, works of art included within the text, sometimes incorporating actual photographs.

Moving from this feminist Chicana version of *Sartor Resartus* to another family album, chapter 5, on N. Scott Momaday's *The Names*, begins the middle section of this book by examining a text filled not only with photographs but also with the author's own drawings and prose descriptions of sketches. Chapter 6, which covers three autobiographical texts by Michael Ondaatje and one by his brother, Christopher, in each of which photographs are prominent, shows another set of siblings writing about the same family, in this case separately rather than collaboratively as was true of the Ortiz Taylor sisters. Although Michael Ondaatje is the only non-U.S. author in my study, I have chosen to include his work because it so often concentrates on legendary figures associated with this country, including Billy the Kid, Buddy Bolden, and the photographer E. J. Bellocq. Chapter 7 ends the middle section of the book with a focus on Reynolds Price, another autobiographer, along with Auster and Ondaatje, whose central theme is father and son relationships and a writer whose frequent introductions to photography books indicate his attraction for image as well as word.

The last section of *Light Writing and Life Writing* takes up autobiographers who are also photographers, beginning with chapter 8, on Eudora Welty, whose early career as a Farm Security Administration photographer gave way to her life as a writer, described so gracefully in her *One Writer's Beginnings*. While Welty is clearly more a writer than a photographer, despite the publication of four books of her own photographs, Wright Morris, the subject of chapter 9, has been equally celebrated in both art forms, separately and in his photo-texts, books

that combine his own photographs with his prose. In addition, Morris has produced an important volume of photography criticism, *Time Pieces: Photographs, Writing, and Memory*, which contains both his own photographs and his essays about the art of photography. I end this third section with chapter 10, a study of Edward Weston, a central figure in the history of photography and also the author of *The Daybooks of Edward Weston*, a two-volume diary of his life, illustrated with his classic photographs.

Chapter 11 concludes the book by moving from photography in autobiography to autobiography in photography. In the conclusion I sketch out future possibilities for interdisciplinary scholarly work on autobiography and photography through comparisons between portraiture and self-portraiture and parallels between painting and photography and between photography and various genres of life writing.

I have chosen the eleven autobiographers and fourteen autobiographies covered in depth in *Light Writing and Life Writing* because each of them emerged when I organized this book into a movement from life writing made out of words alone to personal narratives of photographers. I deliberately chose books that blend autobiography and biography to illustrate parallels to self-portraiture and portraiture. Maxine Hong Kingston's *The Woman Warrior* and *China Men* are both partly biography because of the author's chapters on her father, brother, and other relatives. The Taylor sisters are in a sense writing biographically because, as their title, *Imaginary Parents: A Family Autobiography*, attests, they are collaborating on the story of their family, especially their parents. The first half of Paul Auster's *The Invention of Solitude* is in effect a biography of his father, while N. Scott Momaday's *The Names* is a tribal and family history more than the personal story of Momaday himself. Most biographical are Michael Ondaatje's books, in which he is almost always less at the center than others (Billy the Kid, Buddy Bolden, E. J. Bellocq, his brother, and his father). Reynolds Price's *Clear Pictures*, as its subtitle suggests, is about those family members, teachers, and friends who served as his earliest guides, and Eudora Welty's *One Writer's Beginnings* spends much time on her parents. While Wright Morris's books are mostly centered on his own life, one of my main points about *The Daybooks of Edward Weston* is the author's complicated relationship with Tina Modotti.

Throughout this book I also discuss other literary genres, including Ondaatje's poetry within *Running in the Family* and his long poem *The Collected Works of Billy the Kid*, as well as Margaret Gibson's 1987 Mel-

ville Cane Award–winning poetry collection *Memories of the Future: The Daybooks of Tina Modotti* in the Weston chapter. I consider autobiographical novels in the case of Eudora Welty's *The Optimist's Daughter*, Wright Morris's *The Home Place* and *The Man Who Was There*, and N. Scott Momaday's *The Ancient Child*. In short, most of the books I write about are hybrids, texts that exist somewhere between autobiography, biography, and memoir and are therefore comparable to many of the photographs to which I refer.

Because autobiographers often include photographs on the covers or flyleaves of their books, I considered a chapter just on that topic, concentrating on the relationship between inside and outside in such texts as Marguerite Duras's *The Lover*, Lucy Grealy's *Autobiography of a Face*, Lorene Cary's *Black Ice*, Ruth Sidransky's *In Silence*, Deborah McDowell's *Leaving Pipe Shop*, Gregory Howard Williams's *Life on the Color Line*, James McBride's *The Color of Water*, David Mura's *Turning Japanese*, Paul Monette's *Becoming a Man*, Geoffrey Wolff's *The Duke of Deception*, Henry Louis Gates Jr.'s *Colored People*, John Updike's *Self-Consciousness*, Eva Hoffman's *Lost in Translation*, and Mary Karr's *The Liars' Club*, which includes a cover photograph of a young barefoot girl on horseback that seems to be of the author but is actually Dorothea Lange's *Connie on Horseback, ca. 1920*.[17]

Of course, there were numerous other choices available besides those I finally chose. Had I not already discussed them in *Telling Lies in Modern American Autobiography*, I would have covered Mary McCarthy, Lillian Hellman, and Gertrude Stein, three multiple autobiographers in whose work photographs are central. Although I had always assumed that James Agee and Walker Evans's *Let Us Now Praise Famous Men* would be a part of this book, finally I decided that enough has been written on that particular text. Wanting to show a wide range of possibilities, I had decided to write about Art Spiegelman's *Maus: A Survivor's Tale*, parts 1 and 2, because of the compelling combination of actual and cartoon photographs, especially when I came across the even more intriguing possibilities of using the Voyager CD-Rom version of *The Complete Maus*, which includes family photographs not in the print version, as well as Spiegelman's home movies of his research visits to concentration camps, actual live interviews with the author and his father, numerous drafts of both sketches and text, and other valuable material. Unfortunately, legal technicalities prevented my using any version of the *Maus* texts.

My original idea to conclude with life writing that consisted pri-

marily of images separate from text originated with Richard Avedon's massive *Autobiography*, but even that book begins with the photographer's textual description of the patterns he has laid out in the photographic portion of the text. Eventually I came to see that photographs without text were as difficult to locate as examples of autobiographies without photographs in which the idea of photography was important, and finally I decided to concentrate, in the last section, on autobiographies by photographers. Here I also considered a number of texts that never found their way into this book, including Todd Webb's *Looking Back: Memories and Photographs*, Rollie McKenna's *A Life in Photography*, Gordon Parks's *Voices in the Mirror*, Margaret Bourke-White's *Portrait of Myself*, Man Ray's *Self-Portrait*, Ansel Adams's *Autobiography*, Tony Mendoza's *Ernie: A Photographer's Memoir* (a study of the photographer's model cat, counterpart to William Wegman's model dog Man Ray), and Beaumont Newhall's *In Focus*.

For most of the books I did write about, I considered others, at one time thinking in pairs. In addition to Maxine Hong Kingston, I thought about Denise Chong's *The Concubine's Children*; besides N. Scott Momaday's text, I considered taking up Gerald Vizenor's *Interior Landscapes* and Leslie Marmon Silko's *Storyteller*, though I have never been sure that Silko's text is best thought of under the heading of life writing. I thought a long time about Maggie Lee Sayre's *"Deaf Maggie Lee Sayre": Photographs of a River Life*, edited by Tom Rankin, a mostly photographic text that documents Sayre's more than fifty years living on houseboats in Kentucky and Tennessee. In the end, however, I have settled on the texts represented here because they were the ones that seemed best suited to help me answer the questions about photography in autobiography that have long interested me.

I hope that some of the discussion in *Light Writing and Life Writing* might begin to move us beyond the scholarly impasse described earlier: although theorists have repeatedly demonstrated that attempting to define autobiography as distinct from autobiographical fiction is fairly futile—finally all writing is to a degree autobiographical and fictional—nevertheless there remains something about life writing that makes it feel distinct, and, as anyone who has ever taught a course on autobiography can attest, if we don't try to make some distinctions, readers begin to treat autobiographies as if they were novels, and the genre begins to disappear just as we enter an era everywhere described as the age of memoir.

Light Writing and Life Writing is intended to explore how pho-

tography may be used or alluded to in modern autobiography. The commonsense view would be that photography operates as a visual supplement (illustration) and a corroboration (verification) of the text—that photographs may help to establish, or at least reinforce, autobiography's referential dimension. In the wake of poststructuralism, however, I argue that the role of photography in autobiography is far from simple or one-dimensional. Both media are increasingly self-conscious, and combining them may intensify rather than reduce the complexity and ambiguity of each taken separately. This book, then, is a series of case studies exploring the various ways in which text and image can interact with and reflect on each other. Photography may stimulate, inspire, or seem to document autobiography; it may also confound verbal narrative. Conversely, autobiography may mediate on, stimulate, or even take the form of photography. In my view, text and image complement, rather than supplement, each other; since reference is not secure in either, neither can compensate for lack of stability in the other. Because both media are located on the border between fact and fiction, they often undercut just as easily as they reinforce each other.[18]

Throughout *Life Writing and Light Writing*, although I begin each chapter with a consideration of genre, my emphasis is not on separating autobiography from fiction by using photographs to establish the accuracy of the text but on the way interrelations between photography and autobiography demonstrate the inherent tendency in both to conceal as much as they reveal, through their built-in ambiguity, their natural relationship to the worlds they depict, which always seems more direct than it really is.

Acknowledgments

But photographs do not explain; they acknowledge.
—*Susan Sontag,* On Photography

Because this book began in Richard Wendorf's NEH Summer Seminar on portraiture and biography, held at Harvard University in 1990, my first thanks go to him and to my fellow seminarians, especially Jeff Wallen. I'm especially appreciative of Miles Orvell's and Tom Couser's readings of my manuscript and thankful to Sheila and Sandra Ortiz Taylor, Norma Elia Cantú, and Wright Morris for their willingness to comment on my reading of their work. Wright Morris, Michael Ondaatje, Christopher Ondaatje, Sandra Ortiz Taylor, N. Scott Momaday, Reynolds Price, and Paul Auster generously gave me permission to use photographs from their books.

Others who have been particularly helpful include Barbara Hanrahan, Josephine Morris, Joseph J. Wydeven, Greg Henry, Paul Jay, Margaret Gibson, Margaret Hooks, Mildred Constantine, Amy Conger, Jane Rabb, Steve Jenkins, Teresa Zackodnik, Dick George, Rixon Reed, Charles Martin, Joanne Leonard, John Eakin, Bill Andrews, Julia Watson, Sidonie Smith, Becky Hogan, Joe Hogan, Kate Drowne, and Susanna Egan. I was encouraged and sustained by everyone from the "Getting a Life" seminar. I want to thank, at West Virginia University, Gailina Gallonovitch, Pat Conner, Bonnie Anderson, Timothy Sweet, Laura Brady, Rudy Almasy, Duane Nellis, Fred King, and the staff of the Wise Library's Interlibrary Loan Department, especially Todd Yeager. Thanks also to everyone in English 3920 Spring 1999.

I am very grateful to the Center for Creative Photography at the University of Arizona for awarding me an Ansel Adams Fellowship to work in the library and archives, especially to Amy Rule, Terence Pitts, Dianne Nilsen, Nancy Solomon, Nancy Lutz, and Timothy Troy. My work on the Welty chapter was greatly augmented by Forrest Galey, head of Special Collections at the Mississippi Department of Archives and History. Thanks also to Jan May and James Patterson of Jackson.

Two sections of this book have been published elsewhere, including part of my introduction, which appeared in "Autobiography, Photography, Narrative," a special issue of *Modern Fiction Studies* I edited, and for which I thank Pat O'Donnell. The chapter on Paul Auster

appears in a different form in *True Relations: Essays on Autobiography and the Postmodern*, edited by G. Thomas Couser and Joseph Fichtelberg.

Everyone at the University of North Carolina Press has always been efficient and helpful, and I am especially grateful for the intelligence, skill, grace, and tact of Sian Hunter. I am lucky to have Pam Upton as a project editor and Grace Buonocore as copyeditor, and I thank them both.

Light Writing &
Life Writing

*What the automatism of the photograph
yields is not the thing or its physical trace but
a display of its representability.*
 —*Stephen Melville*

Introduction
..................................
I Am a Camera

At first I thought that the mere presence of photographs within
the text might constitute an unambiguous sign of the difference be-
tween autobiography and autobiographical fiction, though now I see
that photographs have been included in fiction, almost from the in-
vention of photography, almost always used as illustration of place or
atmosphere rather than of characters, and far more common in the
nineteenth century when novels were commonly illustrated.[1] Photo-
graphs of people directly identified with the text seldom appear in
novels. There are no photographs of Lambert Strether or Daisy Miller
in the Alvin Langdon Coburn New York Edition of the works of
Henry James, no images of Pierre or Ahab in the works of Melville,
and although the autobiographical Hawthorne often slips himself into
his own fiction in the form of fictional prefaces that pose as actual
ones, no photographs of Hawthorne appear within his novels.[2]

An early instance of photography within fiction is *Nadja*, a novel
by André Breton. Interestingly, while *Nadja* has entered the literary
canon as a work of fiction, Marja Wareheim points out that, in a
foreword to the second French edition, Breton asserts that *Nadja*
"was not intended as a literary work, but a document *pris sur le vif,*

'taken from life,' an account of events that neither disguised nor fictionally transposed the real people it portrayed."[3] Françoise Meltzer notes of *Nadja*, "The photographs included are the author's proof, as it were, that his narrative is truth, not story," though she adds that their value as proof is undercut by the fact that they are often images of handwriting, meant to be examples of sentences created by the fictional character's own hand.[4]

Photographs of fictional characters are rare in fiction for the obvious reason that being fictional the characters—no matter how much drawn from life—don't actually exist; therefore, any photograph that purports to represent a fictional character must itself necessarily be fictional. Oddly enough, this is the opposite situation from film, where actors usually play fictional characters, though there is the convention of a cameo appearance in which a person plays him- or herself, as when Marshall McLuhan appears as himself in Woody Allen's *Annie Hall*.

Carol Shields's *The Stone Diaries* begins with a family tree that names the fictional characters and their relationships, including Cuyler Goodwill and Mercy Stone Goodwill, who are described by the narrator, their daughter, in physical details that sometimes differ from what can be observed in the photographs. Although Mercy is depicted as immense, corpulent, elephantine, and extraordinarily obese, for example, the figure in the photograph, while hardly slender, does not seem to justify these terms. Further undercutting the connection between the images and their prose counterparts is the fact that the narrator describes her father as being "an inch or two shorter than she,"[5] whereas the photograph, which is also described in prose within the text, clearly shows that he is the taller of the two. A closer look at the images within this novel, which include a photograph of a minor character labeled " 'Fraidy' Hoyt" next to a drawing of the same character, reveals an interesting autobiographical situation: several of the photographs of children, labeled "Lissa Taylor" and "Jilly Taylor," are actually pictures of Carol Shields's own daughters, a fact that can be reinforced by the family resemblance to the author's photograph on the back cover. When Shields includes photographs of her characters within *The Stone Diaries*, rather than adding verisimilitude to the characters, the photographs automatically become fictional. As Roger Scruton argues: "Of course I may take a photograph of a draped nude and call it *Venus*, but insofar as this can be understood as an exercise in fiction, it should not be thought of as a photographic representation of Venus but rather as the photograph of a representation of Venus."[6]

Photographs are not naturally very adept at being fictional because of their built-in feeling of accuracy and because their tendency to misrepresent is usually described in terms of truth versus lie rather than fact versus fiction. Photographs can be thought of as fictional either when they have been manipulated through the photographer's skill in printing and combining or when they have been staged so that the picture they show is not what it seems to be. Actors can be hired and told to portray certain emotions and scenes, lighting and special effects can be added, and an image can be created with little connection to what would otherwise have happened. The same effect, of course, is often created in ordinary snapshot situations in which actual ceremonies are re-created for purposes of recording them before the camera and everyone is required to smile no matter his or her actual mood before the camera appeared, reminding us that, in a sense, all posed photographs are fictional, as Harry Berger suggests with his phrase "Fictions of the Pose."[7]

For early writers about photography, both the iconic and indexical aspects of photography were imagined as an automatic process. From its beginning in such drawing and drafting aids as the camera obscura, the camera lucida, the silhouette machine, and the physionotrace, the photograph was at first thought of as a naturally iconic process, the action of nature with light as its agency, as evidenced by the names chosen for the process by its inventors: Joseph Nicéphore Niépce preferred the term "heliograph"; Henry Fox Talbot, who first referred to his process as "photogenic drawing," later named his first book of photographs *The Pencil of Nature*; Oliver Wendell Holmes, in an essay called "Sun-Painting and Sun Sculpture," called the daguerreotype a "mirror with a memory." Daguerre himself described his invention as "not merely an instrument which serves to draw Nature; on the contrary it is a chemical and physical process which gives her the power to reproduce herself."[8] The poet Lamartine charged photography with being a "plagiarism of nature,"[9] and a now anonymous author wrote in 1854, "We can hardly accuse the sun of having an imagination."[10]

And yet sophisticated theorists of photography, imagery, and semiotics have repeatedly demonstrated, in a history remarkably similar to that of autobiography, that photography is equally problematic in terms of referentiality, that the old notions that photographs never lie and that photography was an objective "naturally mechanical" process of reproducing reality are much more complicated than they might first appear.[11] Despite decades of discussion about such developing

techniques as burning in, collage, montage, cropping, enlarging, dodging, hand coloring, retouching, solarizing, plus lenses, filters, papers, chemicals, camera position, focus, and depth of field—not to mention the universal reaction of disbelief at seeing one's self in a photograph and the acknowledgment that some people are more photogenic than others—an inherent belief about the photograph's direct connection to the actual persists. As Barthes notes, "From a real body, which was there, proceed radiations which ultimately touch me, who am here."[12] Barthes's notion is not new. Elizabeth Barrett Browning wrote, "It is not merely the likeness which is precious in such cases—but the association and the sense of nearness involved in the thing . . . the fact of the very shadow of the *person* lying there fixed forever"—a thought echoed by Thomas Carlyle's statement: "Any representation made by a faithful human creature of that face and figure which he saw with his eyes, and which I can never see with mine, is now valuable to me."[13]

Apparently no amount of appealing to logic about the obvious distortions of photographs can quite sway viewers from the popular idea that there is something especially authentic or accurate about a photographic likeness. As André Bazin wrote in "The Ontology of the Photographic Image," "A very faithful drawing may actually tell us more about the model but despite the promptings of our critical intelligence it will never have the irrational power of the photograph to bear away our faith."[14]

From the beginning of photography's history, the inherent truthfulness of photographs has always been challenged. John Ruskin, writing in 1865, notes, "Photographs have an imitable mechanical refinement, and their legal evidence is of great use if you knew how to cross-examine them. They are popularly supposed to be 'true,' and, at their worst, they are so, in the sense in which an echo is true to a conversation of which it omits the most important syllables and reduplicates the rest."[15] Seventeenth-century painters were quick to point out the inaccuracy of photographic portraits when compared with painted portraits, as Joel Snyder notes, "When I use your magic box to make portraits, the distance is all wrong. . . . As everyone knows, the mouth should occupy about one quarter of the diameter of the face, but with your pile of junk, it occupies a third."[16]

One of the strongest critics of the idea that a photograph is a trace of the real is Joel Snyder, who in collaboration with Neil Walsh Allen writes in refutation of Rudolph Arnheim's argument that "physical objects themselves print their image."[17] Snyder and Allen counter with

a brief summary of the optics involved: "It is the light reflected by the objects and refracted by the lens which is the agent in the process, not 'the physical objects themselves.' These 'physical objects do not have a single 'image'—'their image'—but, rather, the camera can manipulate the reflected light to create an infinite number of images."[18] Although Pierre Cordier's auto-chemigrams, made by putting photo-sensitive chemicals directly onto his face, which was then applied to printing-out paper—are a direct refutation of Snyder's argument, he is technically correct in arguing that the light and not the object is the agent in photography. His invoking of the physics of optics does, however, leave out both the creative and the magical aspects of photography, as expressed by Stanley Cavell in his *The World Viewed*: "We might say that we don't know how to think of the *connection* between a photograph and what it is a photograph of. The image is not a likeness; it is not exactly a replica, or a relic, or a shadow, or an apparition either, though all of these natural candidates share a striking feature with photographs—an aura or history of magic surrounding them."[19]

In fact, Snyder must admit, five years after the publication of his original argument, "It seems to me that the conclusive refutations of copy or illusion theories somehow fail to be convincing; we are left with a strong feeling, after all the refutations are advanced, that there must, nonetheless, be a natural or privileged or unreasoned relation between realistic picture and world."[20] Corey Creekmur, after having rehearsed all the arguments against photographs as possessing a unique indexical relationship to the world, finally falls back on what he calls "the psychopathology of the everyday *use* of photographs." Intellectually aware of the persuasiveness of the arguments but "troubled by their implicit demand that those who respond to photographs as evidence of the actuality of the objects they represent can only, finally, be characterized as (ideological) dupes," he asserts: "I believe a photograph of a lost loved one might have the affective power to make even a semiotician, who knows better, weep."[21]

Just as autobiographies are obviously artificial representations of lives, so photographs are clearly manufactured images: sitters are artificially posed and lighted, made to conform to the laws of perspective and the ideology of the photographic culture, reduced in size, reproduced on a flat plane often without color—and yet there is something undeniably different about a photographic representation of a person as opposed to a painting of that same person. Although such painted portraits as Jan van Eyck's *The Arnolfini Marriage* were meant

as documentary evidence, photographs quickly assumed a stronger legal representational status, as can be seen in driver's licenses, bank cards with photographic identification, medical records, crime photographs, and passports.

Despite photographs' superior evidentiary value, separating photography from painting is sometimes as difficult as separating autobiography from fiction. Photographs have always been seen as surfaces that could be augmented with painting, as was often the case with tintypes, daguerreotypes, and ambrotypes with their details picked out in paint, and X-rays of early portraits often reveal a photograph beneath the surface.

A number of self-portraits of photographers deliberately play with the differences between painting and photography by blending the two. For example, Edward Steichen's *Self-Portrait with Brush and Palette, Paris, 1901* (fig. I.1), which reinforces its depiction of the photographer as a painter through the use of pigment manipulation to create painterly effects, nicely suggests his transition from painter to photographer.[22] Charles Sheeler, as much a painter as a photographer, chose to indicate both media in his *Self-Portrait at easel, 1931–32* (fig. I.2). In depicting himself sitting before an unfinished painting on an easel, his drawing pencil's point at first appearing to be sketching a shadow of his right arm and hand, Sheeler, by allowing the strong photographic lights to remain as part of the photograph, shows his interest in both forms and anticipates Norman Rockwell's painting *Triple Self-Portrait, 1960*, the subject of Philippe Lejeune's essay "Looking at a Self-Portrait."

Marta Hoepffner's *Self-Portrait in Mirror (double exposure), 1941* (fig. I.3) is another sort of triple self-portrait, produced by double exposure and including a painting of the photographer (apparently holding another image in her painted hands), an empty frame in the background, cubistic angles, and a camera with which Hoepffner has apparently taken the whole picture, though she does not seem to be using its viewfinder.[23] Although Edmund Kesting's *Self-Portrait (with brush), ca. 1928* (fig. I.4) is clearly a photograph, the fact that the hand that is both "retouching" and apparently "painting" his face—with a brush whose blurred end suggests a painted image—seems to belong to another person partially turns this self-portrait into a portrait, the photographic equivalent of combining autobiography and biography.

Countless contemporary photographs continue to blur the distinction between photography and other arts by using a wide variety of

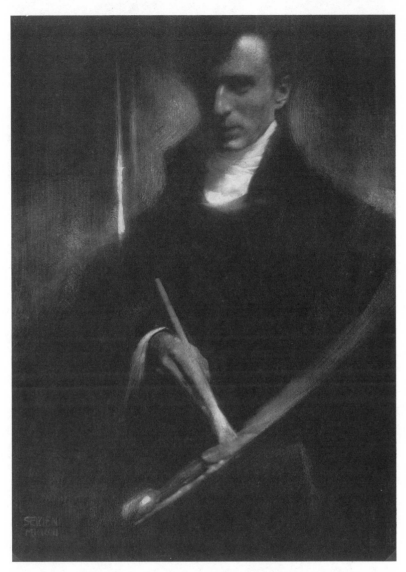

FIGURE I.I. *Edward J. Steichen, American, 1879–1973,* Self-Portrait with Brush and Palette, *gum-bichromate print, 1902, 26.7 × 20 cm, Alfred Stieglitz Collection, 1949.823. (Photograph © The Art Institute of Chicago; all rights reserved)*

techniques. Elizabeth Murray, for instance, manipulates Polaroids with hand tools before they dry to produce painterly effects, sometimes freezing and then defrosting them to work on at a later time,[24] while Skai Fowler photographs herself within classic works of art, by blowing up photographs of famous paintings from art books and then posing herself, often nude, in front of the backdrop, matching skin

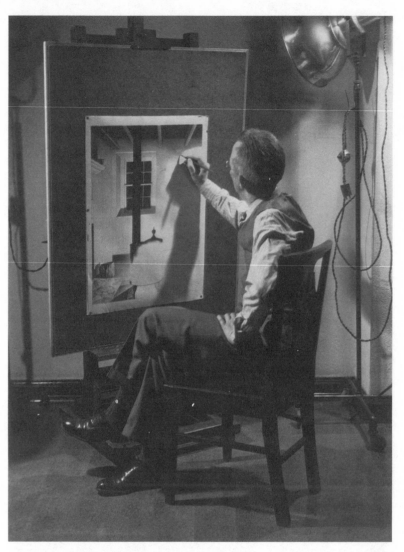

FIGURE I.2. *Charles Sheeler,* Self-Portrait at Easel, *1931–32, silver gelatin print, 24.6 × 19.1 cm, Ada Turnbull Hertle Endowment, 1988.431. (© The Art Institute of Chicago; all rights reserved)*

tones exactly so that she appears to be interacting with the original models. Betty Hahn's career features innovative combinations of media, as can be seen in *Betty Hahn: Photography or Maybe Not.*[25] Hahn prints photographs of others onto drawing boards to produce what appear to be woodcuts, produces enlarged gum bichromate prints with applied watercolors and spray paint, contact prints directly onto fabric (including passport photos embellished with embroidery

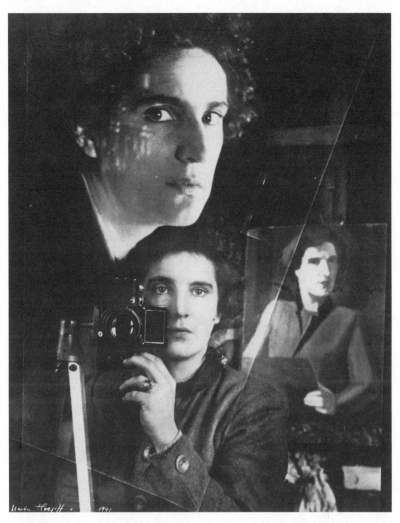

FIGURE 1.3. *Marta Hoepffner,* Self-Portrait in Mirror (double exposure), 1941. *Gelatin silver print, 14 × 11 in. (Collection of Audrey and Sydney Irmas, Gift of Irmas Intervivos Trust of June 1982, Los Angeles County Museum of Art)*

thread), and makes Van Dyke photographs with applied watercolors printed and folded to simulate postcards.

Sue Arrowsmith combines black and white paint, charcoal, and photographic emulsion on canvas. For example, she exposes a negative of a photographic self-portrait onto a canvas and combines it with charcoal and paint. As a result, according to Susan Butler, "The charcoal drawing and the painting both condition, and are conditioned by, the photographic image; the canvas, absorbing all these processes,

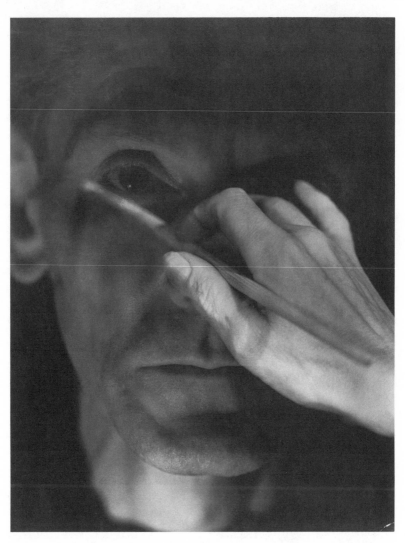

FIGURE I.4. *Edmund Kesting,* Self-Portrait (with brush), ca. 1928. *Gelatin silver print, 11½ × 8¾ in. (Collection of Audrey and Sydney Irmas, Gift of Irmas Intervivos Trust of June 1982, Los Angeles County Museum of Art)*

mediates the rival possibilities."[26] Referring to such European artists as Anselm Kiefer, who includes giant photographs within his paintings, or Gerhard Richter, who makes photo-realist paintings of celebrated news photographs, Andy Grundberg describes such work as "images that gave themselves up to fiction, not fictive masks of reality."[27]

Painting over a photograph is common in self-portraiture, as exemplified by such artists as Arnulf Rainer and Holly Roberts, whose

paintings often completely obscure the photograph beneath. Instead of painting directly on canvas, Roberts prefers the perspective she gains by starting with a photograph. According to David Featherstone: "She insists that raw canvas would give her nothing to break free from, that by starting with the picture, her painting becomes a kind of record of a unique interaction between artist, photograph and paint."[28]

Even though paintings have often made use of photographs for models, not to mention the fact that most of the reproductions of paintings we see in art books are actually photographs, even a close approximation of a photograph reproduced in painting—for example, Chuck Close's photo-realistic *Big Self-Portrait, 1968* (fig. I.5), done in acrylic on canvas using a Polaroid close-up as a model—does not have the same direct connection to reality as an actual photograph. Looking at Close's face closely, we can see, without the aid of a magnifying glass, that first the cigarette, then the pores, the hair, and finally the whole picture are not as precise as a photographed face would be.

Despite these examples, which stand for many more, the general belief persists that photographic images are more connected to the world than are paintings. As Max Kozloff puts it, "A main distinction between a painting and a photograph is that the painting alludes to its content, whereas the photograph summons it, from wherever and whenever, to us."[29] The relationship between the two media could be expressed in an analogy: painting is to fiction as photography is to nonfiction.

The recent emergence of computer-manipulated photography seems to have done little to shake the belief in a direct, physical link between photographs and their subjects. Viewers accustomed to computer-aged suspects on *America's Most Wanted* are apparently unconcerned about the media's ability to "improve upon" reality by such acts as Kathy Grove's electronically face-lifting Dorothea Lange's *Migrant Mother*; Benneton's printing a computer-imaged version of Sylvester Stallone as an African American, Spike Lee as a Caucasian; *New York Newsday's* placing Tonya Harding and Nancy Kerrigan side by side on the same ice; or *Forrest Gump's* repixilating the mouths of presidents. None of these examples attempts to deceive the viewer because all are obviously conditions contrary to fact. Journalistic ethics for digitally manipulated photography have so far maintained the standard that altering photographs for cover art is somehow different from working on the images within. Nevertheless, moving the pyramids of Giza to fit the cover of *National Geographic* caused a contro-

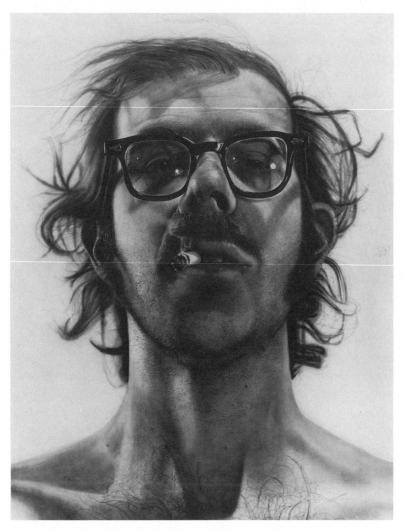

FIGURE 1.5. *Chuck Close,* Big Self-Portrait, 1968. *Acrylic on canvas, 107¹/₂ ×
83¹/₂ in. (Collection of Walker Art Center, Minneapolis Art Center Acquisition Fund,
1969)*

versy, as did darkening and altering O. J. Simpson's face on the cover
of *Time*, which in effect performed the opposite of portraiture's tradi-
tional retouching for enhancement.

One of the major reasons that digitally altered photography has not
significantly shaken the general belief that photographs represent "re-
ality" lies in the fact that many of the effects created by those with
access to Adobe Photoshop or Aldus PhotoStyler software were pos-
sible through earlier though more time-consuming craft or technol-

ogy, exemplified by the work of Jerry Uelsmann. Robert Heinecken, for example, is well known for having appropriated and reassembled existing images from magazines, newspapers, and pornography, as is Richard Prince, whose rephotographs of advertisements use the advertisement's language to undercut itself. Sherrie Levine goes one step further by simply photographing reproductions of famous images such as Edward Weston's *Torso of Neil.* The furor over the rearranged pyramids is not much different from a corresponding uproar over Arthur Rothstein's physically moving a cow skull while documenting the dust bowl.[30]

John F. Collins's arresting photograph *Self-Portrait (with multiple mirror simulation), 1925* (fig. I.6) confounds our perspectives about manipulation as much as many computer-altered images do. *Time*'s Simpson cover, although unethical and racist, is not significantly different from Nadar's nineteenth-century photographic portrait of Alexandre Dumas the elder, which Nadar wrote about in his autobiography, naming the physical characteristics of Dumas he chose to exaggerate: "All those hints of an exotic racial origin, and to bring out the simian echoes of a profile which immediately seems to ratify Darwin's theory . . . to squash that nose, all too fine in the original model, to enlarge those delicately incised nostrils, to tilt further the generous smile on those eyelids, to exaggerate . . . that fleshy lip . . . while not forgetting to give extra body and fluffiness to . . . his topknot."[31] Nadar's racist emphasis on the simian aspects of Dumas are electronically duplicated in a nonracist version by Chinese American photographer Daniel Lee, whose computerized *Manimals* combine images of animal eyeballs and other facial parts with portraits of humans born in the year of the monkey, ox, or tiger.

Just as the advent of photography was supposed to render painting obsolete, and television was reported to be the cause of *Life* magazine's former extinction, so reports of computer imaging eliminating photography are probably exaggerated, despite the subtitle of William Mitchell's book *The Reconfigured Eye: Visual Truth in the Post-Photographic Era.* As a counter to the recent tendency of computer-altered photography to put people into scenes, Alain Jaubert's *Making People Disappear* chronicles decades of propaganda photographs in which people were erased, well before the advent of the computer.

Some of those attracted to digitally altered photography have used the process for decades, such as Nancy Burson, whose computer composite portraits of humans and dolls, morphed mixtures of hu-

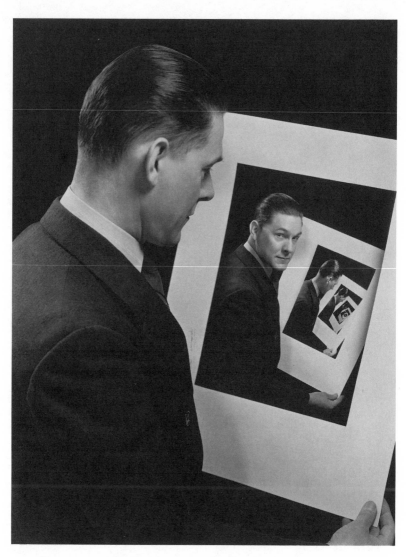

FIGURE 1.6. *John F. Collins,* Self-Portrait (with multiple mirror simulation), 1925. *Gelatin silver print, 14 × 11 in. (Collection of Audrey and Sydney Irmas, Gift of Irmas Intervivos Trust of June 1982, Los Angeles County Museum of Art)*

man faces, and nondigitalized portraits of children with craniofacial anomalies are all designed not to distort reality but to help redefine the narrow dictates of normality. Burson's *Composites* use the computer to blend such groups as Buster Keaton, Charlie Chaplin, and W. C. Fields into a composite perfect comedian; Sirhan Sirhan, Lee Harvey Oswald, and James Earl Ray as a perfect assassin; and Hitler, Mussolini, Stalin, Mao, and Khomeini as a composite big brother. A nondigital

version of Burson's composites was actually produced by Francis Galton, who combined multiple exposures into a sort of average, arguing that such "a composite portrait represents the picture that would rise before the mind's eye of a man who had the gift of pictorial imagination in an exalted degree."[32] Galton went on to use his composites to produce such "types" as the ideal family likeness, the criminal type, and the Jewish type.

Others have begun to use the process of digitally altered photography not as mere demonstrations of technology but to allegorize the past, such as Joseph DeLappe's autobiographical series "Legacies," 1992–93, which combine family photographs, material scanned from such documents as his grandmother's autobiography and suicide note, his own travel diary, and contemporary portraits to create images of the past in the present. In his "Second Generations," 1987, DeLappe works through suicide, parental abuse, and other autobiographical aspects of his childhood to create what he describes as "an illusory physical and psychological environment where I could interact with images of myself as a child." Writing of "I forgive you," 1987 (fig. I.7), which includes the adult photographer cupping his own head as an infant, DeLappe notes, "The series represents an attempt to forge a healing connection with the past by transforming it in the present. I forgave the past, and let it be the past, by reconfiguring the photographic documents of my life."[33]

In these compelling images DeLappe is not so much touching, as Eakin's title asserts, but retouching the world. A similar effect can be seen in the work of Clarissa Sligh, whose *Reframing the Past* uses family photographs, with handwritten comments and quotations from such ironic sources as the Dick and Jane readers, gathered into a collage that includes a picture of one of her brothers holding a nude figure onto which the photographer's face has been superimposed.[34]

Autobiography is a form of narrative characterized by a desire both to reveal and to conceal, an attempt at reconciling a life with a self, and as a result its power comes from the paradoxes I have been discussing throughout this chapter, the indeterminacy of its sense of reference to the world. The fact that life writing and light writing, both by definition and by common perception, have a strong felt relationship to the world, a relationship that on examination seems to disappear, is paradoxically what gives both forms of narration their unusual strength because this situation parallels the way all language works, as Derrida asserts: "There is no writing which does not devise some means of

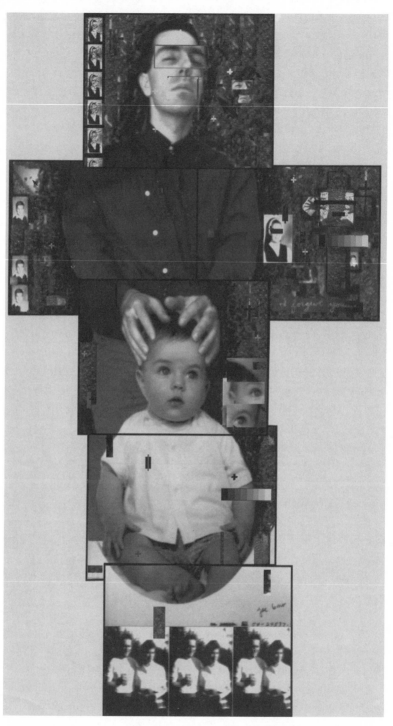

FIGURE I.7. *Joseph DeLappe, "I forgive you," 1987. (Courtesy of Joseph DeLappe)*

protection, to protect against itself, against the writing by which the 'subject' is himself threatened as he lets himself be written: as he exposes himself."[35] Arguing that the urge to conceal has been over-determined in much of the theoretical writing about Barthes, Eakin cites Barthes's use of the figure of the cuttlefish to represent the revealing/concealing inherent within the autobiographical act: "I am writing this day after day; it takes, it sets: the cuttlefish produces its ink: I tie up my image-system (in order to protect myself and at the same time to offer myself)."[36]

In short, autobiography and photography are commonly read as though operating in some stronger ontological world than their counterparts, fiction and painting, despite both logic and a history of scholarly attempts that seem to have proven otherwise. Barthes's description of a photograph could apply as well to autobiography: "a modest, shared hallucination (on the one hand 'it is not there,' on the other 'but it has indeed been'): a mad image, chafed by reality."[37]

In 1995 Norma Elia Cantú published a book that challenges my assertion that photographs of authors do not appear in fiction, and I want to write about it briefly here as one way of getting to the heart of the paradox inherent in the presence of photography within autobiography, as aptly described by Mary Price: "What is said about a photograph depends on what is perceived by the viewer, who must, according to the use intended for the photograph, resolve, explicate, or ignore the significant tension between 'heightened by life' and 'paralyzed by fact.'"[38] *Canícula: Snapshots of a Girlhood en la Frontera*, Cantú's 1995 Premio Aztlán winner, described in the University of New Mexico Press's catalog as a "fictionalized memoir" and in its Library of Congress Cataloging-in-Publication Data as "fiction," contains twenty-one snapshots and two documents illustrated with photographs. The book begins with a hand-drawn map and an introduction that explains that *Canícula* is the second installment in a trilogy that began with *Papeles de mujer* and will conclude with *Cabañuelas*. *Papeles de mujer*, a work entirely in Spanish containing "correspondence and documents that tell the story of a family in the geographical space between Monterrey, Mexico and San Antonio, Texas, from 1880 to 1950," would seem to be nonfiction; however, Cantú notes: "As in most fiction many of the characters and situations in these three works originate in real people and events, and become fictionalized."[39]

Turning to *Canícula*, she writes specifically: "The story is told through the photographs, and so what may appear to be autobio-

graphical is not always so. On the other hand, many of the events are completely fictional, although they may be true in a historical context. For some of these events, there are photographs; for others, the image is a collage; and in all cases, the result is entirely of my doing. So although it may appear that these stories are my family's, they are not precisely, and yet they are."[40] Like Sheila and Sandra Ortiz Taylor's *Imaginary Parents*, *Canícula* is told in numerous small segments, often no more than a paragraph, and includes prose descriptions of photographs not physically reproduced. The photographs that are actually in the text appear to be genuine family snapshots, black-and-white images reproduced with creases, wrinkles, handwritten dates, scalloped edges, and mounting corners as if taken directly from the Cantú family album. In what sense, then, does the story appear to be more autobiographical than it really is?

Comparing the actual photographs with the prose that describes them reveals countless small discrepancies between the words and the corresponding image. For instance, the first photograph, which appears above a prose section titled "May," is accompanied by this description: "Dahlia, Bueli, Tino, cousin Lalo, and I pose one balmy May evening in front of the four-room frame house on San Carlos Street. I and Dahlia wear white organdy—recycled first communion garb. I am all long skinny legs and arms and a flash of white teeth."[41] Although the photograph does show just such a scene, it is unclear who the "I" narrator is—no one in the picture is smiling enough to show any teeth. The first-person narrator describes the last photograph in the book as "a rare photo where I smile unconsciously showing teeth, the broken tooth—the reason I never smile for photos—unnoticeable."[42] Assuming that the narrator is the author is complicated by the book's prologue. While the introduction is signed Norma Elia Cantú, the unsigned prologue begins with an autobiographical narrative of a character referred to as "Nena" who learns of Roland Barthes's death, alludes to *Camera Lucida*, and returns to her childhood home on San Carlos Street in Laredo, Texas, to sort through shoeboxes of old photographs with her mother and other family members before writing her story of a girlhood on the borderland between Laredo and Nuevo Laredo. One of the documents in the text is a "Filiacion" with a photograph of Norma Cantú and an address on San Carlos Street, an official affiliation that claims she is a Mexican national though its actual purpose is to allow her to travel into Mexico without her parents. The document is in Spanish, though the street

address is in Texas, and the official signature is of "Azucena" rather than "Norma" Cantú, the latter a name that does not appear anywhere within the pages of the text. A closer look reveals that the signature has been pasted over another signature, a metaphoric representation of the author's life on the border and of her identity under erasure. Nena is a generic name for a small child, especially the first-born girl, and also a nickname for Azucena, Spanish for Lily.

The first-person pronoun often appears in the text, as in the description that accompanies the author's eighth-grade school picture, in the section called "Body Hair": "An awkward teen, shy and reticent, I face the camera, wearing a sleeveless, morning-glory-blue cotton blouse." Sometimes, however, individual images are captioned in the third person. For example, "Nena of Three" is described as follows: "The three-year-old girl looks off camera, probably at her father who dangles a pair of keys to make her laugh, or at least smile."[43]

How then is this book fiction instead of autobiography? The author's answer, from her prologue, is that she "was calling the work fictional autobiography, until a friend suggested that they really are ethnographic and so if it must fit a genre, I guess it is fictional auto-bioethnography."[44] Although Cantú is herself an English professor, well aware of the complications of genre in literary study, finally it's hard to see how her book is significantly different from almost any other autobiography in terms of its fictionalizing. In response to my question "how do you see the relationship between actual photographs and 'fictionalized memoir,'" Cantú replied: "All I can answer is that my book is about memory, and photos are one way of 'freezing' memories just like words are one way of 'freezing' thoughts—and yet both are tenuous and fleeting. We remember differently from what the photo 'freezes' and our words often don't quite express what we think/feel. I work with the ideas of memory and writing—but all in a cultural context of the border which itself is fleeting and fluid."[45] Finally Cantú, like all autobiographers, wants to have it both ways, wants her book to be taken as an authentic representation of her Chicana childhood and yet wants to protect herself from family members and others who might argue that she has made things up. She wants the freedom to reveal details of her life, coupled with the freedom to conceal the degree to which she has changed the events to suit the needs of narrative. She wants her book to stand for any young Chicana woman growing up along the Mexico-Texas border in the 1950s. And in the end she has written a book that I would call simply

autobiography, a book that like all autobiographies exists on *la frontera*, the borderland between fiction and nonfiction.

Norma Cantú's inclusion of actual photographs of herself, even though they are often captioned fictionally and operate within a semifictional narrative, clearly illustrates the unique referential power of photography, for no matter how much she wishes to efface herself or make her childhood emblematic of a generic Chicana childhood, photographs, unlike drawings, are always specific rather than general. This distinction is nicely demonstrated in Ingrid Sischy's comparison of Roger Tory Peterson's classic *A Field Guide to the Birds* (drawings) and the Audubon Society's *Field Guide to the North American Birds* (photographs). "The photographs show *a* bird at *a* given moment," Sischy writes, "but the drawings generalize, conceptualize a particular bird-essence. The photograph shows a real bird in a real place and because of its inclusive depiction, often glosses over the most palpable, identifying details pertinent to *that family of birds*."[46]

Warning her readers that the book is somewhat fictional but includes nonfictional photographs directly linked to the author does not finally undercut my assertion that the presence of photographs of the author within a text constitutes a clear sign that we are reading autobiography. Instead this situation only reinforces the parallels between photography and autobiography because Cantú's disclaimers operate in a fashion similar to our disclaimers about photography in general. Just as we all know that photographs are not always accurate likenesses because some people are more photogenic than others, so some people's lives are similarly more compelling because of a quality we might call being "autobiogenic." Because almost anyone can take a competent photograph and there's always a possibility that an amateur might take a great photograph, detractors have often claimed that photography was not really an art, just as the fact that all autobiographers have a built-in plot made some critics see autobiography initially as a less than literary form. We claim that photographs are effective on identification cards and drivers' licenses though we all hate our own driver's license photo. We pretend to the claims of accuracy for photographs because we all know that there's always the possibility that we will appear more attractive or interesting in a particular photograph than we actually do in real life. In all these ways photography and autobiography operate in a parallel fashion, both deliberately blurring the boundaries between fact and fiction, between representation and creation. According to Stephen Melville, "photography seems at once

to dissolve identity of self and of medium and to discover these things" because it "has the peculiar power to insist upon allegory not as a trope of hiddenness but as one of revelation."[47]

In an essay titled "What Photography Calls Thinking," Stanley Cavell explains that part of the problem in trying to pin down how photographs represent lies in the language we use: "A representation emphasizes the identity of its subject, hence it may be called a likeness; a photograph emphasizes the existence of its subject, recording it, hence it is that it may be called a transcription."[48] Transcription could apply as well to the way autobiography emphasizes the existence of its author, often including within the text examples of the autobiographical act. What I have often described as autobiography's most salient feature—an attempt at reconciling authors' sense of self with their lives through an art that simultaneously reveals and conceals—is at the heart of the photographic act as well. As Nancy Shawcross puts it: "Historically, photography is the product of two predominant impulses: one being the effort to fix the image of the camera obscura, the other being the struggle to control and ultimately to halt the chemical reactions set in motion when light is brought to bear on certain substances such as silver salts."[49]

In the chapters that follow, I consider the ideas raised in this introduction in the cases of eleven different autobiographers, using as my approach—not an attempt to make artificial distinctions between fiction and nonfiction, between autobiography and other forms of life writing, between portraits and self-portraits, or between art photographs and those found in family albums—but instead focusing on the borders between each of those oppositions where actual authors have themselves deliberately blurred such distinctions. My major themes are family albums, ancestral ghosts, uses of documentary, likeness and copy, surface and depth in photographs, relations between photographs and their captions, posing, turning photographs into narrative, actual photographs, withheld photographs, fictional photographs, trick photographs, damaged photographs, and photographic metaphors.

Writing the Picture

··

*Autobiographies
with Few or No
Photographs*

> *The art of memory recalls us not to the life*
> *we have lost but to the life we have yet to live.*
> —*Paul John Eakin*

1 | Camera Obscura
Paul Auster

Paul Auster's 1982 memoir is a two-part invention: "Portrait of an Invisible Man" and "The Book of Memory." In the first section, Auster attempts to fix some aspect of his father's personality by examining hundreds of photographs he discovers while sorting through his father's belongings following his unexpected death. One of the pictures is reproduced within the text of *The Invention of Solitude*, and another appears on the book's cover. In the second section, a character called A. ruminates on the autobiographical act and the complicated lines of interconnection between Samuel Auster, the author's father, and Daniel Auster, his son.

The Invention of Solitude is a self-consciously literary portrait of fathers and sons, in some ways similar to such autobiographical narratives as Tobias Wolff's *This Boy's Life*, Geoffrey Wolff's *The Duke of Deception*, Philip Roth's *Patrimony*, and Clark Blaise's *I Had a Father*. Unlike the personal narratives just named, however, Auster's book attempts to subvert the congruence of protagonist, subject, and narrator by various devices, including writing in the third person and reproducing two photographs that problematize rather than supplement or document the narrative.

Speaking about the book in interviews, Auster deliberately distances himself from autobiography: "But, in spite of the evidence, I wouldn't actually say that I was 'writing about myself' in either book. *The Invention of Solitude* is autobiographical, of course, but I don't feel that I was telling the story of my life so much as using myself to explore certain questions that are common to us all."[1] Considering that he often includes his own name within his other books, which are classified as novels, and that he backs away from autobiography or biography as accurate terms for this book, it seems at first odd that he would include a photograph on the cover and another as a frontispiece and allow it to be published, in the first Penguin edition, with the subtitle *A Memoir*.

Because the section that concentrates on Auster's father is narrated in the first person and includes prose descriptions of the two actual photographs, it seems to exist on a different narrational level than the second section, which often talks about particular photographs but does not reproduce them physically. However, the two photographs that actually appear in the book are problematic in terms of questions of portraiture because they constitute different kinds of trick photography. And as Roland Barthes has reminded us, tricks in photographs are particularly confusing: "The methodological interest of trick effects is that they intervene without warning in the plane of denotation; they utilize the special credibility of the photograph—... its exceptional power of denotation—in order to pass off as merely denoted a message which is in reality heavily connoted."[2]

In naming the first half of his book "Portrait of an Invisible Man," Auster suggests that portraiture might be an appropriate term for the genre in which he writes; however, the essentially blank nature of his father's personality would seem to undercut the possibility of satisfying even the most straightforward of the requirements for portraiture: a subject. "He did not seem to be a man occupying space, but rather a block of impenetrable space in the form of a man," writes the author.[3] In phrase after phrase, Auster describes his father as an absence, a man "unwilling to reveal himself under any circumstances" (7), "a tourist of his own life" (9), "a man without appetites" (17) "whose capacity for evasion was almost limitless" (15), a father who "never talked about himself, never seemed to know there was anything he *could* talk about" (20).

If portrait is not exactly the right term for the book, perhaps self-portrait would be more accurate, for *The Invention of Solitude* is as much

about Paul Auster as it is about his father. In his book-length study of the *literary* self-portrait, Michel Beaujour describes a type of life writing that is "not quite an autobiography," exemplified by such texts as Malraux's *Anti-Memoirs*, Montaigne's *Essays*, Nietzsche's *Ecce Homo*, and *Roland Barthes by Roland Barthes*. According to Beaujour, "the self-portrait must tack about so as to produce what, essentially, turns out to be the interlocking of an anthropology and a thanatography," which, he argues, "attempts to create coherence through a system of cross-references, anaphoras, superimpositions . . . in such a way as to give the appearance of discontinuity, of anachronistic juxtaposition, or montage, as opposed to the syntagmatics of a narration, no matter how scrambled."[4] Auster's book satisfies Beaujour's call for a system of cross-references; the second part, "The Book of Memory," is connected contrapuntally to the first through such themes as solitude, memory, coincidence, enclosed spaces, differences between fictional and real selves, parallels between Auster as author and A. the character—all connected to other portraits, sometimes literal, of famous fathers and sons, including Rembrandt and Titus, Abraham and Isaac, Mallarmé and Anatole, and especially Gepetto and Pinocchio.

As a title "The Book of Memory" has a double self-consciousness about it, for it is both the title of the second section of *The Invention of Solitude*, which as a memoir *is* a memory book, and a recurring refrain within that section, subdivided into numerous separate books, at times taking on a life of its own. At one point Auster refers to the book of memory as if it actually existed as a separate entity: "The Book of Memory. Book Four. Several blank pages. To be followed by profuse illustrations. Old family photographs, for each person his own family, going back as many generations as possible. To look at these with utmost care" (97).

Although the "profuse illustrations" are not actually present in *The Invention of Solitude* as physical objects, they are constantly referred to throughout the text, in the form of descriptions of famous painted portraits, photographs of Anne Frank's room, pictures of Auster's son, and many other images. In placing these "real" photographs within an imaginary book of photographs, which is itself a part of an actual section of a book called "The Book of Memory," Auster manages to duplicate the effect of our actually looking at photographs of the dead. As Harold Rosenberg observes in his "Portraits: A Meditation on Likeness": "It is in being semi-fictional that photo portraits attain the reality of change and conflict which belongs to the represen-

tation of the living. In portraits of the dead, the fictional aspect is less important, since what has been concealed by the sitter or ignored by the portraitist is now unlikely to emerge and become effective—in short, it has ceased to count."[5] Just as the *Invention of Solitude* exists on the boundaries between fiction and nonfiction, so A., the narrator of "The Book of Memory," has a fictive fictionality about his disguise. Not only is his initial "A." the same as Auster's, but in talking about telling stories to his son, who has the same name as Auster's, A. notes that his son Daniel prefers invented stories in which A. uses his actual name. At that point in the narrative, A. unmasks himself: "He speaks of himself as another in order to tell the story of himself. He must make himself absent in order to find himself there. And so he says A., even as he means to say I" (154).

Both sections of *The Invention of Solitude* are also united by a common narrative thread: Paul Auster's drive to rescue his father so as to become himself both a better father and a better son. The closing words of "Portrait of an Invisible Man" are: "An image of Daniel now, as he lies upstairs in his crib asleep. To end with this. To wonder what he will make of these pages when he is old enough to read them" (69). Because his father's death provided Auster with both a subject about which to write and a small inheritance that allowed him to continue his writing career, he has accrued a double debt to Sam Auster. As Pascal Bruckner tells us in an essay called "Paul Auster, or The Heir Intestate," originally published as the afterword to the French translation of *The Invention of Solitude*, "The father's death not only liberated his son's writing but literally saved his life. The son would never stop repaying this debt, would never finish reimbursing the deceased, in prose, for his fearsome gift."[6]

When Auster uses the metaphor of ventriloquism to describe his father's invisibility, calling him "a puppeteer working the strings of his alter-ego from a dark, solitary place behind the curtain" (16), he emphasizes the narrative's common thread as exemplified in the Collodi version of *The Adventures of Pinocchio*, the children's story he most often reads to his son: "For this act of saving is in effect what a father does: he saves his little boy from harm. And for the little boy to see Pinocchio, that same foolish puppet who . . . is not even a real boy, to become a figure of redemption, the very being who saves his father from the grip of death, is a sublime moment of revelation. The son saves the father. This must be fully imagined from the perspective of the little boy. . . . *Puer Aeternus*. The son saves the father" (134).

By the words "the perspective of the little boy" Auster wants to understand the perspective of all three Austers as little boys: to become a better father to Daniel, Paul must save Samuel from death and obscurity by writing *The Invention of Solitude* or risk not only not being a good father but not being a real boy. The memoirist, performing as the puppet for his father, must also manipulate Daniel, whose sudden onset of "pneumonia with asthmatic complications" is signaled by his "curious, almost mechanical voice" speaking "as though he were a ventriloquist's dummy" (107). In ventriloquizing both himself and his son, Auster is employing the classic rhetorical figure of prosopopoeia, which Paul de Man describes in his well-known essay "Autobiography as De-Facement" as giving "face to the faceless" and "voice to the voiceless." De Man describes "the figure of prosopopoeia" as "the fiction of an apostrophe to an absent, deceased, or voiceless entity, which posits the possibility of the latter's reply and confers upon it the power of speech."[7]

Samuel Auster was a man of no affect, an invisible man who left no traces, except for a few personal effects, including "several hundred photographs—stashed away in faded manilla envelopes, affixed to the blank pages of warped albums, scattered loosely in drawers," along with "one very big album, bound in expensive leather with a gold-stamped title on the cover—This is Our Life: The Austers[, which] was totally blank inside" (13–14). The Auster album is empty because, as Marianne Hirsch reminds us, "family albums include those images on which family members can agree and which tell a shared story."[8] The point of Auster's memoir is to create "a shared story," the story of the family's lack of story and the author's need to share stories with his son.

"This is Our Life: The Austers" would in a sense be an appropriate title for *The Invention of Solitude*, a book in which the author creates and restores four generations of the family's history by sorting through the loose photographs, selecting two as representative documents. In addition to memoir, portrait, and self-portrait, another possible genre for Auster's book might be "photofiction as family album," which Brent MacLaine describes as a subgenre exemplified by such texts as Larry Woiwode's *Beyond the Bedroom Wall: A Family Album*, Joy Kogawa's *Obasan*, David Galloway's *A Family Album*, Anita Brookner's *Family and Friends*, and Michael Ondaatje's *Coming through Slaughter*, a book I discuss in chapter 6.[9]

Looking over a set of photographs he had never seen, Auster is un-

able to replicate the funeral function of photography, as described by Pierre Bourdieu: "There is nothing more decent, reassuring and edifying than a family album; all the unique experiences that give the individual memory the particularity of a secret are banished from it, and the common past . . . has all the clarity of a faithfully visited gravestone."[10] The Auster album is empty because the photographs reveal family secrets and the author is himself responsible both for erecting a gravestone and for writing his father's epitaph as he wrote the obituary actually delivered by another, in yet another act of ventriloquism.

With Auster having written of his father, "It was never possible for him to be where he was. For as long as he lived, he was somewhere else, between here and there" (19), the author's discovery of an unknown cache of photographs is particularly important because, as Susan Sontag asserts, "photographs show people being so irrefutably there and at a specific age in their lives."[11] In photographs, his father's lifelong habit of never dropping his pose might somehow be canceled by the need to strike a pose implicit in portraiture, as described by Max Kozloff: "In portraits the self's ongoing effort at impersonation stops somewhere along the line and is modified, undone, or enriched by the self that doesn't know how to be impersonated."[12] Or, as Auster puts it, "He was so implacably neutral on the surface, his behavior was so flatly predictable, everything he did came as a surprise" (20).

Auster writes: "Discovering these photographs was important to me because they seemed to reaffirm my father's physical presence in the world, to give me the illusion that he was still there. The fact that many of these pictures were ones I had never seen before, especially the ones of his youth, gave me the odd sensation that I was meeting him for the first time, that a part of him was only just beginning to exist" (14). A number of photographs are described in the text in prose, including pictures of Auster's mother and father on their honeymoon, as well as a number of pictures of his father as a young man that Auster allowed to be reproduced in an issue of the photography magazine *Aperture* called "Self and Shadow."[13]

However, only two photographs are actually reproduced in the text, the first of which is the picture on the cover of what looks like five men sitting around a table (fig. 1.1). On closer inspection this group portrait turns out to be a trick photograph; actually all five men are the author's father seen from different angles, reflected in mirrors in Atlantic City. This particular type of trick photograph is quite common; another example is a photograph of Marcel Duchamp,

FIGURE I.I. *Cover Photograph*, The Invention of Solitude.

taken in 1917 by his friend Henri-Pierre Roche.[14] Describing Roche's picture, Dawn Ades writes, "Duchamp appears to be looking at himself, but not at himself looking at himself."[15] This description of Duchamp is particularly apt for Auster's father, a person completely "solitary in the sense of retreat. In the sense of not having to see himself, of not having to see himself being seen by anyone else" (*Invention*, 16–17).

Commenting on the picture on the cover of *The Invention of Solitude*, Auster writes:

> Because of the gloom that surrounds them, because of the utter stillness of their poses, it looks as if they have gathered there to conduct a seance. And then, as you study the picture, you begin to realize that all these men are the same man. The seance becomes a real seance, and it is as if he has come there only to invoke himself, to bring himself back from the dead, as if, by multiplying himself, he had inadvertently made himself disappear. There are five of him there, and yet the nature of the trick photography denies the possibility of eye contact among the various selves. Each one is condemned to go on staring into space, as if under the gaze of the others, but seeing nothing, never able to see anything. It is a picture of death, a portrait of an invisible man. (31)

In conducting his own seance, calling his father back from the dead, treating the photographs as "irresistible, precious, the equivalent

FIGURE 1.2. *Frontispiece,* The Invention of Solitude.

of holy relics" (14), Auster echoes the words of the subject of chapter 9 of this study, the novelist/photographer Wright Morris, who writes, in his *Time Pieces: Photographs, Writing, and Memory,* "Invoking memory's presence may prove similar to a seance. Is it really him, we wonder, or an impostor. Imagination can be lured, but not willed, to do this restoration for us."[16] The cover picture is also emblematic of Auster's

realization that "at times I have the feeling that I am writing about three or four different men, each one distinct, each one a contradiction of all the others" (61).

In addition to the cover photograph, the other actual photograph within the text is a group portrait (fig. 1.2), including Samuel Auster as a baby sitting on his mother's lap, that has been torn apart and awkwardly mended so that Auster's grandfather's image is no longer present. Auster describes the photograph as follows: "And then I realized what was strange about the picture: my grandfather had been cut out of it. The image was distorted because part of it had been eliminated. My grandfather had been sitting in a chair next to his wife with one of his sons standing between his knees—and he was not there. Only his fingertips remained: as if he were trying to crawl back into the picture from some hole deep in time, as if he had been exiled to another dimension" (34). In describing himself at the start of "The Book of Memory" as suffering in solitude while trying to write this book, Auster uses virtually the same phrases: "It is as if he were being forced to watch his own disappearance, as if, by crossing the threshold of this room, he were entering another dimension, taking up residence inside a black hole" (77).

The description of the grandfather living inside the photograph, one of many images of Austers living in dark, enclosed spaces, parallels a general argument among photography critics who have thought of photographs in terms of their transparency and the sense of penetrating their surface from the outside in. In this case the author is imagining his grandfather coming back into the picture, crossing back from the inner to the outer surface. And while he refers to his book's first half as a "Portrait of an Invisible Man," in the combination of looking at pictures and writing his memoir, Auster is beginning to see something besides his father's missing traces, for as Kendall Walton reminds us, "To be transparent is not necessarily to be invisible. We see photographs themselves when we see through them."[17]

In this portrait of an invisible man (the grandfather) within another portrait of an invisible man (Sam Auster), we have a literal example of Roland Barthes's famous description of the photograph's *punctum*, the "element which rises from the scene, shoots out of it like an arrow, and pierces me . . . this wound . . . sting, speck, cut, little hole."[18] The photograph that serves as a frontispiece to *The Invention of Solitude* has literally been punctured, a hole cut through its surface. Subsequent research revealed to the memoirist that his father's father had been

murdered by his father's mother, a fact that had been suppressed in family history as awkwardly as the photograph had been mended. Unlike the photographs not reproduced in Maxine Hong Kingston's or the Taylor sisters' autobiographies, the subjects of my next two chapters, the photograph in this case contains a person not reproduced. A similar situation occurs in "The Absence of George Alexander," which Alexander describes as "an autobiography by disappearance, or by backgrounds," made entirely out of "snaps from the photo album reprinted with my image cut out of every one."[19]

Like Maxine Hong Kingston's father, Auster's father has multiple stories about his past: "During my own childhood," notes Auster, "he told me three different stories about his father's death. In one version he had been killed in a hunting accident. In another, he had fallen off a ladder. In the third, he had been shot down during the First World War" (33). As a consequence of the murder, the subsequent trial in which the Auster children were called on to testify, and the eventual exoneration of their mother, "the four brothers stuck together. . . . Although they had their differences . . . I think of them not as four separate individuals but as a clan, a quadruplicate image of solidarity" (49). This "quadruplicate image" of four brothers as one is another echo of the book's cover photograph.

In addition to acting as an example of a Barthesian *punctum*, the "wound" in the frontispiece is especially important as a physical emblem of the wound that the author of the memoir feels, both as he looks at the picture and as he writes about it. Moving from biography to autobiography, Auster describes himself actually suffering as he attempts to write about his father: "afflicted, cursed by some failure of mind to concentrate," he says of the auto/biographical act; "Never before have I been so aware of the rift between thinking and writing" (32), an unconscious echo of his earlier descriptions of his father as not seeming to be present to himself: "Often, he seemed to lose his concentration, to forget where he was, as if he had lost the sense of his own continuity" (29). Describing the experience of watching an experimental version of *Hamlet* without any words, George Alexander says, "It revealed . . . the way cut-out photos make you realise the strange *voodoo* that exists between a person and his image even when we live in a time that doesn't operate with those equations."[20]

The author's description of his father as inhabiting "a dark, solitary place behind the curtain" (16) and that of his grandfather as having "taken up residence inside a black hole" (77) are two examples of the

many occurrences throughout both sections in which Auster uses the image of a dark room to suggest the atmosphere in which a whole family of male Austers seem to thrive. In this sense *The Invention of Solitude* could be thought of as another Auster detective novel in the classic format of "the locked room," in this case the solitary room being both literal and figurative, the actual room Auster occupies on Varick Street in Brooklyn as he writes the book we are reading, and the dark rooms in which he tries to develop photographic memories of an invisible man.

Having described his father as being "neither here nor there," Auster thinks of himself, during the "Winter solstice: the darkest time of the year," in which he hardly leaves his apartment, "as if he were living somewhere to the side of himself—not really here, but not anywhere else either" (78). "There is no light to sink his teeth into, no sense of time unfolding" (78), he continues. Like his friend, known only as S., who lived in Paris in a tiny room that was "covered with heavy black cloth" so "the sun did not penetrate" (90), Auster comes more and more to work on his portrait in the dark. Before his father's death, Auster and his wife had been depressed at the darkness within the family's house, the camera obscura in which his father lived. "Finding the darkness of the house oppressive, we raised all the shades to let in the daylight. When my father returned home from work and saw what we had done, he flew into an uncontrollable rage, far out of proportion to any offense that might have been committed" (31). Although he is ill at ease in the dark house while his father is still alive, once his father has died and the author is at work on reviving his image, Auster now finds himself at home in black enclosures, his penchant for the dark room eventually paralleling an imagined entry into his father's grave: "A feeling that if I am to understand anything, I must penetrate this image of darkness, that I must enter the absolute darkness of earth" (33).

In all these instances of darkness, Auster's attempt to produce a portrait of an invisible man, a portrait that slowly takes shape as he writes a self-portrait, the memoirist's language, with its photographic overtones, suggests the reversal of light and dark that characterizes the photographic act, the action of light that first produces a negative. As Carol Armstrong explains, in a passage that includes Auster's characteristic emphasis on chance: "For all its sightedness, there is also a kind of blindness that characterizes the practice of photography—the photographic process is split into acts of vision and functions accom-

plished by touch alone, in the dark (darkness and blindness are funda-
mental to the names given to photography's places of operation such
as the *camera obscura*, the dark cloth, and the darkroom). . . . So the
intentionality of photographic vision is inflected not only by chance
and reflex but by an unknowingness that is just as fundamental to it as
light."[21] Although Daniel is in one case also depicted as living within a
closed space described with a photographic metaphor—in an emer-
gency brought on by his sudden breathing problems, he is placed
within "a vapor machine with a hood, reminiscent of a nineteenth
century camera" (107)—he is usually associated not with darkness but
with light. For instance, on showing a photograph of Daniel to a
friend, R., the friend says of the image, "He has the same radiance as
Titus" (113).

Disturbed, not so much by his father's death as by his own inability
to write about it, Auster describes himself as having undertaken an
absurd task. "When I first started, I thought it would come spontane-
ously in a trance-like outpouring," he writes, adding, "So great was my
need to write that I thought the story would be written by itself" (32).
By the end of the memoir, he is reduced to fragmentary descriptions
of the autobiographical act: "He stares at the ceiling. He closes his
eyes. He opens his eyes. He walks back and forth between the table
and the window. . . . He finds a fresh sheet of paper. He lays it out on
the table before him and writes these words with his pen. It was. It will
never be again. Remember" (172). Unable to salve his wounds by
making his invisible father visible, the writer ends by beginning again,
endlessly trying to write about Samuel Auster by using literary allu-
sions and parallels, all the while realizing that the attempt itself is just
as impossible as his childhood attempts to impress his father, through
either his writing or his athletic ability: "Whether I succeeded or failed
did not essentially matter to him. I was not defined for him by any-
thing I did, but by what I was, and this meant that his perception of me
would never change, that we were fixed in an unmovable relationship,
cut off from each other on opposite sides of a wall" (24).

Cut off now from his father by death, Auster comes to see that
writing *The Invention of Solitude* has not been therapeutic but wounding,
not so much portraiture as self-portraiture: "The book wasn't written
as a form of therapy; it was an attempt to turn myself inside-out and
examine what I was made of."[22] Originally he wrote that looking at the
newly found photographs of his father seemed not so much to bring
his father back from the dead as to keep him from dying: "As long as I

continued to study them with my complete attention, it was as though he were still alive, even in death. . . . Or rather, somehow suspended, locked in a universe that had nothing to do with death" (14). But after having attempted to use the photographs as documents, as proof of his father's existence as a son before he was a father, as if somehow Auster's own failures as a son had been responsible for his father's invisibility, the author comes to a striking confession:

> There has been a wound, and I realize now that it is very deep. Instead of healing me as I thought it would, the act of writing has kept this wound open. At times I have even felt the pain of it concentrated in my right hand, as if each time I picked up the pen and pressed it against the page, my hand were being torn apart. Instead of burying my father for me, these words have kept him alive, perhaps more so than ever. . . . Each day he is there, invading my thoughts, stealing up on me without warning: lying in the coffin underground, his body still intact, his fingernails and hair continuing to grow. A feeling that if I am to understand anything, I must penetrate this image of darkness. (32–33)

In this image—familiar from a range of sources as wide as Donald Barthelme's *The Dead Father—"dead, but still with us, still with us, but dead"—Hamlet*, and Sylvia Plath's "Daddy"—we see that his perusal of these photographs has affected the author far more significantly than his actual relationships with his father and that in using photographs to get back to the past, Auster has felt more than metaphorical wounds.

Although he has struggled to penetrate his father's facade, to go behind the surface of both the grave and the pictures, Auster has actually shown, through his use of photographs as through his repeated metaphor of Gepetto and Pinocchio, that in many ways the silent, manipulative father is still controlling the apparently animated but actually wooden son. When asked in another interview why he chose to write the second section of the memoir in the third person, Auster answered: "What it came down to was creating a distance between myself and myself. . . . It's the mirror of self-consciousness, a way of watching yourself think."[23]

In this description, as in much of *The Invention of Solitude*, he consciously blurs portraiture and self-portraiture, echoing his father's trick photograph in this tricky postmodern memoir. According to Adam Begley, "Auster is not given to confession," a statement sup-

ported by novelist Russell Banks, part of Auster's circle of friends, who says, "One way to keep his private life private is to smooth over the seams."[24] Russell Banks may be accurate in describing Auster's having chosen to present an apparently seamless private life to his friends in his "real life," a notion seconded by Gerald Howard, Auster's first editor, who notes, "Paul has got his mental ecology in balance—he saves the dark stuff for his art."[25] The way photographs reveal aspects of dailiness that are not always apparent, according to Andy Grundberg, suggests another reason for Auster's having including two photographs within his text: "Indeed, the camera sometimes seems to leak subconscious information unintentionally, and to catch the everyday world at moments when its seams are most exposed."[26]

In the darker aspects of *The Invention of Solitude*, Auster is in danger of being seen as reenacting the vacuous or opaque self-multiplication of the cover's photograph by doubling himself as autobiographer, reenacting as well his father's distancing and invisibility by taking cover behind the third-person pronoun and the initial A. But in simultaneously burying his father and resurrecting him through writing the darker aspects of their shared and unshared past, in suturing the wounds but leaving the scars as visible as the raw seam of the torn photograph, Paul Auster saves himself from the family's love of solitude, while simultaneously saving his father and his son. The following summary of *The Adventures of Pinocchio* could also serve as Auster's summation of his own autobiographical and familial act: "And it is in this darkness, where the puppet will eventually find the courage to save his father and thereby bring about his transformation into a real boy, that the essential creative act of the book takes place" (*Invention*, 163).

For all the book's postmodernism, *The Invention of Solitude* is profoundly relational and, in a sense, referential—if not reverential—gracefully performing a variety of the functions of life writing, serving not just as biography, autobiography, memoir, portraiture, self-portraiture, and family album but also as confession, eulogy, and epitaph. A consideration of photography and *The Invention of Solitude* demonstrates that Paul John Eakin's call for reopening autobiography's reference file might profitably be expanded to include renaming and merging that file into other directories and making use of a computer with full multimedia capabilities.

Using the newly discovered photographs of his father as one reference source on which he depends as he writes his autobiography,

Auster sees the images not as reminders of the past but as evidence for the present. Because he has never seen his grandfather, or any photograph of him, and because the images of his father as a young man depict a person Auster never knew, he uses the photographs not to reinforce memory but to invent memory. As Edmund Blair Bolles notes in a definition of memory that sounds very much like a definition of autobiography: "Memory is a living product of desire, attention, insight, and consciousness."[27]

Like Sheila Ortiz Taylor, whose autobiography I will be considering in detail and who refers to herself as a family detective, Auster is described in the afterword to the French translation of *The Invention of Solitude* as a "detective of the self."[28] The two photographs he chooses to reproduce within *The Invention of Solitude* from the hundreds available are clues for his detective work, clues that reveal not only what might have happened to his father but also warnings about what might happen to him and his child. As Mary Price reminds us, "Photography is neither mirror with a memory nor window but a picture of that which is about to become a memory, a capturing of what, in the present which is about to become the past, is to be remembered."[29]

One of the themes of "The Book of Memory" is the interconnectivity between memory and imagination and the way classic memory systems, what Auster calls "mnemotechnics," depend on "places and images as catalysts for remembering other places and images" (*Invention*, 76). Just as the classic mnemotechnic known as "The Memory Palace" uses the rooms of an imaginary palace as imaginary locations for objects to be remembered, so Auster uses the recurring images of a solitary life within dark rooms as a memory device. For Paul Auster, his father's solitary, surface existence within a closed-up house becomes itself a metaphor for his own memory.

It is among that legion of phantoms,
fixed momentarily by the camera,
that we can find one way "to read
what has never been written."
—*Liz Heron*

2 | Sojourner Truth
Maxine Hong Kingston

Although no actual photographs appear in either of Maxine Hong Kingston's two autobiographical works, both *The Woman Warrior* and *China Men* are filled with prose descriptions of family photographs that contributed significantly to the complex combination of documentation, memory, and imagination that lies behind the author's improvisations. Because she often writes about other family members as much as about herself in *The Woman Warrior* and *China Men*, both texts fall somewhere between autobiography and memoir, and photography is a revealing metaphor for the double exposure inherent in her autobiographical act.[1] That Kingston is in this liminal stage, exposing her own family pictures, makes hers a complicated task of balancing the "double bind" of her Chinese American identity.

Like Kingston's ethnic identity, impossible to divide cleanly into Chinese or American parts, autobiography is also in what Diana Chang has called "the hyphenated condition,"[2] neither fiction nor history nor exactly a combination of the two but a genre of its own, a complex equation designed to tell the story of a person's life with whatever degree of invention is needed to reconcile one's self with one's life. For Kingston the hyphenated condition of her relation to

her Chinese ancestry is more bothersome than the hyphenated condition of her autobiographical books. "And lately I have been thinking that we ought to leave out the hyphen in 'Chinese-American,'" she writes, explaining that "the hyphen gives the word on either side equal weight, as if linking two nouns. It looks as if a Chinese-American has double citizenship, which is impossible in today's world. Without the hyphen, 'Chinese' is an adjective and 'American' a noun; a Chinese American is a type of American."[3]

Perhaps the former high school English teacher in her allows Kingston to attempt to reconcile her ethnic identities through punctuation; however, she is not so precise in straightening out the generic categorization of her first two books. While *The Woman Warrior* is subtitled *Memoirs*, *China Men* stands alone as a title, though both are categorized on the back of the Vintage International editions as "nonfiction/literature." Often treated as autobiographies, the books have also been called epics, historical fictions, dreams, elegies, cultural histories, and family history. Kingston first thought of both books as part of one long volume, an epic novel, actually writing sections of each simultaneously. According to Kingston, both are examples of "a new kind of biography," which she describes as "biographies of imaginative people . . . the imaginative lives and dreams and fictions of real people."[4]

Well after both books had been published and reviewed, Kingston noted, "After going back and forth on my classification for a couple of years, I've decided that I am writing biography and autobiography of imaginative people," adding, "I invented new literary structures to contain multi versions and to tell the true lives of non-fiction people who are storytellers."[5] Kingston is not saying here that *The Woman Warrior* and *China Men* are biographies of imaginary people but of imaginative ones, though she adds that she only realized what she had written after she began to write *Tripmaster Monkey*, her novel. In referring to her first two books as "the imaginative lives and dreams and fictions of real people," Kingston suggests that these two books should be read in light of Wolfgang Iser's formulation: "The literary text is a mixture of reality and fictions, and as such it brings about an interaction between the given and the imagined. Because this interaction produces far more than just a contrast between the two, we might do better to discard the old opposition of fiction and reality altogether, and to replace this duality with a triad: the real, the fictive, and what we shall henceforth call the imaginary."[6]

Because the usual distinction between memoir and autobiography holds that the former focuses outwardly on events and people as observed by the narrator whereas the latter concentrates on the author's life story with an inward attention, some readers have had trouble initially in understanding who's talking in *The Woman Warrior* and whose story is being related. Answering an interviewer's question, Kingston agreed that the words "memoir" and "ghost" in her subtitle represent the same thing, by which she seems to mean that both words are so ambiguous that they can stand for all the levels of discourse within her first book.[7]

The traditional autobiographical beginning doesn't occur until halfway through *The Woman Warrior* with the words "I was born in the middle of World War II,"[8] and there are places where the narrator is described in the third person in a manner similar to Gertrude Stein's complicated narrative strategy in *The Autobiography of Alice B. Toklas*. For instance, when Moon Orchid tries to match her actual nieces with their descriptions in letters, she says of Maxine: "There was indeed an oldest girl who was absent-minded and messy. She had an American name that sounded like 'Ink' in Chinese. 'Ink!' Moon Orchid called out; sure enough, a girl smeared with ink said, 'Yes?' " (152). In matching faces from prose descriptions rather than from photographs, the grandmother parallels the author's method of privileging word over image and inadvertently undercuts the narrator's question of her mother "Did you send *my* picture to Grandmother?" (46).

The evoking of spirits in the subtitle, *Memoirs of a Girlhood among Ghosts*, is particularly interesting in light of the following statement by Françoise Meltzer from her book on *ekphrasis*, the representation in literary prose of an art object: "One of the complexities of photography is that, whereas the referent in a painting, a portrait, is the real, living person depicted, the referent for a photograph is once removed from life. . . . The referent of photography is less life, in this sense, than the pictorial—its ghost, or shadow, or double."[9] In this curious statement, in which photography and painting appear to be reversed, Meltzer seems to be evoking Roland Barthes's notion that "photography has been, and is still, tormented by the ghost of Painting."[10] However, she is also suggesting one of photography's natural parallels with autobiography.

In both of her autobiographical texts, Kingston herself is both subject and object, in a sense, both photographer and photographed, a condition similar to the way photographs represent, as Roland

Barthes explains in *Camera Lucida*: "In terms of image-repertoire, the Photograph (the one I *intend*) represents that very subtle moment when, to tell the truth, I am neither subject nor object but a subject who feels he is becoming an object. . . . I am truly becoming a specter."[11] Barthes's and Meltzer's ghostly metaphors are particularly helpful in thinking about the nature of *The Woman Warrior*, a book in which the ghosts include not only Poesque or Jamesian figures from China haunting the narrator's Chinese American present but also all Americans except those of Chinese or Japanese ancestry, as well as actual Chinese ectoplasms, literal spirits hovering in the background of this ghost-written autobiography.

In her thoughtful argument that *The Woman Warrior* should be read as a collection of memoirs, Lee Quinby makes the point that Kingston herself argued for the term "memoir," adding that "in adulthood the writing of her memoirs serves as a ritual of exorcism that 'drives the fear away.'"[12] Although Kingston may once have agreed with the word "memoir" as the most apt description of her writing, as I have noted above she later adopted the terms "biography and autobiography of imaginative people," in reference to both *The Woman Warrior* and *China Men*, and she clearly disagreed with the idea that her writing was intended as an exorcism: "Yes, but not *exorcized*. I have learned that writing does not make ghosts go away. I wanted to record, to find the words for, the 'ghosts,' which are only visions."[13] In this formulation, with its emphasis on vision and on recording ghosts, Kingston might be thought of as paralleling the nineteenth-century ghost or spirit photograph in which a ghostly figure appears, accidentally or deliberately, hovering behind a portrait.[14]

From its beginning photography was associated with such nineteenth-century phenomena as physiognomy, seances, spirit photography, alchemy, and other quasi-magical beliefs. Rosalind Krauss describes as "breathtaking in its loony rationality" the "post-mortem photograph," in which a photograph could supposedly be reproduced using the cremated remains of the subject, which were said to "adhere to the parts unexposed to light," producing a picture "composed entirely of the person it represents."[15] Connections between ghosts and photography were posited by Balzac in what he called a "Theory of Specters," a singular notion described by the photographer and writer Nadar in *his* memoir: "According to Balzac's theory, all physical bodies are made up entirely of layers of ghostlike images, an infinite number of leaflike skins laid one on top of the other. Since Balzac

believed man was incapable of making something material from an apparition . . . he concluded that every time someone had his photograph taken, one of the spectral layers was removed from the body and transferred to the photograph."[16]

Sometimes direct connections between ghosts and photography occur, as when Kingston's mother describes a "Photo Ghost": "The stranger with arms hanging at its sides who stood beside the wall in the background of the photograph was a ghost. The girl would insist there had been nobody there when she took the picture" (*Woman Warrior*, 65). In *China Men* Sahm Goong repeatedly claims his dead brother Say Goon appears to him as a spirit, and one of the grandfathers is described as always appearing alone in family albums because on those occasions when a professional photographer came to the village and "set up a spinet, potted trees, an ornate table stacked with hardbound books of matching size, and a backdrop with a picture of paths curving through gardens into panoramas," most of the family tried to hide him. Only the author's mother "would have slipped him into the group and had the camera catch him like a peeping ghost, but grandmother chased him away. 'What a waste of film,' she said."[17] When Pierre Bourdieu notes of the family album that "all the unique experiences that give the individual memory the particularity of a secret are banished from it" because, "while seeming to evoke the past, photography actually exorcizes it," he partially explains Kingston's decision not to reproduce actual pictures within *The Woman Warrior*.[18] She is not interested in exorcizing the ghosts of her past but in recording them because she is intent on exposing some of the family secrets missing from the albums.

While the No Name Woman is obviously not represented in the family's albums, when Kingston writes about her, she not only improvises a number of possible scenarios to explain what might have actually happened but also imagines photographs that do not exist. Referring to her husband, the No Name Woman can only remember him as real through "the black and white face in the group photograph the men had had taken before leaving" (*Woman Warrior*, 7), a parallel to the repeated idea in both books that for women left behind, the husband sojourning in the United States documents his activities with a mailed photograph: "And my bridegroom will go too out-on-the-road and send me photographs of an old man" (*China Men*, 30). Trying to envision her unnamed aunt, Kingston thinks of her hair in a bun, countering this image with the knowledge, gained from family albums,

that "only the older women in our picture album wear buns" (*Woman Warrior*, 9).

Although Balzac's specter theory now seems charmingly naive, its image of the photographic act as removing a layer of skin parallels a number of instances in *The Woman Warrior* in which the act of flaying is described, sometimes with metaphors that suggest photography. Kingston describes the unnamed aunt, while giving birth after having been driven out into the fields, as "flayed, unprotected against space" (*Woman Warrior* 14). In the "White Tigers" section, the narrator, imagining herself in training for revenging her village, with words both carved and painted onto her back, thinks: "If an enemy should flay me, the light would shine through my skin like lace" (*Woman Warrior*, 35). Although haunted by her unnamed aunt, Kingston does not want to exorcize her spirit because "the Chinese are always frightened of the drowned one, whose weeping ghost, wet hair waiting and skin bloated, waits silently by the water to pull down a substitute" (*Woman Warrior*, 16).

Clearly the substitute Kingston imagines is herself, who "devotes pages and pages of paper" to her aunt, "though not origamied into houses and clothes" (*Woman Warrior*, 16). Though Kingston does not make paper replicas of her aunt except in prose descriptions, she does imagine herself revenging the No Name Woman by becoming Fa Mu Lan, the woman warrior, whose paper likeness is among the paper dolls she receives as a present from Moon Orchid in another image that suggests both layers of skin and the action of light: "She was holding up a paper warrior-saint, and he was all intricacies and light. . . . Through the spaces you could see light and the room and each other" (*Woman Warrior*, 120). This series of flaying images culminates in the scene in "A Song for a Barbarian Reed Pipe" in which the narrator confronts her silent double in the school bathroom: "I had stopped pinching her cheek because I did not like the feel of her skin. I would go crazy if it came away in my hands. 'I skinned her,' I would have to confess" (*Woman Warrior*, 181). [19]

Recurring questions about which forms of life writing seem most appropriate for *The Woman Warrior* and *China Men* as works of literature are paralleled by similar questions of genre in terms of her use of photography as metaphor within the texts. Because Kingston describes in prose both real and fictional photographs, clearly she is deliberately blurring distinctions between genres—both autobiography and photography—as a way to understand her own life. Although

attempts at cleanly separating the fictional from the nonfictional in her texts, in either media, will always remain unresolvable, nevertheless discussions about her books' genres are important because of reactions against *The Woman Warrior* and *China Men* as inauthentic.

Although the books have generally been praised, both receiving national literary awards, a number of critics, particularly Chinese American males, have attacked them for lack of historical accuracy, misrepresentations of legends, and "feminization" and "Christianization" of Chinese American history and for using white racist stereotypes. Most active of Kingston's attackers is the playwright and novelist Frank Chin, who writes in an essay called "This Is Not an Autobiography," published in *Genre*, a journal whose title indicates its interest in generic criticism, that *The Woman Warrior* is a fake. Although his essay's title ironically supports the contention that Kingston's text is a memoir and not an autobiography, Chin goes on to argue through an imaginary dialogue with Kwan Kung that Chinese Americans should not write autobiography because "the form was invented by Christians to save Christianity." "The autobiography is a longer more submissive form of confession,"[20] continues Chin, who has also written a parody of *The Woman Warrior* in which a white woman in China named Smith Mei-Jing retells the story of Joan of Arc in a book called "Unmanly Warrior."[21]

Unfair as Chin's attacks are, a number of his claims are echoed by undergraduate students to whom I have taught these books. Students often have difficulty adjusting to Kingston's improvisations in a way that parallels the passage toward the end of the book when the narrator says to her mother: "You lie with stories. You won't tell me a story and then say, 'This is a true story,' or, 'This is just a story'" (*Woman Warrior*, 235). For some students the confusion becomes overwhelming; nothing seems completely true. The narrator has explained that she is Chinese American, not Chinese, and yet she mentions that her parents always advise, "Lie to Americans" (*Woman Warrior*, 214), as though she and her siblings were not Americans. She informs us early on that her mother's words are not to be taken at face value: "She said I would grow up a wife and a slave, but she taught me the song of the warrior woman" (*Woman Warrior*, 24), and yet she seems surprised toward the end of the book when she reports her mother's remark: "That's what Chinese say. We like to say the opposite" (*Woman Warrior*, 237). While declaring to her mother that she cannot understand "what's real and what you make up" (*Woman Warrior*, 235), the narrator

has, of course, adopted this very style throughout the book, even joining her mother toward the end in a talk-story built upon a talk-story, even though the narrator has earlier mentioned that she is "mad at the Chinese for lying so much" *(Woman Warrior,* 25).

Looking at Kingston's autobiographies through a photographic lens is a particularly effective way of focusing these charges of lying and inauthenticity because connections between photography and truth have so often been assumed, as discussed in chapter 1. John Berger explains the way photographs work when he notes in *Another Way of Telling* that "the camera can bestow authenticity upon any set of appearances, however false."[22]

For Chinese Americans, whose stories about entering the United States frequently include deliberate ambiguities about authenticity of names, ages, dates, a group for whom false papers and forged documents seem as accurate as anything else, the truth of photographs is in what stories they suggest, not in their literal accuracy or in the photogenic qualities of their subjects. In showing how Chinese Americans use ancestral photographs, Kingston is making another distinction between Chinese and Chinese American, between her family and her self, for as Sontag asserts, "The Chinese resist the photographic dismemberment of reality. Close-ups are not used. Even the postcards of antiquities and works of art sold in museums do not show part of something; the object is always photographed straight on, centered, evenly lit, and in its entirety."[23]

Kingston turns to photographs not just to search for the truth of her family's past but also as sources for inventions in the present. To those of her critics who see her autobiographies as lies, she might answer with the words of Vicki Goldberg in an article on staged photographs: "Actually, the crucial issue may not be the camera but a gnawing sense that the world itself, knowable only through imprecise perceptions, is a tissue of uncertainties, ambiguities, fictions masquerading as facts and facts as tenuous as clouds."[24] Throughout, both autobiographies photographs are described, often as official documents, the few tangible physical records of Kingston's past. But in describing her ancestors' photographs, the author often comes to express her own doubts about their authenticity. As a result, the photographs described in the text often become less documentary and more the occasions for Kingston to exercise her imagination and memory. Had she chosen to include reproductions of her family photographs within the text, she might have been able to forestall the

charges that her work was inauthentic, and yet, as André Bazin reminds us of family photograph albums: "No matter how fuzzy, distorted, or discolored, no matter how lacking in documentary value the image may be, it shares, by virtue of the very process of its becoming, the being of the model of which it is the reproduction; it *is* the model. Hence the charm of family albums."[25]

A striking example of the lack of documentary value of family photographs occurs in a situation in *China Men* involving a confluence of the personal and the historical. Having detailed at length the contributions of Chinese workers, including some of her own relatives, to the building of the railroads, in "The Grandfather of the Sierra Nevada Mountains" section Kingston describes the uniting of the transcontinental railroads at Promontory Point, Utah, now using the word "demon" for "ghost." Despite the fact that "the Central Pacific Railroad depended almost entirely on Chinese labor," as Ronald Takaki explains in *Iron Cages: Race and Culture in Nineteenth-Century America*, adding that "approximately ninety percent of its 10,000 workers were Chinese,"[26] in the official ceremony, Chinese are virtually absent: "The white demon officials gave speeches. 'The Greatest Feat of the Nineteenth Century,' they said. 'The Greatest Feat in the History of Mankind,' they said. 'Only Americans could have done it,' they said, which is true. Even if Ah Goong had not spent half his gold on Citizenship Papers, he was an American for having built the railroad. A white demon in top hat tap-tapped on the gold spike, and pulled it back out. Then one China Man held the real spike, the steel one, and another hammered it in" (*China Men*, 145).

In addition to demonstrating the way Chinese American labor was historically excluded from recognition, Kingston's description shows how her relatives came to think about the nature of documentary evidence, as she explains in a description of a picture of the scene: "While the demons posed for photographs, the China Men dispersed. It was dangerous to stay. The Driving Out had begun. Ah Goong does not appear in railroad photographs" (*China Men*, 145). Interestingly, Joseph Fichtelberg points out that unlike the famous meeting of the railroads, which appears in many photographs, in the case of the railroad workers' strike of 1867, which forms an essential part of Ah Goong's narrative section, "artists from local newspapers come to sketch the men, and the same scene yields contradictory images."[27] In his *Chinese in America*, Jack Chen recounts yet another ironic aspect of the whole scene of the completion of the transcontinental railroad: as

four Chinese workers brought the final rails, cries to the photographers of "Shoot!" scared the workers, who assumed they were being shot at by guns rather than cameras.[28]

Unlike earlier cases, such as in the No Name Woman, where Kingston invented photographs that never existed—what Nancy Shawcross calls in reference to Marguerite Duras's *The Lover* "the photograph not taken"[29]—or nineteenth-century spirit images where figures appear to hover in the background, in the case of documenting the meeting at Promontory Point, numerous actual, historical photographs do exist, though Chinese Americans are seldom depicted in them.[30] The opposite situation prevails when the narrator's family takes relatives just arrived from China to see the site where two grandfathers had once lived. "My father pointed out where each thing had stood, 'They had two horses, which lived in a stable here. Their house stood over there'" (*China Men*, 171). In an effort at documenting what is absent, the relatives "took pictures with a delayed-shutter camera, everyone standing together where the house had been" (*China Men*, 171), in this case including themselves within the photograph they are taking.[31]

Earlier, looking at her family's photograph albums in an attempt at establishing the existence of the horses, the narrator sees that while they appear in the albums, they are not attended by the grandfathers. Having been introduced to the concept "horse" as a young girl more by touch than by sight—"a horse was a black creature so immense I could not see the outlines" (*China Men*, 167), Kingston discovers at a later date that the horses are no longer in their stalls. Hearing only "they're gone" as explanation from her parents, she turns to the album: "I have looked for proof of horses, and found it in the family album, which has photographs of horses with blinders, though the men standing in front of the wagons are not the grandfathers but the uncles" (*China Men*, 168). In this scene, Kingston establishes one of the reasons why photographs retain such a strong documentary effect despite extensive evidence of their ability to distort, invent, and omit, as William Mitchell explains in *The Reconfigured Eye*. Although his book is subtitled *Visual Truth in the Post-Photographic Era*, still Mitchell explains that photography as opposed to painting always retains a built-in degree of specificity, using as his example just the sort of image that Kingston, as a young girl, had relied on for proof: "The existence of horses means that you can take a photograph of some particular horse but it does not prevent a horse painting from showing no horse

in particular. You cannot, however, take a photograph of no horse in particular."[32]

In addition to family pictures, official images sometimes appear in her texts, such as at the beginning of the "Shaman" chapter of *The Woman Warrior* when Kingston describes a photograph of her mother, at the age of thirty-seven, that has a medical school seal superimposed on it: "The diploma gives her age as twenty-seven. . . . She has spacy eyes, as all people recently from Asia have. Her eyes do not focus on the camera. My mother is not smiling; Chinese do not smile for photographs. Their faces command relatives in foreign lands—'Send money'—and posterity forever—'Put food in front of this picture.' My mother does not understand Chinese-American snapshots. 'What are you laughing at?' she asks" (*Woman Warrior*, 68).

The photograph fails as documentation, her mother's age being ten years off, the face emerging from behind the official seal, like one of Lillian Hellman's pentimenti. To the Chinese American daughter, the picture of her mother is a Chinese document, evidence not for what her mother was like as a person of the same age as the author as she is writing this book but a further confusion of the differences between Chinese and Chinese Americans. Her mother has what Kingston describes as a characteristic faraway focus of the Chinese. In a description of a photograph of her mother's graduation class at the Hackett Medical College for Women, Kingston again emphasizes the characteristic Chinese look: "Perhaps they couldn't shorten that far gaze that lasts only a few years after a Chinese emigrates" (*Woman Warrior*, 59). When newly arrived Chinese in Stockton, Fresh-off-the-Boats (FOB's), place advertisements in the *Gold Mountain News* seeking wives, "their eyes do not focus correctly—shifty eyed" (*Woman Warrior*, 194). Fortunately, when her mother brings one of these men home in search of a potential wife, they are allowed to choose not from the assembled sisters but from photographs (*Woman Warrior*, 194).

Kingston seems not to have resolved the issue of the far-focusing eyes, for she notes in "Reservations about China," a short essay she published in 1978, that the eyes of the Chinese volleyball team had that same faraway look, and by the time she had written "The Brother in Vietnam" chapter of *China Men*, she seems to undercut this distinction.[33] En route to Taiwan, where he is stationed during the Vietnam War, the brother-narrator meets a Japanese American ophthalmology student who says that "the eyes of ethnic Asians have a naturally faraway focus," claiming that if Asian Americans lived in Asia, "where

everything is arranged according to our eyesight, we wouldn't need glasses" (*China Men*, 294). Noticing after living for a while in Taiwan that his vision has not improved, the narrator realizes "that eye doctor trainee was a crackpot" (*China Men*, 295).

Her mother's photograph, which reminds Kingston of typical pictures from China asking simultaneously for money and for reverence as an icon, is also a particularly womanly picture. Unlike the formal documentary picture just described, the father's pictures are often casual snapshots, exactly the sort that Chinese people are said to have difficulty understanding. But "there are no snapshots of my mother," writes Kingston. "In two small portraits, however, there is a black thumbprint on her forehead, as if someone had inked in bangs, as if someone had marked her" (*Woman Warrior*, 71). Her mother's Chinese face is always presented as a sort of photographic palimpsest, always showing forth from underneath an official surface, including another version of the same photograph as on the diploma, this time with "Department of Health, Canton" imprinted in English on her mother's face.

In contrast to these official pictures, Kingston describes, within *The Woman Warrior*, the sort of photographs sent from her father to her mother during the time when they were separated: "He and his friends took pictures of one another in bathing suits at Coney Island beach. . . . He's the one in the middle with his arms about the necks of his buddies. They pose in the cockpit of a biplane, on a motorcycle, and on a lawn beside the 'Keep Off the Grass' sign. They are always laughing" (70). Photographs are valuable for the author not as documentation but as proof that improvisation, imagination, and memory, the Americanization and feminization of the past, are equally powerful ways to present an authentic portrait. These same snapshots described in *The Woman Warrior* are further described in *China Men*, the second time from a male, American point of view, telling details about her father, now called Edison, and his Chinese American friends, Worldster, Woodrow, and Roosevelt: "Woodrow asked a blonde to take pictures of the four friends with their arms on the railing and their black hair flying in the wind. At the beach a bathing beauty photographed them in their bathing suits, nobody wearing a jockstrap, which might not yet have come into fashion. . . . Ed sent many pictures to his wife, including one of himself sitting on the sand with his arms around his knees and his sweat shirt tied around his neck; he was smiling and looking out to sea" (66).

Here both Chinese and Chinese American traits are emphasized; Maxine's father is smiling, yet he is looking not at the camera but out to sea, ostensibly toward his wife, who will receive the photograph in China. In a sense the frequent confusion of the faraway versus the inward gaze is emblematic of the similar confusion in genres. Where memoir is said to focus outwardly, autobiography is more concerned with an inward vision. Lee Quinby's argument that *The Woman Warrior* is a collection of memoirs rather than an autobiography rests on the idea that memoir's outward angle of vision is "in resistance to the modern era's dominant construction of individualized selfhood," and as a result, "in relation to autobiography, then, memoirs function as countermemory."[34] Interestingly, Kingston, revolting against her family's idea that "an outward tendency in females," by which is meant "getting straight A's for the good of my future husband's family, not my own," stops getting good grades (*Woman Warrior*, 47). The whole issue of looking into the camera is part of Kingston's argument in her description of these photographs. "Most emigrants learn the barbarians' directness—how to gather themselves and stare rudely into talking faces as if trying to catch lies" (*Woman Warrior*, 70), she notes, which is an accurate description of exactly what she is doing in examining her parent's portraits.

While Kingston is concerned with countermemory, she wants to demonstrate that her photographic memories are themselves counters to the actual images in the photographs. She wants to counter her family's memories, which are themselves often contradictory, with her own imagination through the use of an improvised language that will enable her to depict in English the stories of family members about other family members, using myths from China from an oral rather than written tradition. "One of the problems in writing the books," she remarks in an interview with Arturo Islas, "was to figure out what to do with the language. So many of the people are not speaking English or they speak it with an accent. They use Chinese words, and they aren't just speaking Chinese-Chinese. They're speaking Chinese with an American change in the language, and also they are speaking the dialect of one little village"[35]

Because Chinese must not only be translated but also romanized, Kingston has the additional problem, addressed by Lee Quinby, of constructing "a subjectivity through a form of writing that forces the American script of her text to reveal its intricacies in the way Chinese ideographs do."[36] Quinby's observation that Kingston is caught be-

tween language as script and as image is evocative of Paul de Man's formulation, cited in my preface, in which he argues that autobiography is "a figure of reading" rather than a genre. De Man continues his argument by extending that idea to all language: "To the extent that language is a figure . . . it is indeed not the thing itself but the representation, the picture of the thing and, as such, it is silent, mute as pictures are mute."[37] While de Man sees autobiography's metaphors as mere pictures, he is answered by Janet Varner Gunn, who writes: "Autobiography completes no pictures. Instead, it rejects wholeness and harmony, ascribed by formalists to the well-made art object, as a false unity which serves as no more than a defense against the self's deeper knowledge of its finitude."[38]

That de Man sees pictures as mute is interesting in light of the fact that silence plays such an important part in both of Kingston's autobiographies. The Maxine of the first book must break the silence imposed by her mother's injunction not to tell on the No Name Woman; yet breaking the silence includes admitting her own torture of an even more silent Chinese American girl and requires her to give voice to her own life of voicelessness. In *China Men* Kingston's father is the silent figure, except for the period of his life when he is out of work, punctuating the night with "wordless male screams" (13). Because her father is unwilling to talk about his Chinese past, the author goes first to documentary sources, but "there are no photographs of you in Chinese clothes nor against Chinese landscapes" (*China Men*, 14), she writes, addressing her father directly. "I want to be able to rely on you, who inked each piece of our own laundry with the word *Center*, to find out how we landed in a country where we are eccentric people" (15).

Although Kingston, who answered to a name that sounded like "Ink" in *The Woman Warrior*, now finds that the inked center will not hold, the image of ink on laundry, black on white, suggests her reliance on photographs to remind her that history is not always black or white. When as a child Kingston covered all her school paintings with black chalk and paint for three years (*Woman Warrior*, 165), she was thought disturbed; however, in an essay called "Through the Black Curtain," she explained with a camera obscura image, "I loved black crayons and black paint and ink and blackboards, through which I could almost see glorious light."[39] In *China Men* when her male relatives consider among various ways of avoiding the draft during the Vietnam War the possibility of swallowing ink—"What you do to foil

the X-ray machine is drink ink straight. Then the photograph comes out black" (270)—they are, in a sense, echoing Kingston's methodology in her autobiographical texts. She shows us that, on the one hand, black photographs still have meaning and, on the other, it is not really possible to swallow the past straightforwardly, either in the ink of text or from a child whose body is covered with the ink that symbolizes her American name to a Chinese ear.

Because her father chooses to remain silent, Kingston must further elaborate the context of the snapshots described in the first autobiography by inventing stories about them in the second: "In the spring Ed sent his wife a picture of the four partners with their arms around one another's shoulders, laughing next to a Keep Off the Grass sign. He was wearing another two-hundred-dollar suit, a navy blue one, and a shirt with French cuffs, which closed with gold cuff links. . . . In his quiet time at night, he mounted the photographs in a fine leather album. With his first spending money, he had bought a post card of the Statue of Liberty. . . . He pasted that postcard in his expensive album, then added the other pictures" (*China Men*, 67). Giving her father the Chinese American name Edison (pronounced Ed-Da-San, after Thomas Edison, inventor of the motion picture camera), Kingston tries to see her father not from a Chinese American point of view but from the perspective of her mother in China. His poses—wearing goggles and a flapped skull cap in front of an airplane, dressed in expensive Western suits—are not meant to be authentic in the sense of representing his actual living conditions in America.

Instead they correspond to the pictures sent from China to America, photographs such as the one of Ah Po, the author's paternal grandmother, sent to prove that she was still alive and therefore deserving of money from her son. But her photograph, in which she the ninety-nine-year-old woman is "lying on her side on a lounge chair, alone, her head pillowed on her arm," seems less than convincing to the Hong children, who say, "Maybe she's dead and propped up" (*China Men*, 249).

That Kingston describes photographs so often in her autobiographies but does not include the actual pictures within the text suggests that she does not want the pictures thought of as documents. Instead she wants to invoke a sense of transparency, a re-vision, a portrait of the artist from both sides of the mirror, the concept that Françoise Meltzer is getting at when she writes that "in literature, the photograph is always 'good,' "[40] an interesting counter to Sontag's observa-

tion that "in China, what makes an image true is that it is good for people to see it."[41] Valuable though Meltzer's observation is for the interrelation of literature and photography in general, it is even more important in autobiography, where our entry into the literary portrait is simultaneously our entry into the artist's life. In autobiography we are always asked to go through the looking glass from both sides.

Those who have seen *The Woman Warrior* and *China Men* as inauthentic because of distortions of the past can be thought of as paralleling the following complaint about photography expressed by Sontag: "Photographs turn the past into an object of tender regard, scrambling moral distinctions and disarming historical judgments by the generalized pathos of looking at time past."[42] Far from sentimentalizing the past, Kingston is at work at authenticating her present. Because she had never been to China at the time she wrote her autobiographical books, she was required to rely literally on a photographic memory to make sense of the contradictory stories her mother told her and the contradictory way in which she told them. Kingston describes herself while writing her novel *Tripmaster Monkey* in a way that suggests how she was working on her first two books: "If there is such a thing as reverse memory, maybe that's what I am getting into; because it seems to me, I'm writing the memory of the future rather than a memory of the past."[43] What she has described is a clear example of the way memory actually works as illustrated by the following account, taken from Richard Powers's novel *Three Farmers on Their Way to a Dance*: "Memory, then, is not only a backward retrieval of a vanished event, but also a posting forward, at the remembered instant to all other future moments of corresponding circumstance."[44]

That Maxine Hong Kingston's autobiographies are collages, made out of stories, fables, dreams, imaginative rerenderings of legends, improvisations, talk-stories and think-stories, and, as in "The Laws" section of *China Men*, historical documents, should not be surprising when we read that one of her major influences was William Carlos Williams's *In the American Grain*.[45] Like Williams, who based his reinterpretations of American lives on original documents yet also was willing to depict Lincoln as a woman, Kingston has used the few family pictures available to her to reconstruct the past to suit her needs as an autobiographer. Her method is illustrated in Michael Ignatieff's *The Russian Album*: "Photographs are the freeze frames that remind us how discontinuous our lives actually are. It is in a tight weave of forgetting and selective remembering that a continual self is

knitted together."[46] Even if there were pictures of her father in China or if her brother in Vietnam had taken photographs of the Hong family house when he visited China, the pictures would never be as authentic as the prose portraits and self-portraits taken by Maxine Hong Kingston. Nor would more actual photographs solve her dilemma as an autobiographer, as I show in the next chapter, which takes up the similarly ghostly past of Sheila and Sandra Ortiz Taylor.

*Photography is concerned with images which
are the product of light and awareness.*
—*Ainslie Ellis*

*My family has a troubled relationship with
sources of energy and light.*
—*Sheila Ortiz Taylor*

3 | Case History
......................................
Sheila Ortiz Taylor & Sandra Ortiz Taylor

Like Maxine Hong Kingston's *The Woman Warrior*, the collabora-
tive family autobiography *Imaginary Parents* includes suicide, improvisa-
tion, and ghosts. Sheila Ortiz Taylor, the younger sister, begins her ad-
dress to the reader by proclaiming that "this book is made of bones,"
describing herself as "*La Huesera*, bone woman, [who] crouching over
the bones of the dead coyote, sings them back to life."[1] Where Sheila
chooses La Huesera from among the shifting identities describing the
archetypal outlaw figure celebrated most recently in Clarissa Estes's
Women Who Run with Wolves, Sandra Ortiz Taylor, her older sister, might
better be described as La Traperer, "the Gatherer." Together, the
sisters, La Huesera y La Trapera, assemble an entire skeleton from
their shared past.[2]

"I crouch over the bones of my parents, remembering and trans-
forming," Sheila notes, adding, "All the ghosts that rise up are mine. I
claim them" (foreword, xiii). In a similar scene, Sandra Ortiz Taylor,
the older sister, is described lying on her bed in the room formerly
occupied by the sisters' paternal grandmother, now dead: "A book is
open on her bed. . . . lying open over the bones of her grandmother."[3]
Following the father's funeral, mother and daughters are depicted

asleep in the house as if all three are caught in a spell. Writing from the point of view of Sandra, Sheila describes the ghost of their father appearing in the bedroom: "The breeze stirs, sending moonlight in little explosions across the left toe of her father's shoe. He had been standing by the drapes, watching, listening to the sighing of his wife. . . . He lingers now, having taken on the shape of the handsome twenty-four-year-old musician he has carried inside himself, curved like a saxophone, melodious" (239).[4] Next the father appears to Sheila: "In his hand is the alto saxophone that rests in her own closet next to the baseball bat" (240).

In addition to ghosts, *Imaginary Parents* also includes the improvisational style of *The Woman Warrior*, its tendency to write from multiple points of view, and its habit of describing scenes at which the author could not have been present. Especially evocative are the multiple possibilities in the description of Mypapa, the sisters' maternal grandfather, preparing to take his own life following the death of his wife:

> In a moment he will get up and ease open the top drawer of the tall narrow chest he has always shared with his wife. His clean fingers will move like those of a blind man skirting furniture until they close on something hard, something wrapped in a soft cloth (his eldest son's old flannel shirt; the green silk scarf that belonged to his mother; his wife's black mantilla) and he will set the bundle down (on the bed; on the small table; on the stool) and slowly unwrap it until the gun (the Colt given him by Pancho Villa; the German Luger his son David brought back from the war; the 38 he bought last week in a pawn shop on Riverside Drive) lies in the single bar of light from the window. (130)[5]

While Maxine Hong Kingston refers to her autobiographical books as "biographies of imaginative people," the Ortiz Taylor sisters have chosen to title their collective autobiography *Imaginary Parents*. Juanita Loretta Ortiz Taylor and John Santray Taylor are hardly imaginary in the sense of never having existed, nor are they semifictional characters invented by their artistic daughters, Sheila, a novelist, poet, essayist, and academic, and Sandra, a visual artist specializing in miniature installations, boxes and cases with found objects arranged in narrative fashion. Rather, their imaginary quality lies in the way each daughter has used her particular artistic medium to depict their parents' own ability to imagine themselves as living "the American Dream, Southern California Style." "It was as if they invented themselves," writes

Sandra; "It is no wonder that we are participants in their myth. Through our art forms, we are now their shadowmasters."[6] Sandra's image suggests a number of the elements that make up this collaborative autobiography. "Shadowmasters" evokes a shadow box, behind which the sisters, like Paul Auster, act as puppeteers, a parallel to Sandra's artwork; the dark shadows of the family history, which includes two suicides; the way her mother is sometimes described as overshadowed by her father; the way the two sisters sometimes shade into each other; the sense, expressed by Sheila, that she is a detective shadowing her parents; and finally, the way both daughters use the shadow and light of photographs in creating *Imaginary Parents*. Describing her artwork *My Mama's Mexi-Briefcase. Interior*, Sandra notes that though Della Caroline Ortiz y Cabares Shrode, her mother's mother, was the "*corazón*, the heart of her family . . . I realize that I never knew her. She remains to me, as she appeared in so many snapshots, a shadow, yet a powerful maternal presence" (art notes, x).

The title page of *Imaginary Parents* specifies "text by Sheila Ortiz Taylor" and "art by Sandra Ortiz Taylor," but that division is not always so precise. As Sheila remarks, "My sister and I have collaborated in this piece. She created the visual art and I wrote the text, though much of my writing was inspired by our conversations and mutual re-collections as we cooked together or dreamed our way through boxes of family photographs" (foreword, xiv). While Sheila is the primary author, having written the bulk of the many individual sections that make up the book, Sandra's prose contributions include "Art Notes," a short explanation of her work in relation to the family's history, which includes an excerpt from her girlhood journal; "Art Catalogue," specifications about size and material of the artworks; and her descriptive annotations to the list of illustrations of her individual art pieces. In some cases, Sandra's artworks incorporate both photographs and prose. One small section, "Requiem for Mymama: A Great Granddaughter Speaks of Her Ancestors," was written by April Fox, a cousin. Photographs of Sandra's artworks by Philip Cohen appear in two formats within the book: "La Vía," black-and-white photographs of ten of her installation pieces, spaced along "the way" throughout books 1 and 2 of *Imaginary Parents*, and "La Galería," fourteen color photographs of her work gathered together between books 2 and 3. There are no illustrations in book 3.

Sheila's work takes the form of prose, except for "River People: An Invocation," which is a poem; as the book progresses, her writing

often approaches prose-poetry, especially in the descriptions of family dinners, prose versions of Judy Chicago's celebrated "Dinner Party," ten set pieces ranging from "Dinner 1942" to "Dinner 1957," printed in a different typeface than the rest of the text. Especially important for this chapter of *Light Writing and Life Writing* are the nine individual sections, also printed in a different typeface than the regular narrative, in which Sheila describes family photographs in prose. "Photograph 9" combines the two separate sets of set pieces by describing a photograph taken at a nightclub arranged "almost like a family dinner" (248).

Imaginary Parents is subtitled *A Family Autobiography* and labeled "memoir" on the back cover, as if fulfilling Sheila's request about genre in her foreword: "Call this book autobiography. Or memoir. Call it poetry. Call it nonfiction. Or creative nonfiction. Call it the purest fiction. Call it a codex. Give it a call number" (foreword, xiii). From that list "codex" seems the most unusual suggestion. At first the book hardly seems to be a code of laws, an ancient scriptural manuscript, or a collection of canons or formulas. One explanation can be found in Sandra's annotation to *House of Pictures. Interior*, a work she describes as "a treasure trove within a narrative." Within the piece the image of a bird speaks the following lines ascribed to a Náhuatl poet: "I am an elegant bird for I make the codices speak within the house of pictures" (foreword, xi). Another explanation for citing "codex" as a descriptive term for the house of pictures created by Sheila's prose and Sandra's art might be the original Latin source for the word "codex," *caudex*, which the *Oxford English Dictionary* tells us refers to a tree trunk. One of the sisters' most treasured shared memories, as described in the section called "Electricity Tree," involves a hideout within a burned-out eucalyptus tree struck by lightning. The sisters established a private space within the tree including "real light switches screwed into the tree walls, and electrical plugs, and bright colored wires strung around" (68). In her annotation for *Homage to a Tree House*, Sandra notes, "Nowhere was composite imagination more active than in our 'Electricity Tree,' a magical powerplace."[7]

Eventually the reader comes to see that some of the tension—often depicted as an almost electrical high-tension humming coming from the father—that lies beneath the happy childhood described in the book is related to the patriarchal codex that operates without being questioned. When, for example, at the age of thirteen Sheila dances with a drunken sailor, she alludes to this codex when she writes,

"Something reaches me, something transmitted, an ancient and ambiguous message, hauntingly ironical, something about great size requiring a smaller being for support, something about men and pallor and sickness" (225).

In answering the question "Who else am I, in this making?" Sheila Taylor also imagines herself as a detective: "I question, I return to the scene of the crime, search for weapons, motives, opportunities. I assemble the witnesses in the drawing room. And yet I cannot interrogate them; I can only heap up evidence" (foreword, xiii). While Vicki Goldberg reminds us that "bearing witness is what photographs do best,"[8] Sheila has not chosen to reproduce any photographs within the text itself, although some of the images she refers to can be seen as part of Sandra's artworks. According to Sheila, "Only once did I have an actual photograph in front of me while writing, the one used in *Catch the Wave* ['Photograph 6']. Otherwise I was deliberately working from recollection because I was more interested in what I selected to remember. But I believe there was a real photograph for all the others, except for the one of Sandra after the dog bite. Actually what I was recalling then was a home movie."[9]

The immediate problem with taking *Imaginary Parents* as autobiographical detective novel or true crime story is not only that the bodies are missing in the sense that only ghosts remain but also that it is hard to determine what crime needs to be investigated, though, as is true of most detective work, the first suspects are the immediate family. Although the witnesses are in the drawing room, they are being used to provide background for Sandra's drawings and Sheila's prose descriptions, more for the intellectual puzzle of the autobiographical act than for interrogating family values of the past. Literally returning to reexamine the scene of her childhood, Sheila was able to "wander through my ancestral house in Los Angeles" (iv).

As is true of any family, there are secrets to be revealed: two members of the family committed suicide, the paternal grandmother is moved to a nursing home without justification or explanation, the father died early of a heart attack, the mother hid her abilities and only blossomed after her first husband's death, tension was sometimes in the air because of the inherent sexism that was a part of daily life, the health food regimen of the time emphasized eggs and red meat, and the mother did not recognize in her "tomboy daughters" (list of illustrations, viii) the possibility of an alternate sexual orientation. And yet the story is, for the most part, celebratory, lyrical, charming, free of

sibling rivalry except for a few brief spats over pancakes, evocative of the happiest of childhoods, and filled with the smell of hand-made tortillas and roasting chiles.

When Sheila writes of the sisters' assembling evidence, including sorting through boxes of family photographs, she is at first evoking photography's vaunted power as evidence. As William Mitchell observes, "A photograph is fossilized light, and its aura of superior evidential efficacy has frequently been ascribed to the special bond between fugitive reality and permanent image that is formed at the instant of exposure. It is a direct physical imprint, like a fingerprint left at the scene of a crime or lipstick traces on your collar."[10] However, her decision not to include any of the images that helped reinforce and create photographic memories of her actual parents suggests her position as an ironic detective of the self. More Oedipus, or Electra, than Nancy Drew, she supports the following argument from Annette Kuhn about the uses of family photographs: "In order to show what it is evidence of, a photograph must always point you away from itself. Family photographs are supposed to show not so much that we were once there, as how we once were: to evoke memories which might have little or nothing to do with what is actually in the picture. The photograph is a prop, a prompt, a pre-text; it sets the scene for recollection."[11]

What Sheila describes as her attempt to "heap up evidence" suggests another generic possibility for *Imaginary Parents* related to her sister's art and to their ethnic background: "I say it is an altar, an *ofrenda*. Small objects with big meanings set out in order. Food, photographs, flowers, toys, *recuerdos*, candles. *Pocadillas*, my grandmother would say. Scissors and paste, my father would say. *Bricolage*, my sister says" (foreword, xiii). The text is an *ofrenda* in all the senses of the word. It is an offering, tribute, and memorial to the family's history that duplicates the traditional Mexican celebration of Los Dias de Muertos, the Days of the Dead. Celebrated at the start of November, on All Saints' and All Souls' Day, the Days of the Dead feature *altarcitos*, individual family home altars heaped with a mixture of remembrance and refreshment. The altars are stacked to overflowing with flowers, bread, fruits, candles, cigarettes, bottles of beer and soft drinks, beads, crumbled marigold petals, artifacts associated with the family's dead, and photographs of the departed, next to images of Jesus, the Virgin of Guadalupe, and other saints.[12] Sheila's declaration "I am dancing with death" and her description of herself—"I strike

attitudes, postures of innocence, reverence, amusement, anger, tenderness, mirth, fury" (foreword, xiii)—are similar in tone to the celebratory and joyful nature of the Mexican festivities, which simultaneously revel in sadness and comedy. And her description of herself striking attitudes and postures ranging from innocence to fury is characteristic of the autobiographical act as described by Jerome Bruner: "The task of autobiographical composition consists, of course, in combining witness, interpretation, and stance to create an account that has both verisimilitude and negotiability."[13]

The juxtaposition of religious and secular artifacts in the family altars suggests many of Sandra's individual installments, which include various miniature objects representative of family members assembled in boxes that are reminiscent of the Days of the Dead *retablos*, boxes featuring *calaca*, skeleton figures dressed as if alive and arranged in a tableau. Sandra reinforces Sheila's idea that their joint production is an offering when she titles one piece *Ofrenda for a Maja*, a tribute to her mother featuring small artifacts—sunglasses, broom, cigarette, bags, flower—associated with her. In her *Recuerdos para los Abuelitos*, a tribute to her grandfather that re-creates his suicide, he is represented by a skeleton, similar to Sandra's dream of pulling her father, who appears as a skeleton in clothes, in a wagon (197).

Following her admonition to call *Imaginary Parents* by various suggestive titles and her self-identification as La Huesera, Bone Woman—another reference to the Days of the Dead—Sheila Taylor asks her readers to "call me Coyote too, driving my Selves too fast in weather too hot, through ambiguous zones of time, gender, and race with all the windows down. When you ask for my papers I hand you this book" (foreword, xiv). With this statement she makes clearer the dichotomy between the sharper, more aggressive tone of her foreword and her characteristically nostalgic and lyrical voice within the autobiography itself. Instead of returning to Los Angeles in the forties and fifties to investigate a crime, Sheila's driving force throughout the book is an attempt at reconciling her identity as an adult—all the various selves who are not present in the text that ends when the sisters are just out of high school—with her childhood self as depicted throughout her family autobiography. Crossing and recrossing the borders between Anglo and Chicana identity and between heterosexual and homosexual orientation, Sheila imagines herself answering the constant demand that she declare herself at each cultural customs checkpoint with completely unambiguous identification papers by

presenting *Imaginary Parents* as a sort of passport, including photographs and visas that would show her to be the sum of her life's travels rather than any single identity.

Although she has always written under the name Sheila Ortiz Taylor and prefaced her first novel, *Faultlines*, with a photograph of herself and the statement "The family I knew in Los Angeles was my mother's family, thirteen children presided over by my Mexican-American grandmother, who made flour tortillas so thin you could read a book through them," she has not been read, for the most part, as a Chicana writer.[14] According to Juan Bruce-Novoa, for example, "that Ortiz Taylor has attracted little attention from Chicano critics is probably due to the lack of overt ethnic identification in her work, and to the tendency in criticism . . . to impose mutually exclusive categories into which authors and books are distributed accordingly."[15] Because *Faultline* speaks more directly about its protagonist's lesbian identity than her Chicana roots, and because until *Imaginary Parents* her work has been published by a press associated with lesbian feminism, Sheila Ortiz Taylor's work has been identified more often under the heading of sexual orientation than ethnicity. Unlike Cherríe Moraga and Gloria Anzaldúa, lesbian Chicana writers whose names appear often in bibliographies attached to studies of both lesbian writers and Chicano studies, her writing has been taken primarily in terms of the sexual orientations of its characters, as Karen Christian argues in her "Will the 'Real Chicano' Please Stand Up?"[16] Taylor's work before her family autobiography remains almost completely outside the Chicano world, though sections of *Imaginary Parents* were published in such places as *Americas Review* and *Chicana Criticism and Creativity: New Frontiers in American Literature* and her papers are on deposit in the California Ethnic and Multicultural Archives at the University of California, Santa Barbara. Following *Imaginary Parents*, Taylor's next book was *Coachella*, a novel that combines her gay and Chicana orientations.

Bruce-Novoa argues persuasively and elegantly that *Faultline* is both more enriched with a Mexican American flavor and less rigid about sharp lines between heterosexual and homosexual orientations than it is generally taken to be, focusing his attention on the implications in the title: "Two apparently opposing systems touch at the line which marks their separation and union, similar to the example of the oxymoron. And we come to understand that life should be lived in that ever shifting zone, the most fertile and natural of all spaces, never static nor stable because it is always in the process of transformation,

rearticulating its intra and inter relationships."[17] *Imaginary Parents*, certainly a study of "intra and inter relationships," could also have been titled *Faultline*, not just because it is set on that same potential earthquake border in California and includes a reference to a cracked mirror's resemblance to the faultline but because, like Sheila's first novel, it argues for the idea that one can live a satisfying life while straddling the line, that a writer is not at fault for not choosing a particular racial line of ancestral descent or a never changing sexual identity with which to identify.

Sheila represents her resistance to the idea that one must always choose between binary oppositions by describing her father's choices as life-threatening. "His life seems to be splitting in two: music or law, left or right ventricle" (144), a situation she represents in her own life when in high school she fell in love with both her English and French teachers, one male, the other female. Unwilling to declare herself absolutely hetero- or homosexual at that point in her life, she imagines the situation in an image that echoes Sandra's art cases: "The saint who had a little glass case in her ceramic chest right where her heart should have been. A glass case divided down the middle. On one side was Mary and on the other was Jesus. She could see inside her own heart now, divided this same way, left and right, woman and man" (245).

Of course the whole situation is complicated by the facts that *Imaginary Parents* is a collaboration, Sandra is darker skinned while Sheila is lighter, Sandra's sexual orientation is not disclosed, and Sheila identifies more closely with her father, Sandra with her mother. For both sisters a clear demarcation between their Anglo and Mexican backgrounds is confused by the fact that their father, John (Jack) Santray Taylor, who was originally from Beaumont, Texas, is the only one in her immediate family who speaks Spanish. He is often described speaking in Spanish to barbers, other family members on his wife's side, and to waiters, giving his wife Spanish lessons while he awaits his dream of moving the whole family to Mexico. Juanita Loretta Ortiz Taylor, on the other hand, whose great-grandfather was Miguel Ortiz and whose grandmother is Theresa Cabares from Moralia, Mexico, is described as speaking virtually no Spanish at all during most of the sisters' childhood, claiming, "We're not Mexicans, We're Early Californians" (110), despite the fact that her eyes are said to look like Spanish accent marks (161).

Confusing the racial issue further, the mother's father is second-generation German, seen on his first appearance eating a taco (3), and

Sheila sometimes refers to her mother as an "Indian maiden" (16) and her great grandmother as an "Indian princess" (112). Because the father is a dynamic, multitalented, and charming figure, both a lawyer and a musician, he often overshadows the mother, whose background includes small parts in Tom Mix movies and a brief stint as a painter in a yo-yo factory. Juanita Ortiz Taylor subjugates her many talents and her intelligence to her husband, living the standard sexist relationship of the time, until his first heart attack. Although she is relegated to the domestic side of family life, once her husband is in the hospital, the mother learns to drive in three days. Described as being unable to conjugate "to be" in Spanish, following his death of a second heart attack she successfully carries out his dream by moving the family to Mexico, where Sheila and Sandra realize that she understands an overheard conversation in which a group of men are speaking about her in Spanish.

In an especially lyrical passage within the section titled "Re/collection," she is described cooking *chiles relleños* with interior Mexican rhythms: "She moves back and forth from the counter to the flame, scorching the skins, crackling them black, filling the house with the sharp smell of Mexican dirt and lizards, cooking *en un acento puro*, this woman who says she cannot speak one word of Spanish, cooking only *en la lengua*, moving with a *ritmo* that is her own. Is her mother's" (231). Throughout the text she is described as resisting the status quo, hiding her preferred dull knife from her husband, who insists on sharp knives and soft pressure. That what looks on the surface like domination of the weak by the strong also includes some elements of the opposite is the lesson Sheila learns, mentioned earlier as an example of the codex, when she dances with a drunken sailor.

Sheila clearly describes her ancestral heritage when she writes, "She [Sandra] has the Ortiz nose. I don't have it yet" (65), at first referring not to the family physiognomy but to the Ortiz ability to smell. While Sheila describes herself throughout her childhood as especially good at smelling, as a teenager she suddenly becomes obsessed with the shape of her nose. "The nose looms," she writes, followed by a description of her face in her parents' three-part mirror, a parallel to Sandra's three-sectioned boxes: "Nobody is in sight and soon I'll have the mirror adjusted so I can see my nose angling off in two directions, four hundred noses west and four hundred east. They all have a hook in them, confused by the Taylor blobiness" (205). Unlike her own successful attempts at bridging the gaps between her various selves,

she sees her nose as "the unhappy issue of a union between two antithetical cultures" (204).

Because the mother's identity was in many ways submerged during her husband's life, she is depicted in Sandra's *El Músico y la Dama. Interior*, despite the title of the piece, which suggests an equal pairing, only in one section of this three-part case. The center section of the triptych shows the father's two-tone dancing shoes, his tuxedo and saxophone, a model sailboat, and a photograph of his actual sailboat, while the right-hand section includes the Mexican lottery card "El Corazon" (a heart pierced with an arrow) signed by Sandra, a cut-out photograph of the father as the sailboat captain on top of a cut-out photograph of him with clarinet, and two sketches of Gatsbyesque shirts in the background. The mother only appears in the left-hand section, represented by a miniature glass slipper, the lottery card for "La Dama" underneath another for "El Músico," and in photographs of her with Sandra and with a bottle of tequila. In contrast, in *El Músico y la Dama. Exterior*, in which the case is folded up, the outside presents a small cut-out photograph of the father behind a set of musical instruments, with the eyes of the mother, many times larger, hovering in the background.

Sandra writes of the interior version in which the case is open, "This *caja* (box), the musician and the Lady/Woman, is the most narrative of the twenty-five family pieces I have done," explaining that the Lotería cards represent her parents at their first meeting, while "the *corazón* card is of special significance in the futures of our family. My father's first heart attack hung like a shadow over our daily lives" (list of illustrations, xi). In contrast, her *Ofrenda for a Maja*, another three-part case, is devoted almost entirely to her mother. This artwork includes the same photograph of Juanita Ortiz Taylor's eyes that appears in *El Músico y la Dama. Exterior*, covered not by a sailboat but by an ocean liner, plus another version of the same eye image, this time featuring her full face, plus family photographs of the mother standing alone and seated with the father. In the center section a large artificial hibiscus, the flower often associated with the mother, appears behind miniature versions of the same furniture seen in the photograph on the left, as well as miniature luggage, which, Sandra notes, refers to her "solo voyage of discovery," her life following her widowhood. "Only with the death of my father does she begin to emerge as a self-defining individual" (list of illustrations, xi).

One of the major threads that runs throughout *Imaginary Parents* is

the especially strong bond between couples, ties that often cause one or the other to live with a diminished sense of self. When Jack Taylor tries to teach Juanita Taylor how to tie knots, for example, during the years in which his heart is devoted to the sailing ship he has bought without consulting her, she pretends to be incapable, though, as Sheila notes, she's been braiding her hair in a complicated pattern for years, a parallel to Maxine Hong Kingston as "an outlaw knot-maker."[18] Although sometimes the mother and father reverse roles, she tying a clove hitch and he making dinner (153), that her identity is usually subsumed in his is summed up by the fact that the boat is named *Bojac* (Bonita for her nickname, Jack for his), although it really belongs to him and is his idea. A similar dependence is represented by the fact that when Mymama dies, her husband is unable to live by himself and so takes his own life. In her description of *Recuerdos Para Los Abuelitos*, her version of Mypapa's suicide, Sandra makes a statement that summarizes the thread I have been describing: "My family had a disturbing tendency to merge so totally in partnerships that the death of one would create a void so great as to endanger or even destroy the other" (list of illustrations, x). While Sheila does not actually describe Mypapa's suicide, Sandra's text explains the situation, positioned directly under a constructed miniature window behind which are photographs of Mymama and Mypapa, together as both an old and a young couple.

The fact that the family history is characterized by couples having difficulty in living both together and separately makes the collaboration between the two sisters especially remarkable. Each is able to practice her own art while maintaining an intricate relationship between individual identity and collective memory. Rather than having to decide between one format or the other to reconstruct their family autobiography, the sisters avoid the dilemma of having to choose. And because the writing sister includes images in her text, while the painting sister's art includes words, they are also able to avoid the common tendency, described by W. J. T. Mitchell, "to conceive of the relation between words and images in political terms, as a struggle for territory, a contest of rival ideologies."[19] Unlike other autobiographical siblings who wrote separate texts, such as Michael and Christopher Ondaatje, whose separate versions of the family past I take up in chapter 6, or Tobias and Geoffrey Wolfe, the Taylor sisters have managed to present their individual slant on the past without undercutting each other's personal memories. Unlike their father, who thought he had to pick either law or music, or their grandmother, described by

Sandra as "the family archivist," whose *Mexi-Briefcase* is divided into "her life, *vida*, her family, *familia*" (list of illustrations, x), the sisters have it both ways, another echo of Sheila's desire to live as both Chicano and Anglo, lesbian and mother, living on a no-fault line. As Laura Doyle has noted of the continual critical tendency to separate or subjugate race and gender, "Despite forceful arguments from theoretical critics such as bell hooks, Hortense Spillers, Karen Sanchez-Eppler, and Claudia Tate about the absolutely intertwined formations and histories of these identities, and despite the seeming omnipresence of this pair of terms, they regularly continue to enter as an unequal couple."[20]

The relationship between the two sisters described in Sheila's text is often paralleled by the relationship in the book between the two sisters' individual art forms. For instance, sometimes within the text their art forms are reversed, Sandra becoming a writer, Sheila an artist, as when Sandra describes her work as a book: "When I work with boxes as 'found objects' they may be containers for pieces. As such I frequently regard them as books; that is, the outside is the cover that sets the mood for the interior action" (list of illustrations, xvi). Included within Sandra's *Pelorus* is a miniature book inscribed with half of the autobiography's title: "I/Magin/Ary." "My sister has a way with words" (74), writes Sheila, who sometimes writes about herself as a childhood painter. An Anglo classmate's insistence not only that her skies are wrong and that people should be done in "the color of pale seafood sauce" (53) but also that her tendency to "paint the stories in [her] head" is incorrect eventually causes Sheila to leave people out of her paintings, while continuing to put them at the heart of her prose. Sandra is often depicted with pencils in her hand and in the act of writing, as when she pours her first initial onto pancakes in syrup or when she signs her ashtray with the initials "S.T.," which are, of course, also Sheila's initials.

"In our working we did not try to make art and text replicate each other but rather to refract, casting new shadows, throwing new angles of light," writes Sheila in a description that sounds as much like a photograph as prose (foreword, xiii). On a few occasions, Sheila's prose and Sandra's art contradict each other. Sheila imagines Mypapa shooting himself with three kinds of handguns, while Sandra depicts that act as involving a rifle in her art, a shotgun in her prose description. None of the objects that Sheila remembers as part of Mymama's *pocadillas*, curios she has collected over the years, match the actual ob-

jects depicted in Sandra's artwork named *Pocadillas*. Sandra describes the father "mercilessly teasing my little sister about wanting a horse," a detail absent from Sheila's prose. In Sheila's description of "Photograph 3," a snapshot of a birthday party at which Sandra is described bandaged like a mummy following a severe dog bite, the "bad" dog turns out to be a German shepherd; however, in Sandra's *Good Dog/ Bad Dog*, the "good" dog is represented by a lighted German shepherd.

In many cases, though, the two art forms echo each other in a way reminiscent of the relationship between James Agee's prose and Walker Evans's photographs in their collaborative *Let Us Now Praise Famous Men*. As Sandra puts it, "My sister's partner said, perceptively, that she regarded the art for *Imaginary Parents* as a separate but parallel narrative to the text, that the texts intertwined like the double helix" (art notes, xvi). Another apt description of the collaboration might be Mary Ann Caws's term "interference," by which she means not a negative quality but "the mutual interference of two objects, a visual and a verbal one," which "involves a dialogue, which the reader or observer enters into and sponsors, and which with other dialogues forms part of a more general conversation."[21]

Sometimes the connections are direct, as when Sandra uses Sheila's textual version of the suicide of Winifred, the sisters' favorite "in-law" aunt, within her installation *Winifred, Her Story. Exterior*, where it appears inside what Sandra calls "an artist's book" attached to the case in which Winifred's story is depicted. Sandra has written the words "L.A. Snapshots" on the exterior of *Winifred, Her Story*; however, because of her suicide, "all the family snapshots in which Winifred appeared were torn to eliminate her visage," and so Sheila does not write about her in one of her prose photographs. Instead the sisters collaborate in "restoring her image," as Sandra describes it (list of illustrations, x).

Another example of the way the two media work together can be seen in the case of the matching dresses. Although their mother wants to dress all three alike in what Sheila describes as "pinafores that look like banana cream pie," so that all three of them will look like sisters, Sheila says that "these dresses don't just happen" (83), that is, despite her daughters' reluctant willingness to submit to fittings, the mother's strong will and her skill as a seamstress bring about the image of mother and daughters seen in matching dresses in Sandra's *Ofrenda for a Maja*, within the Galería section and in one of the details reproduced on the book's cover.

Sheila's prose piece "Photograph 6" is another example of the way

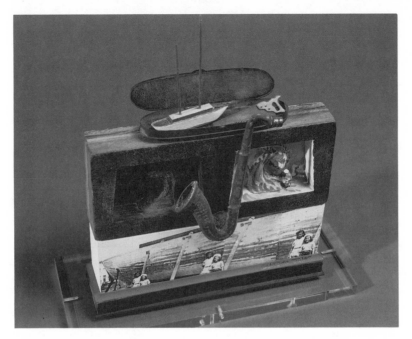

FIGURE 3.1. *Philip Cohen,* Sandra Ortiz Taylor's Catch the Wave.

the two art forms operate separately yet together. Although Sheila is describing an actual photograph, she is a writer rather than a visual artist, and so she has chosen to reproduce the image only in prose. "In this photograph my sister and I stand in the foreground, but we are in relationship. Behind us looms the skeleton of a boat. My father's sailboat. It is all curved, stripped boards, blotting out the sky, which is reduced to a thin band above" (137). Sheila's prose description is made out of invented images that reinforce her vision of the past. She describes the boat as a skeleton, yet another reference to her father in a Days of the Dead image, and states the importance of the sisters' collaboration: they are always in relationship no matter how much the past looms behind them. Although Sheila was told as a girl that her skies were inaccurate because they did not come down to meet the ground, in this ekphrastic version she has made the sky perform the way she believes it should.

In an installation titled *Catch the Wave* (fig. 3.1), Sandra reproduces the actual photograph, cutting and pasting and enlarging so that the two sisters appear in triplicate in front of what seems to be a single outsized boat, their images larger and larger in each version, moving from left to right. On top she has placed a model boat and a miniature

saw inside an open case that rests on a painted and a sculpted version of a Hokusai-like wave, configured to echo the shape of the miniature saxophone attached to the front. In her prose description of *Catch the Wave*, Sandra describes the piece as evoking "something of the fearsomeness of the experience of sailing on the open sea as a family" (list of illustrations, xi).

That Sandra uses the photograph to create a darker version of the scene than Sheila's is reflected in Sheila's further prose description: "We two are counterpoised to the boat. Reduced, but somehow not into insignificance. The eye is claimed by the two small faces struggling against the bulk of the father's boat. The struggle magnifies the significance of these faces, one brown, one white" (137). Where Sandra tries to reduce the sense of insignificance by altering the scale, making the boat bigger but also adding two more sets of sisters, Sheila sees the struggle more in terms of sisterly differences. Not only are their faces different in complexion, but, notes Sheila, "a closer look at the faces shows in the brown one a certain resistance to this project behind her" (137). In contrast to the older sister's resistance, Sheila writes of herself, "This other girl, the white one, is wearing a white sailor hat set at an angle. Sets her course at an angle, aligning with the dreamer self, making him more plausible, less culpable, less oblivious of everybody's needs and rights" (137).

Revealing that she is more sympathetic to her father, though admitting that her version is romanticized, Sheila says of Sandra, "This girl has chosen her mother, who was content . . . in her house on the hill" (137). Beginning her description of "Photograph 6" in the first person, Sheila shifts the point of view so that by the end she refers to herself as "this other," Sandra as "this girl." This shifting is common to her photographic set pieces and to other scenes in the text. For instance, following the death of Jack Taylor, mother and daughters are described on a beach in Mexico from the point of view of a woman named Clara Ignacia Ríos, who refers to Sandra as "*la morena*" [brunette] and to Sheila as "*la otra*" [other] (242). In another scene, the point of view shifts to Sandra, who describes Sheila as if she were the other sister, in a manner that duplicates the ventriloquy made famous by Gertrude Stein in *The Autobiography of Alice B. Toklas*. No matter how different the sisters are however, "they always remain," as Sheila notes, "as this photograph shows: in relationship" (38).

Sheila's tendency to shift the point of view as she describes the family photographs is common to several of her descriptions. "Photo-

graph 1," for example, begins: "In this picture my sister is sitting in a tiny Mexican chair holding me in her lap. . . . I am naked, and so new that my legs have not quite unfolded. Her brown arms encircle me. She smiles at the camera" (5). In this case, Sheila, speaking in the first person, echoes the traditional autobiographical point of view. However, she soon switches to third person: "The tiny baby, drooling in her sister's lap has occasioned all this expense" (138). In turning actual photographs into literary descriptions, Sheila manages to overcome one of photography's inherent characteristics, a fixed point of view. As Alan Trachtenberg explains: "If the literary concept of point of view introduces an inherent difficulty for photographs, the mechanism of the camera offers an obvious concept of its own: the physical position the photographer selects to view a scene and take a picture. A clear and self-evident point of view appears in the photograph—indeed, it is identical to it—for the image cannot be separated from the perspective in which it is seen. Where the camera stands is usually unambiguous, a precise and particular place. The image *is* its own point of view—a simple but often neglected truth."[22]

Not only does Sheila overcome the rigid point of view, but she also subverts the instantaneousness that makes still photography different from film. "Photograph 3," for instance, begins: "A study in light and dark, this snapshot. In the foreground a luminous birthday cake seems at first to float. Gradually the fingers of Catherine emerge from the background gripping the giant platter" (44). In this case the descriptions are of only figurative movement, the cake only seems to float, the viewer slowly notices the fingers in the background. However, in "Photograph 4" actual movement occurs. The piece begins as though Sheila and Sandra are looking at a family album: "In this one my Uncle Jimmy Doll, wearing his navy dress uniform, is seated in the doorway of a black limousine, his head between his knees. . . . I am standing next to my father and wearing a pale yellow dotted swiss dress that scratches under the arms" (78). After some explanation about the tension behind the image (Jimmy, the sisters' youngest uncle, is not marrying the person he loves), the exposition begins to sound as much like a home movie as a family album: "I look over at Jimmy Doll. My mother is rubbing his back in slow circles. He lifts his head momentarily, his face the color of dough, then lowers it. My father is discussing marriage and divorce law with my two uncles who have refused to marry their common-law wives" (79).[23]

A similar transformation from still image to home movie occurs in

"Photograph 5," which begins: "This photo is large, tinted brightly by an artist. My lips are the same color as the appliqué roses on the arms of my cowgirl shirt. . . . My sister and I sit on our heels, our arms encircling [the collie]" (121). As the description continues, the photograph becomes animated; dialogue is added and then motion: "At last I look up to see my mother moving toward us slowly with a man on either side. Then they stop below us and we listen, as if we are invisible" (121–22). "Photograph 7" begins with a description of a kitchen scene, moves to a parallel photograph, and then, as if a transition is being made from silent to talking pictures, adds sound: " 'Watch what you're doing,' says my father, rescuing the bowl of steaming rice from my hands" (160). Using the individual photographs as backdrops for a domestic drama, Sheila invests each with dynamism, just as Sandra, working in an entirely different medium, transforms objects into what Terri Cohn calls "sculptural narratives."[24] Referring to her own artwork, Sandra echoes Sheila's sense of movement: "Frequently a piece will become a small theater where the actor/objects (or symbols) will demand resolution as much as any aesthetic consideration. I feel like I am both spectator and author/director as the miniature dramas unfold."[25]

As she turns from photograph to photograph, alternating with descriptions of family dinners, and with the major narrative, Sheila moves chronologically forward in time, agreeing with Annette Kuhn's assessment of the way we actually use family images: "Family photographs are quite often deployed—shown, talked about—in series: pictures get displayed one after another, their selection and ordering as meaningful as the pictures themselves. . . . In the process of using—producing, selecting, ordering displaying—photographs, the family is actually in process of making itself."[26] And yet the book's smooth chronological progression also contains a number of instances in which the act of viewing a family photograph produces not a nostalgic look backward to a more innocent time but a jump forward to the future in a manner paralleled by Sandra. Referring to *House of Pictures. Interior*, she describes its exterior—an image not reproduced in any of the photographs of her art—in terms that suggest the way Sheila's embeds the future within the present: "The lid's exterior has elements that represent time congruent with the narrative as well as the future" (list of illustrations, xi). In both cases the sisters echo novelist Josephine Humphrey: "I have come to doubt the validity of photography as historical record. Instead it occurs to me that these pictures tell our

fortune. They reveal something that is normally not visible: how the future lies curled and hidden in the present."[27]

In the final prose photograph, "Photograph 9," Sheila describes a scene in a nightclub in Mexico City that nicely illustrates Humphrey's idea that we can almost see the future hidden in a photograph. Referring to the image as a photograph "taken under duress," Sheila presents a group of women—herself, Sandra, their mother, their aunt "Crazy Rena," Sheila's best friend from high school (Betty Lou Feinstein, nicknamed "Chabela") and her mother, all described with much tension in the air, everyone with a glazed expression. Betty Lou, an Anglo with a Chicana nickname, sits with her legs crossed "like a warning sign" and is "definitely not amused," while Sandra, "in her Audrey Hepburn mode," is "smiling in an open way, as if she believes we will all survive this." Sheila writes of herself, "I sit, staring obliquely at some indistinct spot in the foreground . . . my smile deflected." The Ortiz Taylor sisters' mother, "the only person looking directly into the camera," is said to look delighted and surprised, while "a corpulent man in white dinner jacket at the table behind ours seems poised . . . to somehow act, a stranger brought into this family photo all unbeknownst" (248).

At first the tone of these descriptions and the introduction of the stranger seem more ominous than the situation calls for. Other than the slight duress of having to pose in a nightclub for a picture that one is then under some obligation to purchase, a mother-daughter dinner hardly seems an occasion just to be survived. What lies embedded in the picture, according to Sheila, is the masculine codex that shapes the scene:

The assumptions bringing these people together are patriarchal. The "corpulent man" is in the photo as if by accident. But his presence is no accident. It is in anticipation of the possibility of his appearance—this male stranger—that the mother has pressured the daughters into their uncomfortable clothes and bodily positions. Chabela does not want to become her mother, nor do the Ortiz Taylor sisters. Yet they have all assembled in costume because they honor their mothers. These three daughters are here caught in the act of obeying and resisting their mothers, women who see their task as ushering their daughters into the culture in which the male may be almost unseen but who is nevertheless the organizing principle. Crazy Rena illustrates what can come to those who obey the codex.[28]

In addition to Sheila as bone woman, coyote, detective, sister, and daughter making an offering, she also describes herself at the start of *Imaginary Parents* as a diver: "I am a diver, too. Not in wet suit, mask, tank, knife. No, the kind of diver called from the village because she is known for her skill at swimming, because everybody knows this woman is running toward the river even before she has been told of the drownings" (foreword, xiv). Unlike Maxine Hong Kingston—who responded to her mother's "Let me tell you a true story about a girl who saved her village" with "I could not figure out what was my village"[29]—Sheila Taylor sees her autobiographical act as the story of herself as the natural village hero, saving those who are on the verge of drowning. Sheila imagines herself not as a scuba diver or as the speaker in Adrienne Rich's "Diving into the Wreck," who returns to the "scene / carrying a knife, a camera / a book of myths / in which our names do not appear."[30] Instead of carrying a camera, she relies on giving meaning to photographs already taken; in place of a book of myths without the sisters' names, she relies on their collaborative re-creation of the past in the form of *Imaginary Parents* to create a new book of myths to replace the old codex.

Although she describes herself in the chapter called "Esther Williams's Sister" as clinging to the side of the *Bojac*, relying on an inner tube for support, because "the swimming lessons have not worked" (151), writing as an adult in the foreword she is specific about the sort of diver she has become: "She swims back and forth across the river in an intricate pattern, her head disappearing below the surface, then reappearing. She is patient. Finding nothing, she begins a new pattern, one intersecting at different angles the old one. She is as committed to finding the drowned ones as if they were her own parents" (foreword, xiv). In this description, again emphasizing Sheila's angular rather than direct vision, she emphasizes looking both beneath and on the surface, her need to try to rescue her parents from the glamorous Hollywood images they projected, the father as a tap-dancing musician dressed in Ricky Ricardo costumes, the mother as described by Sandra as the "Dolores Del Rio of L.A.'s Silver Lake district" (art notes, xv).

Sheila's metaphor echoes Sandra's emphasis on the insides and outsides of her artwork. At the moment of his fatal heart attack, for example, Jack Santray Taylor smells the *chiles relleños* described earlier and opens his new reed case. Like Sandra's cases, the father's, with its dark green velvet lining, is depicted in terms of exterior and interior, but for Sheila-the-detective, this is more than an open-and-shut case,

for, as she writes, "he does not know how long he stands inside his own interiority" (232). Sheila's sense that the father has begun to hide within himself is echoed by the fact that *Texas Two-Step / History of a Self-made Man*, Sandra's version of her father's autobiography depicted within a tool box, is only presented in its interior view.

This sense of interior versus exterior is part of the difference between the two sisters' art forms. Where Sheila makes use of the specificity of the actual family photographs, though transformed in her prose into passages that reveal what was beneath the surface, Sheila's installations, which are made out of many different objects, are flattened into photographs. "The surface of a photograph might be matte or glossy, but it is always *flat*," writes Graham Clarke. "The obvious nature of the point belies the implications for the photograph as a form of representation. The three-dimensional illusion it offers is based on the uninterrupted expansion of a flat surface which, unlike a painting, does not draw attention to itself. Indeed, the photograph 'buries' its surface appearance, in favour of the illusion of depth and the promise of the actual."[31] Desiring to penetrate beneath the surface of the Ortiz Taylor family photograph album, Sheila solves the inherent difficulty when actual photographs are reproduced within an autobiographical text by leaving the photographs out, substituting her in-depth prose versions in their place. She expresses this sense of herself in a poem called "35MM," where she reverses the usual metaphor "I am a camera," noting of herself, "I am the film."[32]

In this collaborative "case history," Sheila's prose includes as many images of cases, containers, and boxes as Sandra's art, including a box covered with eyes, secret doors holding an elephant tusk, drawers in the parents' and others' chests, a Fuller Brush Man's case, violin cases like coffins, actual coffins compared to chests, some houses in the neighborhood being moved by the Star House Movers that are sawed in half like one of Sandra's open and shut cases, a mummy in a box the sisters like to visit in "The Holy Land Museum" despite the earlier scene when Sandra was wrapped in bandages after her severe dog attack, and an iron lung the mother is imagined occupying immediately after her husband's death, and finally, "In the Closet," a section in which Sheila describes her lack of interest in dolls or dresses and hints about her future sexual orientation. Through her use of photographic imagery, Sheila demonstrates the truth of Lauren Sedofsky's comment: "If photography's generative power has a tense, it is the future perfect,"[33] she and her sister having used their creative powers to the

fullest in what Sheila describes in the book's last sentence: "dreaming the past into tropes and signs and symbols, beginning the dangerous art of fitting it all back inside the heart of a child" (257). In their collaborative creation *Imaginary Parents*, the Ortiz Taylor sisters have crafted a lasting case to contain and display their collective childhoods.

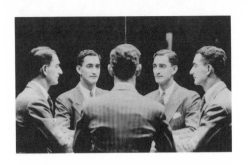

PART II
Collage
...

Autobiographies
That Combine Words
and Photographs

The personal past and the personal future
might be compared to the photograph, whose
paper-thin surface is literally an interface
between projection and reflection.

—*Dennis Grady*

4 | We Have All Gone into the World of Light

..................................
N. Scott Momaday

N. Scott Momaday's *The Names* is an odd book, difficult to classify by any generic standards, though it would seem to be as much autobiography as anything else, if we use Sidonie Smith's definition: "Autobiography becomes both the process and the product of assigning meaning to a series of experiences, after they have taken place, by means of emphasis, juxtaposition, commentary, omission."[1] Although all the terms from Smith's list are applicable to *The Names*, juxtaposition and commentary seem especially apt for this text, in which the author juxtaposes words and images and comments on the thirty photographs with lengthy narrative captions.[2] In his "Native American Autobiography and the Synecdochic Self," Arnold Krupat makes a nice distinction between two major camps: "Indian autobiography and autobiography by Indians."[3] "Indian autobiographies" are stories as told to another person, from another culture, as exemplified by a text such as *Black Elk Speaks*, while "autobiographies by Indians" are life stories written in English by someone of Native American heritage who has moved into a bicultural world, for example, *A Son of the Forest* by William Apess.

By this rule *The Names* is an autobiography by an Indian, or per-

haps, a memoir by an Indian. Its outward focus on ancestors, family, and others, as well as its story of Momaday's childhood—the characteristics that make the book tend toward memoir—also confuse another of Krupat's distinctions. His major claim, the idea that gives his essay its title, is this: "While modern Western autobiography has been essentially metonymic in orientation, Native American autobiography has been and continues to be persistently synecdochic."[4]

Although Krupat's terms and his argument about metonymy versus synecdoche are generally helpful, they are less than productive when applied to *The Names*, a text he picks out, along with Momaday's other autobiography, *The Way to Rainy Mountain*, as anomalies because they are "as metonymic in their orientation as those by Rousseau and Thoreau, for example."[5] Krupat writes in *The Voice in the Margin* of Momaday's style, "His writing offers a single, invariant poetic voice that everywhere commits itself to subsuming and translating all other voices."[6] With these arguments, which on a lower register echo those of Frank Chin against Maxine Hong Kingston as described in chapter 3, Krupat seems unwilling to allow Momaday the freedom to create another category of autobiography by Indians, one better suited to an author who grew up separated from his Kiowa culture, although immersed in the culture of the Jemez Pueblo, as well as other tribal and nontribal cultures in Arizona and New Mexico. As a child Momaday attended Catholic, Indian, and Anglo schools, including a boys' military academy in Virginia. Because Momaday, like Kingston and Sheila Ortiz Taylor, is an English professor—one who sometimes teaches a course on autobiography at the University of Arizona—he is, like Kingston and Ortiz Taylor, in a "hyphenated condition," caught between a number of cultural worlds. As Matthias Schubnell notes, "His upbringing was less than tribal, and more than tribal."[7]

Metonymy and synecdoche have always been slippery figures of speech because like autobiography and memoir they frequently overlap. Handbook definitions often try to separate them by stressing that metonymy is characterized by an association or connection, while synecdoche implies a part to a whole comparison. According to Holman and Harmon's classic *A Handbook to Literature*, then, synecdoche is "a trope in which a part signifies the whole or the whole signifies the part." While that part of the definition seems clear enough, the whole discussion adds confusion: "Usually, the part selected to stand for the whole must be one directly associated with the subject under discussion."[8] *A Handbook to Literature* ends its treatment of synecdoche by

giving as good examples foot soldiers for infantry and hired hands for workers, which produces just the sort of overlap that commonly occurs, foot and hand being associated with humans but also, of course, parts of the human body. And, to add another layer of association, according to James Mooney, in *Calendar History of the Kiowa Indians*, a name is "as much part of the owner as his hand or his foot."[9]

Just as autobiography is sometimes said to be a subspecies of biography, so synecdoche is often subsumed under the wider term metonymy, both rhetorical tropes being taken as smaller units in the master set called metaphor.[10] However, Roman Jakobson's often cited *Fundamentals of Language* maintains that metaphor and metonymy are radically different.[11] Krupat's argument, based on his contention that the two terms can be thought of as "part-to-part [metonymy]" versus "part-to-whole" [synecdoche], divides autobiography into native and non-native categories: "Thus, where personal accounts are marked by the individual's sense of herself predominantly in relation to other distinct individuals, one might speak of a *metonymic* sense of self; where narration of personal history is more nearly marked by the individual's sense of himself in relation to collective social units or groupings, one might speak of a *Synecdochic* sense of self."[12]

This whole discussion about metonymy and synecdoche, the Rosenkrantz and Guildenstern of rhetorical terminology, suggests how complicated the study of autobiography has become—James Olney's classic formulation "metaphor of self" has been transformed into "metonymy of self." Metonymy and synecdoche are significant in reading *The Names* fairly because, as W. J. T. Mitchell observes in *Iconology*, Jakobson believes "that the world of figurative language is divided between metaphor, based in resemblance, and metonymy, based in juxtaposition."[13] Resemblance, another form of likeness, is central to many of the issues about photography and autobiography I have been discussing, and juxtaposition is one of Sidonie Smith's key terms in her definition of autobiography cited above. And, as Hertha Wong observes in her *Sending My Heart Back across the Years*, "At times, Momaday uses typographical devices . . . to cue the reader to a special passage," which, she explains, cause his paragraphs to be "linked by association, image, or tone, or they may be juxtaposed for emphasis or surprise."[14] Wong's terms are another echo of Smith's list of characteristics of autobiography: emphasis, juxtaposition, commentary, and omission.

Resemblance and juxtaposition are both important in *The Names*, a

text made out of both English and Kiowa words and out of both photographic and sketched images, a book Robert Sayre describes as a "family scrapbook."[15] One answer to Krupat's belief that *The Names* is more metonymic than synecdochic lies in the presence within the text of photographs that, according to Nancy Shawcross, are themselves metonymic: "The photograph functions like a metonym, which draws its figurative expression directly from the object, usually from some part of its physical characteristics."[16]

Although *The Names* is subtitled *A Memoir*, the author begins, after having named himself, Tsoai-talee, by naming his genre: "*In general my narrative is an autobiographical account. Specifically it is an act of the imagination. When I turn my mind to my early life, it is the imaginative part of it that comes first and irresistibly into reach, and of that part I take hold.*"[17] This interesting reversal of the usual levels of specificity—we would expect an auto-biographical narrative to be imaginative generally rather than specifi-cally—suggests a pattern that prevails throughout the text. At first the actual photographs within the book would seem more specific than the prose descriptions; however, a consideration of both word and image suggests that the opposite is true; often the words are more specific, the pictures more general, although frequently word and image blend.

Unlike *The Way to Rainy Mountain*, which was illustrated by his fa-ther, Momaday's memoir incorporates both photographs and his drawings within the text, including photographs with handwritten captions. A reproduced painting, *Dragonfly* by N. Scott Momaday, clearly modeled on a photograph of Will Soule called *Kiowa Brave in War Dress*, appears on the cover of the University of Arizona Press paperback edition.[18] One photograph is itself a combination of por-trait/self-portrait, biography and autobiography: Momaday, as a child, and his grandmother, which includes a shadow of the photographer, his father, the whole image captioned "My grandmother and I regard my father, who casts a long shadow" (44).[19]

Throughout *The Names*, Momaday illustrates this reversal of the general and the specific through the act of naming. For example, in describing the grounds of the Jemez Pueblo school, he writes of "the meanest rooster I have ever known; perhaps his name was Oliver Blount, or Thaddeus Waring" (125). Following a description of a brief glimpse of a "lithe, lovely Navajo girl on a black horse," he adds, "Later I looked for her among the camps, but I did not find her. I imagined that her name was Desbah Yazzie and that she looked out

for me from the shadows" (131). In other instances the author is very specific about memories, providing exact names. For example, in describing a Kentucky Derby race that took place in 1913, twenty-one years before he was born, he informs the reader that the winner was named "Donerail," the jockey named "Goose," and the payoff for a "two dollar ticket to win" was "$184.90" (20).

According to Paul Jay, "The mythic, storylike aspect of past images for Momaday suggests that autobiography involves an extended kind of 'naming' of those images, and that this meaning is integral to the construction of identity."[20] For this memoirist, visual memory acts on the imagination rather than the other way around. Momaday's earliest memories are not of events or stories but images: "Memory begins to qualify the imagination, to give it another formation, one that is peculiar to the self. I remember isolated, yet fragmented and confused, images . . . which are mine alone and which are especially vivid to me. . . . Of all that must have happened to and about me in those my earliest days, why should these odd particulars alone be fixed in my mind? If I were to remember other things, I should be someone else" (62–63).

In short, if his memory were different, not necessarily more accurate, he would not have the same sense of self. In this formulation, Momaday explains Pohd-lohk's idea that "a man's life proceeds from his name, in the way that a river proceeds from its source" (ix). Pohd-lohk's notion, for all its tribal feel, is echoed by Virginia Woolf's words from *Moments of Being*, words that include a camera connection: "The past only comes back when the present runs so smoothly that it is like the sliding surface of a deep river. . . . For the present when backed by the past is a thousand times deeper than the present when it presses so close that you can feel nothing else, when the film on the camera reaches only the eye."[21]

Momaday's "account" of his "imagination" can be seen in the particular combination of images and words, in the way he uses photographs as documents or accounts undercut by words, often in the form of imaginative captions. For example, the genealogical chart that precedes the narrative (fig. 4.1)—a schematic diagram that combines actual names with both photographs and drawings—appears at first to function as a document designed to authenticate Momaday's native heritage. But as a careful reading of *The Names* makes clear, the authenticity of this chart is constantly called into question by a number of complications. The diagram, labeled "Genealogical chart" in the

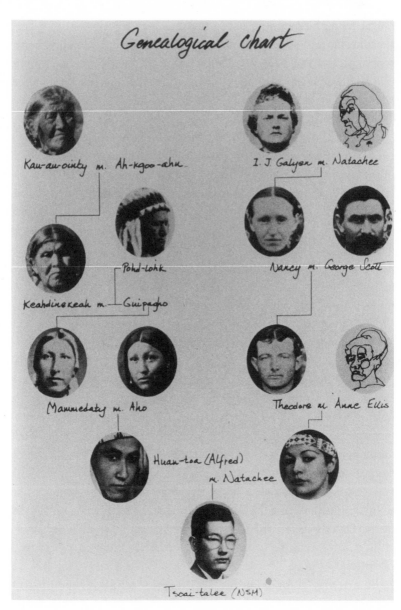

FIGURE 4.1. *Genealogical chart from* The Names. *(Courtesy of N. Scott Momaday)*

author's own handwriting (printed in the original 1976 Harper & Row edition in brown and sepia tones as if it were an old album), initially appears to be *specific*, some sort of historical document. Actually this family tree is *imaginative*, created by Momaday, who supplemented the "names" with photographs, adding sketches for most of the family members for whom photographs do not exist, such as the two women

on his father's side: his paternal grandmother, Anne Elizabeth Ellis Scott, and "that dark mystery" (20), his great-great-grandmother Natachee, the only Native American on his mother's side, the woman after whom his mother was named. Neither photograph nor sketch accompanies his maternal great-great-grandfather's name, Ah-kgoo-anh, or Guipagho the Younger, his paternal great-grandfather.

The two drawings and all the photographs in the chart, except for the picture of the author, have been "vignetted," cropped and reproduced within oval-shaped backgrounds as though they were taken in a studio and mounted in a family album, even though all the pictures in the chart are actually taken from photographs reproduced elsewhere in *The Names*. Although there are a number of photographs within the text of the author's father and mother, he has taken the picture captioned "My parents about the time of their marriage" (82), in which both appear to parody Indian authenticity—his father wearing a full headdress and his mother a single feather in a headband, her body covered with a blanket—and cropped it so that only their faces remain. Similarly, he has separated and reversed the faces of Nancy and George Scott, his paternal great-grandparents, who appear together in a separate photograph within *The Names*. In recycling photographs from one part of *The Names* into the genealogical chart at the beginning, Momaday replicates his recycling of parts of his first autobiography, *The Way to Rainy Mountain*, within his second.

The photographs of the author's mother and father dressed in inauthentic Hollywood-style garb are a good illustration of the way that photography works in terms of documentation. The portrait is false in that the clothes and feathers and the fake sky in the background do not ring true, especially when compared with other photographs in the text and with Momaday's lyrical evocations: "God has drawn the sky with light" (80). On the other hand, the photograph of his mother and father about the time of their marriage does capture the truth of their actual crossing from non-Indian to Indian identified for his mother and from Indian to nonreservation Indian for his father. The truth of the image, despite the fact that it is in some ways a modern version of the traditional practice of taking ethnographic photographs of Native Americans, including costuming and posing them, in the style of Edward Curtis, lies in the way it depicts the author's parents' own constructions of their selves. Although the image fails as an authentic Kiowa representation, it succeeds in showing both how earnest and determined Natachee Scott Momaday was in

her decision to overcome her future husband's family's disapproval of her marriage and how much an authentic Kiowa such as Al Momaday was influenced by popular images of Indians. According to Paul Jay, "The ironic quality in these photographs of Momaday's mother has the effect of muting the element of parody they seem on the surface to embody."[22]

The photographs in the chart come from other photographs, but what were the sources for the sketches? Were they drawn from Momaday's memories of verbal descriptions or from his imagination? For example, a picture of the author's grandfather, Theodore Scott, carries a confusing caption: "I like to think that Theodore looks like his grandmother Natachee here. There is no photograph of her" (14). How can the author see a family resemblance to a person he has never seen and of whom no photographs exist? One answer might be Roland Barthes's statement from *Camera Lucida*: "The Photograph sometimes makes appear what we never see in a real face (or in a face reflected in a mirror): a genetic feature, the fragment of oneself or of a relative which comes from some ancestor. . . . The Photograph gives a little truth. . . . But this truth is not that of the individual, who remains irreducible; it it the truth of lineage."[23]

The issue of lineage is particularly complicated for N. Scott Momaday, whose maternal relatives include French settlers in Kentucky and Cherokees and whose paternal side includes, in addition to Kiowas, his great-great-grandmother, who was stolen as a slave from Mexico, and his grandmother, who is said to be descended from French Canadians. He describes his mother as both a southern belle and as having "something Russian or Asian about her" (23), and as a boy in New Mexico during the Second World War, Momaday was often taken for Japanese. According to Matthias Schubnell, Momaday did not begin to explore his Kiowa heritage until he was in his early thirties. In a lecture given in 1971, Momaday said: "I think of myself as an Indian because at one time in my life I suddenly realized that my father had grown up speaking a language that I didn't grow up speaking . . . and so I determined to find out something about these things and in the process I acquired an identity; it is an Indian identity, as far as I am concerned."[24]

Although this lecture suggests that Momaday began to explore his Kiowa heritage in a serious and sustained fashion in his thirties, of course his worry about an Indian versus Anglo identity is one of the major components of *The Names*. The stream-of-consciousness sec-

tion in chapter 3, for example, shows the young Momaday trying to answer a teacher's question about his roots by sorting through what is and is not Indian in his family. Although Momaday's vision of Indian is constructed out of a combination of family lore and such popular cultural images as Billy the Kid and other "Western" movies, sports stars, World War II stories, and Boy Scouts, he also sees as especially Indian such things as eating catfish and the Rainy Mountain Baptist Church (102). Momaday's childhood interest in Billy the Kid eventually resulted in his publishing *The Ancient Child*, a novel featuring interactions between Billy the Kid and fictional characters and including "The Billy the Kid Suite," a collection of paintings.[25] He also published "The Strange and True Story of My Life with Billy the Kid."[26] Of all his attempts to separate Indian from non-Indian memories, Momaday finds particularly helpful the family photographs, some of which are most likely the very images reproduced in the book: "Wait I know why it's an Indian house because there are pictures of Indians on the walls photographs of people with long braids and buckskin clothes dresses and shirts and moccasins and necklaces and beadwork yes that's it" (101).[27]

Like the visual images, the names in the genealogical chart are similarly confusing for a number of reasons, including the Kiowa naming system and translations from Kiowa to English and from pictographs to Arabic letters, as well as alternative spellings, misspellings, and pronunciations. Although the traditional sign of autobiography has sometimes been described as a congruence between the name of the author, protagonist, and narrator, the author of *The Names* lists two Indian names, each with an English translation, Tsoai-talee (Rock-Tree Boy) and Tsotohah (Red Bluff), though he signs the book N. Scott Momaday, reducing his first name to an initial, taking the "Scott" from his mother's non-Indian side.

Further authentication for his name occurs within the text, where "a notarized document issued by the United States Department of the Interior, Office of Indian Affairs, Anadarko Area Office," is reproduced in a different type style, certifying that his official name is Novarro Scott Mammedaty, even though his "Standard Certificate of Birth" lists his name as "Novarro Scotte Mammedaty, ('Momaday' having first been entered, then crossed out)" (42), and Scott being misspelled. His father, Huan-toa ("War Lance"), christened Alfred Morris, changed his surname from Mammedaty to Momaday—surnames for Kiowas only becoming popular during the author's grand-

father's generation—a fact recorded in *The Names* as an aside: Alfred Mammedaty, "who had begun, for reasons of his own, to sign his name Momaday" (38).

The author does not specify whether his father's decision to change his name for purposes of signing is distinct from changing his name for all purposes. This flat description of his father's changing his name within a memoir named *The Names* is further confounded by the fact that the name Mammedaty is translated in the glossary at the end of the book as "Walking Above," while in Mildred Mayhall's book-length study *The Kiowas*, "Walking Above" is said to be English for Mama'nte or Dohate, and a Kiowa named Mamay-day-te has been given the name Lone Wolf (Guipagho),[28] an ancestor of Guipagho the Elder, whose picture Momaday captions, "I see Mammedaty in this man; I know this man in my blood" (165).[29] That his father chose to change his name from Mammedaty to Momaday for unnamed or unknown reasons does not explain why the author's name made the same transformation.

The pattern I have been describing for Momaday's genealogical chart—a reversal of the general and the specific, an undercutting of the visual by the verbal—is also characteristic of his photographs and captions throughout the book. Although Krupat has described *The Names* as having "very little in the way of wit or humor,"[30] for me the captions are often quite humorous, evidence of a wry wit. For instance, a picture of Momaday as a boy (fig. 4.2), captioned "The Horse is Tony. I am being pursued" (62), strikes me as amusing. Another example is the family picture, reproduced in the text as a snapshot complete with an off-center, dog-eared frame and captioned "I believe that I was thinking on great things" (71).[31]

Krupat contrasts Momaday's captioned photographs in *The Names* with Leslie Marmon Silko's uncaptioned ones in *Storyteller*, arguing that "Momaday has seen fit to provide captions for his photos. Here, too, there is the determination to full control; the photos may speak as they will to their viewers, but they may do so only in the presence of Momaday's own cues as to their content or meaning."[32] Here Krupat is captious about the captions, missing the humor, mistaking the handwritten remarks as controlling cues rather than as examples of Momaday's reversal of the general and the specific. For example, the caption to a picture of the graves of the author's maternal great-great-grandfather and great-grandmother ends with the words "There are wild chickens in the woods" (13), a general fact that adds nothing to

The horse is Tony. I am being pursued.

FIGURE 4.2. *"The horse is Tony. I am being pursued." From* The Names, *p. 62. (Courtesy of N. Scott Momaday)*

our reading of the photograph and is further undercut as a memory by the earlier narrative description of his visit to the graves, during which he met a local man named Belcher, who reported, "They's wald chickens in them woods. Y'all listen; you c'n hyear them wald chickens by" (11). Rather than rigidly controlling our response to the picture, Momaday re-creates the experience of visiting his ancestor's graves.

My mother. (Perhaps the doll's name was Natachee, too.)

FIGURE 4.3. *"My mother. (Perhaps the doll's name was Natachee, too.)" From* The Names, *p. 21. (Courtesy of N. Scott Momaday)*

Similarly noncontrolling is the caption to a photograph of his mother as a child before she began to imagine herself as an Indian, holding a doll in Indian dress (fig. 4.3): "My mother. (Perhaps the doll's name was Natachee, too)" (21). Another undercutting of the documentary value of the photographs occurs accidentally when the captions for his relatives Robie Ellis and Granville Scott are re-

versed in both the original and the paperback versions of the memoir.[33] Momaday's way with captions is aptly described by John Berger, writing about photographs in general: "In the relation between a photograph and words, the photograph begs for an interpretation, and the words usually supply it. The photograph, irrefutable as evidence but weak in meaning, is given a meaning by the words. And the words, which by themselves remain at the level of generalisation, are given specific authenticity by the irrefutability of the photograph. Together the two then become very powerful; an open question appears to have been fully answered."[34]

According to Hertha Wong, Momaday's captions are "reminiscent of Zo-tom's, Howling Wolf's, and White Bull's written commentary on their pictographic drawings and of the enduring Euro-American tradition of family photograph albums."[35] Perhaps Krupat's preference for Silko's way with photographs and captions over Momaday's has to do with his amendment to his synecdoche/metonymy argument. When "Native American Autobiography and the Synecdochic Self" was republished in Krupat's *Ethnocriticism*, he added as a footnote the notion that the whole discussion was connected to gender: "Men tend toward metonymic presentations of self, and women—in this like Indians and tribal peoples generally—tend toward synecdochic presentations of self."[36]

When Momaday describes his narrative method on the first page— *"This is one way to tell a story. In this instance it is my way, and it is the way of my people. When Pohd-lohk told a story he began by being quiet. Then he said* Ah-keah-de, *'They were camping,' and he said it every time. I have tried to write in the same way, in the same spirit. Imagine: They were camping"* (ix)—he means that in using the Kiowa storytelling tradition he will not be relying on images only as documents to reinforce his memories but that he will begin with images and then imagine himself retelling ancient stories "shifting, enlarging," allowing the storylike ideas to evolve mythically, copying Pohd-lohk's narrative style, as Pohd-lohk copied those who came before him. As Momaday observed, "That part of the book is fiction in a way, because I imagined how he lived on a particular day in his life. He wasn't there for me to draw on any documents or histories. . . . He did that in his stories, I do that in mine; it's been a long, growing tradition."[37]

The man known as Pohd-lohk (Old Wolf) in *The Names*, celebrated for having given Momaday his Kiowa name, is also known as Kiowa George Poolaw, famous for his calendar history of the Kiowas, one

FIGURE 4.4. *The Anko Annual Calendar.*
From The Kiowas *by Mildred P. Mayhall.*
(Copyright © 1962, 1971 The University of Oklahoma Press)

of only a handful that have survived.[38] Hertha Wong details the Plains Indian tradition of incorporating coup tales, winter counts, and other tribal and personal events into such forms as narrative wampum belts, quillwork, and pictographs painted on animal hides, tepees, and shields. The Kiowa eventually recorded these pictographic records on hides as monthly and semiannual calendars, an example of which is depicted in figure 4.4. These Kiowa calendars were recorded in 1896 by the ethnologist James Mooney, who wrote that "the records rather resemble the personal reminiscences of a garrulous old man than the history of a nation."[39] One of the calendars, long since transferred to a ledgerbook, was among Pohd-lohk's sacred possessions. Following the original format, Pohd-lohk continued to record events in Kiowa

history and used the calendar as a mnemonic device to remember and retell tribal stories from as far back as 1833.

When Momaday writes that he is adopting Pohd-lohk's narrative ways, he means that like Pohd-lohk he will not separate images from words but think in pictographs to imagine the ancient stories. For example, the calendar entries duplicated in figure 4.5 are representations of such events as the year of a large meteoric shower and devastating epidemics of smallpox and measles. When in *The Names* Pohd-lohk, who is unable to read or write English, "opened the book to the first page, and it was *Da-pegya-de Sai*, November, 1833, and the stars were falling" (48), he begins literally to imagine the falling stars: "He closed his eyes, the better to see them. They were everywhere in the darkness, so numerous and bright indeed that the night was shattered. . . . They fell in long arcs and traces, bright delineations of time and space, describing eternity. He looked after them with strange exhilaration, straining to see" (48–49). Not only has Pohd-lohk apparently returned to the actual time and place he is describing, but so also has Momaday, who has here imagined Pohd-lohk's imagination, though he represents the pictographs as prose.

The word "imagine"—to form a mental image—means for Momaday more than just a call to ponder a situation; to imagine is an act of creation and re-creation, as when he imagined the unknown Navajo girl's name. When he says of his mother's transformation from southern belle to Indian, "She imagined herself audaciously" (20), and later, "She imagined who she was" (25), he suggests that despite the obviously inauthentic studio portrait of his mother as a young woman, in which she names herself "Little Moon," her becoming a Native American is "among the most important events of my mother's early life, as later the same essential act was to be among the most important of my own" (25). His mother's imaginative transformation of her Kentucky/Cherokee self into the daily life of a Kiowa family living mainly among Navajos is authentic because of the way her imagination duplicated the native way of imagining: she became an Indian by imagining as an Indian. Momaday's own Indian identity, as he describes it in "the Man Made of Words," involves the act of imagination over genetics: "An Indian is an idea which a given man has of himself."[40] Like Maxine Hong Kingston's, Momaday's childhood was lived among ghosts, including the ghosts of gourd, sun, and ghost dancers, his autobiographical narrative like hers an attempt not to exorcise but to celebrate his spiritual past. In "The Man Made of Words," for

1. WINTER 1833-34
2. SUMMER 1844
3. SUMMER 1854
4. SUMMER 1861
5. WINTER 1861-62
6. SUMMER 1892

FIGURE 4.5. *Detail from Sett'an and Anko annual calendars. From* The Kiowas *by Mildred P. Mayhall. (Copyright © 1962, 1971 The University of Oklahoma Press)*

instance, he describes Ko-sahn appearing to him in a vision in which she reminds him that "You see, I have existence, whole being, in your imagination."[41]

The reversed relationship between pictures and words, specificity and generalization, memory and imagination in *The Names* produces an affirmative answer to Paul de Man's questions in "Autobiography as De-Facement": "But are we so certain that autobiography depends on reference, as a photograph depends on its subject or a (realistic) picture on its model? We assume that life produces the autobiography as an act produces its consequences, but can we not suggest, with equal justice, that the autobiographical project may itself produce and determine the life and that whatever the writer does is in fact governed by the technical demands of self-portraiture and thus determined, in all its aspects, by the resources of his medium?"[42] The "resources of his medium" are confusing because Momaday's media are multiple—photography, drawing, writing, and prose—while the "technical demands of self-portraiture" are especially complicated in Momaday's case because his "self-portrait" is also a portrait.

In addition to the charts and photographs I have been discussing, *The Names* also includes prose passages that combine portraiture and self-portraiture, such as the following description of the author sketching a physical portrait of himself with pencil as he views his reflection in the base of a kerosene lamp:

> I look for my image then in the globe, rising a little in my chair, but I see nothing but my ghost, another transparency, glass upon glass, the wall beyond, another distortion. I take up a pencil and set the point against a sheet of paper and define the head of a boy, bowed slightly, facing right. . . . I like him certainly, but I don't know who or where or what he is, except that he is the inscrutable reflection of my own vague certainty. And then I write, in my child's hand, beneath the drawing, "This is someone. Maybe this is Mammedaty. This is Mammedaty when he was a boy." (93)

In this complicated passage Momaday imagines himself as if he were Mammedaty, the grandfather he has never seen. The author as an adult describes himself as a child inventing memories out of names, deliberately blurring autobiography and biography in representing a pencil drawing described in prose but not actually reproduced physically within the text. In addition to the combination of portraiture and self-portraiture in the image just quoted above, Momaday also

literally combines word and image. Referring to the words just quoted, with their progressive movement from the general to the specific— "This is someone. Maybe this is Mammedaty. This is Mammedaty when he was a boy"—Momaday adds the following comments: "And I wonder at the words. *What are they?* They stand, they lean and run upon the page of a manuscript—I have made a manuscript, rude and illustrious" (93).

Here, in describing his illuminated manuscript, he demonstrates not only the way words become images as he creates them but also an ancestral way of constructing an indexical and iconic signature. As Hertha Wong explains: "The Plains Indian way to 'write' a name pictographically was to draw a head with a line coming from the head or mouth, connecting the body and the pictured object which signified the name (known as a name-symbol)."[43]

His description of his words almost coming alive, standing, leaning, and running, also parallels a description of himself as an imaginary football player, feinting and dodging his way through the words of his schoolbooks: "What I do sometimes is draw in the books move the pencil down through the words not through the crowds but around the words well among the words not touching them oh make believe I'm running with the football the words are tacklers move the pencil real fast if you touch a word you're tackled" (112). "Painting and drawing and writing are in some respects the same thing," he commented, "at least in the sense that writing is incising." Referring to his many etchings of shields, which often included calligraphy, Momaday notes, "Well, writing is also a kind of drawing, as I've suggested. So I like the idea of words on the picture plane."[44]

Momaday's work as a painter has been widely exhibited and sometimes includes self-portraits in which he appears in profile or in the guise of a bear.[45] Some of these self-portraits, along with painted portraits of Mammedaty, have appeared in his *In the Presence of the Sun* and elsewhere; however, he has not chosen to publish any photographic portraits or self-portraits, though he has painted a number of portraits of Set-anyhga (Sitting Bull) using Will Soule's photographs as a model.[46] And in *The Names* he includes—in addition to snapshots and a studio photograph of Aho, his paternal grandmother—a lengthy ekphrastic description of her as if she were a formal portrait:

> Momentarily the light shivered in her hair, so lowly that it seemed barely to emanate there. Her head, her face, her shoulders, her bosom were ample and round. Nothing, neither the corners of her

eyes and mouth, nor the folds of her flesh and the shadows that were set upon her, hardened to an edge or an angle or a flatness anywhere. Her skin was dark, and yet her face was so radiant against the shadows and the deeper darkness of her hair and her dress that her whole expression was laid out and defined there, fashioned upon the broad, round bone of her skull, which was prominent just now in the strange quality of the light. (78)[47]

This description, with its emphasis on light and dark, sounds as if it could refer to a photograph; however, Momaday makes clear that he is imagining a painted portrait: "She was entirely composed. A painter should have loved her in her composure then, in the lamplight" (78).

While his text is filled with descriptions of the quality of the ambient light and the majority of the images he has chosen to include are photographs rather than paintings, the painterly description of Aho he has imagined suggests another example of his reversal of the general and the specific. Stanley Cavell's observation that "a painting *is* a world; a photograph is *of* the world" turns on the fact that photography is generally thought of as being more directly connected to the world than painting.[48]

For Momaday, then, imagining people and the landscape in terms of artistic vision and seeing in a painterly and photographic manner, which he connects to both the art of remembering and the nature of writing, are always completely intertwined. As Suzanne Seed has observed: "Photographs have an ontological function as well as the obviously anthropological, descriptive one they are often narrowed to by iconoclasts. Photographs are an extension not just of our sight, but of our thought. . . . They allow us to evolve."[49] One way in which Momaday evolves is in reversing the flow of time, tracing his life back through his grandfather Mammedaty, whose photograph in *The Names* (fig. 4.6) has earlier been described in Momaday's first autobiography, *The Way to Rainy Mountain*: "He is looking past the camera and a little to one side. In his face there is calm and good will, strength and intelligence. His hair is drawn close to the scalp, and his braids are long and wrapped with fur. He wears a kilt, fringed leggings, and beaded moccasins. In his right hand there is a peyote fan. A family characteristic: the veins stand out in his hands, and his hands are small and rather long."[50]

In that earlier autobiography Momaday pictured Mammedaty as having seen four truly remarkable things, one of which was an early

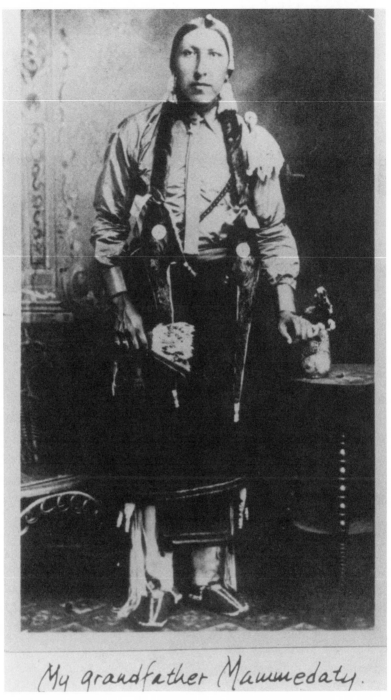

My grandfather Mammedaty.

FIGURE 4.6. *"My Grandfather Mammedaty." From* The Names, *p. 95. (Courtesy of N. Scott Momaday)*

morning vision of "the head of a little boy above the grass" when "there was no one; there was nothing there."[51] In *The Names* he returns to this image, imagining *himself* now as that little boy, "the intermediary in whose hands the gift is passed" (94), bestowing a black horse upon Mammedaty, a vision anchored to reality by his description of the fingers that have both drawn the picture of Mammedaty and captioned it: "My fingers are crisped, my fingertips bear hard upon the life of this black horse" (95–96).[52]

The autobiographical act of imagining a self, both his own and his grandfather's, is thus specific: fingers cramped from writing the section of *The Names* that deals with a childhood memory of drawing and writing coincide with a specific circling back to a childhood legend (Mammedaty seeing a child's head in the grass) in which the same fingers are cramped from holding the imaginary reins of an imaginary horse, all re-created in the text through prose. "About this time I was formulating an idea of myself," writes Momaday, adding, "Notions of the past and future are essentially notions of the present." "I invented history. In April's thin white light, in the white landscape of the Staked Plains, I looked for tracks" (97). Following the literal and the figurative tracks of a horse, as he follows the traces impressed on paper by the sun, Momaday sees the pictures he has drawn and the photographs he has inherited as powerful sources, direct links to the people and places he has named in *The Names*, no matter how imaginatively. Rather than "the art of fixing a shadow," Momaday is performing a complex autobiographical act common to all portrait photography. And as Susan Sontag reminds us: "The force of photographic images comes from their being material realities in their own right, richly informative deposits left in the wake of whatever emitted them, potent means for turning the tables on reality—for turning *it* into a shadow."[53]

In addition to the actual photographs reproduced or described in the book, Momaday sometimes uses photographic imagery to depict an image not photographed, as in the following description: "The old people and the children peered out from beneath the canopies, dark-skinned and black-eyed, nearly tentative in the shadows, beautiful in the way that certain photographic negatives are beautiful, dimly traced with light" (129). The texture of the prose in *The Names* is frequently almost photographic, the whole text being suffused with images of light, illustrative of what Catherine Rainwater calls Momaday's "iconological imagination."[54] In many instances, Momaday records the angle of light with much precision—a reflection perhaps of his fond-

ness for Emily Dickinson's "There's a Certain Slant of Light"[55]—as in the following description of the angle where the Washita River and Rainy Mountain Creek meet: "The light there is of a certain kind. In the mornings and evenings it is soft and pervasive, and the earth seems to absorb it, to become enlarged with light. About the noons there are edges and angles—and a brightness that is hard and thin like a glaze" (4). In another passage, he writes, "The light was not yet flat, but nearly golden in the yard, where it was broken upon the limbs and leaves of an elm and scattered on the grass and ground" (47), a sentence that almost duplicates a photograph, as is also true of another description: "There were shafts of sunlight all about, smoking, so many planes of bright light on the dark shadows of the creek" (56). As a younger boy he blurs talk and light into a photographic image: "There is a line of light under the door, not a line, really, but a long, thin triangle of light, under the door. The talk is there in that splinter of light, sliding along, now . . . now . . . now, now sharp, now muffled, close, distant, drawing away, and the black at the window going to blue within my reach" (77; ellipsis in original). In another instance, he writes, "Light was laced among the willows; it set a brightness like fire upon the grass, and it rose and floated like smoke" (80).

In these and many other cases in which Momaday fixes a memory with light writing, he is demonstrating not just an "iconological imagination" but a photographic one. His constructions of a self developing like prints from a camera, he superimposes pictures from his family's past, Pohd-lohk's calender-inspired imaginations, his father's paintings, his own sketches and drawings, collapsing writing and drawing backward toward pictographic images.

*Canadian literature is the autobiography of a
culture that insists it will not tell its story.*

—*Robert Kroetsch*

5 | Available Light
Michael Ondaatje

The Camera I: *The Collected Works of Billy the Kid*

When N. Scott Momaday was asked about the irony of his fas-
cination with William "Billy the Kid" Bonney, he replied that "Billy
the Kid is opposed to one part of my experience—to the Indian side
of me. He's diametrically opposed to that, but at the same time he's
very much a reflection of the world I love. The Wild West."[1] Billy the
Kid is just as opposed to the personal experience of Sri Lankan–born
Michael Ondaatje, who shares a fascination with the legend of the
western figure, having published *The Collected Works of Billy the Kid: Left
Handed Poems* in 1970. And like Momaday, who wrote poetry about
Billy and painted a "Billy the Kid Suite" and whose *The Ancient Child*
features a Billy the Kid who is brought back to life through a fictional
character's imagination, as I have described in the previous chapter, so
Ondaatje combines words and images in his version and has Billy
think and speak from the grave.

The Collected Works of Billy the Kid is a collage of poetry and poetic
prose accompanied by reworked and recontextualized prose taken
from such sources as historical documents, excerpts from a news-

paper interview, dime novels, and comic books, all of which is illustrated with etchings and, finally, photographs. Douglas Barbour refers to the book as a "documentary poem"; Manina Jones reads it as "a documentary collage" or a "docudrama"; Smaro Kamboureli treats it as a "long poem"; and Barbara Godard calls it "a modular fiction."[2] Ondaatje originally thought of *The Collected Works of Billy the Kid* as a film, and the text eventually became a stage play.[3]

Ondaatje notes that some of the incidents he relates "are essentially made up of statements made to Walter Noble Burns in his book *The Saga of Billy the Kid*, published in 1926," which makes "saga" another generic possibility.[4] Although Ondaatje's pastiche of materials is often described as postmodern, in some ways his blend of fiction and nonfiction parallels one of the first books about Billy, *The Authentic Life of Billy, the Kid*, a "biography" supposedly written by his putative killer, Pat Garrett, a book that was actually written by Marshall Ashmun Upson.[5] In his novel *The Ancient Child*, Momaday's fictive character Grey, a medicine woman, says of Garrett's biography: "Finally the thing that fascinated her was Garrett's pose as the author, that he was supposed to have written the life of the man whose life he ended."[6]

The Collected Works of Billy the Kid opens with a variation on the withheld photograph, a black frame with no image, captioned: "*I send you a picture of Billy made with the Perry shutter as quick as it can be worked— Pyro and soda developer. I am making daily experiments now and find I am able to take passing horses at a lively trot square across the line of fire—bits of snow in the air—spokes well defined—some blur on top of wheel but sharp in the main— men walking are no trick—I will send you proofs sometime*" (5). These words, which express the difficulty of capturing movement with a still camera, seem to refer to Billy the Kid; actually they are Ondaatje's samplings from two letters written by frontier photographer L. A. Huffman, as Ondaatje acknowledges (iv). Because the photograph that accompanies these words is not present within the black frame, its absence suggests both the inherent problem of representing a complex figure through a single image and Ondaatje's characteristic way of cutting and pasting, what he refers to in this case as his having "edited, rephrased, and slightly reworked the originals" (iv). Huffman's book might also have suggested the device of a frame without a photograph, for throughout his book frames, made out of clubs, hearts, diamonds, and spades, surround words where a photograph might be expected. One of the uncaptioned photographs in *The Collected Works of Billy the Kid* is actually Huffman's photographic studio at Fort Keogh, Montana.[7]

Part of the fascination Billy the Kid has for Ondaatje, according to Stephen Scobie, involves personality: "Billy's poetic personality is not entirely distinct from Michael Ondaatje's," he writes, noting that the text's title produces a composite figure: "Billy the Kid, outlaw as artist, and Michael Ondaatje, artist as outlaw, meeting in one persona."[8] Ondaatje suggests the somewhat autobiographical nature of his book in noting that "Billy is a personal book, very much about my world then, even though it's set in a different country and it's about an absolute stranger to me."[9] For some commentators, Michael Ondaatje the author speaks directly and autobiographically in the closing lines of *The Collected Works*, when he writes, "It is now early morning, was a bad night" (105). Ajay Heble, for example, believes that "the final lines of *Billy the Kid* signal Ondaatje's entry into the text and contain an implicit suggestion that even the author cannot finally make unambiguous sense of what he has just written."[10] Making "unambiguous sense" of Billy the Kid has never been possible because of the history of multiple Billys the Kid, which by now includes many Hollywood movies, comic books, dime novels, ballets, ballads, an album by Bob Dylan, a video game, and more than one Billy the Kid home page. In Lincoln County, New Mexico, there are tours of "Billy the Kid Country," as well as the "Billy the Kid Tombstone Race," an outdoor drama called "The Real Billy the Kid," and an outdoor pageant titled "The Last Days of Billy the Kid," not to mention a reenactment of the "Kid's Christmas Day, 1880."

When Paulita Maxwell says of Billy's photograph, "I never liked the picture. I don't think it does Billy justice" (*Collected*, 19), she is referring to the often reproduced full-length tintype, said to be the only photograph ever made of the Kid, that appears in virtually every book about him (fig. 5.1). The original 1882 first edition of Pat Garrett's *The Authentic Life of Billy, the Kid* includes a drawing of the photograph. Because only one photographic image of Billy the Kid is said to exist, the famous photograph, which is reproduced and hand-colored by Susan Krause on the cover of the Penguin paperback version of *The Collected Works*, the absence of a photograph in the text's opening frame also suggests Ondaatje's desire to present a fresh image of the famous outlaw.[11] In place of the "Wanted" poster image that might fit the frame, he produces a collage of images of William Bonney, hand-colored by his imagination.

The author describes Bonney's facial expression in a prose passage narrated by Pat Garrett: "The rather cruel smile, when seen close,

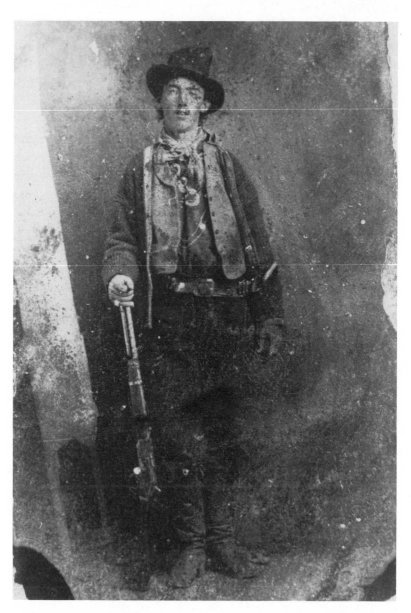

FIGURE 5.1. Billy the Kid. *(Courtesy of the Lincoln County Heritage Trust)*

turned out to be intricate and witty" (43). According to Jefferson
Hunter, "The basic ambition of portrait photography has always been
to fix personality, to draw a distinct character from someone's face."[12]
Even if we could agree with Hunter's definition, the inherent ambigu-
ity of the word "fix" is problematic. Whether Billy's personality is
frozen by the process or repaired is part of the confusing nature of

portraiture, and personality in portraiture is, of course, an ambiguous concept, which photographer Duane Michals describes in an essay called "I Am Much Nicer than My Face" as the self dressed up: "my true self, that random and illusive thing, decorated with personality."[13] Later, reading Billy's facial expression from the photograph through the lens of a contemporary interview, Ondaatje wants to demonstrate that the legendary figure is "nicer than his face": "Billy has a denture system which is prominent, buck teeth you at the paper would call it. So that even when he has no intention of smiling his teeth force his mouth in a half grin" (82).[14]

In a section of *The Ancient Child* titled "He Looks Remarkably Like the Famous Photograph," in which Grey first meets Bonney, Moma-day has a fictional character describe a fictional encounter in words that accurately describe the celebrated photograph, except that color has been added: "His face was somewhat crooked, with outstanding ears and long curly hair. His expression was passive, almost empty. His mouth slightly open, exposing his yellow, protruding front teeth."[15] When Momaday ends his description with details that exactly match the photograph—"In his left hand he held the barrel of a lever-action rifle, stock to the floor; the right hand, the arm slightly bowed and relaxed, cupped at his side"—he wants to correct the fact, supposedly established in part by the photograph, of Billy's left-handedness, one source of the Arthur Penn film *The Left Handed Gun*, as alluded to in Ondaatje's subtitle, *Left Handed Poems*. However, one of Ondaatje's major reasons for including photographs within the text is to demonstrate that, despite their reputation for historical authenticity, they can often be misleading as documentation. As Scobie reminds us, "Indeed, it was the reversed image of one famous photograph of Billy which led to the mistaken idea that he was left-handed. All contemporary authorities . . . remember Billy as right-handed."[16] This reversal reminds us of Lejeune's playful distinction: "I have my criterion! If the painter is painting with his left hand, it's a self-portrait; with the right, a portrait."[17]

Ondaatje twice has Billy refer to the occasion on which this photograph was taken. In one case Billy, thinking of a blurred photograph, notes, "I remember when they took the picture of me. . . . I was waiting standing still for the acid in the camera to dry firm" (68). In another instance, he imagines a direct, Barthesian link between the occasion of being photographed in the past and himself in the present: "I was thinking of a photograph someone had taken of me, the

only one I had then. I was standing on a wall, at my feet there was this bucket and in the bucket was a pump and I was pumping water out over the wall. Only now, with the red dirt, water started dripping out of the photo" (50). In the first case, Billy is reminded of his full-length photograph because of the irrefutable direct link between subject and photographer, especially in the early days of photography: if one moved while a picture was being taken, he or she appeared as a blur; if one moved too fast, he or she was absent from the final image. In the second case, he imagines a transformation; the well water has some-how been contained within the photograph and is now able to flow out of it in the present. In providing the photograph with the ability to hold water, Ondaatje captures one of the essential qualities that make photographs interesting, as described by Nancy Shawcross: "The en-gorgement of physical time is the method by which photographs are made. Photographs are pictures of time: they are this before they are anything else. And because this engorgement of time is the necessary condition of each photograph, photographs can be seen as completely atemporal."[18]

The photograph of Billy the Kid, taken by an unknown traveling tintypist, is especially celebrated because—as is claimed of the photo-graph of Buddy Bolden's band in *Coming through Slaughter* and of the author's parents together in *Running in the Family*—it is the only one known to exist, though that fact has frequently been challenged. Bob Bose Bell's *The Illustrated Life and Times of Billy the Kid* includes seven different candidates for a second photograph; however, none of the claims has been substantiated by the Lincoln County Heritage Trust Museum, which owns the only original known to exist.[19]

Further undercutting of the authenticating power of photographs is built into another photograph in Ondaatje's text, the picture of a seated man and woman, he with a beard and hat and she in a long blouse with a brooch, which appears opposite the words "*Miss Sallie Chisum, later Mrs. Roberts, was living in Roswell in 1924, a sweet faced, kindly old lady of a thousand memories of frontier days*" (30). Actually the couple in the photograph are Stuart and Sallie Mackinnon, friends of Ondaatje's from his own frontier days and among those to whom the book is dedicated.[20] The author makes a similar substitution when, in describ-ing Billy's last night, he replaces the historical deputy named McKin-ney with Mackinnon (92). The final photograph in the text—a tiny snapshot in the corner of a page-sized frame of a small boy in a cowboy outfit, complete with gun and holster—is actually a picture of Michael Ondaatje as a boy.[21]

Ondaatje-the-kid, dressing up in Sri Lanka, is described as being equally attracted to photography as an adult: "Ondaatje had always been interested in the camera—in fact it was an obsession. Stuart Mackinnon claims that 'one hardly ever saw him without one.' He had a good eye, a good sense of what would make a photograph. But he was especially good at catching people in revealing poses, or, more often, deliberately getting people to pose.' "[22] Not only is Ondaatje interested in photography in itself, but his writing is itself often photographic. As T. D. MacLulich notes of *The Collected Works*, photography is "the controlling metaphor for both perception and the artistic process" because it "supplies an apt metaphor for Billy's detached way of responding to the external world."[23]

Although a number of commentators have pointed out the image of Billy as a camera: "I am very still / I take in all the angles of the room" (17), many other photographic metaphors occur, often with connections to dark rooms and, as is true of Momaday's *The Names*, images of sunlight.[24] Describing a barn he stayed in for a week, Billy remarks, "It was the colour and light of the place that made me stay there, not my fever," adding, "I sat, setting up patterns in the dark" (17). Although the words just quoted are those of Ondaatje's Billy the Kid, they parallel Ondaatje's own situation as he wrote *The Collected Works* at a table in the back corner of a barn of his Blue Roof Farm.[25]

Playing on the etymological associations between camera/chamber/room, Ondaatje describes Billy as if he were inside a camera, thinking, "When I had arrived I opened two windows and a door and the sun poured blocks and angles in, lighting up the floor's skin of feathers and dust and old grain" (17). As opposed to the closing lines of the text, quoted earlier, in which a voice—perhaps the author's own—describes waking up after a bad night in a room suffused with smoke made visible by the sunlight, Billy is often depicted not in a camera obscura, a dark chamber, but in a camera lucida, a lighted room that suggests the early apparatus used by artists to fix a view.[26] "So it was a bad night. But this morning the room is white and silvery shadows roll across the ceiling" (71), Billy thinks in one passage, echoed by another in which he observes: "Waking in the white rooms of Texas after a bad night must be like heaven I think now" (69). The series of white rooms concludes with: "It is afternoon still, the room white with light. My last white room, the sun coming through the shutters making the white walls whiter. I lie on my left cheek looking to that light" (79). This series of white rooms is echoed by a similar

scene in *Coming through Slaughter* in which Buddy Bolden thinks: "Here. Where I am anonymous and alone in a white room with no history and no parading" (86).

In describing Billy's death, Ondaatje again uses photographic metaphors; the famous midnight shooting by Pat Garrett is said to take place in "a dark room." But no photographs of the scene will ever be developed, for Billy, reflecting the text's initial absent photograph, is trying to get out of the room, to escape from the frame. In an image that will resurface throughout *Coming through Slaughter*, he thinks, even in death, "My right arm is through the window pane / and the cut veins awake me / so I can watch inside and through the window" (95).

Storyville Portraits: *Coming through Slaughter*

Coming through Slaughter appears at first to be a biography of Buddy Bolden; however, the book is actually an imaginative improvisation in the style of New Orleans jazz, involving the mysterious and legendary Charles Buddy Bolden, the famous cornet player and band leader who was among the originators of jazz; E. J. Bellocq, the photographer of Storyville prostitutes, who appears in the book as a fictional character; and Michael Ondaatje himself. Although the book reproduces only one actual photograph (fig. 5.2), a controversial picture of Buddy Bolden and his band, it is filled with complicated connections between photographs, portraiture, and self-portraiture.

Various generic terms have clustered around *Coming through Slaughter*, ranging from Brent MacLaine's "photofiction" and "family album novel" to Jerry Varsava's "biographical fiction" to the *Toronto Globe's* "memoirs, hallucinations, conversations, history, melancholy, fantasy, trivia and truth . . . a new prose form," quoted on the back cover of the Avon/Bard paperback edition. Smaro Kamboureli calls it "a long poem or a poetic novel"; Naomi Jacobs refers to the book as "fiction biography," placing it into the same genre as William Styron's *The Confessions of Nat Turner* and Marguerite Yourcenar's *Memoires d'Hadrien*; and Douglas Barbour has recently introduced the term "bricolage."[27]

Sam Solecki thinks that the most accurate label for *Coming through Slaughter* would be self-portraiture. As Solecki writes, "But *Coming Through Slaughter*, even granting that it is fiction and not autobiography or even confessional poetry, is the story of Michael Ondaatje; it is the work in which he most explicitly declares that a fictional character

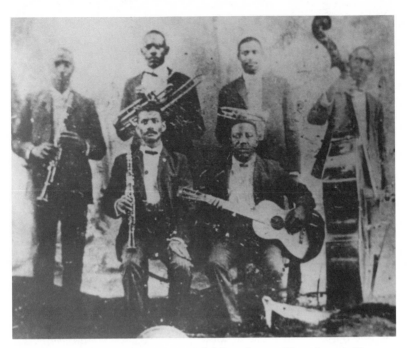

FIGURE 5.2. *Buddy Bolden and his band. (William Ransom Hogan Jazz Archive, Howard-Tilton Memorial Library, Tulane University)*

created by him is really a self-portrait."[28] As defined by Michel Beaujour in his *Poetics of the Literary Self-Portrait*, written, as opposed to visual, self-portraiture "attempts to create coherence through a system of cross-references, anaphoras, superimpositions, or correspondences among homologous and substitutable elements, in such a way as to give the appearance of discontinuity, of anachronistic juxtaposition, or montage, as opposed to the syntagmatics of a narration, no matter how scrambled, since the scrambling of a narrative always tempts the reader to 'reconstruct' its chronology."[29] Beaujour's call for self-portraiture as a literary term for those forms of life writing distinguished from autobiography by "the absence of a continuous narrative" is similar to the following description by jazz historian William Schafer of the confusion involved in determining exactly who Buddy Bolden was: "We know a good deal about this 'Buddy Bolden' after all—it is just that none of it fits together into one seamless narrative."[30] As John Chilton writes in his *Who's Who of Jazz*, "Every scrap of information that comes to light seems, in some small way, to contradict the previous story. The only clear fact that has emerged from my questions to veteran musicians is that they are not all talking about the same man."[31]

Although the name Michael Ondaatje only appears on the front and back covers and title page, and as the initials M.O. at the end of the credits and acknowledgments—never within the actual pages of *Coming through Slaughter*—the book has often been read as autobiography or memoir as much as biography, mainly because of the often quoted passage in which Ondaatje transforms a photograph into a mirror: "When he went mad he was the same age I am now. The photograph moves and becomes a mirror. When I read he stood in front of mirrors and attacked himself, there was the shock of memory. For I had done that. Stood, and with a razor blade cut into cheeks and forehead, shaved hair. Defiling people we did not wish to be."[32]

According to Douglas Barbour, "In this moment of pure *frisson* we 'naturally' identify this 'I' as Michael Ondaatje, the author of the book. Nevertheless, because it is a book, it is only the inscribed figure, 'Michael Ondaatje,' who identifies with Bolden, seeing his photograph as a mirror."[33] But does Barbour's formulation really help? All narrators of autobiographies are inscribed figures, and Barbour's using documentation to determine somehow where fiction and nonfiction blend is undercut by his claim about Ondaatje's having read that Bolden attacked himself while looking in a mirror: "That particular piece of information appears in none of the documented sources referred to in the acknowledgments."[34] Actually there is a brief description in Martin Williams's *Jazz Masters of New Orleans* (one of the books cited by Ondaatje) of Bolden "verbally abusing himself in the mirror" just before Williams's version of the fight between Bolden and Tom Pickett.[35]

Whether the Ondaatje-identified narrative voice in the book is autobiographical, fictional, or a sort of fictive fiction, that same voice speaks on the next page about the genesis of the book: "The thin sheaf of information. Why did my senses stop at you? There was the sentence, 'Buddy Bolden who became a legend when he went berserk in a parade . . .' What was there in that, before I knew your nation your colour your age, that made me push my arm forward and spill it through the front of your mirror and clutch myself" (34)? In this *Through the Looking Glass* image—putting an arm through a mirror/window/glass/photograph—which figures prominently throughout the book, Ondaatje at first seems to be using a now familiar postmodern technique, a deliberate blurring of the boundaries between genres; just a figurative gesture—no need to examine actual photographs of Michael Ondaatje for retouched scars.

And yet that same narrative voice also describes a sort of field trip to New Orleans and environs on research, a search for documents and atmosphere, a literal journey to the streets where Bolden lived and worked: "This is where he lived seventy years ago, where his mind on the pinnacle of something collapsed. . . . There is so little noise that I easily hear the click of my camera as I take fast bad photographs into the sun aiming at the barber shop he probably worked in" (133).[36] The N. Joseph Shaving Parlor, where Bolden was said to have worked at the beginning of the book, and where much of the narrative shows him actually working as a barber, has now become the place where he "probably" worked, a precursor of Donald Marquis's biography of Bolden, published two years after *Coming through Slaughter*, which demonstrates fairly conclusively that Bolden never worked at any barber shop.

The identity of the narrative voice becomes interestingly complicated because of the fact that the photograph being described by the inscribed, fictive Ondaatje actually exists and was published in Stephen Scobie's essay *"Coming Through Slaughter*: Fictional Magnets and Spider's Webbs," a parallel to the photograph of the same site published in Marquis's biography as documentary evidence, ironically to show where Bolden did not work.

That Michael Ondaatje's books blend nonfiction and fiction is confusing enough without the addition of photographs that would at first seem, as part of the discipline of documentary, outside the literary world's fiction/nonfiction dichotomy. Paul John Eakin argues that Roland Barthes's claim that "the photographic record offers incontrovertible proof that 'someone has seen the referent . . . *in flesh and blood, or again in person,*'" undercuts the poststructuralist position that the self is a culturally performed construct.[37] However, like Barthes's, Ondaatje's meditations on memory and identity are brought about as much by photographs that do not exist or are not reproduced as by those that do. Because of photography's link with an actual referent, a photographic portrait is somehow on a different plane of reference than a painted portrait, such as the only other image of Buddy Bolden extant, the painting Marquis reproduces in his biography.

When Linda Hutcheon asks, "But why have so many *Canadian* writers, in particular, turned to the notion of taking photographs for their analogue of literary production?" she mistakenly assumes that these writers are using photographs as a metaphor for "an act of petrifying into stasis the dynamic of experience."[38] Actually, Ondaatje does just

the opposite. Despite photography's claim to accuracy, Ondaatje's use of photography demonstrates that rather than fixing Buddy Bolden's personality, in Hutcheon's words "petrifying into stasis the dynamic of experience," actually the photograph reproduced in *Coming through Slaughter* shows Bolden "dissolving out of his pose" (67). The famous photograph of Buddy Bolden's band—the only one of Buddy Bolden in existence—that appears on the cover is reprinted in the Anansi paperback version on the title page as well. The words "Buddy Bolden" appear at first to be the picture's title, but actually they are printed slightly left of center, right above Bolden's head, identifying him. The rest of the band members, including Willie Cornish, trombonist, who appears as a character in *Coming through Slaughter* and who is credited by Ondaatje as the original owner of the photograph that "is now in the Ramsey Archive" (4), are not identified here. In the American Avon/ Bard paperback edition, the Bolden band picture includes a long caption from jazzman Louis Jones, an interview listed in the credits for the Canadian version despite the fact that the Jones interview is not printed in the Anansi version.

The photograph has often been reproduced in jazz histories and reference books, such as Frederick Turner's 1982 *Remembering Song: Encounters with the New Orleans Jazz Tradition*, in which the author credits the photograph to New Orleans historian Donald M. Marquis— biographer of Bolden—and describes it as "a photograph so blotched and scratched that you cannot tell his eyes from the imperfections of age and the original of which has perversely disappeared."[39] Interestingly, the photograph in Turner's book is reversed, so that Bolden stands on the right rather than the left of center, although still identified as "standing second from left" (*Coming*, xviii), despite the fact that that figure is clearly holding a trombone rather than a cornet.

In *In Search of Buddy Bolden* Marquis summarizes the photograph's history as far as he can determine it, and he concludes that the photograph has always been misdated as being before 1895. Subsequent research by jazz scholars has supported Marquis's revelation that the original published version (in the first edition of the *Jazzman* in 1939), as was true of the celebrated Billy the Kid photograph, was "reversed," or "flopped," printed with Bolden second from the left rather than second from the right. However the picture is printed, some of the musicians are apparently playing their instruments left-handed, which contradicts both the historical record and the memories of many of the musicians themselves. According to Alden Ashforth,

writing in the *Annual Review of Jazz Studies*, a study of the particular types of clarinet and cornet construction from the period proves finally that the photograph should be printed with Bolden on the right—the opposite of Ondaatje's cover—and with Frank Lewis on B-flat clarinet standing and William Warner, clarinet, seated, again the opposite of Ondaatje's versions.[40]

In thus reproducing a "left-handed" picture, Ondaatje echoes his theme of left-handedness, while providing a visual pun for his description of Bolden being developed, "the friend who in reality had reversed the process and gone back into white" (52–53), showing through the reversing process another example of coming through the window from the other side. Marquis presents the photograph both ways, in the second case including the musicians' signatures, a visual analogue to Ondaatje's sonograph of dolphin sounds, about which he writes, "No one knows how a dolphin makes both whistles and echolocation clicks simultaneously" (5), that is, location and signature. Neither locating Buddy Bolden in city directories nor listening to other peoples' recordings of his signature piece "Buddy Bolden's Blues" (which features a variety of lyrics based on the phrase "I thought I heard Buddy Bolden say") will pinpoint his identity. The fact that nothing is left of Bolden but his name is reflected in Ondaatje's presentation of another version of the band photograph, another captioned photograph without the actual image, about which he says, "As a photograph it is not good or precise, partly because the print was found after the fire" (66). Ondaatje writes, "There is only one photograph that exists today of Bolden and the band. This is what you see":

| Jimmy Johnson on bass | Bolden | Willie Cornish on valve trombone | Willy Warner on clarinet |
| | | Brock Mumford on guitar | Frank Lewis on clarinet. (66) |

The photographer is not credited in Ondaatje's book or jazz histories, but a partially fictional E. J. Bellocq is described in *Coming through Slaughter* in the act of reproducing a print of the photograph in question, "watching the pink rectangle as it slowly began to grow black shapes" (52), in a manner that suggests Ondaatje's creative act in bringing Bolden to life as a character based on imagination and research in the jazz archives at Tulane University. Ondaatje is not really arguing that Bellocq could have been the actual photographer of the

Bolden photograph, for not only did their lives not actually cross, but, as Wolfgang Hochbruck points out, the Bolden band photograph was supposedly damaged and waterlogged by the fire that Bellocq sets after the scene in which he hands the picture to Webb.[41] Ondaatje credits a number of histories of jazz as well as Bellocq's *Storyville Portraits*, which were "an inspiration of mood and character" (158), plus "important landscapes" and rare records and files from the hospital where Bolden died; however, he adds at the end, "some facts have been expanded or polished to suit the truth of fiction" (158).

Like Bolden, Bellocq is a shadowy figure despite his being portrayed in Louis Malle's 1978 film *Pretty Baby*, and *no* photographs of him exist. As John Szarkowski writes, "Our knowledge of E. J. Bellocq barely transcends the level of rumor."[42] His portraits of prostitutes, taken around 1912, were discovered after his death and in 1966 were eventually reproduced by photographer Lee Friedlander from the original glass plates, yet another example of putting hands through the glass. As a result, many of the pictures are "broken, vitriolized, eaten away by time,"[43] while others have been mysteriously scarred or mutilated, often the faces having been scratched away, literal examples of Roland Barthes's famous description of the photograph's *punctum*.

The parallel between Bellocq's photographs having been defaced and Michael Ondaatje's autobiographical intrusion into the narrative with a description of his own face being scarred—which also echoes the description of Pickett as "a guy with scars on his cheek" (116) and Jefferson Mumford's being nicknamed Brock because his face was scared by smallpox[44]—becomes both a literal and a figurative example of Paul de Man's "Autobiography as De-Facement." However, as Susan Sontag observes, "photographs, when they get scrofulous, tarnished, stained, cracked, faded still look good; do often look better,"[45] a statement that begins to explain Ondaatje's impulse toward simultaneous defacing and effacing in his argument about Bellocq: "the making and destroying coming from the same source" (55). Coming through the destruction of the glass plates on which the prostitutes were captured, coming through the slaughter of the photographer, is the hand of Michael Ondaatje, reaching back through the photographs, retouching them, as he retouches his own scars.

When Ondaatje writes, "The sun has swallowed the colour of the street. It is a black and white photograph, part of a history book" (134), he is referring both to his act of photographing the N. Joseph Shaving Parlor and to his autobiographical act; however, he is also

alluding here to the personified sun, Bolden's daily visitor in the East Louisiana State Hospital, who follows the lines of perspective in Buddy Bolden's dark room, his camera obscura, until reaching Bolden, ostensibly the sitter for the portrait, who laughingly says, "As you try to explain me I will spit you, yellow, out of my mouth" (140). Coincidentally, just such a photograph actually exists, taken by Richard Avedon of an unknown patient in the East Louisiana State Hospital on February 5, 1963.[46]

Providing a literal example of the etymology of the word "photography," turning sun writing to light writing to life writing, Buddy Bolden restores color to his life, comes through slaughter by coming alive from inside a notoriously unreliable historical photograph. In one sense, the Bolden band photograph is flat and impenetrable. As Ondaatje says of one of Bellocq's portraits, "the picture is just a figure against a wall" (54); however, in this formulation the word "figure" is itself figurative, as becomes apparent when we look at an actual Bellocq photograph that shows an uncanny parallel between a butterfly-shaped scar on the subject's body and the butterfly she is drawing on the wall (fig. 5.3). In all the complicated interrelationships between autobiography and photography within Michael Ondaatje's *Coming through Slaughter*, he supports another Canadian, Michael Ignatieff, who claims in his autobiographical *The Russian Album* that the relationship between photographs and memory is often confused: "More often than not photographs subvert the continuity that memory weaves out of experience. . . . Memory heals the scars of time. Photography documents the wounds."[47]

"We Are Not Our Own Light":
Running in the Family and *The Man-Eater of Punanai*

While there is some doubt about the autobiographical nature of *The Collected Works of Billy the Kid* and *Coming through Slaughter*, clearly Michael Ondaatje's *Running in the Family* (1982) is autobiographical, as is his brother Christopher's *The Man-Eater of Punanai*, which appeared in 1992. Both brothers have as their central purpose in writing biographically and autobiographically their separate attempts at coming to terms with their father by reconciling their own personal memories with those of other family members and with documentary evidence, including photographs.

FIGURE 5.3. *Untitled, Plate 60 from E. J. Bellocq's* Storyville Portraits.
(© Collection Lee Friedlander; courtesy Fraenkel Gallery, San Francisco)

Given the instability of photographic and autobiographic represen-
tation, readers have naturally had difficulty fitting *Running in the Family*
and *The Man-Eater of Punanai* into a definite genre. For example, at the
beginning of her essay on generic slippages in *Running in the Family*,
Smaro Kamboureli lists some of the many labels that have been at-
tached to that book: oral history, memoir, collection of anecdotes,
historiographic metafiction, and biography.[48] Ondaatje's fellow émi-
gré to Canada, Bharati Mukherjee alone refers to the book as "existen-
tial biography, family saga, North American root search, travel ac-

count, and social history."[49] While John Russell names *Running in the Family* "travel memoir as nonfiction novel," the back of the Penguin paperback classifies it as "autobiography/memoir," and the Vintage International edition calls it "memoir/literature."[50]

A similar group of terms has clustered around Christopher Ondaatje's *The Man-Eater of Punanai*. Subtitled *A Journey of Discovery to the Jungles of Old Ceylon*, Christopher's book has been described as "a masala-ish blend of things—coffee table picture book, rich man's travelogue, introspective memoir," as well as "confessional autobiography and a non-fiction variant of . . . *Running in the Family*."[51] Christopher Ondaatje's text, like his earlier *Leopard in the Afternoon*, is a sort of Hemingwayesque nonfiction account that eventually becomes an attempt to counter the portrait of Philip Mervyn Ondaatje presented in *Running in the Family*, while simultaneously undercutting the remark in Michael's book attributed to Christopher: " 'You must get this book right,' my brother tells me, 'You can only write it once.' "[52]

Running in the Family was originally published by McClelland and Stewart in Canada and W. W. Norton in the United States, both in 1982. In the 1984 Penguin paperback version seven different photographs are reproduced within the text, on each occasion appearing on one of the seven title pages of the book's separate sections and also acting as captions for each photograph. "Eclipse Plumage" (fig. 5.4) is also reproduced on the front cover of the Penguin edition as part of a cover design ascribed to Neil Stuart with "cover illustration and hand tinting by Susan Krause." When the book was published in Toronto in 1984 by General Publishing as part of the New Press Canadian Classics series, no actual photographs appeared within the text. The Canadian edition features the same photograph on its cover as the Penguin version, except that the New Press version is titled "Family Breakfast (detail)" and described as "watercolour, acrylic and pencil on photograph by David Hlynsky." The Canadian cover has been cropped so that four people from the left edge of the picture are missing, including a man in a clown suit.

There is no definitive indication within the text or on its cover of the actual photographer or the history of the photograph, though a number of possibilities exist. Within "The Prodigal" section the author describes the cast of an amateur theatrical production of *Camelot* being photographed outdoors: "The dream-like setting is now made more surreal by Sinhalese actors wearing thick velvet costumes, pointed hats, and chain mail in this terrible May heat" (159). Within

FIGURE 5.4. *"Eclipse Plumage." (Copyright © 1993 by Michael Ondaatje; reprinted by permission of Michael Ondaatje)*

the "Eclipse Plumage" section of *Running in the Family* two possible references to the cover picture occur. Ondaatje's Aunt Dolly is described as a costume maker, and his family is said to have often produced family plays including *The Mikado* and *A Midsummer Night's Dream*, and the picture may represent or suggest a sort of family cast party. Aunt Dolly also "points to a group photograph of a fancy dress party that shows herself and my grandmother Lalla among the crowd" (112). It is possible that the photograph on the book's cover and on the "Eclipse Plumage" title page of the American version is a reproduction of the actual picture toward which Aunt Dolly points, a fancy dress party not in the sense of dressing up in formal clothes but in the sense of wearing costumes.

Like the deliberate indeterminacy of the book's genre, somewhere between portrait and self-portrait, the indeterminacy of this photograph is deliberate. Because Aunt Dolly is virtually blind and without her glasses, she can't actually see the photograph but only "reels off names and laughs at the facial expressions" based on having "memorized everyone's place in the picture" (112). As she describes the photograph, in the midst of the author's biographical portrait of her,

the book turns into autobiography, Ondaatje slipping into first-person narration and the biographical subject literally blending into the autobiographical subject: the photograph has "moved tangibly into her brain, the way memory invades the present . . . the way her tiny body steps into mine as intimate as anything I have witnessed" (112). This transformation from biography to autobiography occurs in the same way that the original photograph is transformed from an uncredited group portrait into other genres—a hand-tinted photograph and a painting called "Family Breakfast."

The photograph may be thought of as a portrait in the sense that Ondaatje's Aunt Dolly and his grandmother Lalla might be included in the picture, as they are in the biographical sections called "Lunch Conversation," "Aunts," and "the Passions of Lalla." And the picture may also be considered a self-portrait in the sense that Ondaatje, who is greatly concerned with the overall design and production of his books, has chosen to include the picture on the cover and on the page titled "Eclipse Plumage" as an example of the sort of photograph to which his aunt might actually have pointed. The four people who have been "eclipsed" in the cropped version may include the author's aunt and grandmother, who have been "eclipsed" in the original Greek meaning of the word—having been left out. On the other hand, all the people in the picture are "eclipsed" in the sense of being obscured by having been colorized (one character's costume is shown on the Canadian version as Uncle Sam), and on the American cover the top of the picture's frame is literally eclipsed by the plumagelike foliage. Aunt Dolly's looking at the photograph—which she cannot actually see because of blurred vision and because she's looked so long that she no longer sees the picture as a photograph—is also compared to the operation of memory in old people and to "the way gardens invade houses here" (112), another example of a literal eclipsing by plumage. The author's saying of his family "I wanted to touch them into words" (22) is paralleled by the two different ways in which the original photograph has been "touched up" or hand-tinted.

Unlike the sometimes abstract and metaphoric use of photographs in *Running in the Family*, the photographs in *The Man-Eater of Punanai* are straightforward black-and-white images. Part of the reason for the variation in each book is that each Ondaatje writes with a different purpose. For Michael, known around the world as a prizewinning poet and novelist, the usefulness of *Running in the Family*, as the title suggests, is to come to understand in his father's legends Michael's own

tendencies toward self-destruction and his predilection for such semi-legendary figures as Billy the Kid and Buddy Bolden, both of whom Douglas Barbour believes "share attributes of the romantic figure of the self-destructive artist" with Mervyn Ondaatje.[53] For Christopher, on the other hand, known mostly in Canada as a financier, entrepreneur, publisher, big-game hunter, member of the Canadian Olympic bobsled team in 1964, and author of such history books as *The Prime Ministers of Canada, 1867–1988: MacDonald to Mulroney*, the usefulness of *The Man-Eater of Punanai*, as the subtitle suggests, is as "a journey of discovery" that seeks to reconcile his brother's portrait with his own, an attempt to celebrate those qualities in his father that are characteristic of himself.

Michael's father seems to Christopher to be a charming and eccentric figure, a mythologized man of wild escapades and romantic gestures. While Michael confesses in a direct address to his father, "I am writing this book about you at a time when I am least sure about such words" as "love, passion, duty" (180), deliberately declaring his uncertainty about the word "love," Christopher describes *Running in the Family* as "a love letter to the father he never knew, a large and glamorous man away in the distance."[54] Asserting his authority as biographer, Christopher writes, "But I had been deeply involved with that man, and I had to grapple with his demons, which never seemed either romantic or amusing" (*Man-Eater*, 38).

Christopher's father is a darker, sadder man, an alcoholic whose actions are pathetically embarrassing and self-destructive, a father whose primary legacy is shame but who in his best years shared with his firstborn son a special bond: "More than any other members of the family, my father and I shared a love of the outdoors and of wildlife" (*Man-Eater*, 9). Returning to Sri Lanka after a forty-year absence, Christopher Ondaatje projects onto that same outdoors a hunt for his father's ghost and onto that wildlife a legendary leopard that must be photographed at close range in order to restore both his father and himself to order.

The relationship between the Ondaatje brothers is paralleled by the political situation of Sri Lanka at the time of Christopher's return. The United National Party, headed by the seventy-one-year-old J. R. Jayewardene, described by Christopher as "an idealistic optimist" (*Man-Eater*, 32), is challenged by the twenty-eight-year-old Prabakaran, leader of the rebel Tamil Tigers, a legendary and romantic man called by his followers "Thamby," for "little brother" (*Man-Eater*, 33). One

of the more revealing stories in Christopher's text occurs when he hears that "an Ondaatje has killed himself in Canada" (*Man-Eater*, 42). Thinking at first that the rumor might be about himself, he soon worries that Michael has committed suicide, only to discover that the name Ken Adachi, another Canadian writer, had been confused in transmission.

Although Christopher praises *Running in the Family*, mentioning that the book is well known in Sri Lanka, he is always careful to suggest that *his* paternal portrait is more accurate because he was older. "The great achievement of my brother Michael's superb book . . . was to re-create the world of the Ondaatjes, Sproules, and de Sarams," he writes, adding, "even though he had been too young to remember it in its heyday" (*Man-Eater*, 36). Michael makes clear that his version is an imaginative gesture, a communal act, dedicating it to his children and his siblings, specifically thanking his sisters and Christopher by name, admitting, "This is their book as much as mine" (*Running*, 205).

In contrast, Christopher, who dedicates his book solely to Mervyn Ondaatje, is careful to demonstrate that his is the more trustworthy account. "Even when he exaggerated certain facts, he remained truthful to their spirit" (*Man-Eater*, 37), he writes about Michael, suggesting as usual that Michael's poetic prose has gotten in the way of what actually happened, as illustrated in the story of the father's drunkenly driving the family car on twisting mountainous roads, eventually stalling on the edge.

According to Christopher, "In Michael's book this incident became rather light-hearted. . . . At the time there was only terror. I was in the front seat. My father had passed out. The front right wheel below him was dangling in mid-air" (*Man-Eater*, 39). Christopher's most crucial corrective occurs in this sentence: "I had to make the decision to leave the car, with my sisters in it, to get help" (*Man-Eater*, 39). Readers of *Running in the Family* will recall that the entire description of this incident, which appears in the section called "Dialogues," is enclosed with quotation marks, indicating that Michael is reporting someone else's words. A closer look at this dialogue confirms that the words belong to Christopher. "Once he nearly killed us. Not you. But the three older children" (*Running*, 173), Michael begins, making clear that he was not a part of this experience. "We began by cheering but soon we were terrified. . . . We were in the back seat and once we calmed down, we looked in the front seat and saw that Daddy was asleep. . . . Finally Gillian went off and Janet and I tried to pull him towards the pas-

senger seat" (*Running*, 174). Clearly Michael's account, told through Christopher, is no more light hearted than Christopher's. The important difference lies in the fact that in Michael's version of Christopher's story, Gillian leaves the car for help, whereas in Christopher's revision, he performs that act, sharing the more dangerous front seat with his father. Because leaving the car for help is at best an ambiguous act of heroism, an act some people might interpret as saving oneself, Christopher's insistence that he was the one who left the others suggests the sense of shame he later expresses for having left the family behind in Sri Lanka while he went to school in London. The whole story about the father teetering on the edge of the precipice echoes Michael's evocation of the father-son conflicts in *King Lear*: "And why of Shakespeare's cast of characters do I remain most curious about Edgar? Who if I look deeper into the metaphor, torments his father over an imaginary cliff" (*Running*, 179), he asks, slyly suggesting that he is playing Edgar to Christopher's Edmund.

Another way in which Christopher attempts to provide a corrective to Michael is through photography. The photographs in *Running in the Family* are often enigmatic and symbolic, such as the picture of a train on Sensation Rock, labeled "The Prodigal," which suggests both Mervyn's frequent escapades with trains and Michael's identification with his father as the family's prodigal son. Another example might be the family photograph of the Ondaatje children labeled "The Ceylon Cactus and Succulent Society" (fig. 5.5), an image that echoes the pattern of flooding water that runs throughout the text, and implies that Mervyn's love for his children was more nourishing than it might have seemed. In contrast, the photographs in *The Man-Eater of Punanai* seem more like snapshots, pictures from the Ondaatje family album. Examples include a family portrait without Michael, a picture that presents him as if he were the more militaristic of the two brothers, and portraits of the Ondaatje parents.

When Michael writes, in the acknowledgments section of *Running in the Family*, "I must confess that the book is not a history but a portrait or 'gesture'" (*Running*, 206), he suggests another generic possibility. Interestingly, Nancy Shawcross reminds us that "gesture is a recurring notion in Barthes's work," citing as an example the following Baudelaire quotation from *Roland Barthes by Roland Barthes*: "the emphatic truth of gesture in the great circumstances of life," which he relates to the concept of the *numen*, "this excess of pose . . . which is the silent gesture of the gods pronouncing on human fate."[55]

FIGURE 5.5. *"The Ceylon Cactus and Succulent Society."*
(Copyright © 1993 by Michael Ondaatje; reprinted by permission of Michael Ondaatje)

From all the generic possibilities I have been discussing, I believe both Ondaatje texts are best classified as memoir, a genre that operates somewhere between biography and autobiography, focusing as much on the observer as on the observed. Both *Running in the Family* and *The Man-Eater of Punanai* are naturally concerned with more than getting their father right; each brother is also struggling with a delicate balance of eccentricity and self-destructiveness.

One way to begin to come to terms with memoir's combining autobiography and biography, as exemplified by the Ondaatjes' need to claim allegiance with their father while maintaining their own sense of self, is through the following observation about biography versus autobiography, posited by Philippe Lejeune: *"In biography, it is resemblance that must ground identity; in autobiography, it is identity that grounds resemblance. Identity is the real starting point of autobiography; resemblance, the impossible horizon of biography."*[56] In memoir, both resemblance and identity are foregrounded. When the brothers focus on their father, they are most concerned with resemblance; when they concentrate on themselves, they are worried about their individual identities. In addition, each brother is worried about his resemblance to the historical

Ondaatjes of Sri Lanka. For Christopher the family resemblance is divided. "Those who have known the family have always claimed that Gillian and I are similar in looks and personality," he notes. "She's outgoing and talkative, has a strong sense of history and family pride, and adores dramatic gestures" (*Man-Eater*, 16). It is important to Christopher to separate himself from Gillian's other characteristics: "Her mathematical mind is directed towards contract bridge instead of finance, however, and she may be the worst driver Sri Lanka has ever seen" (*Man-Eater*, 16). The family likenesses that he sees in himself are all positive, whereas being a bad driver and not having a sound financial mind are characteristics he believes he has not inherited. These two traits are particularly telling because both are strongly identified with Mervyn Ondaatje; his drunken driving is one of Christopher's most vivid memories, and his financial problems provide his oldest son with his strongest sense of guilt.

The most significant revelation in *The Man-Eater of Punanai* occurs in the epilogue when a family friend suggests to Christopher that the real reason why his father went into debt was "that he borrowed heavily to send you to England and to pay for your school fees!" (*Man-Eater*, 164). In contrast, Michael's presentation of the likenesses running in the family Ondaatje emphasizes his father's privateness and sense of decorum rather than his financial abilities: "It is from my mother's side that we got a sense of the dramatic, the tall stories, the determination to now and then hold the floor. The ham in us. While from my father, in spite of his temporary manic behaviour, we got our sense of secrecy, the desire to be reclusive" (*Running*, 168).

Michael's book begins with the observation that he wished to return to Sri Lanka for two purposes. The first is related to resemblance: to try to make sense out of "a bright bone of a dream I could hardly hold onto" in which he saw his "father, chaotic, surrounded by dogs, and all of them were screaming and barking into the tropical landscape" (*Running*, 21), an echo of his poem "Biography" from *Dainty Monsters*. His second purpose is connected to identity: "In my mid-thirties I realised I had slipped past a childhood I had ignored and not understood" (*Running*, 22). What the biography tells us about the biographer is more a matter of language than fact, as emphasized in "Letters and Other Worlds," Michael Ondaatje's biographical poem about his father, which dramatically summarizes his views of biographer and biographee: "He hid that he had been where we were going. . . . He hid where he had been that we might lose him."[57]

Similarly, Christopher's dual purposes for writing a memoir can be associated with resemblance and identity; speaking of his father, he writes, "And his sad end drove me because of my own frustration and loss," adding, "Shame had kept me away too. Because I was ashamed of what had happened to my father and our family, I never wanted to return as a nobody" (*Man-Eater*, 115). Where Michael worries about his childhood, Christopher is more concerned about his adult identity. Where Michael presents his father's death by assuming his voice and writing as Mervyn in the first person, a literal case of resemblance, Christopher is more concerned with accuracy, twice providing the exact details, missing from *Running in the Family*, of the father's death: Mervyn Ondaatje "tripped on some matting at the entrance to the living-room off the veranda and smashed his head on the concrete floor" (*Man-Eater*, 120).

Running throughout Christopher's book is the image of a legendary man-eating leopard, an image that eventually becomes symbolic of the older brother's way of coming to terms with his father. Deliberately putting himself into physical danger by venturing into the parts of the country controlled by the Tamil Tigers, Christopher goes on a big-game safari in an attempt to photograph a leopard at close range. "I had no reason to believe there would be anything dramatic to 'see,' but I needed to experience whatever was there to be experienced," he writes, continuing, "I was certain I was going to be killed" (*Man-Eater*, 138–39). At the moment of face-to-face confrontation with the leopard, Christopher suddenly admits what the reader has long realized, that the leopard and his father are synonymous: "And there it appeared, like some beautiful white devil, baring its fangs, swishing its tail—my father's self-destructive madness within me!" (*Man-Eater*, 157). By photographing rather than killing the leopard, Christopher asserts that his journey is complete, remarking, "Now I could pay attention to the voice of caution" (*Man-Eater*, 158). This dramatically rendered confrontation with a symbolic leopard can be contrasted with Michael's encounter with a comic wild boar who appears while he and his family are bathing in the rain and who is said to have later stolen his bar of Pears soap: "If I am to die soon I would choose to die now under his wet alphabet of tusk, while I am cool and clean and in good company" (*Running*, 142).

Michael describes one of the most memorable photographs in *Running in the Family*, a picture of his parents making exaggerated faces and labeled "What We Think of Married Life" (fig. 5.6), as "the photo-

FIGURE 5.6. *"What We Think of Married Life."*
(Copyright © 1993 by Michael Ondaatje; reprinted by permission of Michael Ondaatje)

graph I have been waiting for all my life" (*Running,* 161) and "the only photograph I have found of the two of them together" (*Running,* 162), although he has earlier placed his parents together on the same page with the caption "A Fine Romance" (fig. 5.7). However, unlike the well-known Billy the Kid photograph, "What We Think of Married Life" turns out *not* to be the only picture of Doris Gratiaen and Mervyn Ondaatje.

Because Christopher's major purpose in writing about his family is to assert his identity as the oldest boy, the only eyewitness to the times

FIGURE 5.7. *"A Fine Romance." (Copyright © 1993 by Michael Ondaatje; reprinted by permission of Michael Ondaatje)*

when his parents did have a fine romance, he reproduces another photograph of the Ondaatje parents together (fig. 5.8), labeled "Their charmed existence had a fantastic, make-believe quality" (*Man-Eater*, between 54 and 55). In reproducing this second image, Christopher reveals that his view of the family is as romanticized as his brother's and that Michael did not need to travel all the way to Sri Lanka at the age of thirty-six to see a picture of his parents together; Christopher had not only seen them together in life but possessed a photograph documenting their relationship.

Because their ostensible subject is their father, Philip Mervyn Ondaatje, who is now mainly remembered because of his having fathered Michael and Christopher, the usefulness of each book as biography is immediately called into question. As Paul Murray Kendall writes in *The Art of Biography*: "The biographer must have a talent for invisibility" because "who would read the *Ode to a Nightingale* in order to learn about nightingales"?[58] However, as Ira Bruce Nadel reminds us in his *Biography: Fiction, Fact, and Form*, "the signature of the biographer is as important to recognize as that of his subject. The former signs himself through literary means, the latter through the record of his life."[59]

Michael's biographical signature is a complicated poetic arabesque written in the schoolboy alphabet of Sinhalese, "the self-portrait of

FIGURE 5.8. *"Their charmed existence had a fantastic, make-believe quality."*
(Courtesy of The Ondaatje Foundation)

language" (*Running*, 83), a sort of ideographic representation of the cyclical shape of his book. And in his poem "Signature," Michael clearly explains the relationship of the two brothers: "I was the first appendix in my family. / My brother who was given the stigma / of a rare blood type / proved to have ulcers instead."[60] Christopher's book, on the other hand, seems signed wholly in the standard English script of a stockbroker. *The Man-Eater of Punanai* was written by a man who thought, on hearing of his father's death: "You're the head of the family. Everybody else is looking to you, nobody else but you, and you're the one who's going to make it or break it" (*Man-Eater*, 78–79), but who now realizes a significant problem with that idea: "In Canada I am sometimes known as Michael's brother" (*Man-Eater*, 23). Although the older brother might once have seemed the stable head of the family, he now finds himself following his younger brother's lead, writing a book about returning to Sri Lanka in an attempt to provide a corrective to Michael's version, to come to terms himself with their father, and to reestablish his place at the head of the Ondaatje family.

*Photographs make time proceed to the
present they do not show.*
—*Jefferson Hunter*

6 | A Life Lived like Water
·································
Reynolds Price

Reynolds Price's long-term interest in photography is evident
from his afterword to *Immediate Family*, Sally Mann's book of photo-
graphs, and his introductions to Eudora Welty's collected *Photographs*
and to Caroline Vaughan's *Borrowed Time*, personal essays that not only
comment on the photographs of Mann, Welty, and Vaughan but also
constitute miniature autobiographies of Reynolds Price. In "The Only
News," his introduction to Eudora Welty's second photography book,
Price imagines a child "with a born intensity of witness, a mysterious
urgent need to watch," a child "committed to life as a spy"—all of
which, he argues, are "the first marks" of "a possible artist."[1] Although
this invented child is meant to suggest an incipient artist in general, or
a young Eudora, in many ways Price's description matches his own
childhood as he describes it in *Clear Pictures: First Loves, First Guides*,
especially when he ends his introduction with the following first-
person statement: "*I must copy the world or this piece of it in the hope of
remembering, praising, amending and controlling its face.*"[2] The urge to spy,
remember, praise, amend, control, and especially copy is central to the
author's presentation of his childhood self, a need that is in some ways
at odds with the photographic evidence that plays an important role in
establishing Price's "first loves."

Clear Pictures contains thirty-two photographs and two sketches, distributed throughout the memoir rather than gathered in the center. Many of the images are family photographs, some taken by Price, who describes himself as "the official recorder" and a compulsive "snapper."[3] Often a photograph is both described in prose within the narrative and reproduced physically a few pages later, or in some cases, a few pages earlier, and accompanied by lengthy narrative captions, sometimes several paragraphs long.

On more than one occasion, photography takes the form of memories described in terms that suggest the photographic process: "I lay and watched sunlight press on the window shade. Something in the meeting of the yellow sun and the shade's white cloth made me think of a hula skirt I'd seen in the movies" (36). Price describes his earliest memory, strikingly similar to N. Scott Momaday's first images, in words that turn his mother's womb into a sort of camera obscura: "those uncomplicated but still-consoling pictures of light as it works through Elizabeth's skin to my open embryonic eyes" (180). He renders the relationship between his father and Grant Terry as though the room they occupied were a camera: "A lot of what they sought in one another was the mutual shapes they made in a room, the prints of their faces and bodies on the air" (97).

If portrait is to biography as self-portrait is to autobiography, what photographic equivalent might usefully parallel memoir? One answer might be a narrative in which photographs are used literally as evidence and figuratively as metaphor, as is the case with a series of family images within *Clear Pictures*. Price says of his book, "Whatever a sound-and-sight documentary would show of my past, each picture I claim here has hung in my head for long years now—my buried archive: true or false, for good or bad" (12). That the author feels the need to "claim" the photographs he has chosen for his memoir suggests the hold each image has on his memory and on his sense of the self constructed by the act of writing *Clear Pictures*. Writing in "For The Family," his afterword to Mann's *Immediate Family*, Price expresses an occasional worry that some of his memories might have been created by a particular photograph, and he wonders why so much of his childhood seems absent: "Why are none of those long scenarios of pleasure or deprivation detectable, even by me now, in the photographic record of my youth?"[4]

Although *Clear Pictures* includes photographs used as documentation (pictures, for example, of the various houses in which the author

lived as a child), clearly Price thinks of most of the images less as documents to authenticate the past and more as sources for memory's improvisation. Although he is aware of the potential inaccuracy of photographic memories, he expresses a deep wish that more of his childhood had been recorded on film: "Even with blurred and fading results, I'd have at least an unquestionable set of accurate gauges for tuning the ancient myths I've made in the absence of hard-edged visible facts about my world and the people who made it around me as I grew."[5]

Of all the "first loves, first guides" of the book, the relationship between Reynolds Price and Will Price, his father, is most interesting when considered in terms of both their verbal and visual aspects, which combine to reinforce a Wordsworthian "the child is father of the man" motif that runs throughout *Clear Pictures*. Price's physical picture of his father begins with a photograph taken before the son's birth (fig. 6.1). Referring to this photograph, he writes in the text, "Pictures of Will Price in youth show a strong upturned face with a radiance almost better than beauty, a heat centered in the gray eyes that burn with what seems fervor—where does it come from; what fuel does it take?" (27). Readers of the memoir come to know that whatever fuels the father's burning eyes eventually is replaced by alcohol, resulting in a profound drunkenness that characterizes Will throughout the first three years of his son's life. The photograph appears with the following caption: "Will Price in 1918. He's eighteen and wears a National Guard button. He thinks he will soon be shipped away to the trenches of France and cannot know that the armistice of November 11th will save him. Unclouded yet by drink or care, his gray eyes burn with the hopeful fervor he'll fight to reclaim, fifteen years from now" (22). The words "fifteen years from now" refer not to fifteen years from the time that Reynolds Price is writing the memoir but to 1933, fifteen years from the time of the photograph, the date of Reynolds's difficult breech birth.

This narrative caption is typical of Price's style; rather than merely identifying the people or location of a photograph, he writes an extended statement about both the image itself and the past and future of the people who appear within it. Obviously the son has no way of knowing what his long-dead father was thinking at the time his photograph was made, no way of knowing that his father's thoughts were on the future, and yet in imagining what lies outside the time frame of the photograph, he is putting the picture into the narrative flow of his

FIGURE 6.1. *"Will Price in 1918." (Courtesy of Reynolds Price)*

own memoir rather than simply inserting it into the middle of his text, in a manner described by André Malraux: "Images do not make up a life story; nor do events. It is the narrative illusion, the biographical work, that creates the life story."[6] Price's way of writing captions in the present for photographs from the past, of captioning his family im-

ages not with titles but with autobiographical narrative, is described by John Berger as necessary for making any photograph meaningful: "An instant photographed can only acquire meaning in so far as the viewer can read into it a duration extending beyond itself. When we find a photograph meaningful, we are lending it a past and a future."[7]

The difficulty of the author's birth is described as a family epic told and retold by all the members of the family except for his father. The story centers on the moment when Will, hearing that both his wife, Elizabeth, and his son, Reynolds, are near death, "sealed a bargain with God, as stark and unbreakable as any blood pact in Genesis—if Elizabeth lived, and the child, he'd never drink again" (29). Although both mother and son come through the birth safely, the father is unable to keep his promise, reverting almost immediately to his "nightmarish and paralyzing thirst" (27). Unable to sustain his half of the bargain and believing "the unquestioned corollary . . . that God had every right to reclaim Elizabeth and Reynolds" (32), Will Price is finally able to give up drinking instantly and forever in 1936 when young Reynolds has a seizure, a precursor perhaps of the astrocytoma of the spinal cord that has kept him confined to a wheelchair since 1984.

Price describes his relationship with his father in a biblical analogy: "If I'd known so early for instance that I was, for my father, an actual hostage given to God—an Isaac to his Abraham—I might not have understood or borne the weight of the office. Luckily, that knowledge and my understanding of its clandestine but vital role in my growth, was not leaked to me till the age of five" (36).[8] It is hard to see how Reynolds can compare himself to Isaac, his father to Abraham, for while the figure from Genesis stands ready to sacrifice his son, Will Price is willing to sacrifice himself for his son through the act of giving up drinking. This reversed analogy suggests a tendency of Reynolds Price to think of himself—now that he has outlived the age at which his father died—as being his father's father rather than his son, a situation echoed by the fact that he often writes in the third person, calling himself "Reynolds" and "the son," autobiography in the guise of biography.

The reversal of father and son is clear in another meditation on the photograph "Will Price in 1918." In a prose piece called "Life for Life" within a section labeled "Late Warnings" in *The Collected Stories*, Price depicts his discovering, after his mother's death, a demonstration record of his father's actual voice, a documentation of Will Price's sales pitch for toasters, fans, lamps, stoves, and other department

store appliances.[9] Simultaneously moved by his father's forgotten pro-
nunciations and yet chastened at his "endless bottled plea for hope"
(*Collected*, 146), the son interrupts the recording—though desperate to
hear his father's voice again—deliberately giving his father "silence,
rest" (146). Although he stops the recording, Price resurrects this
image of his father as salesman in the film version of *Clear Pictures*, in
which his father can be seen in a home movie opening and closing a
refrigerator and pointing to its features.[10] Vowing not to force Will
through his pitch again, Reynolds turns to "Will Price in 1918," ap-
pearing originally in prose nineteen years before its physical appear-
ance in his memoir, and expresses the following apostrophe:

> And still your gaze though high is clear, undoubting; a surety that
> even now seems firm, not boyish foolishness, seems well-informed
> as though you saw sure detailed happy futures, a life like water
> (clear, needed, useful, permanent, free), spared all you will soon
> acquire (drink, wife, sons, labor, thirty-six more years). I touch the
> glass above your silent mouth, say silently—
>
> Dear boy (dear gray eyes, broad nose, curling lip), locked on your
> browning cracking paper card, I offer you my life—look, it will
> serve. Cancel all plan of me, let me not be, so you may have free
> time, move always sure, accept with smooth hands what your eyes
> still see, elude brute ambush of your gurgling death. (*Collected*, 147)

In this passage about a picture, with its repetition of the word "clear,"
the author speaks to his father's boyhood photograph as though Rey-
nolds were the Abraham figure, willingly sacrificing himself for his
father's future, although he is addressing the boyish picture ten years
after his father's death. Berger argues persuasively that "all photo-
graphs are of the past, yet in them an instant of the past is arrested so
that, unlike a lived past, it can never lead to the present";[11] however, in
reversing the roles of father and son, Reynolds Price attempts to lead
his father to a present he can never experience.

The words "a life like water" and "gurgling death" suggest a recur-
ring image from *Clear Pictures*: the course of life expressed in terms of
water—swimming and drowning, the dailiness of life and its under-
ground currents. In a memoir that emphasizes both the surface clarity
of photographs and the author's need to read through that surface,
Reynolds Price, author of *Surface of the Earth*, is often concerned with
images of subterranean springs. The final photograph of father and
son (fig. 6.2), for instance, shows both men kneeling in a spring-fed

FIGURE 6.2. *"Will and I on Vacation (White Lake)."* *(Courtesy of Reynolds Price)*

lake, facial expressions parallel, the son now taller than the father. The caption ends with these words: "Will is fifty-two, with twenty months to live and, as always, wears his glasses in swimming—prepared for all but the death rushing toward him" (264).

The way their lower halves blur together beneath the water's surface suggests the book's constant blending of father and son and parallels the memoir's organizational principle: "I'd see my early life, not as a road or a knotted cord but as a kind of archipelago—a ring of islands connected, intricately but invisibly, underwater" (10–11). Describing his earliest memory, he suggests the underwater pattern—"I was suspended in a straw-colored fluid, staring out at the feeble light which barely seeped through Mother's skin" (43)—and later he saw himself as "treading water in a dangerous contentment" (170), an innocence destroyed by one of the saddest moments of his childhood, a private and public betrayal by newfound friends, some of the details of which he admits to having completely repressed. In describing his tormentors Price uses another watery image: "They seeped out of hiding like a stain in water" (167).

FIGURE 6.3. *"Will and I in the Summer of 1933." (Courtesy of Reynolds Price)*

The prose description of another early father and son image (fig. 6.3) occurs in *Clear Pictures* seven pages before the photograph to which it refers. Concentrating again on his father's eyes, the author emphasizes a blurring of vision, an additional presence behind Will's gaze: "It's only with my birth that he appears in the albums again, holding me with the winning edginess of a fledgling member of the

bomb-disposal squad. But by then, in his early thirties, he's taken on weight. It looks like bloat and, worse, there's a blurring glaze on the once-hot eyes. Half-smiling still, thoughtful and protective as he is, by now there's a presence in his life even more demanding than his wife and first son" (27). The presence is alcoholism and behind that a sense of failure brought on by his inability to give it up and by the depression. In his caption to this image Price writes, "Will's face is still bloated; and I've assumed the unknowing but apt solemnity that marks so many of my early pictures" (34), another example of the memoirist's need to use photographs not so much to bring the past forward but to allow the present to go back to the past. Although Price is speaking ironically about his own expression—obviously babies are unable to assume poses—he fails to note that father and son have similar facial expressions.[12]

The extended narrative captions that accompany a number of the family photographs in *Clear Pictures* maintain the author's sense that he can somehow see the future in an old picture. Writing of a photograph of Ida Lee Rodwell, he notes, "Though she can't be more than twenty here, the eyes already see life" (52), while the caption to a picture of a young Reynolds in a Cub Scout uniform ends with the words "The bicycle, red and white with a much-prized speedometer, will be beside me in the coal-pile drubbing that waits in Warrenton, seven months from now" (166), a reference to an ugly childhood incident that has just been described in the text. In captioning the photograph with a future tense—"seven months from now"—but placing the photograph at a point that occupies the immediate past of the memoir's narrative time line, Price would seem at first to be undercutting the documentary quality of the image. However, as Peter Wollen explains, the function of captions for documentary images is different from that of captions for news or art photography: "A documentary photograph would imply the question: 'Is anything going to happen to end or to interrupt this?' A news photograph would imply: 'What was it like just before and what's the result going to be?' An art photograph would imply: 'How did it come to be like this or has it always been the same?'"[13]

In a later chapter concerned with his childhood fears, Price makes a further comment about his father's vow to stop drinking, a remark that sheds some light on his apparently reversed Abraham/Isaac figure: "The strongest remembered fear of my childhood was of Will's drinking, and at times the fear amounted to terror" (154), a curious fear in that Price had never actually seen his father drink:

From age five . . . I quickly became a sleepless home-detective. . . . Any possibility that my father might renege on his promise became the worst fear, and none since has eclipsed it.

The early fear was stoked even higher by Will's very ease around his friendly drinkers. . . . The worst moment was bedtime when I had to go off duty and leave my excited father on his own recognizance in the midst of friends already glazed and raucous. I believed Will meant to keep his promise, but I also knew that one of his life's aims was pleasing his friends. . . . Because a child knows so little of the possible strength of human will, I doubted Will's power to keep his vow. I'd lie in the dark as long as I could, my favorite toys all near at hand but powerless to help; and I'd listen through the door till the final weight of my diligence drowned me. (155)

With this reference to drowning, the memoirist again expresses the complicated father-son relationship in terms of water. "What did I think would happen if my guard failed and Will drank again," wonders the adult Price, answering, "destitution was what I feared, that and the shame of my self-respecting parents" (157). This caption-picture combination seems particularly telling in terms of the merging of father and son that flows beneath the surface of this memoir. The young child who believed that his duty included worrying about allowing his father to be alone "on his own recognizance in the midst of friends" believed also that his watchfulness was the primary force keeping the family together.

The caption for another photograph of father and son (fig. 6.4) reads in part: "Like other great comedians, he seldom smiles in pictures. And he never removes his tie till bedtime; but we sit at a natural ease with one another, despite the fact that some of our friends are drinking in the kitchen" (156). Again the adult author has reconstructed his past so as to reverse the traditional father and son roles. The caption suggests that both father and son share the same friends, and the photograph, with its ventriloquist/dummy aspect, presents an ambiguous picture of who is in charge.

Although Price's relationship with his father is particularly important to *Clear Pictures*, his sense of himself at the center of his whole family is also central. The caption to the photograph of the author in a sailor suit that appears on the cover of the paperback version of *Clear Pictures* emphasizes that his sense of reversing the father-son relationship also applies to his mother: "With the curious smile, I mean to

FIGURE 6.4. *"Will and I in our apartment on Cranford Street in Asheboro, 1938."*
(Courtesy of Reynolds Price)

conceal my secret career as guide and defender of two young parents, helpless as babes" (48). Price, who says of himself, "All my life I'd had my instinct for slicing a way into tight-sealed bonds" (163), presents as one of his earliest and most staying memories a scene that ends with the words "I knew for the first and final time that we were all married: Elizabeth, Will and Reynolds" (42). In describing his sense of being one with his parents, Price echoes Eudora Welty's description in *One Writer's Beginnings* of her "fast-beating heart in step together" with "the chief secret there was": "the two of them, father and mother, sitting there as one."[14]

Because he sees himself as part of a triad—father, mother, son in equal parts—Price is sometimes almost surprised to discover photographs of his parents before he was born. "Knowing nothing of the

FIGURE 6.5. *"Will Price and Elizabeth Rodwell near Macon, North Carolina."*
(Courtesy of Reynolds Price)

mechanics of reproduction," he writes, "I lamented my absence from
so much fun and from all the magical snapshots in their albums. Why
hadn't they wanted to bring me in sooner?" (26). Referring, for exam-
ple, to a photograph of his parents taken before he was born (fig. 6.5),
Price ends its caption with these words: "As a child I was puzzled by

the apparent absence of my father's left leg and by his and mother's strangely merged shadow; but from early on, it was my choice image of the love that made me" (16). The same photograph of father and mother merged is described within Price's novel *Love and Work* (1968), appears uncaptioned on the cover of his collection *Permanent Errors*, and is the source of a meditation from the "Elegies" section of that book: "My parents—not yet my parents—stand on a crude plank bridge. . . . Why does their shadow not resemble them?"[15] In writing about their shadow, Price means to suggest not just that ambiguous section of an otherwise clear picture but also his own occluded presence within the portrait. Price's sense of absence from early family photographs causes him to question his childish notion that he and his parents formed a triangle, a discovery that he expresses in terms of a water image: "Will and Elizabeth had not only started without me; they had prior claims on one another, and those claims swam in powerful secret beneath our triad" (47).

Although his memoir is called *Clear Pictures*, Price's uses of photography within the book suggests that by "clear" he means transparent rather than unambiguous. "I would often watch a picture till my mind broke through it," he writes (176). Similarly, describing his method in writing the memoir, he says, "I was trying one more time to make the thing I've tried since childhood—at least a room of tall clear pictures that look like the world and are mainly worth watching" (15). Both of these remarks, with their emphasis not just on looking at photographs but on watching them until he could go beneath the surface, suggest Price's particular idea about how to see a photograph, an aesthetic that echoes Kendall Walton's argument that like mirrors, telescopes, spectacles, and microscopes, "photographs are an aid to vision." According to Walton, "photographs are transparent. We see the world through them."[16]

Walton's claim is countered by Nigel Warburton, who argues in his "Seeing through 'Seeing through Photographs'" that while we may in a sense see through a camera obscura or a television image to an object or person, what we see in a photograph is on the surface. Warburton argues that still photographs are not transparent because they lack virtual simultaneity (the photograph does not register physical changes as they occur) and temporal congruity ("the time it takes to see a photograph has nothing to do with the length of time represented in that image).[17] Unlike a painted self-portrait, which does have a sense of virtual simultaneity behind it (as the painter moves his

or her brush to begin the self-portrait, the brush in the mirrored model must also move at the same time), a still photograph can only hint at simultaneity. At the time the photograph is taken, a moving subject will produce a blurred photograph, a situation built into some self-portraits, such as Dieter Appelt's *The Spot on the Mirror Made by Exhaling, 1978*, a self-portrait whose title suggests the physical connection between the photographer and his mirrored reflection.

In her *Fabrications: Staged, Altered, and Appropriated Photographs*, Anne H. Hoy describes an attempt at imitating virtual simultaneity by turning a self-portrait into a sort of performance piece. In the case of Jean-François Lecourt, "an assault on a portrait stands for an assault upon its subject" because the photographer, "an accomplished marksman," produces a series of self-portraits "by simultaneously tripping his camera shutter and firing a rifle through the apparatus into the negative. The narcissism of self-portrait photography is countered by the self-denial of symbolic suicide."[18]

While Warburton may be philosophically accurate, his argument fails to take into account the magical quality of the photographic act, the way looking at family photographs can call up memories and confuse temporality, the temporal shock of looking at new photographs of someone now dead. As Price notes, "The best photographs . . . reach us with an instant indelible force that no prose genius has yet mastered."[19] Because so many of the photographs in his memoir involve either a caption with a reference to the future or a reversal of father and son, the sense of temporal congruity that Warburton stresses is undercut by Price's need to use family photographs for his own needs.

The sense that pictures have a clarity that allows them to be penetrated is also at the heart of the traditional idea that a portrait reveals the character of the sitter, that we read through the surface to the person beneath. For Reynolds Price, the fact that as a child he could so easily capture likeness through drawing but could not always reveal what was beneath the surface resulted in a corresponding change in emphasis from painted to photographed portraits. "I did have the peculiar ability, so beloved of onlookers, to catch a human likeness," he writes. "My hand could transfer the lines and planes of your face to paper" (*Clear*, 203). In a chapter titled "Real Copies," he describes his early penchant for sketching family and friends as well as such famous faces as Laurence Olivier, Vivien Leigh, and Ethel Waters as they performed various stage roles. Included within *Clear Pictures*, for instance,

is his sketch of Ethel Waters as Bernice Sadie Brown in Carson McCullers's *The Member of the Wedding*, complete with the artist's signature.

Instead of seeing his ability to capture likeness as a positive artistic attribute, the autobiographer describes it as an art form in which he lacks originality. "I was a faithful copyist—people recognized themselves when I drew them—but for whatever cause, I apparently possessed no trace of visual imagination, not of the sort I could set on paper in lines and colors" (194). Although he is praised for the accuracy of his representations, he is also aware that too exact a likeness can lead to charges of mere mechanical reproduction, as occurs when his childhood friends accuse him of "tracing," that early form of scholastic cheating.

Price transferred his boyhood's artistic talents from drawing to photography because of problems in matching his mind's images with his hand's ability to copy: "From the first day, I could imagine and actually see far more intricate and satisfying pictures that I was capable of transcribing" (184). Only in the medium of words, in composing prose portraits, could he penetrate the surface, see through the shadows and under the water: "I work to clarify the salient faces and whatever sign of unseen power is pressing from inside with love or havoc" (304). Later he took up photography, specializing in portraits of family members and friends and snapshots of roadside historical markers. "In my adolescent photographs, and in thousands more through the years since," he notes, "I was concerned to mirror 'reality' as perfectly as the prevailing light and my camera permitted. I was never interested in darkroom manipulation or intensification of my evidence . . . or in elaborate posing of my human subjects" (202).

To compound the problem, he is as attracted to copying writing as images, "spending whole afternoons in the effort to copy, and learn to execute as effortlessly as my originals, the precise handwriting of several dead geniuses" (195). "To this day I can still scrawl out a presentable *F. Chopin*, a skill I learned more than forty years ago" (196), he writes, adding that he eventually gave up what was leading to "rank forgery" when his father, seeing that the son was producing exact duplicates of his signature, asked him to stop. Copying is so central to his sense of self that Reynolds notes, "I could attract notice, even love, into my empty spaces by means of my various imitations, my disguises and decoys. And I suspect that I'm now far enough along in my life to grant that the making of irresistible decoys was the chief conscious energy in all my work before my mid-forties" (181).

Ironically, Reynolds Price's tendency to copy is itself a copy of his father, about whom he writes, "He was a brilliant mimic and a quick-change deceiver in domestic pranks" (265). The father's copying took the form of practical jokes and impersonations, which the son describes as a lifelong predilection for "impenetrable disguises, ruses, forged letters and convincing crank-phone calls" (45). In imitating his father's imitations, Price is not producing another false copy; rather, as the chapter title "Real Copies" suggests, he is going beneath the surface to the wit and humor not visible on his father's countenance in the photographs within the text. As Rosalind Krauss writes in an essay called "A Note on Photograph and the Simulacral," "Everything, of course, is a copy; but the true copy—the valid imitation—is that which is truly resemblant, copying the inner idea of the form and not just its empty shell."[20]

Not only are copying and likeness central to Price's memoir, but they are also behind his repeated reversal of father and son. Having learned both to draw and to make copies from his father, Price eventually records an adolescent longing to make a copy of himself in the form of a child: "My body was yearning to make real copies of itself in the visible world, live human babies" (193). Of course, in reproducing himself he would also be making another likeness of his father, both by actually becoming a father and by producing another child. Instead the author reproduces a copy of his life in the form of *Clear Pictures*, a memoir in which he often seems to be his father's father, an echo of his later revelation that he has spent "thirty years of a life barren of all copies but a long shelf of books" (218).

Unlike Paul Auster, whose *The Invention of Solitude* came into being as a result of his perusal of his father's unsorted photographs, discovered after the father's death, Reynolds Price went in search of images to illustrate *Clear Pictures*. Writing in *A Whole New Life*, his second memoir, published in 1994, Price says of this occasion: "Awhile before, hunting illustrations for *Clear Pictures*, I'd also written a daybook poem that was triggered by sorting the family pictures—more than a hundred years of kinsmen buried in shoeboxes, albums and drawers."[21] Although he characterizes the poem as private, "a daybook poem," he reproduces it in *A Whole New Life* as "The Rack," asserting that he will let the poem represent "the balance of what I've done and felt in the years since 1989." "The Rack" begins: "Weeks of threshing the family photos / Gleaning faces to feed a memoir— / I start each day expecting sadness," a suggestion that *Clear Pictures* has a life of its own and

needs nourishment to continue to grow. Instead of sadness, he sees in each family face "frank displays of a taste for time." Again he emphasizes watching the pictures, suggesting that his writing about them will bring "more life," both to those long dead and to those reading about them in his memoirs, an echo of his earlier urge to reproduce himself. The poem ends with the suggestion that Price himself will soon enough be dead, "a random ghost, all face, no voice," an echo of Maxine Hong Kingston's ghostly metaphor.[22]

The relationship between words and images in *Clear Pictures* is described by author-photographer John Berger as common to all photographs accompanied with verbal descriptions:

> A photograph preserves a moment of time and prevents it being effaced by the supersession of further moments. In this respect photographs might be compared to images stored in the memory. Yet there is a fundamental difference: whereas remembered images are the residue of continuous experience, a photograph isolates the appearances of a disconnected instant.
>
> And in life, meaning is not instantaneous. Meaning is discovered in what connects, and cannot exist without development. Without a story, without an unfolding, there is no meaning.[23]

Answering an interviewer's question about the fact that his house outside Durham, North Carolina, is filled with "personal pictures . . . in almost every room—in bedrooms, in the hallways, even in the bathrooms," Price notes, "They are here, and here in such numbers, for the sake of my present and future work, not for the sake of nostalgia, not as souvenirs of a lifeless past."[24] Unlike the traditional idea of a photographic memory as one that can instantly recall images, Price's use of interlaced photograph, captions, and text reveals the efficacy of his title. Clear pictures are both photographs and visual memories, a combination of his own life and his father's, ample illustrations of that set of five adjectives with which he defines the phrase "a life lived like water": "clear, needed, useful, permanent, free" (*Collected*, 147). Both photographs and text are lucid and useful when the author needs to fix a permanent memory of his past, but they are also able to be penetrated when he needs to delve beneath the surface to free himself from doubts about the accuracy of his own memory.

Picturing the Writing

..

*Autobiographies
by Photographers*

Memory sees what knowing remembers.

—*William Faulkner,* Light in August

7 | Every Feeling Waits upon Its Gesture
................................
Eudora Welty

As the title *One Writer's Beginnings* suggests, Eudora Welty has always thought of herself primarily as a writer, despite the publication of four books of her photographs: *One Time, One Place* (1971; reissued 1996), *Twenty Photographs* (1980), *In Black and White* (1985), and *Photographs* (1989). Toward the end of her autobiography, she makes her priorities clear: "The direction my mind took was a writer's direction from the start, not a photographer's, or a recorder's."[1] Nevertheless, a brief overview of Welty's life reveals a long-term connection with photography, especially during the years when she first began publishing fiction, and although there is little evidence of a direct, one-to-one link between her photographic and literary artistry, still a number of her photographs and her statements about them provide an interesting way into her autobiography.

She began taking snapshots as an adolescent, advancing by the mid-1930s to a Recomar and then to a Rolleiflex camera, which she used regularly until she accidentally lost it in the Paris métro in 1950. Returning to Jackson, Mississippi, from her studies at the University of Wisconsin and Columbia University, Welty was a "Publicity Agent, Junior Grade" from 1933 to 1936 for the Works Progress Administra-

tion, for which she traveled throughout the state of Mississippi taking photographs, in some cases connected to her position, in others for her own interest.[2] Because her WPA job ended "ten seconds after the election," she next worked as a writer and photographer for the Mississippi Advertising Commission.[3]

In 1944 three of her images with a brief text were published in *Vogue* magazine with the title "Literature and the Lens."[4] Welty was eventually photographed by Cecil Beaton, Louise Dahl-Wolfe, and Irving Penn; however, her attraction to fashion photography was slight, as evidenced by the mocking photographs she and her friends took during the depression, including one in which Welty appears wrapped in a sheet applying cosmetics from the kitchen, including pea soup, scouring powder, shoe shine paste, and bug spray, the whole scene labeled "Helena Arden," spoofing Helena Rubinstein and Elizabeth Arden.[5]

Early in her career she contemplated a book that would combine her words and images, to be called "Black Sunday"—a phototext that would pair many of the stories that eventually appeared in *A Curtain of Green* with some of the photographs that became *One Time, One Place*— but she was not able to interest a publisher in her photographs until 1971.[6] As early as 1936 a small group of Welty's photographs were shown at the Photographic Galleries in New York sponsored by Lugene Opticians, followed the next year by another small New York show at Camera House.[7]

Despite all this photographic involvement, Welty has consistently resisted attempts to make too direct a connection between her photographs and her stories. In answer to an interviewer's question "What did the pictures teach you about writing fiction?" she answered, "Nothing consciously, I guess, or specifically."[8] In other interviews Welty frequently mentions her love of both painting and photography, often adding that she had no talent for the former but that "I love photography, and it taught me a lot, too."[9] Although resistant to the idea that her *fiction* emerges out of her photography, she has not specifically discussed photographic connections to her *nonfiction*. Welty often expresses her strong sense of visual memory: "But mostly I remember things visually. I remember how people looked, just people standing against the sky sometimes, at the end of a day's work. Something like that is indelible to me."[10] Although she later cut it from the final published version of *One Writer's Beginnings*, in one of the drafts of her autobiography Welty again emphasizes her strong visual sense: "I

didn't see that my stories and novels suggest any line of development. . . . The clearest patterns are those that form around family, around journeys, around myth and tales that reached me out of reading in my earliest years, and most interestingly of all perhaps around the theme of vision."[11]

While she often emphasizes her visual memory, she chose to place "Learning to See" between "Listening" and "Finding a Voice" when she arranged the three sections of the original lectures that became *One Writer's Beginnings.*[12] The book's movement from ear to eye to voice is paralleled by her own life's course from girlhood to adulthood, the "Listening" section concentrating mainly on her earliest girlhood, the "Learning to See" sequence focusing on family trips to West Virginia and Ohio during her girlhood years, and "Finding a Voice" corresponding to her high school and college years, as well as the parts of her later life about which she chose to write.

Of course, as any reader of *One Writer's Beginnings* soon realizes, the individual sections are not very strict in terms of either sensory impressions or chronology; "Listening" is full of reading, "Learning to See" often talks about sounds, and "Finding a Voice" is about the confluence of the earlier two sections. If we think of her autobiography as answering the question posed by her well-known short story "Where Is the Voice Coming From?" we realize that for Eudora Welty the voice of her stories comes after she has learned to see: "I do have a visual mind, she notes," adding, "I see when I'm reading—pictures. The sounds come more slow."[13] Although she seems to be carefully explaining the necessary sequence involved in turning life into literature for those who read her autobiography as a handbook for how to become a writer, actually her book is carefully structured not in sequential but in a cyclical order, paralleling her formulation: "It is our inward journey that leads us through time—forward or back, seldom in a straight line, most often spiraling" (*Beginnings*, 112).

The sense of tension between straight lines and spirals is a constant theme in the book, as can be seen in numerous passages that involve both movement back and forth along a line and cyclical movement. For example, Welty describes journeys by car that involve crossing and recrossing the same river as well as train trips that include both straightforward movement and going around a curve, seeing the train bending behind, "a mountain of meaning rising behind you on the way you've come" (98). We can see this linear versus cyclical movement in the description of the author as a schoolgirl running back and

forth in a relay race and as a young woman at college spiraling down the fire escapes. Often linear journeys are equated with narration, as when Welty describes the "towns little or big" that the family passed through on their trips, in terms of "beginnings and ends. . . . They were intact and to themselves" (50), an idea echoed by her later words "the trips were wholes unto themselves. They were stories. Not only in form, but in their taking on direction, movement, development, change" (75). Similarly, her description of herself in the relay race parallels her mother's inability to narrate the story of where babies come from. Like her mother, who "couldn't get started" (17) mainly because of her daughter's interruptions, Welty tells the reader that she "lost the relay race for our side before I started through living ahead of myself, dreading to make my start, feeling too late prematurely, and standing transfixed by emergency, trying to think of a password" (29). The sense of a straightforward narration being interrupted by "living ahead of myself" and "feeling too late prematurely"—both terms involving the disruption of time—echoes Welty's own pattern of narration in *One Writer's Beginnings*.

Just as the three separate sections of her autobiography lead from one to the other linearly—listening-seeing-voicing—so they also form a continuous loop. She must listen first in order to see her way clear to a sense of voice, which she then listens to in order to keep reading and writing. The opening section, which starts with listening, quickly turns into reading and writing. She begins with listening to the sounds of her first childhood home—clocks, toy trains, the ticking of her mother's rocking chair—and then describes listening to her mother read stories, followed by what she calls "listening *for* stories," a kind of listening "more acute than listening *to* them" because "it's an early form of participation in what goes on" (16). Not only does she participate by turning conversations and scenes and secrets into stories, but she also begins to hear not her actual speaking voice but her reading voice, what she calls "the voice of the story": "My own words, when I am at work on a story I hear too as they go, in the same voice that I hear when I read in books" (13). These linkages between seeing, hearing, speaking, and writing demonstrate that Welty's photographic eye, though not necessarily a direct connection to her writing, is certainly reflective of her ways of ordering the world, a system as sophisticated as Roland Barthes's realization that "cameras, in short, were clocks for seeing."[14]

And her emphasis on not just hearing and observing but also on

participating in the process of turning sensory material into narrative is supported by her ability to produce a body of photographs characterized by a sense of more than a detached observer. Although the photographs in *One Time, One Place* were taken during the depression and Welty was working for the WPA, she is always quick to point out that her photographic project had nothing to do with the documentary enterprise of the time as practiced by Walker Evans and James Agee or other Farm Security Administration photographers.[15] Referring to *One Time, One Place*, she writes, "This book is offered not as a social document but as a family album."[16] That the photographs are in a sense a family album is supported by the fact that one of the portraits, captioned "Storekeeper, Rankin County," depicts a man who later appears in a photograph apparently taken by someone else, with his family and Welty standing side by side (fig. 7.1).[17] In a panel discussion with Louis Rubin and Shelby Foote, Welty is asked by Rubin about her first photography book, "Did you have the sense at the time that you were preserving something?" Her response, "Oh, no, indeed not. I took them because something appealed to me in the form that a story or anecdote might have,"[18] reinforces the idea that the connection between image and word is not direct in the sense that the author-to-be recognized stories in the pictures she took or gleaned descriptions or ideas for stories straight from them. Rather, she seems to have been looking for stories in the picture-taking situation in the same way that she was listening for stories in the random conversation that went on around her daily life.

In her introduction to a book called *Anthropology and Photography*, Elizabeth Edwards points out that "there are strong visualist metaphors in anthropology—'observing,' 'seeing,' reading,'" a list of words strikingly similar to Welty's own headings. "The anthropological tradition has been to look *into* culture and society whereas photographs have been looked *at*," continues Edwards, asking instead for an anthropology that would look through photographs "into culture, both the culture portrayed and the representing culture."[19] Edwards's call for a new way of using photography to study culture was prefigured by Welty's own approach, both at the time she took her early photographs and later in writing her fiction, as well as her autobiography, in which she often takes a participant-observer's stance. As she describes herself in *One Writer's Beginning's*: "I suppose I was exercising as early as then the turn of mind, the nature of temperament, of a privileged observer" (23).

FIGURE 7.1. *Eudora Welty (left), WPA junior publicity agent. (Eudora Welty Collection, Mississippi Department of Archives and History)*

Part of what makes her photographs so remarkable as we look at them now is the sense of interaction between Eudora Welty and the people she photographed. She points out that the subjects of her images were not posed: "I let my subjects go on with what they were doing and, by framing or cutting and by selection, found what composition rose from that."[20] Looking at *One Time, One Place* and *Photo-*

graphs, we cannot help thinking about the fact that the person we now see as an internationally celebrated writer was interacting with a series of anonymous people who not only had no idea who was taking their picture but in many cases were not even aware that their picture was being taken. Welty makes clear that she did not think of the people in her photographs as anonymous, even though she did not know all their names. From time to time she received positive comments or requests for copies from the subjects or families of the people in her pictures, and she was happy to send them prints.[21] Reversing the usual practice of celebrities being photographed, in this case we have a rare glimpse into a famous author's mind. As Welty wrote in a brief introduction to *Twenty Photographs*: "The eye of the camera is recording what the eye of the photographer is discovering."[22]

We also cannot help but notice that the photographer, who was not yet an author, seems to have an unusual rapport, especially given that many of her pictures are of black people. Welty herself says of her approach, "I was never questioned, or avoided. There was no self-consciousness on either side. I just spoke to persons on the street and said, 'do you mind if I take this picture?' And they didn't care. There was no sense of violation of anything on either side."[23] For most commentators on Welty's photographs, the sense of interplay between observer and observed is central. As Robert MacNeil—of the Mac-Neil and Lehrer news team—notes of her subjects: "They do not sense in her anything to make them strike attitudes, to strut or conceal. She puts their vanity at ease, she does not arouse their shame."[24] According to Alan Trachtenberg, the idea that viewers of photographs can in a sense also see something about the photographer is inherently naive: "A photograph may seem to embody the 'character' of the photographer, its quality of wit or judgment representing an individual vision. But the editor cannot rely on the viewer's understanding of a picture as if it were a voice, a word in a story of drama."[25] Although Trachtenberg is right about photographs in general, Welty seems to be a different case. "Understanding a picture as if it were a voice" is just the sort of complication inherent in her autobiography, in which "finding a voice" and "learning to see" are intertwined.

Both Robert MacNeil's and Reynolds Price's assessments of Welty as a photographer are couched in terms of imaginary attempts at seeing the photographer as anonymous. In his introduction to *Photographs,* Price notes that even "assuming [he] was told that all the pictures are from one artist, and she a woman (neither of which [he]

FIGURE 7.2. *Eudora Welty,* Ruins of Windsor/Port Gibson/1942.
(Eudora Welty Collection, Mississippi Department of Archives and History)

could be sure of guessing)," he would recognize that the anonymous
photographer was "benignly stealthy and hard to glimpse but she's
seldom invisible."[26] Price's observation is often true in the case of her
photographs, although there are several instances in which, though
Welty is in some ways invisible, a shadow of the author can be seen
within the image, a literal example of what she describes in her essay
"Place in Fiction" as "two pictures at once in his frame."[27] The most
obvious is *Ruins of Windsor/Port Gibson/1942* (fig. 7.2), from *Photo-
graphs,* in which a Welty-shaped shadow can be seen in the road, the
photographer bent over to see into her Rolleiflex viewfinder. Inter-
estingly, an alternate version of this image appears in *One Time, One
Place,* captioned *Home after high water/Rodney.* In this second version,
taken from a farther distance, the author's shadow is more faint,

though still clearly visible. A less obvious Welty-shadow can be seen in *Pet Pig/Jackson/1930s* (fig. 7.3) from *Photographs*, and sometimes I think I see her reflected in the store window in *Town in a store window/Canton* from *One Time, One Place* and in a closer view of the same store in *Lanterns/Canton, 1936* from *Photographs*. In her autobiography, Welty said of her intrusion into her own fiction, "My temperament and my instinct had told me alike that the author, who writes at his own emergency, remains and needs to remain at his private remove. I wished to be not effaced, but invisible—actually a powerful position" (95). When Welty describes the power of her own invisibility, she is referring to the relatively anonymous position she could assume by looking through her camera, ostensibly as part of her position as a WPA worker but actually because of her own growing interest in "learning to see." Part of Welty's natural manner with her subjects comes from her own shyness: "The camera I focused in front of me may have been a shy person's protection, in which I see no harm."[28]

Looking though her two major books of photographs, the viewer notices over and over that Welty is not invisible to those she is photographing and that many of her subjects do not pretend that they are unaware of the photographer. In such images as *Saturday off/Jackson/1930s* (fig. 7.4), which appears in both of her major collections and is enlarged and cropped on the cover of *Photographs*, the subject seems to be looking at but not examining Welty, the opposite of the author's description of her mother in *One Writer's Beginnings*, who is said to be "not naturally observant, but she could scrutinize" (48). In many of the group pictures, the people on the street, either because of the novelty of having their picture taken or because of the complicated familiarity combined with distance that characterized black and white relations of the time, often seem to see her and not notice her at the same time, thereby violating what Susan Sontag describes as "the good manners of a camera culture," which "dictate that one is supposed to pretend not to notice when one is being photographed by a stranger in a public place as long as the photographer stays at a discreet distance—that is, one is supposed neither to forbid the picture-taking nor to start posing."[29] Sontag's etiquette for subjects is undercut, in Welty's case, by her unique position in relation to her subjects. As Louise Westling points out, the sense of trust is more pronounced in her black subjects than in her white ones, mainly because of the odd juxtaposition of a shy observer: "Because she was white, they were required by the racial code to cooperate with her," writes Westling in

FIGURE 7.3. *Eudora Welty*, Pet Pig/Jackson/1930s. *(Eudora Welty Collection, Mississippi Department of Archives and History)*

FIGURE 7.4. *Eudora Welty,* Saturday off/Jackson/1930s.
(Eudora Welty Collection, Mississippi Department of Archives and History)

FIGURE 7.5. *Eudora Welty,* Schoolchildren meeting a visitor/Jackson.
(Eudora Welty Collection, Mississippi Department of Archives and History)

an essay whose title describes Welty as a "loving observer," adding,
"but because she was female and shy, they had nothing to fear."[30]

Often only one person in a group looks directly at Welty, though
in such an instance as *Schoolchildren meeting a visitor/Jackson* (fig. 7.5),
clearly all eyes are on the author, including the child who is pointing
directly at her. In this version of "Among Schoolchildren," the author-
photographer might at first seem invisible, making it hard to separate
the dancer from the dance, but slowly the viewer realizes that the
visitor of the caption is Eudora Welty herself.

Robert MacNeil wonders "if someone had come upon this collec-
tion of photographs in an attic with no evidence of who took them,"
answering that he believes in such a situation one could "divine that
the photographer was a woman because the subjects, particularly the
female subjects, find her so unthreatening."[31] Even a portrait such as
the one captioned *The bootlegger's house. Pretending to drive away customers
with an ice pick/Hinds County* (fig. 7.6) in *One Time, One Place,* and *Woman
with ice pick/Hinds County/1930s* in *Photographs,* demonstrates the natu-
ral ease with which Welty approached her subjects. According to
Welty, the woman in the photograph—who also appears in another
image from *Photographs* in the same setting but without brandishing

FIGURE 7.6. *Eudora Welty,* The bootlegger's house. *(Eudora Welty Collection, Mississippi Department of Archives and History)*

her ice pick—"was teasing, like 'I'm gonna get you.'"[32] The original caption, which included the explanation "pretending to drive away customers with an ice pick," serves on the one hand to demonstrate what might not be obvious—that the picture's threatening gesture is a pretense—and on the other to show the complicated relationship between photographer and subject. For Welty the woman in the pho-

tograph is only pretending to drive away customers rather than pretending to drive away an inquiring photographer whose image and caption combination might actually cause her to lose customers.

Most of the photographs in *One Time, One Place* are divided into three sequential categories: "Workday," "Saturday," and "Sunday"; however, the book ends with a fourth section, labeled "Portraits," containing eleven additional images. At first it seems hard to understand why Welty put some of the photographs into the narrative structure imposed by the movement from a workday to the weekend rather than into the portraits section. While many of the images might genuinely be labeled snapshots, as Welty says of all of the images, it is hard to see why *Nurse at home*, *Saturday off*, *Boy with his kite*, *Sunday School child*, *Baptist deacon*, and the previously mentioned *The bootlegger's house* are more important to the book's narrative structure than as individual examples of the genre of portraiture. According to E. H. Gombrich, writing in his *Art and Illusion*, a portrait "is not a faithful record of a visual experience but a faithful construction of a relational model."[33] In using the term "relational model," Gombrich predates the emphasis on the relational aspects of the autobiographer's sense of self so often encountered in recent autobiographical theorizing and summarized by Paul John Eakin's "Relational Selves, Relational Lives: The Story of the Story."

Welty herself explains that the "snapshots that resulted in portraits" that she included in the final section of *One Time, One Place* are the result of a different relation with those depicted: "Here the subjects were altogether knowing and they look back at the camera."[34] With this statement, Welty seems to be making two separate claims, first, that the subjects in the portraits look back not at her but at the camera, and second, that in so doing they were more knowing about being photographed, that is, they were more self-aware than the other subjects, whose gaze is especially innocent. In the manuscript for *One Writer's Beginnings* in the Mississippi Department of Archives and History, Welty makes another statement about the portraits, though her words are crossed out and do not appear in the published version of her autobiography: "Of the photographs I made, the portraits told me most. Black men and white Mississippi faces look out at me now, of people I saw only once and whose names I do not know; and it seems to me that the very soul of our human transience is its inherent dignity; that is what has stayed. What I do, in some sense, know about my people is their *story*."[35] Again the writer emerges from the pho-

FIGURE 7.7. *Eudora Welty,* Ida M'Toy, Retired Midwife.
(Eudora Welty Collection, Mississippi Department of Archives and History)

tographer, the author in the act of writing her autobiography seeing in
her early portraits stories as well as images, even though most of her
subjects were people she did not really know personally.

An exception, however, is *Ida M'Toy, Retired Midwife* (fig. 7.7), about
which Welty writes, "The only one I knew beforehand was Ida M'Toy,"
adding, "She wanted and expected her picture to be taken in the one
and only pose that would let the world know that the leading citizens of
Jackson had been 'born in this hand.'"[36] Not only did Welty know
M'Toy ahead of time, but she had previously published a prose portrait
of her, originally in 1942.[37] Like Gertrude Stein's prose portraits,
Welty's portrait of the well-known Jackson midwife and secondhand
clothes seller emphasizes her subject's gestures. In another parallel to
Stein, Ida M'Toy "speaks of herself in the third person and in indirect

discourse often and especially when she says something good of herself or something of herself long ago."[38] In both her prose and her photographic portraits of M'Toy, Welty emphasizes her physical gesture: "Ida's constant gestures today still involve a dramatic outthrust of the right hand," a demonstration of her skill as a midwife.[39]

Emphasizing gesture as a form of likeness, Welty echoes a statement that appears first in her preface to *One Time, One Place*: "Every feeling waits upon its gesture."[40] This phrase is important enough to the author that she repeats it in her autobiography: "I learned in the doing how *ready* I had to be. . . . Making pictures of people in all sorts of situations, I learned that every feeling waits upon its gesture; and I had to be prepared to recognize this moment when I saw it" (92). The phrase "every feeling waits upon its gesture" also suggests another connection between Welty's photographic and narrative vision, as she explains when she reprints a section of her early story "A Memory" in her autobiography.

Asserting that this story is a "discovery in the making" (95), a phrase that parallels her "the camera was a hand-held auxiliary of wanting-to-know" (92), Welty reminds us that like the narrator of "A Memory," she wanted to remain a privileged observer by finding the right distance, a function of "perspective, the line of vision, the frame of vision" (95). The narrator of the story gains perspective on the scene before her by forming a frame with her fingers as "a kind of protection" that would allow her "to watch everything about [her]," admitting, "I do not know even now what it was that I was waiting to see" (96). Toward the end of "A Memory" the narrator concludes that she has been framing and watching "the smallest gesture of a stranger," hoping that a secret will be revealed.

Not only is this sense of watching and waiting similar to Welty's photographic technique, but in her essay "Place in Fiction" she describes the literary idea of point of view in terms that seem to come from the sense of framing in photography: "Point of view is an instrument, not an end in itself, that is useful as a glass, and not as a mirror to reflect a dear and pensive face."[41] With these words Welty almost seems to be describing a camera—"the mirror with a memory"—an actual instrument whose physical placement becomes the picture's point of view. In Welty's work there are always "two pictures at once" in her frame; in this situation the double pictures result from the fact that the whole discussion of framing and memory comes from a fictional work, a story inserted into the frame of autobiography.

In addition to reproducing fiction within her ostensibly nonfictional autobiography (including excerpts from her own fiction, especially from *The Optimist's Daughter*), Welty balances the nonfictional photographs with other documents, including family letters and excerpts from her father's "keepsake book." The interrelations between her fiction, autobiography, and photography are further emphasized by the fact that a number of the covers of the Harcourt Brace Jovanovich paperback editions of her work feature paintings of her photographs; the Barry Moser illustration, for example, on the cover of *The Collected Stories of Eudora Welty* is obviously taken directly from *Baby Bluebird, Bird Pageant/Jackson/1930s* from *Photographs*.

The words "every feeling waits upon its gesture" occur in the "Finding a Voice" section of the autobiography, long after she has explained back in the "Listening" section the sequence that she first went through as a child in order to become a writer: listening for stories, noticing secrets, becoming aware that behind one secret might lie another, and, finally, finding a voice to set up dramatic scenes where this sequence could be played out. At the heart of this sequence— paralleling the autobiography's ear-eye-voice order and the repeated pattern of linear versus spiral movement—is timing, learning to wait. And what she was waiting for, in the case of stories, photographic opportunities, and writing, was the word that echoes throughout *One Writer's Beginnings*: confluence. Only when Welty can wait for her imagination to understand what her memory presents, wait for her writer's voice to make a story out of her photographer's eye, can she bring together through narrative all the interconnected stories of "the greatest confluence of all . . . the human memory" (113).

Confluence is everywhere in Welty's autobiography, starting with the combination of the photograph captioned "My mother coming down the stairs at 741 North Congress Street, Jackson" and the italicized preface that appears before "Listening," "Learning to See," and "Finding a Voice." The photograph shows the author's mother descending the stairs, the notation "My father took all of these photos" positioning Christian Welty at the bottom of the stairs. In the preface, however, Welty's father is upstairs shaving, while her mother is in the kitchen downstairs making breakfast. Welty herself is apparently upstairs also, buttoning her shoes. The passage ends with "*They kept it running between them, up and down the stairs where I was now just about ready to run clattering down and show them my shoes*" (n.p.). Not only has her parents' duet brought them together in an early instance of con-

fluence, but somehow her father is now downstairs with his wife, in position to see his daughter's buttoned shoes.

This sense of waiting for confluence is behind what she describes as one of the central events of her childhood, "the very element in my character that took possession of me there on top of the mountain, the fierce independence that was suddenly mine, to remain inside me no matter how it scared me when I tumbled, was an inheritance" (66). Here Welty is literally providing an example of a feeling waiting upon its gesture, for the feeling of independence she describes as central to her character, despite having lived "a sheltered life," occurs as she is in the act of writing *One Writer's Beginnings*, years after the events have taken place. The author is referring to an earlier scene in which, while visiting her mother's family in West Virginia, she chose a shortcut, a linear rather than spiral route to the bottom of the mountain. "Well, now Girlie's learned what a log chute is" (63), says one of her uncles, bringing her straight to her Grandmother Carden, her mother's mother, the original Eudora. Unlike a similar scene at her father's home in Ohio—"up in the loft, jumping wild in the new hay, I skinned through the hole in the floor, the way it went down when it was tossed to the trough below, and the trough caught me neatly" (72)—the young Welty learned from her fall in West Virginia a lesson about confluence that seems to have been vital to her, a lesson that included waiting for her grandmother's gesture to make sense. Following her fall down the log chute, Welty was brought directly in front of her Grandmother Andrews:

> Her gesture then was the last other thing I remembered from being here before: with her forefinger she pushed my hair behind my ears and bared my face to hers. She looked seriously right into my eyes. Hadn't we come right to the point of our both being named Eudora?
>
> "Run take that little dress of yours off, and Grandma'll sew up the hole in it right quick," she said. Then she looked from me to my mother and back. I learned on our trip what that look meant: it was matching family faces. (63–64)

Readers of *One Writer's Beginnings* cannot copy Eudora Carden Andrews's gesture, comparing the faces of her daughter and her granddaughter for family likeness, because none of the photographs in the autobiography shows all three faces together. In the sixteen family photographs—grouped between "Listening" and "Learning to

See" in the original hardbound Harvard University Press version and within the "Learning to See" section in subsequent paperback versions—both grandmother and mother, Chestina Andrews Welty, appear together only once, in a photograph whose caption begins with "My grandmother, Eudora Carden Andrews, seated in the chair, with five of her six children," a photograph in which grandmother and mother, wearing similar blouses and hairstyles, are close enough to each other to see family resemblance, especially in the eyes. Although it does not appear in the autobiography, a picture captioned "My namesake, Grandmother Eudora Carden Andrews" was published in Patti Carr Black's *Eudora*, a collection of family photographs also featured in an exhibition at the Mississippi State Historical Museum. This image is especially interesting because of the young Eudora's hand reaching up to hold the face of the older Eudora, a gesture duplicating the phrase "matching family faces."

Another photograph of the author's grandmother appearing in *One Writer's Beginnings*, labeled "My mother's mother, Eudora Carden Andrews," is a reproduction of a tintype originally made by the author's grandfather Ned Andrews around 1882. This image is described in detail within the text of the autobiography: "She is standing up behind a chair, with her long hands crossed at the wrist over the back of it; she is dressed in her best, with her dark hair drawn high above her oval face and tucked with a flower that looks like a wild rose" (53–54). Only in the original Harvard hardback version of the autobiography can we see her crossed hands, the paperback versions having been cropped just below the neck. Following her usual practice of moving from photography to writing, Welty goes on in the prose description of the picture to present a story behind her grandmother's pose. "She told her daughter Chessie years later that she was objecting to his taking this picture," writes Welty, "because she was pregnant at the time, and the pose—the crossed hands on the back of a chair—had been to hide that" (54). Like the pictures in *One Time, One Place*, which the author thinks of as a family album, the photographs within *One Writer's Beginnings* are presented as if they were literally part of a family album, especially in the second Warner paperback version, in which the images are presented at angles as though pasted onto the actual pages of an album. In both hardback and paperback editions, the pages with photographs simulate a family photograph album, each corner reproducing a stylized mounting device, as though the images are actually pasted onto the pages.[42]

In some cases, Welty has chosen to include family photographs only in prose. For example, she describes a photograph of her grandfather Carden, though the image does not appear physically within the autobiography. "In our picture of Grandpa Carden, his long beard and side whiskers are pure white, and seem to be stirred by some mountain wind," she writes. His large black hat is resting upside-down on his knee as he sits on a straight-back bench. His right hand is holding, straight up and down and thin as a rod, his staff; it looks four or five feet tall" (65). This actual image could have been included within *One Writer's Beginnings* along with its prose description, for it has been published in *Eudora*, in which all the physical details Welty describes are present, though Grandpa Carden's hat is not upside-down on the bench. It is possible that the published photograph and the prose description are referring to two slightly different versions of the same occasion, though her words "in our picture" suggest that only one such photograph exists. Although we cannot see the picture in the autobiography, we cannot see in the photograph what is written across its back: "to Chessie, if she will have it" (65). Perhaps Welty chose not to reproduce this photograph in her autobiography because there are already three pictures of her mother's family and only one from her father's side.[43]

Although it is important to Welty to establish that she did not pose the subjects in *One Time, One Place* or *Photographs* because of a sense of not wanting to manipulate their appearance, in her autobiography she shows a number of photographs in which the whole idea of pose is not so much a manipulation by the photographer as a protective device for the subject. Her grandmother's folded hands, for example, are an apt illustration of Geoffrey Batchen's argument that "posing can at the same time be a form of passive resistance to photography's intrusion, a protective re-making of the self as an always already photogenic object."[44] Although not in the autobiography, another tintype of Eudora Carden Andrews is included within Black's *Eudora*, this second image captioned by Welty: "The other shows it couldn't have been easy for them, bringing up six children in their remote mountain-top home."[45] Both photographs of Welty's grandmother have in common the presence of hands, especially expressive eyes, and a frontal pose, examples of pose containing a sense of narrative, as argued by Suren Lalvani: "The head-on stare in such cases should be read in contrast to the cultivated asymmetries of aristocratic pose, for pose is a function of leisure while frontality confirms the complete lack of it."[46]

The sense of searching for likeness inherent in the gesture of "matching family faces" means more to Welty than simply finding facial similarities. What she did not learn from falling down the hayloft in Ohio is the sense of independence she associated with falling down the log chute in West Virginia, because the first fall was associated with her mother's family's sense of independence, storytelling, openness, noise, and discovery, while the second was connected to her father's family's sense of quiet, closeness, and reticence. Where the West Virginia side of her family is filled with stories, the Ohio side is noticeably lacking; Welty says of her father, "He never happened to tell us a single family story" (70).

And yet the two falls are brought together in her emphasis on confluence, another form of likeness. As she notes earlier in *One Writer's Beginnings*, "It took me a long time to manage the independence, for I loved those who protected me—and I wanted inevitably to protect them back. I have never managed to handle the guilt. In the act and the course of writing stories, these are two of the springs, one bright, one dark, that feed the stream" (22). In this metaphor, with its figurative confluence of waters, Welty explains her own sense of narrative as a confluence: her mother's independence and her own guilt over having inherited it, which results in the author's independence from both her parents, while she nevertheless continued to live "a sheltered life."

"It took the mountain-top, it seems to me now, to give me the sensation of independence," writes Welty, adding, "It was as if I'd discovered something I'd never tasted before in my short life. Or rediscovered it—for I associated it with the taste of the water that came out of the well, accompanied with the ring of that iron metal sleeve against the sides of the living mountain. . . . The coldness, the far, unseen, unheard springs of what was in my mouth now, the iron strength of its flavor that drew my cheeks in, its fern-laced smell, all said mountain, mountain, mountain as I swallowed" (62–63). In this passage Welty's sense of association (independence–taste of water–mountain) matches with her mother's way of discovering connections—her "mind was a mass of associations" (21). Unlike the "bright and dark springs" of guilt and independence that feed her narrative stream, here she discovers that "sorrows springs are not the same," for the well water's taste, smell, and feel in her mouth voice its source in Welty's familiar pattern of triple repetition—mountain, mountain, mountain—that suggests an echo.[47]

That Welty discovered her sense of independence on top of the mountain, while simultaneously discovering how much she matched her mother and grandmother, and associated the experience with drinking from the well is connected also to her new way of seeing and hearing in hilly West Virginia as opposed to relatively flat Mississippi. Because of the mountainous geography that sometimes obscures sight lines, one can often not see something nearby, although an object or person in the distance may be visible, just as one can often see a particular location but only be able to get to it by a circuitous route that renders the destination out of sight, peculiarities of life in the mountains that parallel the tension in *One Writer's Beginnings* between straight lines and spirals. Unlike Mississippi, where the author as a young child can see cause and effect directly (Miss Duling rings her bell, and the schoolchildren at the Davis School go into the classroom), in the mountains she must learn to make connections between sounds and sights.

Another of the revelations leading toward independence she learned on the mountaintop comes about because the topography often causes her to hear but not see the source of sounds, as exemplified in two cases, also involving bells. The first example occurs when she hears a cowbell: "In the mountains, what might be out of sight had never really gone away" (62). This bell echoes an earlier reference to one of her first mountain memories: "It was an early summer dawn; everything was a cloud of mist—we were standing on the bank of a river and I didn't know it. When my mother pulled the rope of an iron bell, we watched a boat come out of the mist to meet us, with her five brothers all inside" (56).[48] In both of these examples of bells being heard but not seen, which occur in the chapter of *One Writer's Beginnings* called "Learning to See," Welty reinforces her way of becoming a writer, the need for a sequence (learning to listen, see, and voice) followed by a sense of timing—waiting for the decisive moment. To the writer whose sense of narrative first found a pattern of form and frame and distance through a photographic eye, part of learning to see stories is learning to sense the inherent difference between the first two senses in her familiar sequence, hearing and seeing.

The difference between hearing and seeing blends in her mother's memories of West Virginia, especially in the scene in which the author describes her mother as never really getting over her absence from that state: "I think she could listen sometimes and hear the mountain's voice—the delayed echo of the unseen and distant old man—

. . . chopping wood with his ax and calling on God in alternation, in answering blows" (59–60).[49] Like the peal of unseen bells, Chestina Welty's picture of West Virginia is not dimmed by not being physically observed. Not only does this quotation demonstrate her mother's blending of senses and chronology, but it once again demonstrates the daughter's sense of likeness with her mother, for the author's own voice begins to take over halfway through her evocation of her mother's words, adding her own sense of having learned in West Virginia something about frame, perspective, and distance from the experience of being able to hear but not see the same mountain man with his ax: "the prattling of the Queen's Shoals in Elk river somewhere below, equally out of sight, which I believed I could hear from Grandma's front-yard rocking chair, though I was told that I must be listening to something else; the loss and recovery of traveling sound, the *carrying* of the voice that called as if on long threads the hand could hold to, so I would keep asking who that was, who was still out of sight but calling in the mountains as he neared us, as we brought him near" (60).

This experience of making a person visible by gathering in the threads, an echo of Welty's phrase "the strands are all there: to the memory nothing is ever really lost" (98), also occurs when the author looks at snapshots of her father taken long before she was born. These negatives from the past that, when she developed them at about the same time she wrote *One Writer's Beginnings*, she first took to be "the festival scenes of his last fling" (106) later turned out to be images of the Thousand Islands, Niagara Falls, and the St. Lawrence Seaway, the other places besides Jackson, Mississippi, that the young Christian Welty had offered to his new bride. "And here they were, the choice she didn't take," writes Welty. "She'd chosen the other place, and here was I now, one of the results, in it, with pictures of the other choice now turning up in my hand" (107). In this passage, with its emphasis on developing photographs of the road not taken by a man long dead, a set of images that allow her to go back in time but that have waited until this moment for her to see for the first time, Welty parallels her frequent motif of waiting for just the right moment, both to fix the scene in memory or on film and then later to match it with a feeling, another example of the maxim "every feeling waits upon its gesture."

In his *The World Viewed* Stanley Cavell makes the point that comparing hearing and seeing produces an odd effect of language that helps us to understand how photographs work: "The problem is not that

photographs are not visual copies of objects, or that objects can't be visually copied. The problem is that even if a photograph were a copy of an object, so to speak, it would not bear the relation to its object that a recording bears to the sound it copies. We said that the record reproduces its sound, but we cannot say that a photograph reproduces a sight (or a look, or an appearance). It can seem that language is missing a word at this place."[50]

The difference between what we remember through the sense of sound and what through the sense of sight is integral to the way old yet new photographs work on Welty's memory. Because there is no photographic equivalent for the word "sound," as Cavell reminds us, we have difficulty explaining exactly what photographs represent, just as we have difficulty explaining the presence of photography within Welty's life and her life writing. Cavell's questions about the difference between the transcription of sounds and sights suggest some of the difference between Welty's way with writing as opposed to photographing. Wondering if "the difference between auditory and visual transcription" is "a function of the fact that we are fully accustomed to hearing things that are invisible" whereas "we are not accustomed to seeing things that are invisible, or not present to us, not present with us," Cavell answers, "Yet this seems, ontologically, to be what is happening when we look at a photograph: we see things that are not present."[51]

Seeing more in photographs than is actually present is what makes Eudora Welty a celebrated writer rather than a famous photographer, for in addition to the physical details, she sees a story. Even though she sometimes describes within *One Writer's Beginnings* a particular photograph that is tangentially connected to a particular scene in her fiction, Welty always insists on a difference. In answer to the question "Have you ever relied upon any of your photographs for a scene of an element in a story you've written," she replied: "No. The memory is far better. Personal experience casts its essential light upon it."[52] Because she needs to wait for her feelings and her gestures to coincide, Welty thinks of the photographic act as separate from personal feeling. When an interviewer remarked of her photographs, "They're a record not only of what you saw, but they're a record of your feelings," Welty responded, "Yes, but I didn't take them for that. If they do that, it's because I took them with the right feeling."[53]

For Eudora Welty the act of taking the photograph *is* the very gesture she needs to get at the right feeling, just as writing her auto-

biography is the gesture she needed to bring together her photographic and writerly ways of remembering the past. While there may be no specific, conscious connection between her early career as a photographer and her learning to write *fiction*, there are important connections between her photography and her *nonfiction*, especially *One Writer's Beginnings*. For Welty the fictional and the nonfictional are two more strands in her family's legacy that she brings together in another confluence, for her mother was a reader of fiction, her father a proponent of nonfiction. As she tells us in *One Writer's Beginnings*, unlike her father—"though he was a reader, he was not a lover of fiction, because fiction is not true, and for that flaw it was forever inferior to fact" (89)—her mother "read secondarily for information; she sank as a hedonist into novels" (7). For Welty the photographer, words and images are separate; however, for Welty the autobiographer, words and images blend in a confluence of past and present. And just as her mother attempted to make a literal confluence through a desperate last-minute blood transfusion, so Welty has made a sort of transfusion of her mother and father through the writing of *One Writer's Beginnings*, bringing together the nonfictional voice of her reviews, lectures, and essays and the fictional voice of her novels and stories. She is a writer who needs to hear not only the *voice* of the story but, as the title of her nonfiction collection attests, "the eye of the story" as well.

Only fiction will accommodate the facts of life.
—*Wright Morris*

The photographer who has no hand to hide
will conceal it with the least difficulty.
—*Wright Morris*

8 | The Mirror without a Memory
................................
Wright Morris

Because of Wright Morris's complicated and original way of
incorporating photography into and behind his writing, as well as
within his actual life, this section on Morris could fit anywhere in *Life
Writing and Light Writing*. Wright Morris is the author of three separate
autobiographies, *Will's Boy: A Memoir* (1981), *Solo: An American Dreamer
in Europe: 1933–1934* (1983), and *A Cloak of Light: Writing My Life* (1985),
all of which were collected in a one-volume version titled *Writing My
Life: An Autobiography* (1993).[1] This chapter could have been paired
with Maxine Hong Kingston and Sheila and Sandra Ortiz Taylor in
part 1 because *Writing My Life* contains no actual photographs. No
photographs appeared in *Solo* when that book was published sepa-
rately, though a single image of the author as a child appears in the
original version of *Will's Boy*. *A Cloak of Light* originally contained
thirty-three photographs. When those books were collected in the
one-volume version, none of the photographs was included.

My study of Wright Morris could also appear with the chapters on
Paul Auster, Michael Ondaatje, and Reynolds Price because his rela-
tion with his father is a constant theme, both in his autobiographies
and in his numerous novels, which include the National Book Award–

winning *The Field of Vision* (1957) and the American Book Award winner *Plains Song: For Female Voices* (1981). Morris's work as a photographer has also been celebrated, resulting in retrospective shows at museums and galleries across the country and the publication of two major collections of his photography: *Photographs and Words* (1982), published by the Friends of Photography, and *Origin of a Species* (1992), which accompanied his photographic exhibitions at the San Francisco Museum of Modern Art in 1992 and the Museum of Fine Arts in Boston in 1993. However, because Morris's most unique contribution to the worlds of photography and writing occurred in what he called photo-texts—*The Inhabitants* (1946), *The Home Place* (1948), *God's Country and My People* (1968), *Love Affair: A Venetian Journal* (1972), and *Photographs and Words* (1982)—books that include sophisticated combinations of his prose and his photographs, I have decided to put Morris into this transitional position, a link between Eudora Welty, a writer who also photographed, and Edward Weston, a photographer who also wrote.

The tidy categories into which Morris's work is listed in the front of his books belie the complicated intertextuality between words and images in his overall canon. Sometimes virtually the same scene appears and reappears in several novels, as well as in one of the autobiographies. *The Works of Love*, a novel, covers much of the same ground as *Will's Boy*, an autobiography, except that the novel is more about Will Brady, the fictional father. Another novel, *Cause for Wonder*, parallels *Solo*, the second of Morris's autobiographies. Long quotations from both his novels and his nonfictional critical writing appear in italics within his autobiographies, passages from his earlier autobiographies show up in *A Cloak of Light*, and his photo-texts, with the exception of his Venetian journal, recycle many of the same photographs, each time with different prose passages acting sometimes as a counterpoint, sometimes as an enigmatic comment on the images. At times he undercuts the whole distinction between words and images by photographing pages of prose, as in the excerpt from Sinclair Lewis's *Babbitt* that appears in *God's Country and My People* or the photograph of a page of newspaper clippings, some of which also appear in prose within the text of *The Home Place*.[2]

Not only does he put his fictional prose into his nonfictional autobiography, but he also uses his ostensibly nonfictional photographs within his novels in the form of both physical reproductions and prose descriptions of actual pictures. In an essay called "Photography

and My Life," which originally appeared as the "photography" portion of *Photographs and Words*, eventually reappearing throughout *A Cloak of Light*, Morris includes photographs showing the relationship between picture and prose from one of his earlier photo-texts, labeled "*Two-page spread from* The Inhabitants, *1946*," as well as another from one of his earlier novels, *Two-page spread from* The Home Place, *1948*. Morris says of his tendency to intermix and reuse fiction, nonfiction, and photography: "A disinterested observer, pondering my behavior, might say of me that the function of the present was to confirm the nature of the past, and by a commodious vicus of recirculation the reality of the present."[3]

Morris often describes the relationship between his words and pictures as two separate ways of imagining. For instance, in *Cloak of Light* he notes of his earliest photographs that he had no inkling of any real connection between the verbal and the visual at the moment of producing each. "Neither did it occur to me," he continues, "that these photographs, appropriate as they were to my intentions, did not displace, for the writer, the image he sought to describe on his mind's eye. They were collaborating, and reassuring, but not at all the same thing" (12). Later, having moved to Connecticut with Mary Ellen Morris, his first wife, following an unsuccessful attempt at painting, he began photographing again, this time with more sophisticated equipment, including his own darkroom. Apparently by chance, he realized the connection between the two forms of image making that would characterize his career as a man of letters and pictures: "Watching the prints emerge in the dark, like objects in a séance, I began to recall, as if I had them before me, some of the prose passages that I had written back in California. I now saw that these passages, like shadow to substance, belonged with the photographs I was now taking, not to illustrate or describe, but to complement the visual image with one of words" (*Cloak*, 40).

Morris's description of the interrelationship between words and images in what became his first book-length photo-text, *The Inhabitants*, makes clear that the connection is complementary rather than illustrative and that he then thought of the words as more shadowy than the photographs. He was not impressed by the usual way of combining photographs with written text, as seen in such examples as Archibald MacLeish's *Land of the Free*, Dorothea Lange and Paul Taylor's *An American Exodus*, Margaret Bourke-White and Erskine Caldwell's *You Have Seen Their Faces*, or Sherwood Anderson's *Home Town*.

The sort of complicated interconnection of words and image made famous by James Agee and Walker Evans's *Let Us Now Praise Famous Men* seemed much more promising. While many critics and reader-viewers have struggled with the complementary connections between the photographs and prose passages in all of Morris's photograph-word combinations, I believe one answer to understanding his work is to see that the same photograph—whether reproduced literally or in prose—is complemented, in the sense of being completed, by numerous references to it throughout the Morris canon rather than just in its initial appearance.

As early as his second novel, *The Man Who Was There* (1945), Morris's lifelong interest in photography was an essential element, his habit of intertextuality begun. *The Man Who Was There* tells the story of Fayette Agee Ward, a fictional character—with the first name of Morris's real brother who "lived for only a few days."[4] Agee Ward combines aspects of both Wright Morris and his father, Will. As we learn from reading *Will's Boy*, Will Morris, following the death six days after Wright's birth in 1910 of his wife and Wright's mother, Grace Osborn Morris, is—like Paul Auster's portrait of his father as an invisible man—hardly there. Morris describes his conception of Agee Ward in the following words: "I conceived of Agee Ward as one who became more of a presence thorough his absence, rather than in spite of it: a man who was there" (*Cloak*, 107). Throughout *Will's Boy* Will is mostly absent, a Sherwood Anderson sort of father whose major occupation is raising sickly chickens. For most of his early childhood Wright lived with relatives or the families of friends, fending for himself and thinking of Will, who "had always been too busy a father," despite the title of Wright's first autobiography, "as if he were some other boy's father" (*Will's Boy*, 65). And yet Wright is Will's boy and has inherited from his father a lifelong tendency toward going solo, as his second autobiography attests. Having grown up "half an orphan" (*Will's Boy*, 35), he eventually realized that although his father was still alive, on the periphery of his life, by the time he began high school Morris "had become more of a whole orphan than a half one" (*Will's Boy*, 85).

Although Agee Ward clearly shares some of Will's characteristics, he also resembles Will's boy, Wright. *Will's Boy* is the title of both the first autobiography and the only physical photograph within it, the frontispiece, a photograph of the autobiographer as a child reaching for a birdcage, the picture reproduced with stylized scalloped corners

FIGURE 8.1. *Wright Morris,* Will's Boy *frontispiece. (Courtesy of Josephine Morris)*

as if within a family album (fig. 8.1). Although this image is not re-
ferred to within *Will's Boy* the autobiography, it is described in prose
within "The Album," a section of *The Man Who Was There* about a
family photograph album found among the personal property of Agee
Ward, who is reported missing in action during the Second World
War: "In the album of 1912 there is a picture of him. He is in a white
dress and aged two years, four months, and eleven days.... His fingers
still pluck the wires of the cage but he has turned to complain that it is
empty—or to look where the birdie now sits on the camera."[5] This
prose description certainly differs in numerous physical details from
the frontispiece to *Will's Boy*. In the prose Agee is seated with the
birdcage on his lap, his face turned toward the camera, his hair said to
be distinguished by "the long brown curls that hung from each side of
his head" (*Man Who Was There*, 67), while the child in the *Will's Boy*
frontispiece is standing in profile, his short hair without curl.

At first, then, the prose description would seem to be a clear exam-
ple of the difference between fictional prose and nonfictional pho-
tography, clearly supporting evidence for Morris's statement from
Time Pieces: "What I *see* as a writer is on my mind's eye, not a photo-
graph. Although a remarkable composite of impressions, the mind
does not mirror a photographic likeness. To my knowledge I have
never incorporated into my fiction details made available through
photographs."[6] And yet some of the specific prose details deliberately
conflate Fayette and Wright Morris. Morris was born on January 6,
1910, the same year his mother died, while Fayette was born before
him on a date not specified in Morris's autobiographical writing and
died in 1904. Since the child in the prose photograph is said to be
exactly two years, four months, and eleven days old and the picture
is in a fictional album for the year 1912, it is difficult not to con-
nect Wright rather than Fayette with the image, especially when we
notice that the same photograph is also reproduced in Morris's latest
autobiographical piece, "How I Put In the Time," with the caption
"Wright Morris in 1912, when he was about two and a half years old.
(From the Morris family collection)."[7]

According to the novel, the photograph of Agee "is glued down in
the Album in the fear that he might destroy it." When the fictional
Ward discovers, written on the picture, "Fayette Agee Ward/Aged
2yr.4m.11d.," he destroys not the image but the words: "With his first
knife he removed *Fayette*" (*Man Who Was There*, 67). In this compli-
cated situation we have a fictional character removing the name of

Morris's actual brother from a fictional photograph whose dates and image closely resemble an actual photograph of Morris that appears later in his autobiography.

In writing about Fayette, his father, and himself, all three examples of a man who was not there, Morris is also writing about the nature of photographic representation. He writes, "We sense, as we read, that the facts elude us: to have merely been there only adds to our confusion."[8] Concentrating on a man who was not there in fiction also echoes his frequently noted practice of omitting people from his photographs, a practice that caused Roy Stryker to reject Morris as a potential Farm Security Administration photographer. In response to Stryker's "Where, in God's name, were the people?" Morris replied that "the absence of the actual people enhanced their presence in the structures, and in the text" (*Cloak*, 51). "In photography, someone is always acting for us and probing ahead, a proxy figure on reconnaissance, so that whatever is sent back has been gained without our effort or risk," writes Max Kozloff, continuing with a statement that is suggestive of Morris's common practice of evoking the author within his absence: "The ambivalence consists in being thankful for that but yet also in feeling jealous and deprived . . . in not having been there."[9]

It might be argued at this point that Morris has only done what all novelists do: selected small details from his actual life and transferred them into a work of fiction, where they take on a fictional aspect. Or perhaps it would be more accurate to say that he has only done what all autobiographical novelists do, something like Thomas Wolfe's changing Chapel Hill to Pulpit Hill and Asheville to Altamont, fictional names that clearly suggest their nonfictional origins.

And yet in Morris's world something more sophisticated seems to be going on, brought about by the extra complication added by the presence of photographs within both his fictional and nonfictional texts. For example, in *Will's Boy* Morris describes his attempt at getting a baseball autographed by Babe Ruth, who was in Omaha during a barnstorming tour. As Ruth walked away, Morris, struggling in a crowd of mobbing fans, grabbed the rear pocket of his baseball pants, coming away with a souvenir, a flannel pocket he used to "rest my knuckles on when I played marbles" (58). Babe Ruth's pocket becomes one of many physical objects that resonate simultaneously in Morris's fictive and nonfictive worlds—usually ordinary objects such as chairs, doors, and mirrors. "In the clutter of what is remembered and what is imagined some things prove to be symbolic objects," he

writes, adding in his familiar epigrammatic style, "They gather lint. They wear in rather than out. . . . Each time these tokens are handled they give off light."[10] Recording the light given off by objects is, of course, at the heart of the optical process of photography.[11]

The actual artifact from the famous baseball player was once at the center of "Babe Ruth's Pocket," an unpublished manuscript of which Morris notes in *A Cloak of Light*, "This novel-length fiction consisted of characters from my own largely unread novels," which suggested his "ongoing preoccupation with fact and fiction, with what is real-seeming in the world I perceive around me, and the fiction we produce to mirror that world" (212). "Babe Ruth's Pocket," according to the author, "perceived the characters of my novels to be more real-seeming, less shadow and more substance, than the actual people with whom they mingled, and on whom they were based" (212). Morris's manuscript, which seems to have played on the now familiar post-modernist notion of fictional characters taking on a life of their own in a manner similar to Kurt Vonnegut's *Breakfast of Champions*, is echoed by one of his published novels, *Field of Vision*, in which a character named Gordon Boyd, according to Wright, "is too *close* to the author."[12]

One way in which Gordon Boyd (who also appears in *Ceremony in Lone Tree*, another novel) is like the author is his possession of a talismanic object, Ty Cobb's pocket, which he has torn from the baseball player and which he carries around with him well into middle age. What has Morris gained in transforming Babe Ruth's real pocket into Babe Ruth's "real-seeming" pocket and then into Ty Cobb's fictional one? Mere concealment of personal details cannot be the answer, for how would readers of the novel know about the autobiographical similarity, since the novel preceded the first autobiography by twenty-five years? In moving the pocket from the real to the fictional realm, Wright could have simply invented a fictional baseball player's name.

One answer to these questions lies in the way the situation actually works in *The Field of Vision*, a case of fiction within fiction, what the novelist and literary character call a transformation. When the fictional Boyd takes a foul ball to Ty Cobb to be signed, he thinks of the ball, as G. B. Crump notes, as "thereby transformed from fact into fiction and removed from time,"[13] a process that might also describe Morris's attitude toward the objects he transforms into fiction and photography. Morris writes: "The role of time in most photographs is

like that of a sorcerer's apprentice. Alchemy is afoot. Before our very eyes dross metal is transformed into gold. Photographs considered worthless, time's confetti, slipped from their niche in drawer or album, touch us like the tinkle of a bell at a seance or a ghostly murmur in the attic. And why not? They are snippets of the actual gauze from that most durable of ghosts, nostalgia. They restore the scent, if not the substance, of what was believed to be lost."[14] Snippets of the ghostly gauze could serve as an accurate caption for a number of Wright Morris's actual photographs, which often feature rooms glimpsed through screens or curtains, such as *Through the Lace Curtain, Home Place, 1947*.

The connection in tone between Morris's fiction and his photography can also be seen in the transformation of Ruth to Cobb. According to John Szarkowski, "Ty Cobb's pocket is similar to the kind of evidence that is collected by Morris the photographer."[15] A similar transformation seems to take place when actual objects are photographed and the photographs are placed into fictional situations, especially in the case of Wright Morris, who notes, "I use the same eyes to type the pages of a novel and to focus the image on the ground glass."[16]

Morris complicates the situation further by leaving many autobiographical details unchanged from fiction to nonfiction and by writing about many of his life's events from multiple perspectives. For example, where Wright was born on January 6, 1910, Agee Ward is said to have been born on February 6, 1910 (*Man Who Was There*, 72). In deliberately choosing the same day and year of his own date of birth, but one month later, for his fictional character's birthday, Morris demonstrates the thin line that separates fiction from fact in his work. In changing his autobiographical narrator into a fictional protagonist, Morris has deliberately obscured himself. And yet in using an actual photograph of himself as a model for a fictional photograph of his fictional narrator, he has also, perhaps unconsciously, performed another autobiographical act, similar to the hiding/displaying he *reveals* in *Will's Boy*: "I had little or no suspicion that my true feelings were precisely those that I would learn to conceal" (120), the same words being repeated in the coda to *A Cloak of Light* (305).

Another of the photographs said to be part of Agee's album is described as follows: "A photograph of a house—that is all, just a house. Or maybe it is an ark, for the land extends sea-flat and level, vacant as the sea, and falls away from the house as the sea from a

swell" (*Man Who Was There*, 73). Twenty-three years later, in *God's Country and My People*, virtually the same metaphoric comparisons of house to ark and plains to sea appear, this time paired with a photograph, *Farmhouse near McCook, Nebraska, 1940*, that in the novel we could only imagine (*God's Country*, n.p., first prose paragraph). The same photograph, though printed with different emphasis, also appeared in *The Inhabitants*, only a year after the novel, but in that case with a completely different prose accompaniment, one that makes no mention at all of arks or seas.[17]

Looking at other fictional photographs described in *The Man Who Was There*'s fictional albums, we quickly notice that many of the images of Agee are missing or blurred. In one photograph only his feet are shown; in another no record of him appears "due to the fact that the camera shutter had not been wound" (69). Morris writes of a school picture of Agee, "The smallest boy in the class has his face blurred," adding, "We know who this boy is because the boy seated beside him . . . wrote the name *Agee Ward* across the blurred boy's shirt" (68). And of a snapshot taken at Niagara Falls he writes, "Nothing shows in this print but the blurred figure of someone just passing and, nearly as blurred, a boy in knee pants at the rail of a bridge" (71).

As we look at the descriptions of photographs of Agee, moving chronologically through the life of a man who both is and is not really there, we see that the autobiographer has deliberately blurred these pictures, for, as he wrote on another occasion, "in the blur of the photograph, time leaves its gleaming snail-like track."[18] Like the missing yearbook photograph of Cletus Smith in William Maxwell's similarly fictional and nonfictional *So Long, See You Tomorrow*, Agee Ward is neither here nor there. In this album of moving and blurred faces, the photographic equivalent of the phrase "missing in action," we see an example of Morris's statement, made in an essay called "About Voice: Or, The Writer Revealed in Spite of Himself," that "to perceive the writer in his many disguises is one of the great pleasures of reading. Behind his masks we detect his own ineffable voice."[19] Morris's tendency to mask his most personal memories, to blur some aspects of the past while sharpening others, is reflected in Joseph Wydeven's perceptive description of three typical Morris photographs: "All three give the illusion of depthlessness—an illusion which reduces the 'realism' of the objects and renders them in nearly surreal terms. . . . This is a photographic effect often seen in Morris's photographs—the sharp and vivid contrast which emphasizes sheer black and white values and reduces detail in the dark areas."[20]

While his earliest photo-text, *The Inhabitants*, was classified as non-fiction, Morris's second attempt at combining words and images, *The Home Place*, has usually been considered to be a novel, though the degree of its fictiveness is confused by the fact that each page of text is printed next to a full-page photograph. Photography scholars seem to see the book as fiction, though they are aware of an autobiographical element as well. John Szarkowski calls *The Home Place* "essentially a novella, or a fictional memoir, with photographs," and A. D. Coleman, who says the protagonist Clyde Muncy is "drawn semi-autobiographically," concurs: "the novel—for, despite numerous autobiographical overtones, *The Home Place* is a work of fiction," though he adds a confusing codicil about Morris's use of photographs: "The initial result of this startling device is the gradual erasing of the thin, firm line between art and life."[21]

In *A Cloak of Light* Morris mocks the firmness of that line when he describes his own naïveté in imagining the ease with which his narrator, "a young man not unlike myself" (134), might describe the house and grounds of the actual home place of his Aunt Clara and Uncle Harry near Norfolk, Nebraska. Writing this book, observed Morris, "grew out of my preoccupation with a past I had experienced as a child, but never fully possessed. Fiction was an act of repossession. In the *Home Place* I first staked out my claim on a landscape largely of my imagination. It was what I had *not* experienced that I found it necessary to experience."[22] The Nebraska homestead was not, of course, really home to Wright Morris, though he had lived and worked there for a while during the summer when he was thirteen, as described in *Will's Boy*, where the experience is coupled with a quotation from *The Man Who Was There* about Agee Ward's sketch of the home place "as if copied from a photograph" (*Man Who Was There*, 72).

In 1942 Morris and his first wife visited the home place, staying only briefly; however, in 1947, while photographing his way across the country on his second Guggenheim Fellowship, Morris revisited the farm, again looking at family photographs and this time taking many of his own. Driving back from the second visit, as described in *A Cloak of Light*, he imagined writing what became *The Home Place* in "the first-person singular 'I' of the very involved author. What reason did I have for concealment?" (134). Concealed within this ambiguously worded question lies much of Wright Morris's method. At first he seems to have suggested that no concealment occurred; however, in the next paragraph he suggests that his reason for concealment is

revelation: "The ease and flow of the story either concealed, or made light of, the double role of Muncy as a character and as a stand-in for the author. I found it an authorial privilege to exploit this ambivalence" (136). These sentences display the very ambiguity they describe because, as I have often argued, autobiography is an art of both concealing and revealing and because "to make light of" something, in addition to its meaning of belittling, also suggests bringing something to light, a phrase with photographic connotations, especially in a book called *Cloak of Light*, a title that also evokes the idea of displaying while covering up. As Morris notes, "We sense that it lies within the province of photography to make both a personal and an impersonal statement."[23]

A major reason for concealment in Morris's terms involves the issue of privacy and, to use another term with photographic connotations, exposure. Ill at ease with the invasions of privacy that he thought characterized many of the photo-texts of the documentary tradition, he was attracted to revelation rather than exposure. But in taking photographs inside the home place, despite the fact that his Aunt Clara (who admits to having seen the photographs in *The Inhabitants*) gave permission, he suddenly realized that the distinction was not so easily made. Referring to *Bed with Night Pot, Home Place, 1947* (fig. 8.2), as it later emerged in the darkroom, he writes, "I felt remarkably ambivalent about it. A fact it was—but on the scales of value it was all exposure and little revelation,"[24] in part because of the presence of the chamber pot under the bed, which seemed too private to him, and in part because of the "bed sagging with invisible sleepers," an image he elsewhere describes in terms of "the mattress" as "a film that records numberless overlapping exposures."[25]

Unsure at first about whether it would be appropriate to publish the picture in *The Home Place*, and deciding finally not to, he goes on to link the distinction between revealing and exposing with the question of fiction and nonfiction: "My own ambivalence testifies to what is a matter of 'custom' in the blurred gap between revelation and exposure. When in doubt, and the revelation seems thin, exposure can be relied on to clarify the distinction between fact and fiction."[26] Again Morris is deliberately ambiguous. He might simply mean that the act of imagining exposing a photograph to the public tells him whether to put the image into a fictional or nonfictional context. And yet, he left this image out of *The Home Place*, a novel, but published it along with "The Question of Privacy," an essay. Maybe he meant that

FIGURE 8.2. *Wright Morris,* Bed with Night Pot, Home Place, 1947. *(Courtesy of Josephine Morris)*

photographs published within a fictional context are less guilty of exposing privacy, especially someone else's, than those images that appear within a nonfictional context.

One answer to the confusion raised by Morris's stance toward these issues lies in the following sentence from *A Cloak of Light* in which he describes the built-in ambiguity that comes along with first-person narration: "The ambivalence that is part of the voice itself is subject to

both deliberate and unconscious manipulation. The voice that I am now using to describe this occasion, and to comment on it with some detachment, is relatively free of the 'self' deception that comes so easily to the 'I' as narrator but is inherent in the 'I' itself, usually concealed" (136–37). In other words, Morris explains that even in writing in the first person in his autobiography about having written in the first person in his fiction, a degree of concealment is impossible to avoid. That self-deception is inherent in writing in the first person in any genre is in part a positive aspect, Morris is claiming, because it allows both writer and reader a degree of ambivalence that protects privacy and overexposure, thereby allowing for real revelation in the gaps between. Morris's situation is paralleled by Roland Barthes, who writes in *Camera Lucida*: "I want to utter interiority without yielding intimacy."[27]

Morris's ambiguous position toward the fictionality versus reality of photography is, according to Susan Sontag, common to all photographers, inherent in the art of taking pictures. "Photography is the paradigm of an inherently equivocal connection between self and world—its version of the ideology of realism sometimes dictating an effacement of the self in relation to the world, sometimes authorizing an aggressive relation to the world which celebrates the self. One side or the other of the connection is always being rediscovered and championed."[28] This situation is, of course, even more complicated when the photographer is also a writer, and especially when the writer is also an autobiographer.

That there is a direct connection between revelation and genre seems at first reasonable, especially when the reader takes Morris's books singly. For instance, writing about *The Home Place* by itself, David Nye sees a parallel between the literary and photographic points of view: "Morris' narrator adds a new dimension to this subjectivity by supplementing language with photographs taken from the stance and perspective of an adult of normal height walking through the world of the text. There are no images which could not be the result of ordinary vision—no wide angle shots, no collages, no aerial views, no solarization, no obvious tricks."[29] However, many of the same characters, situations, and photographs also reappear in other contexts. Because Morris often described actual photographs fictionally, at other times including real photographs within his novels, while at later dates using the same physical images within photo-texts with different prose accompaniments, or as part of collections of nonfic-

tional essays, and even in collections of his photography without direct links to prose, he is asking his reader-viewers to grant him the same degree of deliberate ambiguity in photography as in prose. Looking closely at the photographs he chose or allowed to be published in *A Cloak of Light* will help unravel these complicated narrative knots.

The photographs in his final autobiography fall into two groups. The first, examples of his art photography, are bound between pages 84 and 85 of the text; the second, more personal family pictures and snapshots, appear between pages 276 and 277. The only person in the first group is Uncle Harry, taken from the back, while people are the only subject of the second group, in which many of the photographs are arranged as if in a family album. Sometimes faces appear in ovals superimposed over portions of other pictures, and many of the images are uncredited, obviously snapshots rather than more formal portraiture. Little attempt is made to connect the images to specific passages within the text, except for a picture of Morris on the beach in Acapulco that reflects a passage in the autobiography in which he says he was used by beach photographers as a model (205). One picture, of the author's first wife, is labeled "Mary Ellen Morris, 1952," though her name is not mentioned elsewhere in the autobiography, while a number of pictures of Wright and Jo, his second wife, abroad and at home echo the ending of the text in which autobiography turns into travel narrative. In short, most of the images in the second group are clearly nonfictional, asking nothing especially complicated of the viewer and revealing little about the author.

The many photographs of Morris in this second group reveal little about the author because they are, except for one, biographical rather than autobiographical. Except for the frontispiece of *Will's Boy*, there are no pictures of Morris as a child in his autobiographies because apparently, given his virtual orphanlike existence, few were taken of him. "In all my childhood no mirror or window returns a reflection I remember," he writes in *Will's Boy* (10), a situation echoed years later in *Solo* when, as a college student living in Paris, he notes: "How do I explain that all the mirrors and windows of Paris had not returned to me one remembered reflection. What did this young American really look like? He *had* lost weight."[30]

In *Will's Boy* he describes in prose a group photograph of children gathered for a picture in which years later he recognizes himself as "the plump-faced open-mouthed child with the adenoids in the first

row" (10), but he doesn't reproduce the picture, though he returns to it in prose in his last autobiographical piece, "How I Put In the Time," noting, "What I had lacked all of my adult life was the *scale* provided by this photograph."[31] Lacking a physical photograph to compare with his imaginary self-images, as an adult autobiographer Morris is naturally attracted to photographs of others, as well as to photographs reflected in mirrors and photographs that contain other photographs within the frame.

Only a single photographic self-portrait exists in all three of his autobiographies, a straightforward picture labeled *Self-portrait, the Home Place, 1947*, which does not appear in *The Home Place*, which seems only natural because it would make no sense for a self-portrait of Morris to appear within a novel. As Abigail Solomon-Godeau reminds us, "We know the photographer had to have been on the scene—indeed, this serves as a further guarantee of the image's truth—but the photographer is manifestly absent from the field of the image."[32] Morris seems to have gone out of his way to efface his own image, going so far as to label as a self-portrait a picture of a house in New Mexico.[33]

"Morris may even use his photographs with words as a kind of disguise," comments Sandra Phillips, "an indirect Midwestern way to tackle intimate emotion."[34] While there are no suggestions of the photographer in most of his photographs, in two often noted cases Morris's shadow in the act of photographing can be seen in the foreground. Speaking of *Farmhouse with White Chimney from Cornfield (near Culpeper), 1940*, in which a shadow of both the photographer and his camera can be seen, Morris notes in *A Cloak of Light*, "This new image would testify to the photographer's inscrutable presence" (57). A similar intrusion of the photographer into the photographed occurs in *Model T with California Top, Ed's Place, 1947* (fig. 8.3).

In an interview with Morris, Peter Bunnell asks, "Could the photographer's shadow in some of the photographs be a kind of self-portrait presence like the autobiographical text of *God's Country?*" To this question Morris replies: "You are getting very close to why I felt it necessary to do that book and why I did it in that manner."[35] Although Morris freely admits the autobiographical nature of these images, neither of these shadow pictures, which parallel the sort of situation I have earlier described as memoir, appears in any of his autobiographies, where a more straightforward image of the Model T and only a prose description of the haystack occur, though the fourteenth photograph in *Love Affair: A Venetian Journal* clearly shows the photographer

FIGURE 8.3. *Wright Morris,* Model T with California Top, Ed's Place, 1947.
(Courtesy of Josephine Morris)

reflected in a store window. Referring to his shadow in the foreground of the Culpepper farmhouse, he writes: "Whether or not it had been my intent, I would end up with something other than what was there. It would be a new likeness, a remarkable approximation, a ponderable resemblance, but not a copy" (*Cloak,* 56).

Morris is especially crafty when the words or images come closest to questions of likeness and his resemblance to his father and mother. His sense of family likeness is particularly acute in the many versions of his visits to Eddie Cahow's barber shop in Chapman, Nebraska. He often returns to this barber shop, both in photographs and in prose, always using the actual names Grace Osborn and Eddie Cahow throughout his writing in any genre. As he notes, "Many people returned to places they had once visited, but I was compelled to return to those where I was still captive. This was at the heart of my agitation" (*Cloak,* 262).

Piecing together the biography of his parents from several sources, we learn that Will Morris first saw Grace Osborn while he was sitting in Eddie Cahow's barber chair and that years later, while visiting the place, Wright Morris is recognized instantly, though obliquely, through his reflection in the barber's mirror: " 'When I saw you,' said Cahow, 'I said, There goes two, three people I know' " (*Cloak,* 98).

In his novels this scene recurs frequently, often Cahow recognizing Morris by the shape of his head or the pattern of his hair (a combination of his father and his mother), or his eyes, which are said to suggest likeness in the family line. In "How I Put In the Time" Morris writes that Cahow recognized him as his "father's son from the wave in my hair," adding that from Cahow he first learned, casually, that he had had a brother named Fayette.[36]

When Sandra Phillips writes, "Like the magician who traffics in indirection, Morris conceals the full disclosure of his tender affections,"[37] she is getting at the sort of displaying and hiding that is characteristic of those photographs that are at the heart of his career. As he wrote in "Photographs, Images, and Words": "Perhaps there is something in all photographs that doubles back on artifice."[38] In many of the Cahow barbershop pictures we can see photographs and other images (postcards, many types of calendars, handwritten signs) reflected in the mirrors, and portions of the rest of the room, which was once the First National Bank of Chapman, most of which are described in prose within both autobiographies and novels.

A close look suggests that some rearrangement has occurred, as sometimes pictures are missing from the mirror that are present in other images, while at other times a braided whisk broom in front of a cabinet or a tangle of extension cords above it are in different configurations. However, the author asserts that the differences can be accounted for by the fact that he took the pictures on different days.[39] Morris tells us in the "Photography in My Life" section of *Photographs and Words* that in *Barber Shop, Weeping Water, Nebraska, 1947* (fig. 8.4) "the photographer can be seen in the mirror,"[40] though this piece of information is omitted from the corresponding passage in *Cloak of Light*. Although the author points specifically to this image as the photograph in which he can be seen in the mirror, it is not clear exactly what he means, for the man in the mirror with hat and overalls does not resemble Wright Morris in age or physical appearance, nor does he seem to be photographing. No other person seems visible in the mirror. Perhaps this is another example of Morris's lack of reflection in mirrors, or the man who was there not being there at all. Potentially, the most revealing of Morris's sleight-of-hand tricks in all the barbershop photographs is *Barber Shop Interior, Cahow's Barber Shop, 1942* (fig. 8.5), in which an image of the photographer *might* be seen reflected in the peanut machine in the center.[41]

If the author is lacking a personal sense of scale, any real idea of

FIGURE 8.4. *Wright Morris,* Barber Shop, Weeping Water, Nebraska, 1947.
(Courtesy of Josephine Morris)

what he actually looked like as a boy, he is unable to find answers in
God's Country and My People, the most autobiographical of his photo-
texts. Using many of the same images that had appeared physically or
ekphrastically in his previous work, Morris takes another look at the
significance of each photograph, adding new prose that he admits is
more autobiographical than his earlier writing. As A. D. Coleman ob-
serves: "In tangible terms, only the photographs endure to prove that

FIGURE 8.5. *Wright Morris,* Barber Shop Interior, Cahow's Barber Shop, 1942. *(Courtesy of Josephine Morris)*

any of it was more than a dream; thus they take on an awesome signifi-cance, like a handful of scattered potsherds at an archaeological site."[42]

Among the first facts recorded in *Will's Boy* is the death of Morris's mother and its impact on him, an emotional situation that parallels much of his life's work: "Much of my life would be spent in an effort to recover the losses I never knew, realized or felt, the past that shaped, yet continued to elude me" (6). Echoing the title of one of his books of short stories, *Real Losses, Imaginary Gains* (1976), he sums up the constant intrusion into the blank places of his life of telling yet man-ufactured memories, a cogent explanation for the strength of his fictional re-creations of a past he never actually experienced. "Had Grace Osborn lived, my compass would have been set on a different course, and my sails full of more than the winds of fiction," he con-tinues, asking, "Am I to register that as a child's loss, or a man's gain?" (*Will's Boy*, 6). The understated manner in which he reveals autobio-graphical detail to his attentive audience in *God's Country and My People* is suggested by its closing words: "God's country is still a fiction in-habited by people with a love for the facts" (n.p., final prose passage).

In *A Cloak of Light* Morris presents the only photographs of Grace

Osborn Morris that are labeled with her name, *The Osborn Family, Chapman, Nebraska, circa 1900*, a group portrait, with another picture of Grace Osborn, within an oval, in the foreground. This image resurfaces throughout the Morris canon in various guises. Although it does not appear physically in *God's Country*, the Osborn family portrait is described there in prose: "All eyes, but two, are tilted upward at the birdie and the grace God sheds on the country. Those of my mother stare level into the camera as if to see the culprit hiding behind it. That would be my father. The future on which she fastened her gaze would prove to be me. I have lived into the world she was denied, but who can say her eyes are not still on it? It is known that I have them, and the look they give you is said to be hers" (n.p., sixth prose passage). When he comments on the photograph within *A Cloak of Light*, more than 170 pages before it actually appears, the author again emphasizes his mother's eyes, imagining that they look out at him, the child she will never know: "Sidewise, she gazed directly into the lens of the camera at who or whatever might be lurking behind it" (100).

In his repeated suggestion that he can somehow exchange glances with the mother he never knew through the eyes in this photograph, transmuting past into present and present into past, Morris echoes Roland Barthes's contention that "a sort of umbilical cord links the body of the photographed thing to my gaze."[43] In his descriptions of the imaginary world in which his mother not only looks out of the photograph and sees him but does so with a look that resembles his own, Morris is also echoing the philosopher Kendell L. Walton, who argues that cameras are akin to microscopes and mirrors and that we need to think of photographs as providing perceptual access rather than representations. "With the assistance of the camera," he asserts, "we can see not only around corners and what is distant or small; we can also see into the past. We see long deceased ancestors when we look at dusty snapshots of them."[44]

Morris's insistence on eyes as a family likeness is compelling, except that in looking at the photograph in question, it is hard to agree with his description of the eyes of his mother. Actually Marion's eyes (the little girl with a hair ribbon) seem to be returning the photographer's gaze rather than Grace's (the woman on the right end). Morris takes care of this problem when he describes the same photograph in the album section of *The Man Who Was There*. In this case he eliminates Myron and changes Agee Ward's mother from Grace to Marion. Referring to a fictional Dwight as he appears third from the left in the

FIGURE 8.6. *Wright Morris,* The Morris Family, near Zanesville, Ohio, circa 1895. *(Courtesy of Josephine Morris)*

factual photograph, Morris writes: "His role here is to emphasize how striking his little sister is. He is a pillar on which she leans, affectionately, but hardly to his advantage—and her high piled hair is responsible for the odd tilt of his head. Except for her they all look to where the photographer holds the birdie, and except for her they are all thrilled to see it there. But she seems to see it within the camera somewhere. Or rather behind—since she looks through it and out at you" (66).

Another significant photograph appears on the same page within *A Cloak of Light* as the Osborn family portrait, *The Morris Family, near Zanesville, Ohio, circa 1895* (fig. 8.6), still another image that resonates throughout Morris's work, appearing both physically and in prose in *The Home Place*, *God's Country and My People*, and *Origin of a Species* and in prose alone in *The Man Who Was There* (on two occasions) and in *Photographs and Words*. When we first encounter the photograph, it is described on the occasion of Morris's first visit to the home place in 1942. During this first, tentative visit, Wright asks if either Aunt Clara or Uncle Harry has a photograph of Will, explaining that his father has died not long before and that he does not have a single picture of him. Not from among the family pictures displayed in the front room but

from within a shoebox of snapshots kept in the bedroom, Aunt Clara retrieves the photograph of the Morris family in Ohio.

Because Wright is concerned with seeing a photographic image of his father, he is at first disappointed that a clear identification of the men and women in the picture is impossible. Uncle Harry cannot see well, even with his glasses; Aunt Clara has only one good eye; and neither particularly liked Will anyway. They are not especially pleased with Wright's sudden appearance at the home place, and the whole incident is confused by his second visit to the home place and the fact that he had written so much about the two visits. "I can no longer distinguish between that actual meeting with Clara, in June, and the fiction I wrote about it that winter in California," he writes in *Photographs and Words*.[45]

" 'If you can find your glasses,' Clara said, 'suppose you tell us who's in this picture?' " (*Cloak*, 95), to which Harry replies: "Lord, it's fadin'," adding, "Come to think, they never had much as faces." At first, Harry seems to have identified Wright's father: "That could be Will standin' there with Mae" (96). Harry's identification of Will as the man on the far right is undercut by the fact that he cannot locate himself in the picture, a fact that causes Clara to declare that neither Will nor Harry is in the picture because both of them had already left for Nebraska. Harry's criterion for judging the individual images seems to be less their likeness to people he remembers and more whether they are alive or not. Although he has earlier counted the fourteen people who appear in front of the house, in this section Morris miscounts, saying only a dozen people are represented (132).

Like Michael Ondaatje, who returns to Sri Lanka to confront a father he hardly knew, only to find the only surviving photograph to be fraught with ambiguity, so Wright is unsure: "Did the last man in the row resemble my father? He had no face, but his wavy hair was parted in the middle" (96). In this case Morris is alluding to the conversation in the barber shop when Cahow seemed to recognize him by the wave of his hair, hairstyle being the crucial identifying factor also in his frontispiece to *Will's Boy* and in the unpublished photograph of himself as a boy with adenoids that he cites as providing some sense of scale.

But the whole question of identity and likeness is deliberately confused whenever photographs of his parents are the subject, because of the difference between that part of Wright that descends from the Morrises and that from the Osborns. In *God's Country* he has Cahow

explain that Wright actually has his mother's hair on his father's head (n.p., tenth prose passage). When the Zanesville Morris photograph appears first in *The Man Who Was There*, it is described as part of the Agee Ward family album; however, its second appearance, paralleling Morris's actual second visit to the home place, falls within the section called "The Ward Line."

In this fictional version, Uncle Harry, who maintains his real name, argues with Aunt Clara, now called Aunt Sarah, about Agee, Morris's fictional counterpart: "He's the Ward line but with the Osborn look. It's Grace in him that's giving you that look" (*Man Who Was There*, 94). Here Morris catches one of the critical qualities that make a photograph into a portrait, not so much the exact physical likeness but a particular look. The look is what portrait painters call "expression," according to E. H. Gombrich, who says that the play of expression is what Petrarch meant by "the *air* of the face."[46] To his aunt and uncle, Wright Morris looks, as he should, like a combination of his parents; he has his mother's air and his father's inheritance, not so much a physical quality (except for his hair) but a way of carrying himself. This combination is what the author is getting at when he writes: "This was how Fayette Agee Ward learned about them. When he learned about his father, his father no longer had a face. His father had a stance" (*Man Who Was There*, 64).

When Morris describes his 1947 visit to the home place in *A Cloak of Light*, he returns to the Zanesville photograph, this time asserting that neither his father nor his Uncle Harry is in the picture. He then decides to rephotograph the image: "The following day I took the photograph into the open air and pinned it to the clapboards on one side of the house. I saw it clearly on the ground glass before the shutter clicked" (132). Surprisingly, the version of this photograph in his last major autobiography (fig. 8.6) is the only example in all the reproductions in which evidence of his having rephotographed the original image is absent. In all the other instances, the photograph appears as a photograph of a photograph, with the texture of the wood siding, the nails, tape, paper backing, and in some cases a date written in hand between the two nails on the left side—all indicating the accuracy of his prose description in *A Cloak of Light*.

The Zanesville group portrait is the only one of eighty-nine photographs in *The Home Place* reproduced to take up a portion of two pages, and the only one with words directly underneath, rather than next to the actual image (154–55), words that again emphasize the difficulty

of seeing the family faces. In fact, in each of its appearances in prose, the photograph is always described in terms of the faces that have faded with time. In the fictional description that occurs in *The Man Who Was There*, a description that is clearly of the same photograph, though many details have been altered and Uncle Harry has been reinstated, the usual emphasis on the indistinct faces is said to be no problem: "And yet it is clear that even without faces these figures are good portraits—the absence of the face is not a great loss. Uncle Harry Ward, third from the right, discovered this for himself. . . . As soon as their faces were gone he knew them right away" (64). Despite his poor vision, Uncle Harry's ability to recognize the members of his family not by their facial features but by their physical stances is not uncommon. According to Gombrich "physiognomic identity" is "based on what is called a global impression, the resultant of many factors,"[47] while Morris notes, "Facts are like faces. There are millions of them. They are disturbingly alike."[48]

In all the versions of the Zanesville portrait, it is the absence of facial features that allows for specific identifications of the people represented. In both fictional and nonfictional versions Uncle Harry always equates the fading faces with the actual physical deaths of the individual family members, as if the photographs are literally connected to the actual faces, as in *The Portrait of Dorian Gray*. If Harry is right in saying that "they never had much as faces," then the facelessness in the portraits would be more rather than less accurate. Morris's emphasis on the faded faces is at odds with the actual photograph, in which individual faces are reasonably distinct. Only the two figures on the far right, including the one fictionally said to be Will Morris, are really close to being featureless. It is less clear that the two smaller men, third and fourth from the right, are twins, another confusion in the issue of likeness.

In describing the Morris family portrait fictionally in *The Man Who Was There*, the novelist makes a point about the grouping of the individual family members: "There is something unnecessary in the length of this line," he writes, commenting ironically on the Morris family line. "They do not stand together as a family, but rather each man for himself, as if for his portrait, a zone of space surrounding him" (64). Although here the author is describing a fictional version of the photograph, one in which he has significantly altered the number and arrangement of the people, nevertheless, in the actual photograph there *is* something odd about the groupings and stance of the family

members. The family seems to be lined up in order of age, though apparently some people in the picture are not actually members of the original family. Men with mustaches are on the left, those without on the right. The fourth man from the left seems to be facing the wrong way, acting as a barrier to the rest of the family, which has arrayed itself in smaller groupings.

All of this sense of arrangement actually reflects a number of Morris's most important themes, as expressed in a quotation from Henry James's *The American Scene* that appears over and over in his writing, serving as the epigraph to *The Home Place*: "Objects and places, coherently grouped, disposed for human use and addressed to it must have a sense of their own, a mystic meaning proper to themselves to give out: to give out that is, to the participant at once so interested and so detached as to be moved to a report of the matter" (*Cloak*, 130). For Morris certain of the objects he photographs become secular icons because of the "coherent grouping" imposed by his photographical act. Referring, for instance, to the sort of ordinary chairs that appear so often in his work, he writes: "The world is full of chairs, many of them works of art, but few chairs speak to me like the veneer-seated straight-backed chairs of The Home Place, saturated with the quality of life that I find both poignant and inexhaustible. I don't want to sit on them; I want to look at them."[49]

This sentiment is echoed by the prose that appears in *The Home Place* opposite *Straight back Chair, the Home Place, 1947*: "Everything in its place, its own place, with a frame of space around it. Nothing arranged. No minority groups, that is. No refined caste system for the furniture."[50] Unlike the Morris family members in the Zanesville picture, who have grouped themselves incoherently, the furniture of his novels is arrayed naturally, he seems to be saying, though a closer look at the pictures of chairs and other objects in *The Home Place* reveals that actually a lot of rearranging went into the scene before the "frame of space" was in place. In addition to the version of the chair in *The Home Place*, another picture shows the same spot with a rounded chair.[51] The same sense of rearrangement by regrouping can be seen in the various versions of the photograph that appears in *Cloak of Light* with the title *Drawer with Silverware, the Home Place, 1947* (fig. 8.7). Sometimes an alternate take with the same title is used, as in *Origin of a Species*, in which the silverware is lined up in groups, allowing more of *Capper's Weekly* for April 29, 1939, to show from underneath.[52] Morris openly admits to arranging Uncle Harry: "I had him walk before me,

FIGURE 8.7. *Wright Morris,* Drawer with Silverware, the Home Place, 1947.
(Courtesy of Josephine Morris)

through the door of the barn he had entered and exited for half a century" (*Cloak,* 131).

Morris is attracted to Henry James's words, I believe, because of their emphasis on objects over people, because of the notion of being simultaneously interested and detached, and because of the fact that the expression "to give out" is ambiguous. On the one hand it can mean to become so exhausted as to give up, as in another Jamesian phrase that reoccurs in Morris's works: "The carpet wears out, but the life of the carpet, the Figure wears in."[53] On the other hand "to give out" can mean to send forth energy—like the light rays that an object sends out to the camera's lens—and to emit an aura, something like the heat that allows human faces to be identified by their individual thermograms or Walter Benjamin's idea of aura as "a strange web of time and space: the unique appearance of a distance, however close at hand."[54]

According to Mary Price, Benjamin uses "aura" in two different ways, which she describes in terms of two cloud metaphors: "The first use of aura corresponds to the cloud, nimbus, aureole of the upper atmosphere, where sacred gods have sway and myth is powerfully

evident. The second use corresponds to clouds on the ground, fog or mist, obscuring objects and hiding the face of reality."[55] For Morris the importance of a photograph's aura lies in its ability to capture the original object's aura; for him not the face of reality but the faces of people should be obscured, leaving an Emersonian natural integrity of object to shine forth. Where Benjamin worried about "the removal of the object from its shell, the fragmentation of the aura," which he describes as happening in some photographs that "suck the aura from reality like water from a sinking ship,"[56] Morris, using a similar nautical metaphor, emphasizes the enhancement of aura: "In the sea of photographs that now surround us, and increasingly threaten to engulf us, photography might be likened to the glow of phosphorous where the ship's prow splits the water. Thanks to it, we do see more than the surface. Thanks to it, we do not see more than is there. Not to see more than is there, we learn from photographs, is to see more than enough."[57]

In the emblematic act of taking his own photograph of his ancestors standing in front of a house in Zanesville, Ohio, Morris performs the same autobiographical act he later enacts in writing three serial autobiographies. He rephotographs an image from the past, just as he rewrites prose from earlier work, and then he brings both the visual and the verbal together: "Was it in this wise I hoped to postpone what was vanishing? A simpler ritual of survival would be hard to imagine. By stopping time, I hoped to suspend mortality" (*Cloak*, 132).

When Morris's three autobiographies were brought together in the one-volume *Writing My Life*, the physical photographs were taken out; however, a brief but significant introduction was put in. Citing Vaclav Havel's speech to the American Congress, Morris sees the answer to why he has neither written a fourth autobiography nor gone back to rework his three earlier ones: "Consciousness preceded being." "These few words alerted me, in my eightieth year, as to why I had stopped *Writing My Life* prematurely. Both my early buried life, and my late one, resisted the intrusion of consciousness. . . . If I had once thought of revising *Will's Boy*—for the easy way he accommodated intractable losses—I could now start paying on the arrears, of both gains and losses, that would prove to be inexhaustible."[58]

In this accounting of writing his life, he alludes to photographing his life, the two together producing a balance in which his losses became both his gains and ours. "To confess up a life requires the same imagination it takes to create one," he notes in one essay, answer-

ing in another, "but it is what escaped memory that stirred the writer to write."[59] What escaped his memory stirs him to write autobiographically, just as what escaped his camera lens stimulates him to photography, as he suggests in describing an image that he *did not* photograph: "A harness-patched plow horse, white as Moby Dick, stood luminous in a piece of overgrazed pasture, his heavy head bowed" (*Cloak*, 67). The lack of a photographic record is compensated for by this prose description but also by another reiteration of the evocative power of what is not there: "I should have stopped. That I didn't is why I have forever borne it so vividly in mind" (*Cloak*, 67).

Throughout his autobiographical and photographical work, Wright Morris repeats the same themes, the same approaches. He photographs what is there, writes fictionally about a man who was there, and then writes critically about seeing what is there, all the while celebrating those aspects of his life that were never there—a midwestern childhood filled with family and a place to call home.

Reflected light is the photographer's
subject matter.
—Edward Weston

9 | Still Life Writing

Edward Weston

Photography critic Mary Price asserts that "Edward Weston, in his *Daybooks*, has written more fully than any other photographer of the circumstances of his life and his photographing," to which she adds, "Looking at his photographs, reading his daybooks, it is hard to decide whether the daybooks contribute to seeing the photographs more fully."[1] For me this question is easy enough to decide: a detailed reading of the daybooks provides abundant autobiographical information which helps to see Weston's photographs more clearly and deeply.

The Daybooks of Edward Weston, first published in two separate volumes, *Mexico* in 1961 (covering 1923–26) and *California* in 1966 (covering 1927–44), was published as one volume in 1973 and reprinted in an Aperture paperback edition in 1990.[2] Michael Hoffman, in his preface to the paperback version, describes the book as "one of the classics of autobiography in the history of art"; Beaumont Newhall, in his foreword to the same edition, refers to the work as a journal; and according to Peter Bunnell, *Daybooks* is "a partial self-portrait."[3]

Although Weston chose *Daybooks* as his title, he often calls his literary work a diary, the term Nancy Newhall, who edited the day-

books, found most appropriate, as did photographer Minor White in his 1962 review, an assessment that is itself written in diary form.[4] The somewhat uncommon term "daybook" has been used less frequently in English than "diary" or "journal," though in German the equivalent *tagebuch* is not unusual. Sometimes thought of as a sort of field book in which scientists record notes, or a book carried around by writers to record ideas, daybooks are often considered a sort of cross between an almanac, a log book, and a calendar.[5]

Barbara Willard argues that the word "diary" comes from *diarium*, Latin for a soldier's daily pay,[6] a usage that reflects its sense of dailiness and makes Weston's title appropriate, especially as *Daybooks* has as a constant theme the need for money derived from the photographer's commercial portraiture, the daily sittings that he eventually reduced to a formula: "I write a few words then retouch a few wrinkles."[7] Diaries and self-portraits have a natural connection, according to Georges May, who writes, "Entries in a diary . . . are more akin to self-portraits than to autobiography,"[8] an idea echoed by Weston's entry for July 16, 1927: "It seems as though I shall practically have to stop writing, except for the briefest notes for memorandum. Too bad indeed, for I have much interesting material to discuss with myself . . ." (II, 29).

The diary's emphasis on daily entries, its record of a day, usually written at day's end, what Robert Fothergill describes as "the experience of life's continuum being divided by the alternation of day and night"[9]—all are directly suggested by Weston's title and its emphasis on the contrast of day and night, and by extension, of black and white, especially appropriate for a photographer with such a highly developed sense of gradations of light and dark. Despite the title, Weston usually wrote in his daybooks just before dawn, a time he often referred to as "his hour." That his writing was usually begun in darkness and completed as the light appeared echoes the fact that his photographic images were taken in full sunlight and yet came to life in the darkroom.

The daybook came naturally to Weston because the genre came closest of any literary form to paralleling two of the properties that he thought distinguished photography from other visual arts: "rapidity of the recording process" and "ability to present an unbroken sequence of infinitely subtle gradations."[10] The first of these characteristics is matched by the dailiness of the diary entries as opposed to autobiography's more sustained observations. Rather than seeing this lack of retrospective time as a drawback, Weston praised the instantaneous-

ness of photography in a sentence that applies equally to diary writing: "The most profound instants—the finest nuances of light and shade may be captured in the magic silver, and at the very instant desired, not when memory has to rebuild—perhaps crudely—the past."[11]

Diaries are by their serial nature a more natural equivalent for Weston's second property. As Fothergill notes, "'The Diary of X' differs from 'The Autobiography of X' precisely in that it consists of fragments, of entries, or enterings. . . . Every entry is written in the knowledge that it is not only the sequel to yesterday's but also the precursor of tomorrow's, which may controvert it."[12] Instead of concentrating on the signal moments of a lifetime, Weston the diarist presents us with multiple exposures of a slowly developing artist, the extreme close-ups that correspond to the photographic style he then preferred, rather than the longer views he sometimes favored in his later years. The daybook's slow accretion of individual entries matched another of photography's properties, as Weston defined it: "The photographic image partakes more of the nature of a mosaic than of a drawing or painting."[13]

Weston's daybooks echo a number of other aspects of his photography. "While diary creates a record of the past," writes Felicity Nussbaum, "its discourse produces a crisis of attention to the present."[14] In the diary entry he precluded both retrospective and prospective views of his life, preferring to echo his central photographic philosophy of "previsualization," which he explained as the "final form of presentation seen on ground glass, the finished print previsioned complete in every detail of texture, movement, proportion, *before exposure*" (II, 154). And just as he destroyed most of his daybook entries before 1923, so he eliminated his early glass plates by washing away the emulsion, turning them into windows for his studio.[15] Before his death in 1958, Weston destroyed many of his early negatives as well. As he recycles field notes into daybook entries, or quotations from earlier entries in the later volume, so he reprinted some of his images when he changed from buff to white stock palladio paper in 1925 (I, 143) and later reprinted much of his best work when he discovered, in 1930, the enhanced quality of glossy paper: "I can print much deeper than heretofore, with no fear of losing shadows, or muddying half tones by drying down: or I can use a more contrasty grade of paper, resulting in amazingly rich blacks yet retaining brilliant whites" (II, 155).

Although at first Weston's *Daybooks* might seem to be only the

combination of diary and journal I have described, actually it contains virtually all the forms of autobiography implied by the term "life writing," including biography, letters, dreams, an autobiographical mock drama, portraiture, and self-portraiture. In 1965 it provided the basis for two films, *How Young I Was* and *The Strongest Way of Seeing*.[16] Although missing from the paperback version, the frontispiece to the Mexico volume reproduces a sample daybook entry from April 20, 1923, in Weston's handwriting, the opposite of *The Autobiography of Alice B. Toklas*, which ends with an image of Gertrude Stein's handwriting of the first page of her autobiography.[17]

Many entries consist of short paragraphs, headed by a date, listing parties attended; names of Mexican bars; complaints about overcast days; vivid descriptions of avocados, sugarcane, and mangoes; and details about bullfights he attended. Other entries focus on his battles with fleas, noise, and a leaking camera; his need for privacy; worries about his children; his repeated attempts to give up smoking; Mexican politics; his introduction into the world of artists in Mexico, including Diego Rivera, José Clemente Orozco, and Jean Charlot; and his constant sexual adventures. Often the writing consists of long ruminations about the philosophy of photography, Weston's opinions of various books, and dreams, including one in which Alfred Stieglitz is dying, and another in which his son Cole has died. Some parts are epistolary, whole letters from family and friends, as well as those Weston wrote himself, some of which quote from *Daybooks*.

One whole section consists of what Weston calls "significant passages" from his letters copied directly into the daybooks, later arranged by Nancy Newhall "as far as possible by date or internal evidence into what seems to me a reasonably coherent sequence" (I, 114). Nancy Newhall's editorial work is described in detail in her letters to Weston in the Edward Weston Archives at the University of Arizona's Center for Creative Photography.[18] Newhall, who had planned originally to write an authorized biography of Weston, summarized the major changes in a letter to Weston, in which she described three drafts of the daybooks: "The first was for clarification and the elimination of the really dubious bits. The second was . . . to see where we were and to sharpen, select and focus. The third—I shall do more than to correct mistypings, if any—is a focusing with the whole in view." By style she seems to have meant both matters of graceful writing, such as Weston's tendency toward somewhat awkwardly poetic inversions, and usage questions, such as his unnecessary splitting of infinitives.[19]

That Newhall would need "to sharpen, select and focus" in a diary can be explained by the fact that even when the events begin as a dated entry, sometimes Weston allows one event to suggest another connected thematically rather than chronologically, as in a passage from June 3, 1924, in which a humorous story about a cab ride leads directly into another transportation story that occurred at some unspecified time during his stay in Mexico (I, 76). Sometimes the daily entries disappear, replaced by what he calls "unconnected notes" (I, 174), on-the-spot travel writing, including brief descriptions that are later incorporated into the act of daybook writing.

A number of sections are self-reflexive, including the author's editorial comments about fragments of earlier daybooks, his positive reaction to reading sections of his son Brett's daybooks, entries in the California volume that describe his reading portions of the Mexico volume aloud to friends, and even the physical presence of his notebooks—packing to leave Mexico he comments, "In go those damn day-books!" (I, 110). Often he questions his purpose in writing: "I had the desire to write this morning—and the hour is early—but I find I have nothing to say!" (II, 110). Rereading earlier entries, he recoils in disgust: "July 8 [1929] A recent evening I thought to read Ramiel passages from my daybook,—those concerning my work. I was appalled and disgusted how often I had indulged in self pity. Most of the writing seemed to be a wail over my financial condition, and the rest about my love affairs" (II, 128). He frequently records his concerns about the autobiographical act: "I am doubting more and more the sincerity of these daily or semi-weekly notes as they concern me personally—my real viewpoint and feelings uncolored by petty reactions, momentary moods" (I, 49). In answer to his own question "Why write at all?" Weston answers, "It is more than the recording of anecdotes, more than emotional release,—it is a way of learning, clarifying my thoughts. I know, now that it is too late, that I should not have destroyed my daybook from 1920 to 1923. . . . I pray for strength not to destroy" (II, 112).

Although this prayer against destruction was written in 1929, two years later Weston quotes from one of the few fragments saved from the burned daybook as an example of the sort of writing that he found so embarrassing, a fragment in which he chastises himself for being too weak to destroy his work—as an example of both what he should and should not have destroyed. Addressing himself directly, he notes in the salvaged fragment, " 'Well I know you Edward Weston, and I

say you have spent a year of writing in trying to build up a fine defense around yourself and your work,—excusing your weakness! And yet knowing all this, you are not strong enough to destroy most of your work, nor these notebooks!' " (II, 209).[20]

On several occasions he writes that reading about himself in the daybooks is more like reading biography than autobiography: "I have been going over my daybook from Mexico. . . . I seemed to be reading about another person" (II, 34), a remark that parallels an observation made by Charis Wilson, his second wife, when looking at some of the famous nudes Weston took of her: "I never really did think of these nude photographs as pictures of *me*. They were photographs by *Edward*—his perceptions and his artistry."[21]

Although the second volume of the *Daybooks* was edited by Nancy Newhall from Weston's longhand manuscript, she reports that "he went through the surviving eleven years of it with a razor and a very thick black pencil, crossing out names, cutting out 'petty reactions, momentary moods' until much of the manuscript is full of holes or sliced to tatters" (I, xv). These attempts by others to alter his original passages, as well as his own incisions, are similar to Weston's views on the manipulation of photographs versus retouching. Because of his repeated assertion that he saw the final print on his camera's glass before taking the picture, and because of his frequent attacks on "photo-painters"—those photographers whose direct manipulations during the printing process he thought made them mere imitators of painters—many of his contemporaries thought that Weston never altered his pictures once he had taken them. In fact, as his biographer Ben Maddow points out, Weston often used dodging, "holding back the light over a particular area of the print by means of the hand; or a bit of wire to hold a shape of paper, in order to create a shadow with a blurred edge, and thus lessen the exposure across a particular portion of the negative."[22] Completely altering the rhythm of his original day-book entries, which were often punctuated with dashes rather than commas, or changing his words by inventing new ones is the life writing equivalent of what George Bernard Shaw describes as the worst aspects of photographic manipulation: "the old barbarous smudging and soaking, the knifing and graving, rocking and scratching, faking and forging."[23] On the other hand, such actions as carefully eliminating an embarrassing personal detail or protecting people by replacing their full names with an initial are similar to the only sort of retouching Weston would admit to: "I spot out dust specks on negatives and

prints. . . . On rare occasion I have even removed a tiny but disturbing highlight on a landscape."[24]

Reflected Light: The Legend of Tina and Edward

In addition to the other types of life writing, *Daybooks* also includes seventy-two plates, reproductions of Weston's photographs arranged chronologically in the Mexico daybook and thematically in the California volume. *Daybooks* proceeds chronologically, with larger and larger gaps toward the end, so that the arrangement of plates in the first section corresponds roughly to the passages within the text in which Weston discusses photography and his reaction to particular images. Because the photographs in the California daybook are arranged in thematic groups—"Shells and Peppers," "Point Lobos," "Portraits and Machines," and "Landscapes and Nudes"—readers (unless they choose to skip about or look at the pictures at their own pace) sometimes see an image before reading about it, sometimes read about an image before coming across its representation, and sometimes realize that no photographic plate exists in *Daybooks* that corresponds with a prose description. Of course the original daybooks as kept by Weston did not contain any photographs, though he made suggestions to Nancy Newhall about which of his Mexican photographs should be included.[25]

Newhall's choices of both photographs and their placement within *Daybooks* often illustrate the numerous entries in which Weston describes the occasion on which a particular photograph was taken as well as his reactions after having printed it. For example, his often quoted *Nude, 1925*, whose subject was Anita Brenner, author of *Idols behind Altars*, a study of folk art of Mexico to which both Tina Modotti and Weston were contributors, was taken in a mood of depression: "I was shaving when A. came, hardly expecting her on such a gloomy, drizzling day. I made excuses, having no desire, no 'inspiration' to work. . . . But she took no hints, undressing while I reluctantly prepared my camera" (I, 136). However, in later describing one of the images that came out of this session, he writes, "I am seldom so happy as I am with the pear-like nude of A. I turn to it again and again. I could hug the print in sheer joy" (I, 147).

While Weston sees the impersonal, abstract quality of the print as an occasion for joy, art critic John Canaday, realizing that his friend

Anita Brenner was the subject, writes of the same photograph: "I keep looking at this photograph and saying to myself, 'That's really Anita? All that roundness, that abstraction of a backside to the form of a great pear-like fruit?' Anita just wasn't like that."[26] Misreading the photograph as a portrait rather than an abstract study in form, Canaday sees the picture's lack of likeness as a defect, though one wonders how often he has seen his friend in such a pose.

Another interesting pairing occurs in *Knees, 1929* and *Shells, 1927*, which Nancy Newhall placed side by side in *Daybooks*, suggesting some of the irony in Weston's repeated denial of the erotic or sexually representational quality so often seen by others in his prints. He writes of a photographic session with Bertha Wardell, the model for *Knees, 1929*: "As she sat with legs bent under, I saw the repeated curve of thigh and calf,—the shin bone, knee and thigh lines forming shapes not unlike great sea shells" (II, 10). On another occasion, he took delight in photographing "a horse-radish which was so ridiculously like a woman's torso that I could not resist doing it" (II, 231).

Although many of the plates are portraits, none is a self-portrait, with the exception of the cover photograph (fig. 9.1), which has until recently been attributed to the central biographical figure in the Mexico daybook: Tina Modotti, Weston's lover, model, onetime apprentice photographer, and eventually well-known revolutionary and photographer whose *Roses* sold in 1991 for $165,00, a Sotheby's record for a single photograph, the bidders including Graham Nash and Madonna.[27] Biographers of Modotti, beginning with Mildred Constantine—who mistakenly refers to the camera as a Graflex[28]—have taken the cover photograph to be a Modotti portrait rather than a Weston self-portrait. The back cover of the Aperture paperback edition of *Daybooks* says the photograph is "attributed to Tina Modotti or Edward Weston." However, according to Weston scholar Amy Conger, who has done extensive bibliographical and biographical research on both Modotti and Weston, the photograph of Weston with his eight by ten Seneca view camera is a self-portrait—the photographic equivalent of autobiography: "The style, composition and spirit of this work . . . do not correspond with Tina's way of seeing."[29]

Weston does not mention this photograph in *Daybooks*, but the confusion of portrait/self-portrait is an apt reflection of the playful bohemian style of that time and place, the frequent collaborations between painters and photographers in Mexico City, including a painted "self-portrait" that Weston explains was copied by Diego Rivera

FIGURE 9.1. Edward Weston *(cover photograph of* Daybooks of Edward Weston*), attributed to Tina Modotti or Edward Weston. Gelatin silver print, ca. 1923– 24. (Accession no. P1980.38;* © *Amon Carter Museum, Fort Worth)*

"quite exactly from one of my photographs of him, one which I could not use because of poor definition, though it was my favorite as well as his" (I, 129). According to Van Deren Coke, "Strangely, Rivera's face is drained of any personality and lacks the introspective mien captured by Weston's camera. One reason for this was that Rivera did not preserve from the photograph the strong shadow across his face."[30] Rivera used Tina as a model, painting her into several of his murals, in the years before he was married to Frida Kahlo, who eventually became a friend of Tina's.

Other confusions of portrait and self-portrait occur when Weston and Modotti attend a movie in which they "saw Tina herself on the screen, a small part she did some years ago in Los Angeles" (I, 56), and in the daybook entry that describes a playful double hoax, a pair of phony wedding anniversary portraits of Tina and Edward taken on a lark. The pictures are fake because Tina and Edward were never married, mutually agreeing to separate after less than five years in Mexico, and because as professional photographers they deliberately misled the photographer, who naively assumed they were genuinely

impressed with his portrait technique: "I was seated; Tina stood with her hand on my shoulder; to one side a plaster Christ; the background a vaulted church interior. Purposely I sat as stiff as possible: feet together, hands outspread on knees. But alas, I couldn't get away with it. The artist insisted I cross my feet, and, in desperation over my hands, placed a book in them" (I, 87).

The photographer's style of portraiture represents everything that Weston abhorred about commercial portrait photography, and his mocking of the Mexican photographer is also a sort of self-mocking, for in an essay called "Thirty-five Years of Portraiture," he describes with chagrin his own early techniques: "I was sure I would never commit such offenses as twisting my subject's neck awry, or saying 'look pleasant please.' But as I look back, I realize I did other things that were just about as bad: posing by command: ('look up, Miss Jones; now turn the head this way'), arbitrarily placing hands for effects of grace and elegance, using chiffon drapes, etc. And I had a vignetter handy which I used to cut off a too prominent bust, dissolve an awkward shoulder line, or otherwise dispose of things I did not know how else to manage."[31] The false anniversary portrait of Modotti and Weston is suggestive of Weston's own regrets over his constant need to make money through commercial portraiture, his inability to stand by his repeated declaration to take only unretouched portraits, and his repugnance over putting his signature on his commercial work.

That the cover picture could be ambiguously attributed to both Modotti and Weston is emblematic of their relationship and the spirit of the times. Weston and Modotti were featured in joint photography exhibitions, one of which was reviewed by Diego Rivera,[32] and a number of critics have suggested that their photographs were hard to tell apart: "Weston, at least, felt that some of Tina's photographs were indistinguishable from his," writes Robert d'Attilio in an essay on Modotti, an idea echoed by Anita Brenner: "It would be impossible really to say whose photographs are which."[33]

Although Amy Conger has demonstrated how false these ideas are, they are suggestive of the interrelationship between Weston and Modotti, as his frequent descriptions of costume parties in Mexico City demonstrate.[34] Depicting a Mardi Gras party in 1924, he explains that he and Tina "exchanged clothes, to the veriest detail" (I, 54), adding that "she smoked my pipe and bound down her breasts, while I wore a pair of cotton ones with pink pointed buttons for nipples. . . . We

imitated each other's gestures. She led me in dancing, and for the first few moments everyone was baffled" (I, 55). According to the daybook entry for September 14, 1925, their cross-dressing act was again successful on that date: "That our make up and acting was well done may be judged from the effect we had upon the Orozcos, who were frankly disappointed that we had merely masked!—until gradually they perceived that 'Tina' was not Tina, nor 'Edward,' Edward!" (I, 127).

The complicated relationship between Tina and Edward, the degree to which they were actually "Tina and Edward," is the subject of many of the entries in the Mexico daybook. The first entry, August 2, 1923, begins with her name, and the last, November 9, 1926, closes their adventure together: "And you, Tina? I feel it must be farewell forever too" (I, 202). In the final entry in the California volume, written in 1944 by a hand halted by Parkinson's disease, Weston also invokes Tina's name, citing her death two years before as one of the especially poignant events that had saddened him (II, 287). Despite their physical separation they continued to exchange letters until 1931, their correspondence indicative of a lifelong admiration and trust. Seeing in the legend of Tina and Edward a similar pattern to the Frida Kahlo/Diego Rivera story, or the Scott and Zelda Fitzgerald saga, several critics have romanticized the story of their relationship over the years, as summarized by Amy Stark, editor of *The Letters from Tina Modotti to Edward Weston*: "The great photographer and the great beauty meet and are irresistibly attracted. . . . Modotti receives her photographic education at his hands and begins her political involvement at the same time. . . . The great beauty becomes a serious photographer too and fulfills a destiny punctuated by political exile and a mysterious death."[35]

Entries in *Daybooks* made during the few years they actually spent together in Mexico already include references to the legendary quality of their relationship: "We have all believed in the legend of Edward and Tina," writes a woman identified only as "M." "You are leaving now, and I want to still believe. It was a beautiful picture" (I, 196).[36] Although Stark thinks that "Weston's last pages in his daybook for 1926 are coldly telling in what they omit" because "weeks pass with no mention of Modotti or their life together,"[37] Nancy Newhall reports that among the material that Weston cut from the Mexico daybook were "nearly all references to the agony he suffered over Tina Modotti's other loves" (I, xvi).

Though they both repeatedly had sexual liaisons with others during

the time they lived together, Modotti's growing interest in the political upheavals in Mexico eventually led to her becoming, in 1927, a member of the Communist Party and lover of the Cuban revolutionary Julio Antonio Mella, whose assassination while he walked in the street with Tina led to her expulsion from Mexico on the false charges of conspiracy to kill both Mella and the president of Mexico, Pascual Ortíz Rugio.

Something of their legendary relationship is captured in two well-known portraits of Tina that Edward made in 1924. The occasion of making the first, *Tina Modotti with Tear, 1924* (fig. 9.2), is described in detail in *Daybooks* in a passage that has led to the charge that Weston was a monster: "The Mexican sun, I thought, will reveal everything. Some of the tragedy of our present life may be captured, nothing can be hidden under this cloudless cruel sky. She leaned against a white-washed wall. I drew close . . . and kissed her. A tear rolled down her cheek—and then I captured forever the moment . . . Let me see, f.8—1/10 sec. K I filter, panchromatic film—how mechanical and calculated it sounds, yet really how spontaneous and genuine, for I have so overcome the mechanics of my camera that it functions responsive to my desires" (I, 46; ellipses in the original). George P. Elliot, author of "The Monster as Photographer," sees this excerpt as indicative of Weston's coldness of heart: "But a chill seizes me to learn that at the moment when he might have consoled her, have wept with her, he instead took her picture."[38] In this argument, Elliot echoes, on a smaller scale, Susan Sontag's concerns about ethical aspects of "situations where the photographer has the choice between a photograph and a life. . . . The person who intervenes cannot record; the person who is recording cannot intervene."[39] Although Sontag is referring to situations in which a photographer is present at a life-threatening scene, her notion of photographers as either participants or observers also applies to the personal relationship described in *Daybooks*. However, as Mary Price points out, "The choice is not between intervention and nonintervention but between photographing and not photographing."[40] To reduce the strength of the Weston-Modotti relationship to the standard sexist pattern—more famous male using less famous female for artistic gain—is unfair in this case. That the legend of Tina and Edward is in part based on a more equal relationship than was common at the time is supported by Harold Rosenberg's comment about the relationship between photographer and subject: "The two images, that of sitter and that of the photo portraitist, are locked

FIGURE 9.2. *Edward Weston,* Tina Modotti with Tear, 1924. *Gelatin silver print, 22.5 × 16.9 cm. (© 1981 Center for Creative Photography, Arizona Board of Regents Collection, The University of Arizona)*

in a silent wrestle of imaginations, until they are thrust apart by the click of the shutter. At that moment the issue is resolved, but not necessarily in favor of either of the contestants."[41]

Weston's apparent heartlessness at the moment this photograph was taken is unfairly enhanced by the fact that the passage as it appears in the published daybook leaves out some of the original passage as

it was recorded. Following the quotation above, Weston originally wrote: "The moment of our mutual emotion was recorded on the silver film—the release of those emotions followed—we pass from the glare of sun on white walls into Tina's darkened room—her olive skin and sombre nipples were revealed beneath a black mantilla—I drew the lace aside—."[42] In a letter from Weston to Newhall, he writes that the entry describing this scene is the very sort of passage he would like to excise: "Reading, for example, such lines as 'I drew close to her and kissed her' shivers me, makes me out a pretentious prig. I can't take it! Seeing it in a Book would turn me into a hermit. Is there much of that stuff?"[43]

A closer reading of Weston's daybooks, even without the excised passages in the published versions, along with *Tina Modotti with Tear*—a combination of visual and verbal portrait/self-portrait—suggests that the portrait is an authentic likeness, both of their relationship and of his philosophy of portraiture. The subject of the portrait *is* the pull between intervention and nonintervention between Weston and Modotti, whether Tina should accompany him back to the United States, continuing as his model and pupil, or whether she should go on with her life in Mexico without his presence, working on her photography independently. As Weston later wrote, "I said in the beginning that the portrait photographer's primary purpose was to *reveal* his subject, but that is a shorthand way of expressing it, for of course, it is the subject who must actually do the *revealing*, so the photographer can record it."[44]

Printing the picture several weeks later, Weston writes: "This head of Tina is noble, majestic, exalted; the face of a woman who has suffered, known death and disillusion" (I, 49). Ironically, given his stated insistence on technical mastery over emotional involvement, Weston does not comment on the fact that this picture is not characterized by the optical sharpness he so prized, Tina's right eye and the outlines of her hair being out of focus. Oddly, in the version of *Tina Modotti with Tear* that appears in *Daybooks* no tear is actually represented, though in the print reproduced in *Weston's Westons: Portraits and Nudes* a tear seems to be visible in her left eye, a detail that does not exactly square with Weston's suggestion that he recorded her image just as a tear rolled down her cheek.[45] However, in the version published in Aperture's edition of Weston's portraits, the tear is quite visible, a teardrop-shaped splotch on her cheek.[46]

It is also possible that the print of *Tina Modotti with Tear* that appears

FIGURE 9.3. *Edward Weston,* Tina Reciting, 1924. *Gelatin silver print, 24 × 19 cm. (© 1981 Center for Creative Photography, Arizona Board of Regents Collection, The University of Arizona)*

in *Daybooks* is not the image being described in the passages I have quoted above. Amy Conger mentions that in addition to this print, there was probably one other made at the same time.[47] A good candidate for this alternate portrait might be *Tina Reciting, 1924* (fig. 9.3), which Conger identifies as being part of the series in which Tina recites poetry, also from 1924.[48] Because of the light rather than dark band around the neckline of her dress, the looser hairstyle, and the similarity of facial expression, I believe this is not part of the Tina reciting series.

On another occasion, Weston describes in detail his detached emotional state while photographing Tina: "My eyes and thoughts were heavenward indeed—until, glancing down, I saw Tina lying naked on the azotea taking a sun-bath. My cloud 'sitting' was ended, my camera turned toward a more earthly theme, and a series of interesting negatives was obtained" (I, 83). Unlike the picture of Tina with a tear, taken in the throes of emotion, the occasion for these pictures seems measured and as passive as Weston's grammatical voice, the cloud and body echoing each other.

The other portrait of Tina reproduced in the daybook for the same year, *Tina, Reciting, 1924,* was an experiment at capturing the essence of Modotti's personality. As Weston writes about that portrait session: "We had long planned that I should do her as I have often seen her, quoting poetry—to attempt the registration of her remarkably mobile face in action" (I, 95). Although Richard Brilliant describes "the act of speaking" as "the most human characteristic of all," he believes that portraits of people talking are unusual because speaking "splits the face wide open."[49] In contrast, Weston believed that "the photographic portrait must always consist of arrested motion," adding, "But if it is not to *look* like arrested motion the photographer must seize on those moments when the motion suggests repose."[50]

When he looks at the results of his portraits of Tina reciting, Weston is both exhilarated and disappointed: "Though the series of heads are the most significant I have ever made, though my vision on the ground glass and my recognition of the critical moment for release were in absolute accord with her emotional crises, I failed technically through underexposure" (I, 95). Because he prided himself on his skill with light, he eventually realized that his flawed portrait of Tina reciting was not so much a result of a technical failure—"I had figured to a nicety, 1/10 sec., f/11, Panchro film, Graflex, knowing though that I was on the borderland of underexposure"—but emotional involvement in the process: "I, working in a state of oblivion, did not note that my reflector no longer reflected! I feel the weakness of my excuse, my intellect should not have been overwhelmed by my emotions, at least not in my work!" (I, 95). His self-analysis also suggests one of the many reasons why he and Tina were not finally compatible. His insistence on privileging art over life was impossible for her, as she wrote in a letter of July 7, 1925: "And speaking of my 'personal self': I cannot—as you once proposed to me 'solve the problem of life by losing myself in the problem of art.'"[51]

In addition to several full-length biographies of Tina Modotti, her life is also the subject of Elena Poniatowska's *Tinisima*, a book labeled a "biographical novel," originally published in Spanish in 1992.[52] Although called a novel, *Tinisima* is illustrated with numerous photographs, including many of her own, as well as some of Weston's. The relationship between Weston and Modotti has even been translated into the form of an Italian comic book, *Tina* by Pino Antonelli, which includes cartoon renditions of several of Weston's famous photographs of Tina, the self-portrait on the cover of *Daybooks*, and the flowers featured in her photograph *Calla-Lillies*.[53] Another form of life writing associated with Weston's *Daybooks* is Margaret Gibson's 1987 Melville Cane Award–winning poetry collection *Memories of the Future: The Daybooks of Tina Modotti*, a title that echoes the closing words of Paul John Eakin's *Touching the World* "The art of memory recalls us not to the life we have lost but to the life we have yet to live."[54] Although Gibson's poems are based in part on biographies of Modotti, she describes her work as "neither biography nor history," adding, "*Memories of the Future* . . . is a creative revision, an indirect translation of the life of Tina Modotti. The poems are drawn from daybooks I imagine Tina Modotti to have kept during the last year of her life in Mexico City."[55]

Echoing Weston's *Daybooks*, these imagined daybooks of Tina Modotti consist of dated entries, rich evocations of Modotti's past, leading to the final poem, "Home," dated January 4, 1942 (the day before Modotti died of a heart attack). "Home" describes, from Tina's point of view, Weston's taking of another portrait of her, *Tina, Mexico*: "Edward has set his tripod at a distance by the well where he washes each morning. I dream sun on the *azotea*, the dark room of a new life— unaware of the pattern composed as he backs farther away and stops down to so great a depth of field that the door goes back into darkness forever. That dark doorway I call home—."[56] Gibson's description of the darkness of the doorway of the house in Tacubaya where Modotti and Weston first lived in Mexico is evocative of Weston's own description of the art of printing: "My prints are controlled, when necessary by printing down and holding back. . . . Quite often, for emphasis or emotional impact, I allow a shadow to go black."[57] Because the cover of *Memories of the Future* reproduces the same cropped print of *Tina* [seated in a doorway] (fig. 9.4) that appears in Constantine's biography, the reader is unaware that in other versions of the same image another darkened doorway is present, emblematic of the fact that for Tina

FIGURE 9.4. *Edward Weston,* Tina, Mexico, 1923. *Gelatin silver print, 19.1* ×
*24.3 cm. (© 1981 Center for Creative Photography, Arizona Board of Regents Collection,
The University of Arizona)*

there were more ways than one to journey homeward.[58] That Weston
meant the dark doorway in Mexico to suggest emotion is seconded by
Gibson's poem, both statement and poem acting as counters to John
Szarkowski's argument that "the trouble with empty black shadows is
that if they become bigger than, say, a thumbnail, they stop represent-
ing a dark place and begin representing merely a black shape."[59]

When Robert Fothergill describes the essential qualities of diaries,
he asserts that "every diary entry negotiates its own settlement on the
issue of closure."[60] While each entry has a natural sense of an ending—
the unit of a day—the diarist recording events and reflections over the
years eventually reaches the point where the accumulation of entries
has produced a diary, and the final entries often look as much back-
ward as forward. But in Weston's case, he is not able to negotiate any
final summing up. The penultimate entry, December 9, 1934, begins
with an apology, "I have not opened this book for almost 8 months"
(II, 283), and the final entry, written ten years later, April 22, 1944, two
years after the death by heart attack of Tina Modotti and the onset of
the Parkinson's disease that would kill him in 1958, is fragmentary.

FIGURE 9.5. *News photograph of Tina Modotti's funeral bier (with Edward Weston's Tina Modotti, 1921). (Courtesy of Mildred Constantine)*

Because the story of his relationship with Charis Wilson, the woman he referred to as "the great love of my life" (II, 283), is not told in the daybooks, the legend of Edward and Tina is the central love story of his diaries, even though Tina occupies only a few years of the earlier volume. The lifelong emotional attachment between them is indicated by the fact that one of his earliest portraits of her, Weston's *Tina Modotti, 1921,* which Constantine reports as having been in Modotti's personal possession throughout her life, was chosen to adorn Tina's funeral bier (fig. 9.5). Although she was not to die until 1942, as far back as 1924 she wrote in a letter the following will: "I—Tina Modotti—do hereby will—upon my death—to Edward Weston—all my personal property: furniture—books—photographs—etc."[61]

For this master of the framed image on the ground glass, the following description by Nancy Newhall of returning to Weston's house in Carmel is especially poignant: "He had been dancing in a corner for half an hour, unable to turn himself."[62] Having summed up his life by selecting and overseeing "the printing of 1,000 negatives that he considered the best of his entire life's production, he turned his attention to the written summation of his life."[63] One of his final letters, written in 1954, indicates the importance of the daybooks in his life, long after he was physically able to write in them: "Nancy . . . Please know that the Daybook is still in your lap, that I have not had any change of heart. . . . This is my last will and testament. What more can I say?"[64]

By combining his photographs with his daily writing, *The Daybooks of Edward Weston* illustrates the interrelationship between what might otherwise be thought of as separate areas of artistic expression, for by reading his writing and his photographs together we can see how much they have in common. Because diary entries cannot cover all the events of a day, and because they are written on a daily basis, individual entries tend to focus on ordinary events seen closely, the very subject often left out of autobiography, which often concentrates in retrospect on major turning points of a life. Similarly, Weston's photography, rather than depicting subjects or scenes that could be described as being of major significance, presents the ordinary and the daily seen in close-up perspective—peppers, toilets, washbowls, shells, dunes, rocks, tidepools. The individual entries in his *Daybooks* are finally as much "Weston's Westons" as are his celebrated images.

It may be averred that, of all the surfaces a few inches square the sun looks upon, none offers more difficulty, artistically speaking, to the photographer, than a smooth, blooming, clean washed, and carefully combed human head.

—*Lady Elizabeth Eastlake, 1857*

Conclusion:
We Are Not Our Own Light
Self-Portraiture and Autobiography

Many scholars of autobiography have unpacked the three Greek words from which we derive the term "autobiography"; however, most of this etymological analysis of "self-life-writing" has concentrated on *autos* or *bios* rather than the third root, *graphe*, which autobiography shares with photography. Because *graphe* is often translated as "writing," rather than as the broader "depiction" or "delineation," too often literary scholars have thought of autobiography only in terms of written texts. If, however, we use Patrick Maynard's more precise definition of *graphe* as "marking,"[1] then we are more likely to begin to take into account not only the uses of photography in autobiography, which has been my subject so far, but also the larger question of autobiography in photography, which is the topic of this concluding chapter.

In many ways the following statement from Walter Benjamin, from his 1931 "A Short History of Photography," predicts the current photographic situation: "The camera will become smaller and smaller, more and more prepared to grasp fleeting, secret images whose shock will bring the mechanism of association in the viewer to a complete halt. At this point captions must begin to function, captions which

understand the photography which turns all the relations of life into literature, and without which all photographic construction must remain bound in coincidences."[2] The forms of photography that most clearly turn life into literature are the portrait and the self-portrait, those forms of light writing that in many ways parallel life writing.

Literary theorists have long made a connection between word and image through the following analogy: biography is to portraiture as autobiography is to self-portraiture.[3] In *The Elements of Life*, his book-length treatment of biography and painted portraiture, Richard Wendorf points out the historical and linguistic parallels between the two art forms, including the tendency to refer to a short biography as a sketch, while William Howarth's groundbreaking study "Some Principles of Autobiography" uses self-portraits by Rembrandt, Hogarth, and Van Gogh and Parmigianino's *Self-Portrait in a Convex Mirror* to make the analogy between autobiography and self-portraiture, as does Ronald Paulson's study of Hogarth's self-representations and Gerald Silk's analysis of Piero Manzoni's autobiographical use of his body. Although I have limited my discussions throughout this book to autobiography's relationships with still photography, a rich area to be explored by others includes autobiography in the form of cinema, as well as in other visual forms including painting, sculpture, and performance art.

According to Michel Beaujour, in his *Poetics of the Literary Self-Portrait*, "The absence of a continuous narrative in the self-portrait distinguishes it from autobiography. So does its subordination of narration to a logical deployment . . . we shall call thematic"; however, as Estelle Jelinek and many other autobiography scholars have pointed out, straightforward chronological narration is hardly a requirement for autobiography, especially in the life narratives of women: "Irregularity rather than orderliness informs the self-portraits of women. The narratives of their lives are often not chronological and progressive but disconnected, fragmentary, or organized into self-sustained units rather than connecting chapters."[4]

Beaujour believes that literary self-portraiture is a specific type of writing, different from autobiography and biography, and exemplified by such texts as Malraux's *Anti-Memoirs*, Montaigne's *Essays*, Michel Leiris's *The Rule of the Game*, and *Roland Barthes by Roland Barthes*. Attempting to define the literary self-portrait, Beaujour writes: "The self-portrait's antinarcissistic mirror is made to represent a 'personless memory.' A memory without a person," thus bringing us full circle—from a mirror with a memory to a memory without a person.[5]

Although the analogy between portraiture and life writing is a productive way to think about the confusions of genre in the purely literary world, debates about the nature of portraiture have been just as convoluted as arguments about the nature of autobiography. As Graham Clarke notes, "At virtually every level, and within every context, the portrait photograph is fraught with ambiguity. For all its literal realism it denotes, above all, the problematic of identity, and exists within a series of cultural codes which simultaneously hide as they reveal what I have termed its enigmatic and paradoxical meaning."[6]

Even if we limit portraiture to photography, we quickly realize that not every picture of a person constitutes a portrait and that determining whether a photograph is a portrait or self-portrait can prove just as complicated as distinguishing between various forms of life writing. In one sense all photographs are self-portraits, particularly in the case of professional photographers, in that they tell us something about the photographer's eye—his or her way of framing the world, just as architects' houses and barbers' haircuts are particularly telling. Among the infinite variety of photographic self-portraits in the history of photography, numerous examples call into question what we mean by the term. As Jean-François Chevrier has observed, in *Staging the Self*, "Every self-portrait, even the simplest and least staged, is the portrait of another."[7]

Initially it seems reasonable to count as portraits or self-portraits all photographs so labeled by photographers, except that in numerous cases that label is almost arbitrary. Wright Morris's *Self-Portrait*, for example, shows only a building; Cindy Sherman's *Untitled Film Stills*, in which she figures as a model, would seem to be self-portraits, except that Sherman herself disavows that claim, noting that although technically they are self-portraits—she sets up the situation, poses herself as the central figure, and in most cases takes the picture—"I don't see these characters as myself. They're like characters from some movie, existing only in film or print."[8] A similar situation prevails with Yasumasa Morimura, whose work as seen in *The Sickness unto Beauty: Self-Portrait as Actress* consists of Morimura's cross posing in re-creations of famous portraits of such celebrities as Brigitte Bardot and Vivien Leigh.

Many photographs labeled "self-portrait" rather than "portrait" or "group portrait" include other people within the image, and in some cases the figure in the self-portrait is not even the photographer. Susan Kae Grant, for example, produces images that she calls "Auto-

biographic Dramas," about which she notes, "My work consists of previsualized imagery created from a journal. They articulate my inner feelings and visions. Sometimes I photograph myself, other times I use models. The models are symbols, the images are not about them, they are self portraits of me."[9]

Although both painted and photographed portraits have always attempted to reveal something of the character of the sitter, Duane Michals debunks the idea of delving into the psyche of his subjects, the traditional province of portraiture: "My portraits in this book have revealed nothing profound about the subjects or captured anything. They were almost all strangers to me. How could I say anything about them when I never knew them? What I did was to share a moment with them, and now I share that moment with you, no more and no less."[10] The interaction between Michals and the strangers with whom he shared a moment is clearly not so simple as he describes it, for during that moment photographer and sitter, with the entire history of portraiture behind them, were performing a complicated photographic act in which both played their part. In an essay titled "Fictions of the Pose," Harry Berger argues persuasively that the genre is not so much an attempt at recording sitters' physical features so as to reflect their inner being but a complex act: "I may not read the painted face as an index of the sitter's mind," he writes, adding that he does "read it as an index of what sitter and painter 'have in mind,' an expression of their designs on the observer."[11]

Richard Avedon's definition, "A photographic portrait is a picture of someone who knows he's being photographed,"[12] is contradicted in numerous cases, including Walker Evans's subway portraits, taken with a hidden Leica, as well as a number of his portraits from *American Photographs* for which he used a right angle finder, a device that enables the photographer to face in one direction and look through the camera in another. In the "Inductions" section of *Let Us Now Praise Famous Men*, James Agee—addressing Fred Ricketts directly— describes Evans's subterfuge: "Walker under the smoke screen of our talking made a dozen pictures of you using the angle finder (you never caught on . . .)."[13] An obvious difference between a portrait and a self-portrait would seem at first to be the impossibility of taking one's self-portrait unawares. However, according to Nancy Roberts, who includes snippets from her diary within her photographs: "Self-portraits can be creatively accidental. After setting the timer, I have only a few seconds to present myself before the shutter goes off. Even when I carefully pose, I'm only partially in control."[14]

The idea that a portrait can be distinguished by a sense of interaction between the photographed and the photographer is, of course, contradicted by the numerous portraits of dead people, especially infants, as documented in such books as Michael Lesy's *Wisconsin Death Trip*. In any case, we cannot usually tell by looking at a photograph what sort of relationship occurred; the subject may be pretending not to notice the photographer or may have been directed by the photographer to take on a certain stance or expression, as is the case with one of the earliest self-portraits in photography's history, Hippolyte Bayard's *Self-Portrait as a Drowned Man, 1840*, in which Bayard, angry over Daguerre's ascendancy, feigns his own suicide.[15]

Richard Brilliant names reference to an actual person as a fundamental prerequisite for portraiture, citing Gadamer's term "occasionality" as essential: "A portrait's claim to significance lies in that intended reference, whether the viewer happens to be aware of it or not."[16] Brilliant thus counters Philippe Lejeune, whose autobiographical essay "Looking at a Self-Portrait" asks: "How does it happen that there is no *internal* sign that allows us to distinguish a self-portrait from a portrait?"[17] Lejeune's question parallels his earlier realization, as expressed in his "The Autobiographical Pact," that there was no internal textual evidence to distinguish autobiography from the autobiographical novel.

When Terence Pitts borrows Avedon's phrase "a portrait is not a likeness" for the title of *The Archive* 29, a monograph from the Center for Creative Photography that presents photographic portraits and self-portraits from its collection, he is touching on one of the elements that makes self-portraiture and autobiography so interesting to study in tandem. If it is true, ironically, that a portrait is not necessarily a likeness, can the same thing be said of a self-portrait? If a self-portrait is not a likeness, then can we see in where it departs from an exact matching of the features of the photographer the very attempt at displaying and concealing that I believe is autobiography's most salient characteristic?

We usually know we are in the presence of a portrait or self-portrait because captions in a book or labels in a museum tell us so, not because we see the likeness between subject and representation. An absolutely direct comparison of such resemblance would, of course, be possible only while the sitter is alive, and yet the very quality we are referring to when we think about likeness is also present in those versions of portraiture that depend on exaggeration of physical features:

caricature, imitation, and impersonation. Likeness is a complicated concept, as illustrated by the series of paired pictures collected by the editors of *Spy* magazine as *Separated at Birth?*, in which such couples as Lillian Hellman and Mordecai Richler, Robert Bork and Tom Thumb, or Mel Tormé and Jean-Paul Sartre are said to share striking physical similarities. Even those photographic portraits in which more than one image of the sitter is present seem to undercut the idea of likeness, as observed by the nineteenth-century photographer Henry Peach Robinson, referring to Oscar Rejlander's "Rejlander the Artist Introducing Rejlander the Volunteer": "The contrast between the artist in velvet coat and . . . the same man in the same picture in his regimentals, was startling."[18] Brilliant observes the paradox that "the more a portrait resembles its human counterpart, the more obvious and destructive of the illusion of comparability are the substantial differences between them," citing Roger Fry's comment on viewing John Singer Sargent's portrait of Ian Hamilton: "I cannot see the man for his likeness."[19] Attempts to make portraits even more lifelike have seldom been successful, including photosculpture, invented by François Willème in 1860, a process in which multiple camera exposures were projected onto clay and traced with a pantograph.[20] In fact Cartier-Bresson said of the genre, "One of the fascinating things about portraits is the way they enable us to trace the sameness of man."[21]

Judy Fiskin's observation that "the more accurate the representation, the more sharply felt is the absence of the represented subject. . . . Representation cannot keep its promises" is borne out by the countless variations of the theme of photographic self-portraiture that call into question the idea of likeness.[22] Some portraits question likeness in simple ways, such as Clarence John Laughlin's multiple exposure *The Masks Grow to Us, 1947*. Others hide resemblance behind self-portraits in which the camera obscures their face, or use other ways to obscure their face, such as Inge Morath's pictures of people wearing masks or John Havinden's *Self-portrait, 1930*, in which the two letter o's in the German word "FOTO" are made out of his eyeglasses.

Other challenges to the concept of likeness occur in such anomalies as Joel-Peter Witkin's grotesque *The Kiss*, in which the photographer, using actual body parts as is his wont, has manipulated the two separate halves of a corpse's head so that the same person appears to be kissing himself,[23] or in the collaborative work of Mike and Doug Starn, identical twins about whom Silvio Gaggi writes, "Not only are they nearly indistinguishable visually, their collaboration is so com-

plete and apparently unproblematical that it is impossible to determine which of them is responsible for any aspect of any particular work."[24] The complication of doubling is an inherent part of the work of the Starn twins, including *Double Stark Portrait in Swirl, 1985–86*, as well as various images of both or one doubled with the word "self-portrait" in the title, or even in the apparently unambiguously titled *Portrait of Doug, 1986*, a doubled image that may or may not have been taken by Mike.[25]

Self-portraitists often deface their images with various manipulative techniques. Susan Hiller's *Gatwick Suite*, for instance, consists of photo booth pictures of herself on which she writes, draws, and scribbles with magic marker, as do many others, while Judith Golden's self-portraits are often covered with chalk, oil pastel, collage elements, and stitches in vinyl. Acting out de Man's "Autobiography as Defacement," Lucas Samaras has consistently manipulated his face and body in a series of self-portraits that began with his "AutoPolaroids" (1969–71). Writing in his *Samaras Album*, which he describes as "auto-interview, autobiography, autopolaroid," Samaras asserts, "When I say 'I' more than one person stands up to be counted."[26]

Although Jeffrey Wallen argues persuasively that "portraiture implies the representation of the face," adding, "It is the face that provides 'human' identity,"[27] not all self-portraits include even a distorted version of the face. Wendy MacNeil, for example, has a number of portraits of hands, and particularly interesting are the many self-portraits of John Coplans that display his large, aging nude body, including the series *Body: Self-Portraits*, which features "A Body of Work" (1987), "Hand" (1988), and "Foot" (1989).[28] In *Self-Portrait (Back of Hand, No 1.) 1986*, Coplans turns a portion of the body thought to be anonymous into a back-handed image as individual as a fingerprint.

In addition to the comparison between portraits/self-portraits and biography/autobiography, other types of life writing have their equivalents. A parallel to the "as-told-to-autobiography," such as *The Autobiography of Malcolm X*, might be those instances in which a photographer sets up a self-portrait situation, moves in front of the camera, and has an assistant actually press the shutter release. In a sense the ubiquitous photo booth produces the equivalent of a ghostwritten autobiography, though Susan Butler, a professional photographer whose work often includes altered photo booth photographs, compares the experience to another form of life writing, the confession: "Its curtains drawn, the photo booth becomes a kind of confessional, a con-

text for looking into one self, or at one self—but without the photographer."[29] Because Richard Avedon is a celebrated photographer, his *Self-Portrait, 1964*, in which he produced an image constructed out of half of his own face and half a mask of James Baldwin's, would seem to be a sort of half self-portrait, half portrait, though Avedon was not behind the camera and Baldwin was not actually present.[30]

Another type of ghostwritten autobiography is suggested by those cases in which professional photographers assist others in producing self-portraits. In André Rival's *Self-Images: 100 Women*, for instance, all the women involved in the project were able to establish their own angle and distance from the camera and could use whatever props they wished, though they had to be nude, a requirement that some subverted with props or paint. A video camera and monitor allowed the women to see themselves posing. With Rival out of the room, each woman decided when to use the hand-held shutter switch.[31] In a somewhat similar setup, Mark Berghash's "Aspects of the True Self," an exhibit of composite portraits and self-portraits was produced by telling the "sitters" to "trip a prefocused camera at successive moments when they were thinking most clearly about their parents, siblings, or selves."[32] In an issue of *La Recherche Photographique* called "De-Picting the Face," Sylvain Maresca describes Patrick Toth's double self-portraits, made by providing his "subjects" with the following instructions: "With an automatic focus in each hand, find an angle, then press the button on both cameras at the same time."[33]

Because memoir is usually thought of as existing somewhere between autobiography and biography, focusing as much inwardly on the life of the narrator as outwardly on other people, a possible analogue might be those photographic portraits in which the photographer is visible, such as Kenneth Josephson's *Season's Greetings, 1963* (fig. C.1). Walker Evans's *Dora Mae Tengle 1936* (fig. C.2) is somewhat like memoir in that it represents Evans's presence in the picture-taking situation. Both Lee Friedlander in *Self Portrait* and Arthur Tress in *Shadow: A Novel in Pictures* have produced books with numerous shadow portraits, similar to those shadow images by Wright Morris, Eudora Welty, and N. Scott Momaday's father I have described in the chapters devoted to each of those writers.

In a sense, though, all photographic portraits are memoirs in that they always include an interaction between photographer and photographed, as Max Kozloff asserts: "At the least, they knew themselves to be partnered in an open-ended but definite transaction. They both

FIGURE C.1. *Kenneth Josephson,* Season's Greetings, 1963 *(baby in photographic shadow). Gelatin silver print, 6 × 4 in. (The Museum of Modern Art, New York, Gift of the Photographer; copy print © 1996 The Museum of Modern Art)*

FIGURE C.2. *Walker Evans,* Dora Mae Tengle, 1936.
(Courtesy of the Library of Congress)

performed gestures, from physically opposed viewpoints, imagining
that a kind of *representation* would be made available. Such a visual
product would stand for the 'person,' much as a verbal statement may
be understood to propose a thought."[34] Other examples of memoir in
photography might include Les Krims's self-portraits that portray his
nude mother covered with photographs of himself, or Charles Mar-
tin's *Picture / Portrait, 1993* (fig. C.3), which, in including a self-portrait
and the camera that ostensibly produced it within a larger photograph,
echoes memoir's simultaneous inward and outward focus.

FIGURE C.3. *Charles Martin,* Picture/Portrait, 1993. *(© Charles Martin)*

According to Anne Hoy, self-portraits can also be seen as suggesting the diary genre: "The viewer may attempt to read self-portraits like a diary in which the handwriting displays changes of mind and heart. But the diary may be a forgery or fiction and such fabrication is also revealing."[35] And in *Self as Subject: Visual Diaries by Fourteen Photographers*, Dana Asbury has collected a sample of photographers whose photographs simulate diary entries in various ways, including Robert Stewart's work, which consists entirely of columns (described in the catalog as "hand-set letter press on BFK paper, 18 × 24") of written descriptions of specific places in which he has had his picture taken. These places range from Montclair, New Jersey, to "Self-Portrait—Paris (at a sidewalk cafe)," which consists of the situation (Stewart at a corner cafe across from Napoleon's Tomb on a very sunny day), the photographer (an unknown Japanese tourist from Hiroshima), and "Probable Results": "good, I assume color film, horizontal image, I

FIGURE C.4. *Friedl Bondy, 1/29/73–3/4/73. From* In/Sights *by Joyce Tenneson Cohen. (Copyright © 1978 by Joyce Tenneson Cohen; reprinted by permission of David R. Godine, Publisher, Inc.)*

am sitting at a small table in foreground with my coffee cup in hand, trying to look as American as possible, legs crossed, smiling, other tables and people are in the middle ground and the street in the background, photograph exists somewhere in Hiroshima."[36]

In this diary of images not displayed, the photographer echoes both Barthes's well-known decision not to include the famous "Winter Garden" photograph in *Camera Lucida* and such autobiographies as Timothy Findlay's *Inside Memory* or Marguerite Duras's *The Lover*.

Other photographic parallels to diary are Sol Lewitt's journal-like entries from a book he calls an autobiography, in which he photographs every object in his apartment, arranging them into such thematic units as pipes, lamps, and chairs, and Friedl Bondy's series of daily photographs, assembled as if a calendar, *1/29/73–3/4/73* (fig. C.4). As the series progresses, sometimes earlier "entries" in this photographic diary can be seen mounted on the wall; on some days there is only a blank space, which Bondy explains is the result of "feelings of aggression against myself, indifference, or forgetting." Speaking of the project as a whole, she adds, "I intend to continue doing one-year self-portraits in five-year intervals until the end of my life."[37] Bernadette Mayer's *Memory*, which consists of 1,116 color photographs taken

every day in July 1972 and mounted in the same style as Bondy's calendar series, is accompanied by six hours of taped narration, making the entire project a combination of diary and oral history.[38]

Perhaps the most remarkable of all diarylike photographic projects are the diaries of Peter Beard, which were displayed in a museum show in Tokyo under the title *Diary. From a Dead Man's Wallet: Confessions of a Bookmaker*. A small portion of Beard's many diaries is reproduced in book form in *Diary of Peter Beard*, a text that includes all of the following, taken from his two decades of writing: photographs of numerous pages from the original diaries, pictures of wildlife, thousands of lists, newspaper clippings, matchbook covers, addresses and phone numbers, sketches, doodles, handwritten notes, snapshots, newspaper and magazine photographs, Beard's own hand prints on the same page as his actual hand covered in ink, tickets, cigar bands, his own hand holding a pen pointing to ink drawing on the page, cartoons, business cards, airline tickets, hotel stationery, a flattened pack of cigarettes, menus, movie schedules, lists of things to do, baggage claim checks, a fragment of a peanut bag from American Airlines, and a series of photographs of a man being attacked by a rhinoceros and tossed into the air, to name only a random sampling. The back end papers present a photograph of Beard, lying on the ground writing in his diary, the lower half of his body encased inside a crocodile, which, readers of the diary realize, is actually dead.

Jon Bowermaster, in his *Adventures and MisAdventures of Peter Beard in Africa*, notes that Beard, who introduces himself as a diarist, "insists that to do his diaries justice requires at least an eight-hour day."[39] In addition to the material objects in his life, Beard also includes his own saliva and blood within the pages of his diaries, thus accomplishing James Agee's wish for *Let Us Now Praise Famous Men*: "If I could do it, I'd do no writing at all here. It would be photographs; the rest would be fragments of cloth, bits of cotton, lumps of earth, records of speech, pieces of wood and iron, phials of odors, plates of food and of excrement."[40]

Exhaustive though the Beard diaries are, Robert W. Shields, the author of an unpublished diary of twenty years, is even more thorough, his diary covering every moment of his life since 1972. Shields notes literally everything, including the time he sleeps, performs bodily functions, and writes in the diary, all recorded at the rate of approximately three million words a year. Included are a continuous stream of measurements, physical location keyed to time ("11:11 The

middle of Dixie, WA 99329, traversing a culvert. 11:15 Intersection of the freeway with Spring Creek Road"), amount of urine discharged, price of each item of food, exact clothing brands worn at each moment, medications taken, and another echo of Agee's call for physical fragments from life—taped nostril hair for DNA purposes—all interspersed with variations on the entry "I was at the keyboard of my IBM Wheelwriter making entries for the diary."[41] A similarly exhaustive display of dailiness can be seen in the explosion on the World Wide Web of personal cameras that constantly update still images of ordinary lives, the most celebrated of which is the Jenni Cam.[42]

Similar combinations of word and image occur in the category named "biographical narration" in Jonathan Green's *American Photography*, which includes Daniel Seymour's *A Loud Song* (1971), Robert Frank's *The Lines of My Hand* (1972), Larry Clark's *Tulsa* (1971), and Minor White's sequence *"Amputations, 1942–43,"* all of which have in common "the use of contact sheets, snapshots, newspaper clippings, film clips, handwritten texts," and the photographers' emphasis on their own lives.[43] During the late seventies and early eighties a group of photographers, who have come to be known as the Boston School, the most celebrated of which is Nan Goldin, began to experiment with a sort of combination diary and family album, the traditional family being replaced by friends and street acquaintances.[44]

In a genre he calls "photobiography," Charles Desmarais names many of the photographers collected in *Visual Diaries* and adds several others. Included in all these accounts of photographic autobiography is Wendy MacNeil, whose *Biographies* (1970–80) and *Album Pages* combine a series of snapshots, family photos, various identification cards, and her own formal studio portraits reproduced through the platinum and palladium process and printed out on translucent vellum tracing paper.[45] Kathleen McCarthy Gauss's description of MacNeil's picture of her husband, *Ronald MacNeil, 1977*, provides an idea of the way the photographer works: "An array of miscellaneous details regarding the subject's background and family are composed as a narrative biography. The portraits arranged across the bottom edge keep pace with the evolution in the top register. Somewhat aptly, the center image is blurred, stressing the decided differences among the four portraits on either side of it. The nonchalant pose and long hair of the subject of the identification card from the Rhode Island School of Design mark the biographical changes since the earlier, straightlaced government photos."[46]

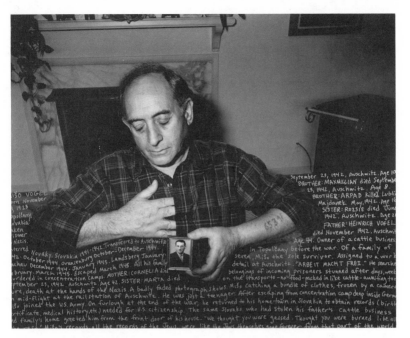

FIGURE C.5. *Jeffrey A. Wolin,* Miso Remembers Auschwitz, 1987. *(Copyright © 1988; courtesy Catherine Edelman Gallery and Jeffrey A. Wolin)*

Many photographers with an autobiographical impulse have combined words and images by such devices as writing on photographs or assembling a collage of family images and documents. Especially interesting in this category is Jeffrey Wolin, whose series of autobiographical photographs of his parents and children are made autobiographical with the addition of handwritten statements, often including quotations from letters or actual conversations. Wolin's *Miso Remembers Auschwitz, 1987* (fig. C.5), part of a series published as *Written in Memory: Portraits of the Holocaust,* is particularly interesting in the way it combines biography and autobiography. The words within which Miso Vogel seems to be sitting are in Wolin's handwriting, taken from a videotaped interview. Collaborating with the subjects of the Holocaust series, the photographer took a series of portraits immediately following the interview, later choosing the particular quotation he thought most apt for the image he wanted to use, always allowing the survivors the final approval.[47] Miso Vogel, himself a survivor of Auschwitz, is holding a photograph of his father, who died there. The whole image combines various types of life writing, including within the silver ink text both autobiography of the son, now older than his

long dead father, and biography of the father, including a prose description of a faded photograph that is not depicted physically. The son's pose, downcast eyes and hand reaching into his shirt as to if to feel his heart, seems to suggest that he is collaborating not just with the photographer but also with his father, as if the overall picture is a memorial for the father. Including a photograph within a photograph, as Kozloff points out, often produces a memoirlike effect: "A photo within a photograph emits a doubling effect that regresses inward. It marks off at least two instants in time, contained and containing. And sometimes the contrast between them, intentional or not, can be nostalgic, even poignant."[48]

Other examples of photographers' having combined photographs and words include Barbara DeGenevieve, whose work is in exploring the unknown self, and Bea Nettles, author of *Flamingo in the Dark: Images by Bea Nettles* (1987) and *Life's Lessons: A Mother's Journal* (1990). Especially effective are Joanne Leonard's series of photocollaged autobiographical and biographical images, exhibited as *Not Losing Her Memory: Stories in Photographs, Words, and Collage*, beginning with a 1934 portrait of Leonard's grandmother, done on commission by Edward Weston.[49]

Celebrating her grandmother, mother, twin sister, and daughter, Leonard circles around this original portrait, sometimes returning physically to the original scene and substituting her daughter or her twin for the grandmother. The series tells the family's history of "allergies, twinning, prematurely gray hair, uterine fibroids and artistic talents" through recurrent images, often taking the same pattern as *Four Generations, One Absent, 1991* (fig. C.6), though at times their torsos are replaced by shadowy outlines, Dalmatians, furniture, or other figures.[50] Like Wolin, Leonard includes handwritten words within the image, though in her case the words are often samples of actual handwriting, which appear at times to be re-creating a family dialogue. Sometimes the words are written on the inside and outside of glasine paper, which gives them a transparent quality. For Leonard, a visual artist, not only do photographs seem to have depth so that we can almost see through them, but they also have an antinarrative impulse so that we must also see around them.

Leonard's title *Four Generations, One Absent, 1991* refers to the absence of her mother, Marjorie Leonard, whose advanced dementia prevented her from appearing between her daughter on the far left and her sister and grandmother, on the right. In the place where the

FIGURE C.6. *Joanne Leonard,* Four Generations, One Absent, 1991.
(© Joanne Leonard)

mother should be Leonard has inserted a handwritten note about her mother's physical and mental absences, pointing directly at the words about a history of twins in the family. The issue of likeness is central to her family history of twins, and her work shows us that too exact a likeness would in fact result in a difficulty with identification; in a sense Joanne Leonard the autobiographer is the absent figure in this collage, represented only by her twin sister, an apt illustration of Herbert Furst's definition: "A portrait should be like the sitter—only more so!"[51]

I wish to bring *Light Writing and Life Writing* to an end with a reference to fiction because for me the clearest discussion of the power of photographs, as well as life writing, simultaneously to display and conceal occurs within a novel by Richard Powers called *Three Farmers on Their Way to a Dance*:

> The strange persuasion of photographs rests on selective accuracy wedded to selective distortion. The reproduction must be enough like the original to start a string of associations in the viewer, but enough unlike the original to leave the viewer room to flesh out and furnish the frame with belief. Photography seems particularly

suited for this precarious hybrid. It produces a finger painting in light-sensitive salts, but one regulated mechanically—simultaneously the most free and determined of procedures. . . . Because the process mixes mechanical control with the surprise of light, and because the product mixes technical exactitude with veiling and distortion, the viewer's response is a cross between essayistic firmness—"this, then, the dossier, the facts—and the invitation of fiction—"What can we make of it?"[52]

In the individual chapters of this book I have shown some of what we can make of the interactions between "the dossier of fact" and "the invitation of fiction" by considering a wide variety of similarities between photography and autobiography. One of the strongest of those parallels is that both have a mysterious, illusive quality that defies scientific observation, in the first case, and theoretical scrutiny, in the second. Just as physicists who specialize in studies of the properties of light have come to accept the impossibility of depicting exactly how waves of light can also be particular photons, so literary scholars, I believe, must come to terms with the realization that no amount of sophisticated poststructuralist theorizing will ever replace a persistent belief in the referentiality of autobiography, what Paul John Eakin names as an "existential imperative, a will to believe that is, finally, impervious to theory's deconstruction of reference as illusion. The presumption of truth-value is experientially essential; it is what makes autobiography matter to autobiographers and their readers."[53] Lives are like the contradictory and yet accurate theories of light in that autobiographers need to record and celebrate both the individual moments that in retrospect seem particularly important (particles) and the larger movements of the course of their lives (waves). Maintaining the balance between revealing and concealing, between developing the latent image but not overexposing it, between negatives and positives, is at the heart of both light writing and life writing, for lives, like light, exist simultaneously as both particle and wave.

Notes

Preface

1. Eakin, *Fictions in Autobiography*, 3, 5.
2. Fleishman, *Figures in Autobiography*, 478; Sacks, *Man Who Mistook His Wife*, 105.
3. Bruss, *Autobiographical Acts*, 119; de Man, "Autobiography as Defacement," 70.
4. McHale, *Postmodernist Fiction*, 203.
5. Updike has also published an autobiography in poetry, *Midpoint* (1969), which includes a series of family photographs reproduced in a pointillist style.
6. See Popkin, "Autobiography versus Postmodernism," for a study of academic autobiography.
7. Bruss, *Autobiographical Acts*, 8.
8. De Man, "Autobiography as De-Facement," 70.
9. Barthes, *Roland Barthes*, 56.
10. Ibid., 145.
11. Eakin, *Touching the World*, 4, 8, 19.
12. Ibid., 3.
13. Barthes, *Camera Lucida*, 80.
14. Sontag, *On Photography*, 154; Krauss, "Photographic Conditions of Surrealism," 26.
15. Peirce, *Collected Papers* 2:281, 2:159. Quoted in Mitchell *Iconology*, 59–60.
16. For a thorough anthology of interactions between writing and photography, see Rabb, *Literature and Photography* and *Short Story and Photography*. See also Lambrecht and Salu, *Photography and Literature*. For studies of literature and photography, see Bogardus, *Pictures and Text*; Bryant, *Photo-Textualities*; Green-Lewis, *Framing the Victorians*; Rugg, *Picturing Ourselves*; Hunter, *Image and Word*; Orvell, *Real Thing*; Shloss, *In Visible Light*; Sweet, *Traces of War*; and Williams, *Confounding Images*. See also Stanley, "Enter the Author."
17. See Partridge, *Dorothea Lange*, 93.
18. Published just as I was completing this book, Linda Haverty Rugg's *Picturing Ourselves* makes a similar claim: "the awareness of the autobiographical self as decentered, multiple, fragmented, and divided against itself in the act of observing and being; and the simultaneous insistence on the pres-

ence of an integrated, authorial self, located in a body, a place, and a time. Photographs enter the autobiographical narrative to support both of these apparently opposing views" (2). Rugg's outstanding book takes up the study of the interactions of photography and autobiography in four literary cases: Mark Twain, August Strindberg, Walter Benjamin, and Christa Wolf.

Introduction

1. As Timothy Sweet reminds us, "The era of the half-tone, beginning around 1885 for magazines and about a decade later for books, saw the emergence of 'categories of appropriateness' for relations between images and texts: fictional literature came to be illustrated with drawings, and factual literature such as news and travel accounts, with photographs." "Photography and the Museum of Rome," 34.
2. See my "Autobiographical Rhetoric in Hawthorne's Prefaces."
3. Wareheim, "Photography, Time, and the Surrealist Sensibility," 45.
4. Meltzer, *Salomé and the Dance of Writing*, 125.
5. Shields, *Stone Diaries*, 33.
6. Scruton, "Photography and Representation," 588.
7. Berger, "Fictions of the Pose."
8. Daguerre, "Daguerreotype," 13.
9. Quoted in Newhall, *History of Photography*, 69.
10. Quoted in Jammes and Janis, *Art of French Calotype*, 247.
11. For detailed arguments about representation and photography, see especially the following: Arnheim, "On the Nature of Photography"; Bazin, "Ontology of the Photographic Image"; Black, "How Do Pictures Represent?"; Gombrich, "Mask and the Face"; Hochberg, "Representation of Things and People"; Maynard, *Engine of Visualization*; Savedoff, "Transforming Images"; Snyder and Allen, "Photography, Vision, and Representation"; Steiner, "Postmodernist Portraits"; Scruton, "Photography and Representation"; and Walton, "Transparent Pictures."
12. Barthes, *Camera Lucida*, 80.
13. Browning quoted in Goldberg, *Power of Photography*, 11; Carlyle quoted in Rogers, *Camera Portraits*, 16.
14. Bazin, "Ontology of the Photographic Image," 241.
15. From *Cestus of Agalia*, quoted in Rabb, *Literature and Photography*, 113. The next year, Mark Twain remarked, partly tongue in cheek, "The sun never looks through a photographic instrument that does not print a lie. The piece of glass it prints is well named a 'negative'—a contradiction—a

misrepresentation—a falsehood." Quoted in Rabb, *Literature and Photography*, 151.

16. Quoted in Kozloff, *Privileged Eye*, 228.

17. Arnheim, "On the Nature of Photography," 155.

18. Snyder and Allen, "Photography, Vision, and Representation," 151.

19. Cavell, *World Viewed*, 17–18.

20. Snyder, "Picturing Vision," 222.

21. Creekmur, "Lost Objects," 75.

22. Writing in his autobiography *A Life in Photography*, Steichen explains that in producing this self-portrait as an artist, he borrowed props from F. Holland Day and "posed in the mirror" for a self-portrait he "thought was going to be photography's answer to 'Man with a Glove'" (n.p.).

23. For a discussion of Hoepffner and a number of other women self-portraitists, see Meskimmon, "Autobiographical Model."

24. Murray, *Painterly Photography*, 8.

25. See Yates, *Betty Hahn*.

26. Butler, "Between Frames," 390.

27. Grundberg, "Photography beside Itself," 15.

28. Featherstone, *Observations*, 10.

29. Kozloff, *Privileged Eye*, 236.

30. Stott, *Documentary Expression*, 61.

31. Quoted in Cardinal, "Nadar and the Photographic Portrait," 11.

32. Quoted in Orvell, "Typology of Late Nineteenth-Century Photography," 153. Galton, who developed the first statistical method in heredity and eugenics, was also fascinated with physiognomic studies and eventually put his composite photographs to use in producing composites of what he called criminal types, ideal family members, and Jewish types. See Sekula, "Body and the Archive," and Green, "Veins of Resemblance."

33. DeLappe, "Statements and Slide List," n.p.

34. See Mulligan, "Autobiographical Impulse," and Willis, "Clarissa Sligh."

35. Derrida, *Writing and Difference*, 224.

36. Barthes, *Roland Barthes*, 162.

37. Barthes, *Camera Lucida*, 115.

38. Price, *The Photograph*, 172.

39. Cantú, *Canícula*, xi.

40. Ibid.

41. Ibid., 4. As it appears in *Canícula*, this photograph is reproduced backward, as can be seen from a label printed at its base that reads, in a mirror, "June 1954."

42. Ibid., 131.

43. Ibid., 53.

44. Ibid., xi.

45. Personal correspondence, July 10, 1997.

46. Sischy, "Self-Portraits in Photography," 237–38.

47. Melville, "Time of Exposure," 20.

48. Cavell, "What Photography Calls Thinking," 8–9.

49. Shawcross, *Roland Barthes on Photography*, 29.

Chapter One

1. McCaffery and Gregory, "Interview" in *Mississippi Review*, 57.

2. Barthes, "Photographic Message," 21.

3. Auster, *Invention of Solitude*, 7. Subsequent citations appear as page numbers within the text.

4. Beaujour, *Poetics of the Literary Self-Portrait*, 3, 7.

5. Rosenberg, "Portraits," n.p.

6. Bruckner, "Paul Auster," 27.

7. De Man, "Autobiography as De-Facement," 75–76.

8. Hirsch, *Family Frames*, 107.

9. MacLaine, "Photofiction as Family Album," 131.

10. Bourdieu, *Photography*, 31.

11. Sontag, *On Photography*, 70.

12. Kozloff, "Variations on a Theme of Portraiture," 26.

13. Auster, "From *The Invention of Solitude*," 24–26.

14. For other examples of multiple mirrored photographs, see the picture of Dorothy Arabella Yorke in Guest, *Herself Defined*, 49; Roche's photograph of Duchamp is in Clarke, *Portrait in Photography*, 99; and Witkiewicz's "Multipart Self-Portrait" is in Lingwood, *Staging the Self*.

15. Ades, "Duchamp's Masquerades," 98.

16. Morris, *Time Pieces*, 76.

17. Walton, "Transparent Pictures," 252.

18. Barthes, *Camera Lucida*, 26–27.

19. Alexander, "Elusions," 19.

20. Ibid., 20.

21. Armstrong, "Reflections on the Mirror," 132–33.

22. McCaffery and Gregory, "Interview" in *Mississippi Review*, 56.

23. McCaffery and Gregory, "Interview" in *Contemporary Literature*, 18.

24. Quoted in Begley, "Case of the Brooklyn Symbolist," 54.

25. Ibid.

26. Grundberg, "Photography beside Itself," 14.

27. Bolles, *Remembering and Forgetting*, xiv.

28. Bruckner, "Paul Auster," 32.

29. Price, *The Photograph*, 163.

Chapter Two

1. Although I am not aware of any studies of photography and *The Woman Warrior*, see Neubauer, "Developing Ties to the Past," for a look at photography and *China Men*.

2. Quoted in Ling, "Writer in the Hyphenated Condition," 69–83.

3. Kingston, "Cultural Mis-readings by American Reviewers," 60.

4. Bonetti, "Interview with Maxine Hong Kingston."

5. Rabinowitz, "Eccentric Memories," 178.

6. Iser, *Fictive and the Imaginary*, 1.

7. Rabinowitz, "Eccentric Memories," 178.

8. Kingston, *Woman Warrior*, 113. Subsequent citations appear as page numbers within the text.

9. Meltzer, *Salomé and the Dance of Writing*, 116.

10. Barthes, *Camera Lucida*, 30.

11. Ibid, 13–14.

12. Quinby, "Subject of Memoirs," 300–301.

13. Rabinowitz, "Eccentric Memories," 178.

14. See Baldwin, *Looking at Photographs*, 49, 78.

15. Krauss, "Tracing Nadar," 43.

16. Nadar, *My Life as a Photographer*, 2.

17. Kingston, *China Men*, 127. Subsequent citations appear as page numbers within the text.

18. Bourdieu, *Photography*, 30–31.

19. The image of being flayed alive also occurs in *China Men* in "The Brother in Vietnam" section, 277.

20. Chin, "This Is Not an Autobiography," 122, 121.

21. Quoted in Leong, "Frank Chin," 163.

22. Berger, *Another Way of Telling*, 96–97.

23. Sontag, *On Photography*, 172.

24. Goldberg, "Photos That Lie," 1.

25. Bazin, "Ontology of the Photographic Image," 241–42.

26. Takaki, *Iron Cages*, 230.

27. Fichtelberg, "Poet and Patriarch," 175.

28. Chen, *Chinese of America*, 73.

29. Shawcross, *Roland Barthes on Photography*, 117.

30. See Rosenblum, *World History of Photography*, 168, for *Meeting of the Rails, Promontory Point, Utah, 1869*, by Andrew J. Russell, and Taft, *Photography and the American Scene*, 259, for a similar picture, *Joining of the Rails, 1869*. According to Taft, more than three hundred stereographs were made by A. A. Hart along the route of the Central Railroad (281).

31. For a similar situation, see Barthes, *Roland Barthes*, in which the author relies on a photograph to establish the former existence of his house: *"The house is gone now swept away by the housing projects of Bayonne"* (8).

32. Mitchell, *Reconfigured Eye*, 29.

33. Kingston, "Reservations about China," 67.

34. Quinby, "Subject of Memoirs," 299.

35. Islas, "Maxine Hong Kingston," 12.

36. Quinby, "Subject of Memoirs," 306.

37. De Man, "Autobiography as De-Facement," 80.

38. Gunn, *Autobiography*, 25.

39. Kingston, *Through the Black Curtain*, 5.

40. Meltzer, *Salomé and the Dance of Writing*, 121.

41. Sontag, *On Photography*, 75.

42. Ibid., 71.

43. Rabinowitz, "Eccentric Memories," 187.

44. Powers, *Three Farmers*, 209.

45. Pfaff, "Talk with Mrs. Kingston," 25.

46. Ignatieff, *Russian Album*, 6.

Chapter Three

1. Sheila Ortiz Taylor, foreword to Taylor and Taylor, *Imaginary Parents*, xiii (hereafter cited within the text as "foreword").

2. Thanks to Laura Brady for this formulation from her unpublished "Recuerdos and Re-Collections: Living Stories New and Old." Sheila Ortiz Taylor notes that she drew her allusion to La Huesera from Estes, *Women Who Run with the Wolves*. Personal correspondence, July 1997.

3. Sheila Ortiz Taylor and Sandra Ortiz Taylor, *Imaginary Parents*, 232. Subsequent citations appear as page numbers within the text.

4. Because following the usual convention of citing authors by their last names would be confusing in this case, I will refer to the Ortiz Taylors by

their first names, except where it is clear which sister I am discussing. I do not mean to imply any sense of false familiarity.

5. Sandra Ortiz Taylor notes that "this piece was the only one done in direct response to Sheila's text. When I read it I began my own intense recollection of how small their shared private space had been and how dominant MyMama remained even in death." Personal correspondence, July 13, 1997.

6. Sandra Ortiz Taylor, "Art Notes," in Taylor and Taylor, *Imaginary Parents*, xv (hereafter cited within the text as "Art Notes").

7. Sandra Ortiz Taylor, "List of Illustrations," in Taylor and Taylor, *Imaginary Parents*, ix (hereafter cited within the text as "List of Illustrations").

8. Goldberg, *Power of Photographs*, 1991.

9. Sheila Ortiz Taylor, personal correspondence, July 12, 1997.

10. Mitchell, *Reconfigured Eye*, 24.

11. Kuhn, "Remembrance," 472.

12. See Gutiérrez et al., *Home Altars of Mexico*; Beimler and Greenleigh, *Days of the Dead*; and Sayer, *Mexico*.

13. Bruner, "Autobiographical Process," 46.

14. Taylor, "About the Author," in *Faultline*, ix. Her name does not appear in Saldivar, *Chicano Narrative*, though she is listed in the bibliography of Horno-Delgado et al., *Breaking Boundaries*.

15. Bruce-Novoa, "Sheila Ortiz Taylor's *Faultline*," 75.

16. In addition to Sheila Ortiz Taylor's situation, Christian's "Will the 'Real Chicano' Please Stand Up?" also takes up the case of John Rechy.

17. Bruce-Novoa, "Sheila Ortiz Taylor's *Faultline*," 84.

18. Kingston, *Woman Warrior*, 163.

19. Mitchell, *Iconology*, 43.

20. Doyle, review of Robin Weigman, 457.

21. Caws, *Art of Interference*, 4.

22. Trachtenberg, *Reading American Photographs*, 251.

23. See Taylor, "The Way Back," in *Slow Dancing at Miss Polly's*, for a poem about another photograph of Jimmy Doll.

24. Terri Cohn, blurb on back cover of *Imaginary Parents*.

25. Sandra Ortiz Taylor, "Art of Sandra Ortiz Taylor," 2.

26. Kuhn, "Remembrance," 475.

27. Humphreys, "My Real Invisible Self," 5.

28. Sheila Ortiz Taylor, personal correspondence, July 12, 1997.

29. Kingston, *Woman Warrior*, 45.

30. Rich, "Diving into the Wreck," 68.

31. Clarke, *The Photograph*, 23.

32. Taylor, "35MM," in *Slow Dancing at Miss Polly's*, 6.

33. Sedofsky, "Time Exposure," 299.

Chapter Four

1. Smith, *Poetics of Women's Autobiography*, 45.

2. Momaday's interest in combining prose and photography includes his collaboration with photographer David Muench on *Colorado: Summer, Fall, Winter, Spring*, published in 1973.

3. Krupat, "Native American Autobiography," 179–80.

4. Ibid., 178.

5. Ibid., 186.

6. Krupat, *Voice in the Margin*, 181.

7. Schubnell, *N. Scott Momaday*, 15.

8. Holman and Harmon, *Handbook to Literature*, 497.

9. Mooney, *Calender History of the Kiowa Indians*, 231.

10. See Olney, "Autobiography: An Anatomy and a Taxonomy," for a strong argument that autobiography is not only *not* a special case of biography but is essentially different from biography (59).

11. Jakobson, "Metaphoric and Metonymic Poles," 76–82.

12. Krupat, "Native American Autobiography," 176.

13. Mitchell, *Iconology*, 59.

14. Wong, *Sending My Heart Back*, 178.

15. Sayre, *American Lives*, 647.

16. Shawcross, *Roland Barthes on Photography*, ix.

17. Momaday, *The Names*, ix. Subsequent citations appear as page numbers within the text. In King, "A MELUS Interview," 70, Momaday notes that he thinks of both *The Way to Rainy Mountain* and *The Names* as memoirs.

18. Nye, *Plains Indian Raiders*, 323.

19. See Momaday, "Photography of Horace Poolaw," 16, for a similar photograph taken by Pohd-lok's son Horace Poolaw.

20. Jay, "Posing," 204.

21. Woolf, *Moments of Being*, 98.

22. Jay, "Posing," 208.

23. Barthes, *Camera Lucida*, 103.

24. Quoted in Schubnell, *N. Scott Momaday*, 141.

25. Ibid., 247.

26. Momaday, "My Life with Billy the Kid," 54–55. For a discussion of Momaday's relationship to Billy the Kid, see Woodard, *Ancestral Voice*, 22–27.

27. Although Momaday here refers to photographs in his family, the last photograph in the book, *Guipagho the Elder*, is not a family snapshot but a more formal portrait taken by Soule. See Nye, *Plains Indian Raiders*, 221.

28. Mayhall, *The Kiowas*, 169, 256. In Nye, *Plains Indian Raiders*, a Will Soule photograph of "Mamay-day-te" is labeled with the fact that he was known as Lone Wolf (332–33). Another photograph, called "Son of Maman-ti," whose name is translated as "Sky-Walker" or "Man-Who-Walks-on-the-Clouds," appears on p. 367.

29. The name "Mamay-day-te" is given as "Lone Wolf" in Nye, *Bad Medicine and Good*, 245.

30. Krupat, *Voice in the Margin*, 178.

31. After I had written about the humor in Momaday's captions, I came across a similar assessment in Woodard, *Ancestral Voice*, 128.

32. Krupat, *Voice in the Margin*, 180.

33. Thanks to Laura Coltelli for pointing out this reversal.

34. Berger, *Another Way of Telling*, 92.

35. Wong, *Sending My Heart Back*, 185.

36. Krupat, *Ethnocriticism*, 217.

37. Schubnell, *N. Scott Momaday*, 185–86.

38. Mayhall, *The Kiowas*, 146.

39. Quoted in ibid.

40. Momaday, "Man Made of Words," 162.

41. Ibid., 164.

42. De Man, "Autobiography as De-Facement," 69.

43. Wong, *Sending My Heart Back*, 44.

44. Woodard, *Ancestral Voice*, 163, 165.

45. See Schubnell, *N. Scott Momaday*, 37, and the chapter in Woodard, *Ancestral Voice*, called "The Vision Plane," 151–87.

46. Woodard, *Ancestral Voice*, 183. See Weiler, "N. Scott Momaday," 174, for a conversation about Momaday's paintings being based on photographs.

47. In Adkins, "Interview," she asks how Momaday located the photographs he used in *The Names*, and he answers, "It was pretty much an accident. My father told his sister what I was doing, and she said, 'Oh, I have a wonderful picture of our mother. I found it in the trunk.' And it turns out to be the best photo of my grandmother that I have ever seen" (216).

48. Cavell, *World Viewed*, 24.

49. Seed, "Viewless Womb," 403.

50. Momaday, *Way to Rainy Mountain*, 98.

51. Ibid., 97. Interestingly, another photograph of Mammedaty appears twice in *The Names*, on the title page and again on p. 58 labeled "Five Generations."

52. In "The Giveaway" section of his poem *The Gourd Dancer*, dedicated to Mammedaty, Momaday describes a boy handing the reins of a black horse to Mammedaty (36–37).

53. Sontag, *On Photography*, 180.

54. Rainwater, "Planes, Lines, Shapes, and Shadows," 376.

55. Momaday's fondness for Dickinson is detailed throughout Woodard, *Ancestral Voice*, especially "Further in Summer than the Birds," which he calls his favorite (146). Schubnell, *N. Scott Momaday*, quotes from Momaday's dissertation's introduction, in which he discusses "There's a Certain Slant of Light" (208).

Chapter Five

1. Woodard, *Ancestral Voice*, 22. The author of *The Names* might also have an interest in the famous outlaw because his names parallel the Kiowa progressive naming system. Billy the Kid was born Henry McCarty, the name sometimes given to him in Momaday's *The Ancient Child*, but was also known as Kid Antrim, as well as William Bonney. See Adams, *Fitting Death for Billy the Kid*, 10. Tuska, *Billy the Kid*, 3–4. The name Antrim, connected to left-handedness, also appears in *Coming through Slaughter*, 142.

2. Barbour, *Michael Ondaatje*, 41; Jones, "*The Collected Works of Billy the Kid*," 129; Kamboureli, *On the Edge of Genre*; Godard, "Stretching the Story," 31.

3. Barbour, *Michael Ondaatje*, 39, 3.

4. Ondaatje, *Collected Works of Billy the Kid*, iv. Subsequent citations appear as page numbers within the text.

5. Tuska, *Billy the Kid*, 37.

6. Momaday, *Ancient Child*, 193. When contemporary critics charged Garrett with writing his book on Billy the Kid with the intent of making money, he replied through his ghostwriter that his critics were "asinine propellers of Faber's No. 2." Garrett, *Authentic Life of Billy, the Kid*, 154.

7. The photograph on page 23 of *The Collected Works of Billy the Kid* is described in Brown, *Frontier Years*, 34.

8. Scobie, "Two Authors," 45.

9. Jewinsky, *Michael Ondaatje*, 65.

10. Heble, "Michael Ondaatje," 109. See also Mundwiler, *Michael Ondaatje*, 71, for a similar assessment of the closing words. T. D. MacLulich sees "passages in which the authorial persona closely resembles the central character" on 40, 41, and 72 of *The Collected Works of Billy the Kid*. "Ondaatje's Mechanical Boy," 116.

11. The original Canadian version of *The Collected Works of Billy the Kid* featured one of Eadweard Muybridge's photographic studies of a horse in motion, an image that a number of commentators have linked to the opening quotation from L. A. Huffman and the text's presentation of Billy the Kid as suggestive of photography's pull between fixity and fluidity. See Mac-Lulich, "Ondaatje's Mechanical Boy," 108, and York, *"Other Side of Dailiness,"* 104, as representative.

12. Hunter, *Image and Word*, 115.

13. Michals, "I Am Much Nicer Than My Face," 5.

14. According to Hochbruck in "Metafictional Biography," the photograph of Billy the Kid bears a striking likeness to the only photograph of Thomas Pynchon regularly available (452).

15. Momaday, *Ancient Child*, 48.

16. Scobie, "Two Authors," 43.

17. Lejeune, "Looking at a Self-Portrait," 111.

18. Shawcross, *Roland Barthes on Photography*, 104.

19. Thanks to the Lincoln County Heritage Trust and to expert Dick George, who reports that "a panel of photographic experts and historians working on behalf of the Lincoln County Heritage Trust Museum in the late 1980s and early 1990s conducted an exhaustive comparative study between the one known photo of Billy the Kid and a number of photos supplied by various sources, including other historians, collectors, photo dealers, and descendents and afficionados of the Lincoln County War. According to the results of the study, including a computerized point-by-point, feature-by-feature analysis, none of the subjects among the photos submitted matched the original tintype. None in fact earned even a modestly high degree of probablity." Personal corespondence, June 29, 1997.

20. Barbour, *Michael Ondaatje*, 54.

21. Scobie, "Two Authors," 54.

22. Jewinsky, *Michael Ondaatje*, 67.

23. MacLulich, "Ondaatje's Mechanical Boy," 107. See also York, *"Other Side of Dailiness,"* 104.

24. In addition to those already cited, see Blott, "Stories to Finish"; Nodelman, "Collected Photographs of Billy the Kid"; and Owens, " 'I Send You a Picture.' "

25. Jewinsky, *Michael Ondaatje*, 88.

26. According to Baldwin in *Looking at Photographs*, "it was William Henry Fox Talbot's discontent with this tool [the camera lucida] . . . that led him to invent the process that evolved into modern photography" (17).

27. MacLaine, "Photofiction as Family Album," 131; Varsava, "History and/

or His Story?" 205; Kamboureli, "Poetics of Geography," 117; Jacobs, *Character of Truth*, 52; Barbour, *Michael Ondaatje*, 99.

28. Solecki, "Making and Destroying," 33.

29. Beaujour, *Poetics of the Literary Self-Portrait*, 3.

30. Ibid., 2; Schafer, "Thoughts on Jazz Historiography," 7.

31. Quoted in Schafer, "Thoughts on Jazz Historiography," 7.

32. Ondaatje, *Coming through Slaughter*, 33. Subsequent citations appear as page numbers within the text.

33. Barbour, *Michael Ondaatje*, 130.

34. Ibid., 131.

35. Williams, *Jazz Masters of New Orleans*, 12.

36. See Jewinsky, *Michael Ondaatje*, 98–99, for a description of Ondaatje's trip to New Orleans in preparation for writing *Coming through Slaughter*.

37. Eakin, *Touching the World*, 52.

38. Hutcheon, *Canadian Postmodern*, 46.

39. Turner, *Remembering Song*, 25.

40. Ashforth, "Bolden Band Photo," 173.

41. Hochbruck, "Metafictional Biography," 456.

42. Szarkowski, *Looking at Photographs*, 68.

43. Roegiers, "Bellocq," 44.

44. Marquis, *In Search of Buddy Bolden*, 48.

45. Sontag, *On Photography*, 79.

46. Avedon, *Autobiography*, fig. 224.

47. Ignatieff, *Russian Album*, 7.

48. Kamboureli, "Alphabet of the Self," 80–82.

49. Quoted in ibid., 80.

50. Russell, "Travel Memoir as Nonfiction Novel," 23–33.

51. Lorinc, review of *The Man-Eater of Punanai*, C15; Carlson, inside front cover of HarperPerennial edition of *The Man-Eater of Punanai*.

52. Ondaatje, *Running in the Family*, 201. Subsequent citations appear as page numbers within the text.

53. Barbour, *Michael Ondaatje*, 8.

54. Ondaatje, *Man-Eater of Punanai*, 38. Subsequent citations appear as page numbers in the text.

55. Shawcross, *Roland Barthes on Photography*, 21.

56. Lejeune, "Autobiographical Pact," 24.

57. Ondaatje, "Letters and Other Worlds," in *There's a Trick with a Knife*, 44.

58. Kendall, *Art of Biography*, 13.

59. Nadel, *Biography*, 4.

60. Ondaatje, "Signature," in *There's a Trick with a Knife*, 8.

Chapter Six

1. Price, "Only News," vii.
2. Ibid.
3. Price, *Clear Pictures*, 202, 143. Subsequent citations appear as page numbers within the text.
4. Price, "For the Family," n.p.
5. Ibid.
6. Malraux, *Lazarus*, 74.
7. Berger, *Another Way of Telling*, 89.
8. For another example of Price's interest in the Abraham-Isaac motif, see his essay "Four Abrahams, Four Isaacs by Rembrandt," 260–69.
9. Price, *Collected Stories*, 145. "Life for Life" originally appeared in the "Elegies" section of Price's *Permanent Errors* in 1970.
10. See Guggenheim, *Clear Pictures*, a film by Charles Guggenheim Productions, Washington, D.C., 1994.
11. Berger, *Another Way of Telling*, 86.
12. In his afterword to Mann's *Immediate Family*, "For the Family," Price elaborates on the solemn expression that characterizes most of his baby pictures: "For at least my first year, I was definitely a comical sight—bald as a pear, bowlegged as a cowpoke and given to dark-eyed lugubrious gazes" (n.p.).
13. Wollen, "Fire and Ice," n.p.
14. Welty, *One Writer's Beginnings*, 23.
15. Price, *Permanent Errors*, 91–92.
16. Walton, "Transparent Pictures," 251.
17. Warburton, "Seeing through 'Seeing through Photographs,'" 73.
18. Hoy, *Fabrications*, 77.
19. Price, "Only News," x.
20. Krauss, "Note on Photography," 23.
21. Price, *Whole New Life*, 175. In the documentary *Clear Pictures* there is a scene of the whole family looking through photograph albums.
22. Price, *Whole New Life*, 175, 176.
23. Berger, *Another Way of Telling*, 89.
24. Kaufman, "Notice I'm Still Smiling," 24–25.

Chapter Seven

1. Welty, *One Writer's Beginnings*, 92. Subsequent citations appear as page numbers within the text.

2. Welty, preface to *One Time, One Place*, 7. In the original 1971 Random House version, Welty's preface was called a foreword. See also Ferris, "Visit with Eudora Welty," 155.

3. Vande Kieft, *Eudora Welty*, 17.

4. Welty, "Literature and the Lens," 102–3.

5. See Cole and Srinivasan, "Introduction," xxi.

6. See Kreyling, *Author and Agent*, 11–12, and Marrs, "Eudora Welty's Photography," 281.

7. For a more detailed outline of Welty's photographic career, see Cole and Srinivasan, "Introduction"; Weston, "Images of the Depression"; Meese, "Constructing Time and Place"; McKenzie, "Eye of Time"; Mann, "Eudora Welty, Photographer"; Westling, "Loving Observer"; and Pollack, "Photographic Convention and Story Composition."

8. Cole and Srinivasan, "Introduction," xv.

9. Yates, "My Visit with Eudora Welty," 98; Wilson, "Looking into the Past," 294; Bunting, " 'Interior World,' " 53.

10. Ferris, "Visit with Eudora Welty," 159.

11. Welty Collection, Mississippi Department of Archives and History, box 75, folder 3, 110.

12. In an early mock-up of the table of contents for *One Writer's Beginnings* in the Welty Collection in the Mississippi Department of Archives and History, box 76, the first section is tentatively called "LEARNING" instead of "LISTENING."

13. Petty, "Town and the Writer," 208.

14. Barthes, *Camera Lucida*, 15.

15. According to James Patterson, Welty actually applied to Roy Stryker at the Farm Security Administration, hoping to be a part of his enterprise. "The Southern Decisive Moment: Eudora Welty's Photographs," lecture, May 3, 1996, the Eudora Welty Film and Fiction Festival, Jackson, Miss.

16. Welty, preface to *One Time, One Place*, 4.

17. This image is reproduced within the interview section of Welty, *Photographs*, xv.

18. Rubin, "Growing Up in the Deep South," 50.

19. Edwards, *Anthropology and Photography*, 14.

20. Cole and Srinivasan, "Introduction," xix.

21. Ibid., xxvi.

22. Welty, "Word on the Photographs," in her *Twenty Photographs*, n.p.

23. Cole and Srinivasan, "Introduction," xiv.

24. MacNeil, *Eudora Welty*, 6.

25. Trachtenberg, *Reading American Photographs*, 251.

26. Price, "Only News," xi.

27. Welty, "Place in Fiction," 125.

28. Welty, preface to *One Time, One Place*, 11.

29. Sontag, *On Photography*, 171.

30. Westling, "Loving Observer," 596.

31. MacNeil, *Eudora Welty*, 6.

32. Cole and Srinivasan, "Introduction," xxv. The same woman also appears in another image, called *In the bag / Canton* in *One Time, One Place* and *Jackson / 1930* in *Photographs*.

33. Gombrich, *Art and Illusion*, 90.

34. Welty, preface to *One Time, One Place*, 10.

35. Mississippi Department of Archives and History, Eudora Welty Collection, box 76, folder 4, p. 104.

36. Welty, preface to *One Time, One Place*, 10.

37. Welty, "Ida M'Toy," *Accent* 2 (Summer 1942): 214–22.

38. Welty, "Ida M'Toy," in *Eye of the Story*, 338.

39. Ibid., 343.

40. Welty, preface to *One Time, One Place*, 12.

41. Welty, "Place in Fiction," 125.

42. The Warner mass-market paperback version of *One Writer's Beginnings* follows the original Harvard University Press version in presenting the photographs without overlapping and uses the same corner devices as the original; however, sometimes the photographs are grouped on the page differently, and the back cover photograph is not reproduced. Although *One Time, One Place* is called a family album, most of the photographs from the first book, when reproduced in *Photographs*, have been removed from the narrative sequence and no longer seem as much a family album, though toward the end of *Photographs* a section on Welty's friends and family clearly constitutes a sort of family album.

43. An additional image of her paternal grandfather, captioned "Grandpa Welty and Eudora on his farm near Bremen, Ohio," was originally scheduled to be published in the autobiography, though a similar photograph, showing a baby Welty with her Grandpa Jefferson Welty rocking, is in Black, *Eudora*, 14.

44. Batchen, "*Le Petit Mort*," 3.

45. Quoted in Black, *Eudora*, 4.

46. Lalvani, *Photography, Vision, and the Production of Modern Bodies*, 66.

47. This triple pattern is so common that it occurs everywhere in Welty's work. See, for example, "pervade, pervade, pervade" from *One Writer's Beginnings*, 69; "dip, dip, dip" from "Moon Lake," 343; "put off, put off, put

off" and "honor, honor, honor" from *Delta Wedding*, 99 and 157; "busy, busy, busy" from *The Ponder Heart*, 30; "waiting, waiting, waiting," and "appeals, appeals, appeals," from *Losing Battles*, 20–21, just to name a few.

48. Virtually the same scene occurs in Welty, *Optimist's Daughter*, 139.

49. Almost the same scene occurs in Welty, *Optimist's Daughter*, 138.

50. Cavell, *World Viewed*, 9–20.

51. Ibid., 18.

52. Cole and Srinivasan, "Introduction," xvi.

53. Ibid., xxviii.

Chapter Eight

1. Memoir, the original generic category of *Will's Boy*, has been transformed into autobiography on the cover and title page of *Writing My Life*; however, in the long list of books also written by Wright Morris that appears at the front of *Writing My Life*, *Will's Boy*, *Solo*, and *A Cloak of Light* are still listed under the heading "Memoirs."

2. Morris, *God's Country and My People*, n.p., sixtieth photograph. Subsequent citations appear as page numbers within the text. Morris, *Home Place*, 139.

3. Morris, *Cloak of Light*, 262. Subsequent citations appear as page numbers within the text.

4. Morris, *Will's Boy*, 5. Subsequent citations appear as page numbers within the text.

5. Morris, *Man Who Was There*, 66–67. Subsequent citations appear as page numbers within the text.

6. Morris, "The Romantic Realist," in *Time Pieces*, 26. See Carlisle and Ireland, "Wright Morris," 92–93, for a similar disclaimer.

7. Morris, "How I Put In the Time," 109.

8. Morris, "About Fiction," in *Time Pieces*, 104.

9. Kozloff, *Privileged Eye*, 8.

10. Morris, "Origins," in Knoll, *Conversations with Wright Morris*, 159.

11. When the essay called "Origins: Reflections on Emotion, Memory, and Imagination" in *Conversations with Wright Morris* was republished in his *Time Pieces* under the title "Origins: The Self Imagined," Morris changed the last sentence to "Each time these tokens are handled they give off sparks" (77).

12. Booth and Morris, "Writing of Organic Fiction," 88.

13. Crump, *Novels of Wright Morris*, 120.

14. Morris, "The Camera Eye," in *Time Pieces*, 18.

15. Szarkowski, "Wright Morris the Photographer," 11.

16. Alinder, "Interview," 120.

17. Both of these versions of house and text appear, side by side, in *Time Pieces*, with their captions reversed (24–25).

18. Morris, "Time Pieces,"in *Time Pieces*, 42.

19. Morris, "About Fiction," 127.

20. Wydeven, "Consciousness Refracted," 97.

21. Szarkowski, "Wright Morris: The Photographer," 20. Coleman, *Light Readings*, 244.

22. Alinder, "Interview," 115.

23. Morris, "In Our Image," in *Time Pieces*, 6.

24. Morris, "The Question of Privacy," in *Time Pieces*, 109.

25. Alinder, "Interview," 112.

26. Morris, "Question of Privacy," 109. Morris writes that he left *Bedroom, Home Place, Norfolk, Nebraska, 1947* out of *The Home Place* because of its imbalance of revelation and exposure, adding that it "would find its place in *God's Country and My People* published twenty years later" *(Time Pieces*, 109). I am not sure what Morris meant by the words "find its place," for this photograph does not appear in *God's Country*, though it is in *Origin of a Species* with the title *Bed with Night Pot, Home Place, 1947*. Another photograph of the same room does appear in *The Home Place*, the string across the bed visible in a mirror (122); however, neither the bed nor the chamber pot is visible.

27. Barthes, *Camera Lucida*, 98.

28. Sontag, *On Photography*, 123.

29. Nye, " 'Negative Capability,' " 164.

30. Morris, *Solo*, 194. Morris confirms in "How I Put In the Time" that he remembers no photographs of him as a child (117).

31. Morris, "How I Put In the Time," 115.

32. Solomon-Godeau, *Photography at the Dock*, 180.

33. Phillips, "Words and Pictures," 26.

34. Ibid., 31.

35. Bunnell, "Photography and Reality," 149.

36. Morris, "How I Put In the Time," 113.

37. Phillips, "Words and Pictures," 31.

38. Morris, "Photographs, Images, Words," in *Time Pieces*, 61.

39. Personal correspondence, Wright Morris, November 1, 1995.

40. Morris, *Photographs and Words*, 48.

41. I have shown this image to a number of audiences, and opinion is divided about whether an image of Morris appears in the photograph, more observers disagreeing with me than agreeing.

42. Coleman, *Light Readings*, 245.

43. Barthes, *Camera Lucida*, 81.

44. Walton, "Transparent Pictures," 251. For a counterargument to Walton's, see Currie, "Photography, Painting, and Perception," and Warburton, "Seeing through 'Seeing through Photographs.'"

45. Morris, *Photographs and Words*, 40.

46. Gombrich, "Mask and the Face," 24.

47. Ibid., 8.

48. Morris, "Technique and Raw Material," in *Time Pieces*, 50.

49. Alinder, "Interview," 118.

50. Morris, *Home Place*, 41.

51. In many versions the picture has been reversed, putting the chair on the left rather than right. For Morris's explanation see Alinder, "Interview," 114.

52. The same sort of rearrangement of objects occurs in the case of the various versions of *Dresser Drawer, Ed's Place, 1947*.

53. Morris, *Home Place*, 176.

54. Benjamin, "Short History of Photography," 209.

55. Price, *The Photograph*, 48.

56. Benjamin, "Short History of Photography," 209.

57. Morris, "Photographs, Images, and Words," 65.

58. Morris, *Writing My Life*, 5.

59. Morris, "About Fiction," 104; Morris, "Origins," in *Time Pieces*, 77.

Chapter Nine

1. Price, *The Photograph*, 78.

2. Although not written for publication, the daybooks were a source for several excerpts in magazine articles Weston published during his lifetime.

3. Hoffman, preface to Weston, *Daybooks*, xi; Newhall, foreword to Weston, *Daybooks*, xiii; Bunnell, introduction to *Edward Weston on Photography*, ix.

4. White, "Daybooks of Edward Weston," 13.

5. The collection of notebooks, accounts of sales, addresses, word lists, and diary that Whitman scholars have often referred to as his "Commonplace Book" was published in 1978 as part of *The Collected Writings of Walt Whitman* under Whitman's original title, *Daybooks*. Whitman's daybooks are reflective of the odd combination of life writing usually gathered together under the term: "What characterized the *Daybook* is that Whitman never really made up his mind what he wanted it to be," writes William White,

editor of Whitman's daybooks, adding, "though it does follow a roughly chronological order" (xxii). Florence Howe's preface to Tillie Olsen's *Mother to Daughter, Daughter to Mother, Mothers on Mothering: A Daybook and a Reader*, for instance, emphasizes portability—"We think you will want this book in your purse, pocket, or briefcase, or by your bedside at night, through the year" (vii)—as well as flexibility: "There is room in these pages for your appointments, or your important dates; or for your own thoughts. . . . You can use the book to keep a record of your days or dreams, your notes or numbers" (vii). Barbara Willard asserts that "eighteenth-century ladies changed the name again and called their diaries *day-books*, in which they recorded not only daily events but every kind of household matter—recipes for preserves and puddings and medicines, and kitchen accounts" (*"I". . . An Anthology of Diarists*, 9–10).

6. Martens, *Diary Novel*, 27–28. Willard, *"I". . . An Anthology of Diarists*, 9. For a thorough introduction to the diary genre, see Bunkers and Huff, *Inscribing the Daily*.

7. Weston, *Daybooks of Edward Weston*, 36. Subsequent citations appear as page numbers within the text. I am using the paperback edition in which "I" refers to the Mexico volume and "II" denotes the California volume.

8. May, "Autobiography and the Eighteenth Century," 323–24.

9. Fothergill, "One Day at a Time," 82.

10. Weston, "What Is Photographic Beauty?," 153.

11. Weston, "Random Notes on Photography," 30.

12. Fothergill, "One Day at a Time," 89.

13. Weston, "Seeing Photographically," 142.

14. Nussbaum, "Toward Conceptualizing Diary," 133.

15. Maddow, *Edward Weston*, 73.

16. Newhall, *Edward Weston: The Flame*, 103.

17. Ironically, the frontispiece to the Mexico daybook undercuts the authenticity of the entries that follow because the entry, dated April 20 in the manuscript, is listed in the table of contents as being from 1922, while in the actual daybook entry it is listed under the year 1923.

18. See Stark, *Edward Weston Papers*.

19. Letter dated April 10, 1949, from Nancy Newhall to Edward Weston, in University of Arizona's Center for Creative Photography, Edward Weston Archive, "Correspondence, Incoming (M-New)," box AG 38.

20. In addition to burning his early writing, Weston also destroyed some pages of the first volume after they had been transformed from his handwriting into print by stenographer Christel Gang, who unfortunately also altered his sentences by correcting his punctuation and syntax (*Daybook* I, xvi).

Even more bothersome to Weston was the editorial work of his lifelong friend Ramiel McGehee, who not only edited some of the original pages but also rewrote some sections.

21. Quoted in Canaday, "Review of Edward Weston Nudes," 185. For his second wife's perspective on their life together, see Wilson, *Through Another Lens*.

22. Maddow, *Edward Weston*, 189.

23. Shaw, "On the London Exhibitions," 224.

24. Weston, "What Is a Purist?," 85.

25. See p. x of Beaumont Newhall's foreword to the hardback Aperture version of the *Daybooks* for a brief description of Weston's assistance with the photographs for the Mexico volume. This passage has been cut out of the foreword by the time of the paperback version. Many of the letters in the University of Arizona's Center for Creative Photography Edward Weston Archive from Weston to Nancy Newhall and from Nancy Newhall to Weston discuss which photographs would be most appropriate and who should do the printing. See Stark, *Edward Weston Papers*.

26. Canaday, "Review of Edward Weston Nudes," 185–86.

27. Danto, "From Matchbooks to Masterpieces," 3; see also "War of the Roses," which lists the price as $150,000.

28. Constantine, *Tina Modotti*, 69.

29. Conger, "Tina Modotti and Edward Weston," 72. Maddow erroneously asserts that Weston did not produce any self-portraits (*Edward Weston*, 111).

30. Coke, *Painter and the Photograph*, 65.

31. Weston, "Thirty-five Years of Portraiture," 105.

32. Rivera, "Edward Weston and Tina Modotti," 21–22.

33. D'Attilio and Brenner quoted in Conger, "Tina Modotti and Edward Weston," 63.

34. Conger, "Tina Modotti and Edward Weston," 63–79.

35. Stark, *Letters from Tina Modotti to Edward Weston*, 7.

36. Stark identifies M. as Mary Louis. Ibid., 34.

37. Ibid., 33.

38. Elliot, "Monster as Photographer," 116.

39. Sontag, *On Photography*, 11–12.

40. Price, *The Photograph*, 15.

41. Rosenberg, "Portraits," n.p.

42. Maddow, *Edward Weston*, 104.

43. Letter dated February 15, 1949, from Edward Weston to Nancy Newhall, in University of Arizona's Center for Creative Photography, Edward Weston Archive, "Correspondence, Incoming (M-New)," box AG 38.

44. Weston, "Portrait Photography," 137.

45. Stebbins, *Weston's Westons*, plate 10.

46. Wilkes, "Edward Weston Portraits," 44.

47. Conger, *Edward Weston: Photographs from the Center for Creative Photography*, fig. 112/1924.

48. Conger, "Tina Modotti and Edward Weston," 63.

49. Brilliant, *Portraiture*," 10.

50. Weston, "Portrait Photography" 136.

51. Stark, *Letters from Tina Modotti to Edward Weston*, 39.

52. See Constantine, *Tina Modotti*, and Hooks, *Tina Modotti*.

53. For Antonelli's comic book *Tina*, see http://www.modotti.com/comic.html.

54. Eakin, *Touching the World*, 229.

55. Gibson, *Memories of the Future*, x. According to Margaret Hooks, Tina kept a diary during her earlier years; however, she eventually substituted letters, including letters to Edward, for diary entries. See Hooks, *Tina Modotti*, 92.

56. Gibson, *Memories of the Future*, 45.

57. Weston, "What Is a Purist?," 84–85.

58. See Conger, *Edward Weston: Photographs from the Collection of the Center for Creative Photography*, fig. 104/1923.

59. Szarkowski, *Photography until Now*, 285.

60. Fothergill, "One Day at a Time," 85.

61. Stark, *Letters from Tina Modotti to Edward Weston*, 23.

62. Quoted in ibid., 240.

63. See Newhall, *Supreme Instants*, 44.

64. Quoted in Maddow, *Edward Weston*, 242.

Conclusion

1. Maynard, *Engine of Visualization*, 20.

2. Benjamin, "Short History of Photography," 215.

3. See, for example, Le Guin, "Language of Portraiture."

4. Beaujour, *Poetics of the Literary Self-Portrait*, 2; Jelinek, *Women's Autobiography*, 17.

5. Beaujour, *Poetics of the Literary Self-Portrait*, 33. For a discussion of portraiture within prose, see Meltzer, *Salomé and the Dance of Writing*.

6. Clarke, *Portrait in Photography*, 4.

7. Chevrier, "Image of the Other," 9. This idea is also discussed at length using the term "*allo portrait*" in Hirsch, *Family Frames*, especially in her chapter "Masking the Subject."

8. Quoted in Dugan, "First Person Singular," 20.

9. *Exploring the Unknown Self*, 40.

10. Ibid., 3.

11. Berger, "Fictions of the Pose," 89–90.

12. Quoted in Rosenberg, "Portraits," n.p.

13. Agee and Evans, *Let Us Now Praise Famous Men*, 362. See Stoekl, "Cartier-Bresson," for a discussion of Cartier-Bresson's use of the right angle finder.

14. Roberts, *Recognitions*, ix.

15. For a discussion of the autobiographical implications of Bayard's mock suicide, see Michal Sapir, "Impossible Photograph."

16. Brilliant, *Portraiture*, 7.

17. LeJeune, "Looking at a Self-Portrait," 110.

18. Robinson, "Oscar Gustav Rejlander," 107.

19. Brilliant, *Portraiture*, 26.

20. See Rosenblum, *World History of Photography*, 65.

21. Quoted in Ashton, "Facing a Milieu," 5.

22. Fishkin, "Borges, Stryker, Evans," 268.

23. See Marsh, "Re-Con-Figuring the Body," 31–32.

24. Gaggi, *From Text to Hypertext*, 30.

25. For a complete study, see Grundberg, *Mike and Doug Starn*.

26. Samaras, *Samaras Album*, 9.

27. Wallen, "Between Text and Image," 55.

28. Ollman, *Persona*, 25.

29. Butler, "So How Do I Look?" 58.

30. See Clarke, *The Photograph*, 121.

31. A similar setup characterizes David Attie's *Russian Self-Portraits*, done in a working photo studio, open on one side to the visiting public.

32. Quoted in Hunter, *Image and Word*, 127.

33. Quoted in Maresca, "Photograph One Another," 85.

34. Kozloff, *Lone Visions*, 21.

35. Hoy, *Fabrications*, 72.

36. Asbury, *Self as Subject*, 31. Other photographers featured in *Self as Subject* are Ellen Brooks, Eileen Cowin, Jack Fulton, Judith Golden, Robert Heinecken, Anne Noggle, Esther Parada, Barbara Jo Revelle, Diane Schoenfeld, Keith Smith, Alex Traube, and Gwen Widmer.

37. Quoted in Cohen, *In/Sights*, 116.

38. Mayer's *Memory* is described in detail in Coleman, *Light Readings*, 98.

39. Bowermaster, *Adventures and Misadventures of Peter Beard in Africa*, 104.

40. Agee and Evans, *Let Us Now Praise Famous Men*, 13.

41. Isay and Wang, *Holding On*, 26–31.

42. See http://www.jennicam.org.

43. Green, *American Photography*, 210. Others named by Green include Meridel Rubenstein, Jacqueline Livingston, Joel Slayton, and Allan Sekula. See also Coleman's "Autobiographical Mode in Photography." Coleman names the following as examples: Lee Friedlander, Lucas Samaras, Mike Mandel, David Pond-Smith, Adal Maldonado, Arthur Tress, Athena Tacha, Dave Heath, John Max, Michael Martone, Nancy Rexroth, Elsa Dorfman, J. H. Lartigue, Wall Batterton, Judy Levy, Adrienne Landau, Robert Delford Brown, Raymond Muxter, Mark and Don Jury, Catherine Noren, Robert Cummings, Mark Silber, and Ralph Eugene Meatyard.

44. See Gangitano, *Boston School*.

45. Desmarais, "From Social Criticism to Art World Cynicism." Desmarais adds Eleanor Antin, William DeLappa, Marcia Resnick, Douglas Huebler, Mark Berghash, and Emmet Gowin.

46. Gauss, *New American Photography*, 58–59.

47. See Foerster, "Portraits Recall Horror of Holocaust," 83.

48. Kozloff, *Photography and Fascination*, 91.

49. See Leonard, "Not Losing Her Memory."

50. The list of family traits is taken from ibid., 670.

51. Quoted in Steiner, "Semiotics of a Genre," 115.

52. Powers, *Three Farmers*, 321–22.

53. Eakin, *Touching the World*, 30.

Works Cited

Adams, Raymond F. *A Fitting Death for Billy the Kid*. Norman: University of Oklahoma Press, 1960.

Adams, Timothy Dow. "Autobiographical Rhetoric in Hawthorne's Prefaces." *ESQ* 23 (1977): 88–98.

——, ed. "Autobiography, Photography, Narrative." *Modern Fiction Studies* 40.3 (Fall 1994).

Ades, Dawn. "Duchamp's Masquerades." In Clarke, *Portrait in Photography*, 94–114.

Adkins, Camille. "Interview with N. Scott Momaday." In Schubnell, *Conversations with N. Scott Momaday*, 216–34.

Agee, James, and Walker Evans. *Let Us Now Praise Famous Men: Three Tenant Families*. Boston: Houghton-Mifflin, 1941.

Alexander, George. "Elusions, or Trying to Catch the Absolute in a Mousetrap: Postphotography and Fascination." In Fereday and Koop, *Post: Photography Post Photography*, 12–26.

Alinder, James. "Interview." In Morris, *Structures and Artifacts*, 110–20.

——, ed. *Self=Portrayal: The Photographer's Image*. Carmel, Calif.: Friends of Photography, 1978.

Antonelli, Pino. *Tina*. http://www.modotti.com/comic.html.

Armstrong, Carol. "Reflections on the Mirror: Painting, Photography, and the Self-Portraits of Edgar Degas." *Representations* 22 (1988): 108–41.

Arnheim, Rudolph. "On the Nature of Photography." *Critical Inquiry* 1.1 (Autumn 1974): 149–61.

Asbury, Dana, ed. *Self as Subject: Visual Diaries by Fourteen Photographers*. Albuquerque, N.Mex.: University Art Museum, 1984.

Ashforth, Alden. "The Bolden Band Photo—One More Time." *Annual Review of Jazz Studies* 3 (1985): 171–80.

Ashton, Dore. "Facing a Milieu." Foreword to *Eye to Eye: The Camera Remembers: Portrait Photographs by Renate Ponsold*. New York: Hudson Hills Press, 1988.

Attie, David. *Russian Self-Portraits*. New York: Harper & Row, 1977.

Auster, Paul. "From *The Invention of Solitude*." *Aperture* 114 (Spring 1989): 24–26.

——. *The Invention of Solitude*. New York: Penguin, 1988.

Avedon, Richard. *An Autobiography*. New York: Random House, 1993.

Baldwin, Gordon. *Looking at Photographs: A Guide to Technical Terms*. Malibu, Calif.: J. Paul Getty Museum in association with British Museum Press, 1991.

Barbour, Douglas. *Michael Ondaatje*. New York: Twayne Publishers, 1993.

Barthelme, Donald. *The Dead Father*. New York: Farrar, Straus, 1975.

Barthes, Roland. *Camera Lucida: Reflections on Photography*. Translated by
Richard Howard. New York: Farrar, Straus, Giroux, 1981.

———. "The Photographic Message." In his *Image—Music—Text*, translated by
Stephen Heath, 15–31. New York: Hill and Wang, 1977.

———. *Roland Barthes by Roland Barthes*. 1975. Translated by Richard Howard.
New York: Hill and Wang, 1977.

Batchen, Geoffrey. "*Le Petit Mort*: Photography and Pose." *SF Camerawork
Quarterly* 15.1 (1988): 3–6.

Bazin, André. "Ontology of the Photographic Image." In Trachtenberg,
Classic Essays on Photography, 237–44.

Beard, Peter. *Diary of Peter Beard*. Tokyo: Libro Port, 1993.

Beaujour, Michel. *Poetics of the Literary Self-Portrait*. Translated by Yara Milos.
New York: New York University Press, 1991.

Begley, Adam. "Case of the Brooklyn Symbolist." *New York Times Magazine*,
August 30, 1992, 41, 52–53.

Beimler, Rosalind Rosoff, and John Greenleigh. *The Days of the Dead: Mexico's
Festival of Communion with the Departed*. San Francisco: Collins Publishers,
1991.

Bell, Bob Bose. *The Illustrated Life and Times of Billy the Kid*. Phoenix: Tri-Star-
Boze Productions, 1996.

Benjamin, Walter. "A Short History of Photography." In Trachtenberg, *Classic
Essays on Photography*, 199–216.

Berger, Harry, Jr. "Fictions of the Pose: Facing the Gaze of Early Modern
Portraiture." *Representations* 46 (Spring 1994): 87–120.

Berger, John, and Jean Mohr. *Another Way of Telling*. New York: Pantheon, 1982.

Black, Max. "How Do Pictures Represent?" In Mandelbaum, *Art, Perception,
and Reality*, 95–130.

Black, Patti Carr, ed. *Eudora*. Jackson: Mississippi Department of Archives
and History, 1984.

Bloom, Harold. *Eudora Welty*. New York: Chelsea, 1986.

Blott, Ann. "Stories to Finish: *The Collected Works of Billy the Kid*." *Studies in
Canadian Literature* 2 (Summer 1977): 188–202.

Bogardus, Ralph F. *Pictures and Text: Henry James, A. L. Coburn, and New Ways of
Seeing in Literary Culture*. Ann Arbor: UMI Research Press, 1984.

Bolles, Edmund Blair. *Remembering and Forgetting: Inquires into the Nature of
Memory*. New York: Walker and Co., 1988.

Bolton, Richard, ed. *The Contest of Meaning: Critical History of Photography*.
Cambridge: MIT Press, 1989.

Bonetti, Kay. "An Interview with Maxine Hong Kingston." Audio cassette from American Audio Prose Library, 1986.

Booth, Wayne C., and Wright Morris. "The Writing of Organic Fiction: A Conversation between Wayne C. Booth and Wright Morris." In Knoll, *Conversations with Wright Morris*, 74–100.

Bourdieu, Pierre. *Photography: A Middle Brow Art*. Translated by Shaun Whiteside. Stanford: Stanford University Press, 1990.

Bowermaster, Jon. *The Adventures and MisAdventures of Peter Beard in Africa*. Boston: Little, Brown, Bullfinch Press, 1993.

Brady, Laura. "Recuerdos and Re-Collections: Living Stories New and Old." Paper delivered at the Conference on College Composition and Communication, Chicago, 1998.

Brilliant, Richard. *Portraiture*. Cambridge: Harvard University Press, 1991.

Brookhart, Mary Hughes. "Reviews of *One Writer's Beginnings*: A Preliminary Checklist." *Eudora Welty Newsletter* 8.2 (Summer 1984): 1–4.

Brown, Mark Herbert, and W. R. Felton. *The Frontier Years: L. A. Huffman, Photographer of the Plains*. New York: Holt, 1955.

Bruce-Novoa, Juan. "Sheila Ortiz Taylor's *Faultline: A Third-Woman Utopia*." *Confluencia: Revista Hispanica de Cultura y Literatura* 6.2 (Spring 1991): 75–87.

Bruckner, Pascal. "Paul Auster, or The Heir Intestate." Translated by Karen Palmunen. In *Beyond the Red Notebook: Essays on Paul Auster*, edited by Dennis Barone, 27–33. Philadelphia: University of Pennsylvania Press, 1995.

Bruner, Jerome. "The Autobiographical Process." In Folkenflik, *Culture of Autobiography*, 38–56.

Bruss, Elizabeth. *Autobiographical Acts: The Changing Situation of a Literary Genre*. Baltimore: Johns Hopkins University Press, 1976.

Bryant, Marsha, ed. *Photo-Textualities: Reading Photographs and Literature*. Newark: University of Delaware Press, 1996.

Bunkers, Suzanne L. "Midwestern Diaries and Journals: What Women Were (Not) Saying in the Late 1800s." In Olney, *Studies in Autobiography*, 190–210.

Bunkers, Suzanne L., and Cynthia A. Huff, eds. *Inscribing the Daily: Critical Essays on Women's Diaries*. Amherst: University of Massachusetts Press, 1996.

Bunnell, Peter C., ed. *Edward Weston on Photography*. Salt Lake City, Utah: Peregrine Smith, 1983.

———. "Photography and Reality: A Conversation between Peter C. Bunnell and Wright Morris." In Knoll, *Conversations with Wright Morris*, 140–52.

Bunnell, Peter C., and David Featherstone, eds. *EW 100: Centennial Essays*. Carmel, Calif.: Friends of Photography, 1986.

Bunting, Charles T. " 'The Interior World': An Interview with Eudora Welty." In Prenshaw, *Conversations with Eudora Welty*: 40–63.

Burson, Nancy, Richard Carling, and David Kramlich. *Composites: Computer Generated Portraits*. New York: Beech Tree Books, 1986.

Buss, Helen M. *Mapping Our Selves: Canadian Women's Autobiography*. Montreal: McGill-Queens University Press, 1993.

——. *Memoirs from Away: A New Found Land Girlhood*. Waterloo: Wilfrid Laurier University Press, 1999.

Butler, Susan. "Between Frames." In Heron and Williams, *Illuminations*, 386–93.

——. "So How Do I Look?" In Lingwood, *Staging the Self*, 51–59.

Canaday, John. "Review of Edward Weston Nudes: Sixty Photographs, Remembrance by Charis Wilson." In Newhall and Conger, *Edward Weston*, 184–86.

Cantú, Norma Elia. *Canícula: Snapshots of a Girlhood en la Frontera*. Albuquerque: University of New Mexico Press, 1995.

Cardinal, Roger. "Nadar and the Photographic Portrait in Nineteenth-Century France." In Clarke, *Portrait in Photography*, 6–24.

Carlisle, Olga, and Jodie Ireland. "Wright Morris: The Art of Fiction CXXV." *Paris Review* 33 (1991): 52–94.

Cavell, Stanley. "What Photography Calls Thinking." *Raritan* 4.4 (Spring 1985): 1–21.

——. *The World Viewed: Reflections on the Ontology of Film*. New York: Viking, 1971.

Caws, Mary Ann. *The Art of Interference: Stressed Readings in Verbal and Visual Texts*. Princeton: Princeton University Press, 1989.

Champion, Larry, ed. *The Critical Response to Eudora Welty's Fiction*. Westport, Conn.: Greenwood Press, 1994.

Chen, Jack. *The Chinese of America*. San Francisco: Harper, 1980.

Chevrier, Jean-François. "The Image of the Other." In Lingwood, *Staging the Self*, 9–15.

Chin, Frank. "This Is Not an Autobiography." *Genre* 17 (Summer 1985): 109–30.

Christian, Karen. "Will the 'Real Chicano' Please Stand Up?: The Challenge of John Rechy and Sheila Ortiz Taylor to Chicano Essentialism." *Americas Review* 20.2 (Summer 1992): 89–104.

Ciuba, Gary M. "Time as Confluence: Self and Structure in Welty's *One Writer's Beginnings*." *Southern Literary Journal* 26.1 (Fall 1993): 78–93.

Clark, Larry. *Tulsa*. New York: Rapoport, 1971.

Clarke, Graham. *The Photograph*. New York: Oxford University Press, 1997.

——, ed. *The Portrait in Photography*. London: Reaktion Books, 1992.

Cohen, Joyce Tenneson, ed. *In/Sights: Self-Portraits by Women*. Boston: David R. Godine, 1978.

Coke, Van Deren. *The Painter and the Photograph*. Albuquerque: University of New Mexico Press, 1964.

Cole, Hunter, and Seetha Srinivasan. "Introduction: Eudora Welty and Photography: An Interview." In Welty, *Photographs*, xii–xxviii.

Coleman, A. D. "The Autobiographical Mode in Photography." In his *Tarnished Silver*, 129–40.

———. "The Directorial Mode: Notes toward a Definition." In his *Light Readings*, 246–57.

———. "Hybridization: A Photographic Tradition." In his *Tarnished Silver*, 153–59.

———. *Light Readings: A Photography Critic's Writings, 1968–1978*. New York: Oxford University Press, 1979.

———. "Novel Pictures: The Photofiction of Wright Morris." In his *Light Readings*, 242–46.

———. *Tarnished Silver: After the Photo Boom, Essays and Lectures 1979–1989*. New York: Midmarch Arts Press, 1996.

Conger, Amy. *Edward Weston: Photographs from the Collection of the Center for Creative Photography*. Tucson: Center for Creative Photography, 1992.

———. *Edward Weston in Mexico, 1923–1926*. Albuquerque: University of New Mexico Press, 1983.

———. "Tina Modotti and Edward Weston: A Re-evaluation of Their Photography." In Bunnell and Featherstone, *EW 100: Centennial Essays*, 62–79.

Constantine, Mildred. *Tina Modotti: A Fragile Life*. San Francisco: Chronicle Books, 1993.

Couser, G. Thomas, and Joseph Fichtelberg, eds. *True Relations: Essays on Autobiography and the Postmodern*. Westport, Conn.: Greenwood Press, 1998.

Creekmur, Corey K. "Lost Objects: Photography, Fiction, and Mourning." In Bryant, *Photo-Textualities*, 73–82.

Crump, G. B. *The Novels of Wright Morris: A Critical Interpretation*. Lincoln: University of Nebraska Press, 1978.

Currie, Gregorie. "Photography, Painting, and Perception." *Journal of Aesthetics and Art Criticism* 49.1 (Winter 1991): 23–29.

Daguerre, Louis Jacques Mandé. "Daguerreotype." In Trachtenberg, *Classic Essays on Photography*, 11–13.

Danto, Arthur C. "From Matchbooks to Masterpieces: Toward a Philosophy of Collecting." *Aperture* 124 (Summer 1991): 2–3.

DeLappe, Joseph. "Statement and Slide List." Personal correspondence, May 1994.

De Man, Paul. "Autobiography as De-Facement." In his *The Rhetoric of Romanticism*, 67–81. New York: Columbia University Press, 1984.

Derrida, Jacques. *Writing and Difference*. Chicago: University of Chicago Press, 1978.

Desmarais, Charles. "From Social Criticism to Art World Cynicism: 1970–1980." In *Decade by Decade: Twentieth-Century American Photography from the Collection of the Center for Creative Photography*, edited by James Enyeart, 85–102. Boston: Little, Brown, 1989.

Devlin, Albert J. *Welty: A Life in Literature*. Jackson: University Press of Mississippi, 1987.

Doyle, Laura. Review of Robin Weigman's *American Anatomies: Theorizing Race and Gender*." *Modern Fiction Studies* 43.2 (Summer 1997): 457–58.

Dugan, Ellen. "First Person Singular: Self-Portrait Photography, 1840–1987." Atlanta: High Museum of Art, 1987.

Eakin, Paul John. *Fictions in Autobiography: Studies in the Art of Self-Representation*. Princeton: Princeton University Press, 1985.

———. "Relational Selves, Relational Lives: The Story of the Story." In Couser and Fichtelberg, *True Relations*, 63–68.

———. *Touching the World: Reference in Autobiography*. Princeton: Princeton University Press, 1992.

———, ed. *American Autobiography: Retrospect and Prospect*. Madison: University of Wisconsin Press, 1991.

Edwards, Elizabeth, ed. *Anthropology and Photography, 1860–1920*. New Haven: Yale University Press, 1992.

Elliot, George P. "The Monster as Photographer." In Newhall and Conger, *Edward Weston*, 114–16.

Estes, Clarissa Pinkola. *Women Who Run with the Wolves: Myths and Stories of the Wild Woman Archetype*. New York: Ballantine, 1995.

Exploring the Unknown Self: Self-Portraits of Contemporary Women. Tokyo: Tokyo Metropolitan Museum of Photography, 1991.

Featherstone, David, ed. *Observations: Essays on Documentary Photography*. Carmel, Calif.: Friends of Photography, 1984.

Fereday, Susan, and Stuart Koop, eds. *Post: Photography Post Photography*. Victoria, Australia: Centre for Contemporary Photography, 1995.

Ferris, Bill. "A Visit with Eudora Welty." In Prenshaw, *Conversations with Eudora Welty*, 154–71.

Fichtelberg, Joseph. "Poet and Patriarch in Maxine Hong Kingston's *China Men*." *Prose Studies* 14.2 (September 1991): 166–85.

Fiskin, Judy. "Borges, Stryker, Evans: The Sorrows of Representation." In Younger, *Multiple Views*, 247–69.

Fleishman, Avrom. *Figures in Autobiography: The Language of Self-Writing*. Berkeley: University of California Press, 1983.

Foerster, Abigail. "Portraits Recall Horror of Holocaust." *Chicago Tribune*, February 11, 1994, sec. 7, p. 83.

Folkenflik, Robert, ed. *The Culture of Autobiography: Constructions of Self-Representation*. Stanford: Stanford University Press, 1993.

Fothergill, Robert. "One Day at a Time: The Diary as Lifewriting." *a/b: Auto/Biography Studies* 10.1 (Spring 1995): 81–91.

Frank, Robert. *The Lines of My Hand*. New York: Lustrum Press, 1972.

Freeman, Mark. *Rewriting the Self: History, Memory, Narrative*. New York: Routledge, 1993.

Gaggi, Silvio. *From Text to Hypertext: Decentering the Subject in Fiction, Film, the Visual Arts, and Electronic Media*. Philadelphia: University of Pennsylvania Press, 1997.

Gangitano, Lia. *Boston School*. Boston: Institute of Contemporary Art, 1995.

Garrett, Pat F. *The Authentic Life of Billy, the Kid: A Faithful and Interesting Narrative*. 1882. Reprint, Norman: University of Oklahoma Press, 1954.

Gauss, Kathleen McCarthy. *New American Photography*. Los Angeles: Los Angeles County Museum of Art, 1985.

Gibson, Margaret. *Memories of the Future: The Daybooks of Tina Modotti*. Baton Rouge: Louisiana State University Press, 1986.

Godard, Barbara. "Stretching the Story: The Canadian Story Cycle." *Open Letter* 7.2 (Fall 1989): 27–71.

Goldberg, Vicki. "Photos That Lie—and Tell the Truth." *New York Times*, March 16, 1997, sec. 2, pp. 1, 34.

———. *The Power of Photography: How Photographs Changed Our Lives*. New York: Abbeville Press, 1991.

———, ed. *Photography in Print: Writings from 1816 to the Present*. Albuquerque: University of New Mexico Press, 1981.

Gombrich, E. H. *Art and Illusion: A Study of the Psychology of Pictorial Representation*. 2d ed. Princeton: Princeton University Press, 1989.

———. "The Mask and the Face: The Perception of Physiognomic Likeness." In Mandelbaum, *Art, Perception, and Reality*, 1–46.

Green, David. "Veins of Resemblance: Photography and Eugenics." In *Photography/Politics: Two*, edited by Patricia Holland, Jo Spence, and Simon Watney, 9–21. London: Comedia, 1986.

Green, Jonathan. *American Photography: A Critical History, 1945–Present*. New York: Abrams, 1984.

Green-Lewis, Jennifer. *Framing the Victorians: Photography and the Culture of Realism*. Ithaca, N.Y.: Cornell University Press, 1996.

Grundberg, Andy. *Mike and Doug Starn*. New York: Abrams, 1990.

———. "Photography beside Itself." In *After Art: Rethinking 150 Years of*

Photography, edited by Robert Longo, 9–18. Seattle: University of Washington Press, 1994.

Guest, Barbara. *Herself Defined: The Poet H.D. and Her World.* New York: Doubleday, 1985.

Guggenheim, Charles, ed. *Clear Pictures.* Washington, D.C.: Guggenheim Productions, 1994.

Gunn, Janet Varner. *Autobiography: Towards a Poetics of Experience.* Philadelphia: University of Pennsylvania Press, 1982.

———. *Second Life: A West Bank Memoir.* Minneapolis: University of Minnesota Press, 1995.

Gutiérrez, Ramón, William Beezley, and Salvatore Scalora, eds., and Dana Salvo, photographer. *Home Altars of Mexico.* Albuquerque: University of New Mexico Press, 1997.

Heble, Ajay. "Michael Ondaatje and the Problem of History." *Clio* 19.2 (Winter 1990): 97–110.

Heron, Liz, and Val Williams, eds. *Illuminations: Women Writing on Photography from the 1850s to the Present.* Durham, N.C.: Duke University Press, 1996.

Hine, Lewis. "Social Photography." In Trachtenberg, *Classic Essays on Photography*, 110–13.

Hirsch, Marianne. *Family Frames: Photography, Narrative, and Postmemory.* Cambridge: Harvard University Press, 1997.

Hochberg, Julian. "The Representation of Things and People." In Mandelbaum, *Art, Perception, and Reality*, 47–94.

Hochbruck, Wolfgang. "Metafictional Biography: Michael Ondaatje's *Coming through Slaughter* and *The Collected Works of Billy the Kid*." In *Historiographic Metafiction in Modern American and Canadian Literature*, edited by Bernd Engler and Kurt Müller, 447–63. Munich: Ferdinand Schöningh, 1994.

Hoffman, Michael. Preface to Edward Weston, *The Daybooks of Edward Weston.* Edited by Nancy Newhall. New York: Aperture, 1990.

Holman, C. Hugh, and William Harmon, eds. *A Handbook to Literature*, 5th ed. New York: Macmillan, 1986.

Holmes, Oliver Wendell. "Sun-Painting and Sun-Sculpture, with a Stereoscopic Trip across the Atlantic." *Atlantic Monthly* 8 (July 1861): 13–26.

Hooks, Margaret. *Tina Modotti: Photographer and Revolutionary.* London: Pandora, 1993.

Horno-Delgado, Asunción, Eliana Ortega, Nina M. Scott, and Nancy Saporta Sternbach, eds. *Breaking Boundaries: Latina Writings and Critical Readings.* Amherst: University of Massachusetts Press, 1989.

Howarth, William L. "Some Principles of Autobiography." In Olney, *Autobiography: Essays Theoretical and Critical*, 84–114.

Howe, Florence. Preface to *Mother to Daughter, Daughter to Mother, Mothers on Mothering: A Daybook and Reader*, selected and shaped by Tillie Olsen. Old Westbury, N.Y.: Feminist Press, 1984.

Hoy, Anne H. *Fabrications: Staged, Altered, and Appropriated Photographs*. New York: Abbeville Press, 1987.

Humphreys, Josephine. "My Real Invisible Self." In *A World Unsuspected: Portraits of Southern Childhood*, edited and with an introduction by Alex Harris, 1–13. Chapel Hill: University of North Carolina Press for the Center for Documentary Photography, 1987.

Hunter, Jefferson. *Image and Word: The Interaction of Twentieth-Century Photographs and Texts*. Cambridge: Harvard University Press, 1987.

Hutcheon, Linda. *The Canadian Postmodern*. Toronto: Oxford University Press, 1988.

Ignatieff, Michael. *The Russian Album*. New York: Viking, 1987.

Isay, David, and Henry Wang. *Holding On: Dreamers, Visionaries, Eccentrics, and Other American Heroes*. New York: Norton, 1996.

Iser, Wolfgang. *The Fictive and the Imaginary: Charting Literary Anthropology*. Baltimore: Johns Hopkins University Press, 1993.

Islas, Arturo. "Maxine Hong Kingston." In *Women Writers of the West Coast: Speaking of Their Lives and Careers*, edited by Marilyn Yalom, 11–19. Santa Barbara, Calif.: Capra Press, 1983.

Jacobs, Naomi. *The Character of Truth: Historical Figures in Contemporary Fiction*. Carbondale: Southern Illinois University Press, 1990.

Jakobson, Roman. "The Metaphoric and Metonymic Poles." In his *Fundamentals of Language*, 76–82. The Hague: Mouton, 1956.

Jammes, André, and Eugenia Parry Janis. *The Art of French Calotype*. Princeton: Princeton University Press, 1983.

Jaubert, Alain. *Making People Disappear: An Amazing Chronicle of Photographic Deception*. McLean, Va.: Pergamon-Brassey's International Defense Publishers, 1989.

Jay, Paul. "Posing: Autobiography and the Subject of Photography." In *Autobiography and Postmodernism*, edited by Kathleen Ashley, Leigh Gilmore, and Gerald Peters, 191–211. Amherst: University of Massachusetts Press, 1994.

Jelinek, Estelle C., ed. *Women's Autobiography: Essays in Criticism*. Bloomington: Indiana University Press, 1980.

Jewinsky, Ed. *Michael Ondaatje: Express Yourself Beautifully*. Toronto: ECW Press, 1994.

Johnson, Brooks, ed. *Photography Speaks: Sixty-six Photographers on Their Art*. New York: Aperture/Chrysler Museum, 1989.

Jones, Manina. "*The Collected Works of Billy the Kid*: Scripting the Docudrama." *Canadian Literature* 122–23 (Autumn–Winter 1989): 26–38.

Kamboureli, Smaro. "The Alphabet of the Self: Generic and Other Slippages in Michael Ondaatje's *Running in the Family*." In *Reflections: Autobiography and Canadian Literature*, edited by K. P. Stich, 79–91. Ottawa: University of Ottawa Press, 1988.

———. *On the Edge of Genre: The Contemporary Canadian Long Poem*. Toronto: University of Toronto Press, 1991.

———. "The Poetics of Geography in Michael Ondaatje's *Coming through Slaughter*." *Descant* 14.4 (Fall 1983): 112–26.

Kaufman, Wallace. "Notice, I'm Still Smiling: Reynolds Price." In *Conversations with Reynolds Price*, edited by Jefferson Humphries, 5–29. Jackson: University Press of Mississippi, 1991.

Kazin, Alfred. "Autobiography as Narrative." *Michigan Quarterly Review* 3 (Fall 1964): 210–16.

Kendall, Paul Murray. *The Art of Biography*. New York: Norton, 1965.

Kennedy, J. Gerald. "Roland Barthes, Autobiography, and the End of Writing." *Georgia Review* 35 (Summer 1981): 381–98.

King, Tom. "A MELUS Interview: N. Scott Momaday on Literature and the Native Writer." *MELUS* 10.4 (Winter, 1983): 66–72.

Kingston, Maxine Hong. *China Men*. New York: Alfred A. Knopf, 1980. Reprint, New York: Vintage International, 1989.

———. "Cultural Mis-readings by American Reviewers." In *Asian and Western Writers in Dialogue: New Cultural Identities*, edited by Guy Amirthanayagam, 55–65. London: Macmillan, 1982.

———. "Reservations about China." *Ms.* (October 1978): 67–68.

———. *Through the Black Curtain*. Berkeley: Arion Press for the Friends of the Bancroft Library, 1987.

———. *The Woman Warrior: Memoirs of a Girlhood among Ghosts*. New York: Alfred A. Knopf, 1976. Reprint, New York: Vintage International, 1989.

Knoll, Robert E. *Conversations with Wright Morris: Critical Views and Responses*. Lincoln: University of Nebraska Press, 1977.

Kozloff, Max. *Lone Visions, Crowded Frames: Essays on Photography*. Albuquerque: University of New Mexico Press, 1994.

———. *Photography and Fascination*. Danbury, N.H.: Addison House, 1979.

———. *The Privileged Eye: Essays on Photography*. Albuquerque: University of New Mexico Press, 1987.

———. "Variations on a Theme of Portraiture." In his *Lone Visions, Crowded Frames*, 21–41.

Krauss, Rosalind. "A Note on Photography and the Simulacral." In *The Critical*

Image: Essays on Contemporary Photography, edited by Carol Squiers, 15–27. Seattle: Bay Press, 1990.

———. "The Photographic Conditions of Surrealism." *October* 19 (Fall 1981): 3–34.

———. "Tracing Nadar." In Heron and Williams, *Illuminations*, 37–49.

Kreyling, Michael. *Author and Agent: Eudora Welty and Diarmuid Russell*. New York: Farrar, Straus, Giroux, 1991.

———. "Subject and Object in *One Writer's Beginnings*." *Mississippi Quarterly* 39 (Fall 1986): 627–38.

Krupat, Arnold. *Ethnocriticism: Ethnography, History, Literature*. Berkeley: University of California Press, 1992.

———. "Native American Autobiography and the Synecdochic Self." In Eakin, *American Autobiography*, 171–94.

———. *The Voice in the Margin: Native American Literature and the Canon*. Berkeley: University of California Press, 1989.

Kuhn, Annette. "Remembrance." In Heron and Williams, *Illuminations*, 471–78.

Lalvani, Suren. *Photography, Vision, and the Production of Modern Bodies*. Albany: State University of New York Press, 1995.

Lambrecht, Eric, and Luc Salu, eds. *Photography and Literature: An International Bibliography of Monographs*. London: Mansell, 1992.

Le Guin, Charles A. "The Language of Portraiture." *Biography* 6.4 (Fall 1983): 333–41.

Leibowitz, Herbert. *Fabricating Lives: Explorations in American Autobiography*. New York: Alfred A. Knopf, 1989.

Lejeune, Philippe. "The Autobiographical Pact." In his *On Autobiography*, 3–30.

———. "The Autobiographical Pact (bis)." In his *On Autobiography*, 119–37.

———. "Looking at a Self-Portait." In his *On Autobiography*, 109–18.

———. *On Autobiography*. Edited and with a foreword by Paul John Eakin. Translated by Katherine Leary. Minneapolis: University of Minnesota Press, 1989.

Leonard, Joanne. "Not Losing Her Memory: Stories in Photographs, Words, and Collage." *Modern Fiction Studies* 40.3 (Fall 1994): 657–85.

Leong, Russell. "Frank Chin: An Authentic One." *Amerasia Journal* 14.2 (1988): 162–64.

Lesy, Michael. *Wisconsin Death Trip*. New York: Pantheon, 1973.

Lewitt, Sol. *Autobiography*. New York: Multiples, 1980.

Ling, Amy. "Writer in the Hyphenated Condition: Diana Chang." *MELUS* 17 (Winter 1980): 69–83.

Lingwood, James, ed. *Staging the Self: Self-Portrait Photography, 1840s–1980s*. London: National Portrait Gallery, 1987.

Lorinc, John. Review of *The Man-Eater of Punanai*. *Toronto Globe and Mail*, April 18, 1992, C15.

MacLaine, Brent. "Photofiction as Family Album: David Galloway, Paul Theroux, and Anita Brookner." *Mosaic* 24.2 (Spring 1991): 131–49.

MacLulich, T. D. "Ondaatje's Mechanical Boy: Portrait of the Artist as Photographer." *Mosaic* 14.2 (Spring 1981): 107–19.

MacNeil, Robert. *Eudora Welty: Seeing Black and White*. Jackson: University Press of Mississippi, 1990.

Maddow, Ben. *Edward Weston: His Life*. New York: Aperture, 1989.

Malraux, André. *Lazarus*. Translated by Terence Kilmartin. New York: Holt, Rinehart and Winston, 1977.

Mandelbaum, Maurice, ed. *Art, Perception, and Reality: E. H. Gombrich, Julian Hochberg, Max Black*. Baltimore: Johns Hopkins University Press, 1972.

Mann, Charles. "Eudora Welty, Photographer." *History of Photography* 6 (April 1982): 145–49.

Maresca, Sylvain. "Photograph One Another: Or The Ambiguous Celebrations of the Institution of Photography." *La Recherche Photographique* 14 (Spring 1993): 81–85.

Marquis, Donald M. *In Search of Buddy Bolden: First Man of Jazz*. Baton Rouge: Louisiana State University Press, 1978.

Marrs, Suzanne. "Eudora Welty's Photography: Images into Fiction." In Turner and Harding, *Critical Essays on Eudora Welty*, 280–96.

——. *The Welty Collection: A Guide to the Eudora Welty Manuscripts and Documents at the Mississippi Department of Archives and History*. Jackson: University Press of Mississippi, 1989.

Marsh, Anne. "Re-Con-Figuring the Body: The Theatre of Photography." In Fereday and Koop, *Post: Photography Post Photography*, 31–32.

Martens, Lorna. *The Diary Novel*. New York: Cambridge University Press, 1985.

May, Georges. "Autobiography and the Eighteenth Century." In *The Author and His Work: Essays on a Problem in Criticism*, edited by Louis L. Martz and Aubrey Williams, 319–35. New Haven: Yale University Press, 1978.

Mayhall, Mildred P. *The Kiowas*. Rev. ed. Norman: University of Oklahoma Press, 1962.

Maynard, Patrick. *The Engine of Visualization: Thinking through Photographs*. Ithaca, N.Y.: Cornell University Press, 1997.

McCaffery, Larry, and Sinda Gregory. "An Interview with Paul Auster." *Contemporary Literature* 33.1 (Spring 1992): 1–23.

——. "An Interview with Paul Auster." *Mississippi Review* 20 (1991): 49–62.

McCauley, Anne. "François Arago and the Politics of the French Invention of Photography." In Younger, *Multiple Views*, 43–69.

McHale, Brian. *Postmodernist Fiction*. New York: Routledge, 1991.

McKenzie, Barbara. "The Eye of Time: The Photographs of Eudora Welty."
In Prenshaw, *Eudora Welty, Critical Essays*, 386–400.

Meese, Elizabeth A. "Constructing Time and Place: Eudora Welty In the
Thirties." In Prenshaw, *Eudora Welty, Critical Essays*, 401–10.

Meltzer, Françoise. *Salomé and the Dance of Writing: Portraits of Mimesis in
Literature*. Chicago: University of Chicago Press, 1987.

Melville, Stephen W. "The Time of Exposure: Allegorical Self-Portraiture in
Cindy Sherman." *Arts Magazine* 60.5 (January 1986): 17–21.

Meskimmon, Marsha. "The Autobiographical Model." In her *The Art of
Reflection: Women Artists' Self-Portraiture in the Twentieth Century*, 64–101. New
York: Columbia University Press, 1996.

Michals, Duane. "I Am Much Nicer Than My Face and Other Thoughts
about Portraiture." In *Album: The Portraits of Duane Michals, 1958–1988*.
Pasadena, Calif.: Twelve Trees Press, 1988.

Mitchell, W. J. T. *Iconology: Image, Text, Ideology*. Chicago: University of Chicago
Press, 1986.

———, ed. *The Languages of Images*. Chicago: University of Chicago Press, 1980.

Mitchell, William J. *The Reconfigured Eye: Visual Truth in the Post-Photographic Era*.
Cambridge: MIT Press, 1992.

Momaday, N. Scott. *The Ancient Child*. New York: Doubleday, 1989.

———. *The Gourd Dancer*. New York: Harper & Row, 1976.

———. "Looking at Life with Journal and Lens." *Viva: Northern New Mexico's
Sunday Magazine*, September 17, 1972, 2.

———. "The Man Made of Words." In *The Remembered Earth: An Anthology of
Contemporary Native American Literature*, edited by Geary Hobson, 162–173.
Albuquerque: University of New Mexico Press, 1979.

———. *The Names: A Memoir*. Tucson: University of Arizona Press, 1976.

———. "The Photography of Horace Poolaw." *Aperture* 139 (Summer 1995):
14–19.

———. "The Strange and True Story of My Life with Billy the Kid." *American
West* 22.5 (September–October 1985): 54–55.

———. *The Way to Rainy Mountain*. New York: Ballantine, 1969.

———. With David Muench. *Colorado: Summer, Fall, Winter, Spring*. New York:
Rand McNally, 1973.

Mooney, James. *Calendar History of the Kiowa Indians*. 1898. Reprint,
Washington, D.C.: Smithsonian Institution Press, 1979.

Morgan, Susan. "Weston's Portraits." *Aperture* 140 (Summer 1995): 5–11.

Morimura, Yasumasa. *The Sickness unto Beauty: Self-Portrait as Actress*.
Yokohama: Yokohama Museum of Art, 1996.

Morris, Wright. *A Cloak of Light: Writing My Life*. New York: Harper & Row, 1985.

——. *God's Country and My People*. New York: Harper & Row, 1968.

——. *The Home Place*. New York: Charles Scribner's Sons, 1948.

——. "How I Put in the Time." In *Growing Up Western*, edited by Clarus Backes, 107–24. New York: Alfred A. Knopf, 1990.

——. *The Inhabitants*. New York: Charles Scribner's Sons, 1946.

——. *Love Affair: A Venetian Journal*. New York: Harper & Row, 1972.

——. *The Man Who Was There*. New York: Charles Scribner's Sons, 1945.

——. "Origins: Reflections in Emotion, Memory, and Imagination." In Knoll, *Conversations with Wright Morris*, 153–67.

——. *Photographs and Words*. Carmel, Calif.: Friends of Photography, 1982.

——. *Solo: An American Dreamer in Europe: 1933–1934*. New York: Harper & Row, 1983.

——. *Structures and Artifacts: Photographs, 1933–1954*. Lincoln, Nebr.: Sheldon Memorial Art Gallery, 1975.

——. *Time Pieces: Photographs, Writing, and Memory*. New York: Aperture, 1989.

——. *Will's Boy: A Memoir*. New York: Harper & Row, 1981.

——. *Writing My Life: An Autobiography*. 1985. Reprint, Santa Rosa, Calif.: Black Sparrow Press, 1993.

Mulligan, Therese. "The Autobiographical Impulse." *Image* 38.3–4 (Fall–Winter 1995): 38–41.

Mundwiler, Leslie. *Michael Ondaatje: Word, Image, Imagination*. Vancouver: Talon Books, 1984.

Murray, Elizabeth. *Painterly Photography*. San Francisco: Pomegranate Art Books, 1993.

Nadar [Gaspard-Félix Tournachon]. *My Life as a Photographer*. Translated by Thomas Repensek. *October* 5 (Summer 1978): 6–10.

Nadel, Ira Bruce. *Biography: Fiction, Fact, and Form*. New York: St. Martin's Press, 1984.

Neubauer, Carol E. "Developing Ties to the Past: Photography and Other Sources of Information in Maxine Hong Kingston's China Men." *MELUS* 10.4 (Winter 1983): 17–36.

Newhall, Beaumont. Foreword to Edward Weston, *The Daybooks of Edward Weston*. Edited by Nancy Newhall. New York: Aperture, 1990.

——. *The History of Photography*. New York: Museum of Modern Art, 1982.

——. *Supreme Instants: The Photography of Edward Weston*. Boston: New York Graphic Society, 1986

Newhall, Beaumont, and Amy Conger, eds. *Edward Weston: An Omnibus*. Salt Lake City, Utah: Peregrine Smith Books, 1984.

Newhall, Nancy, ed. *Edward Weston: The Flame of Recognition*. Millerton, N.Y.: Aperture, 1975.

Nodelman, Perry M. "The Collected Photographs of Billy the Kid." *Canadian Literature* 87 (Winter 1980): 68–79.

Nussbaum, Felicity A. "Toward Conceptualizing Diary." In Olney, *Studies in Autobiography*, 128–40.

Nye, David E. " 'Negative Capability' in Wright Morris' *The Home Place*." *Word & Image: A Journal of Verbal/Visual Enquiry* 4 (January–March 1988): 163–69.

Nye, Wilbur Sturtevant. *Bad Medicine and Good: Tales of the Kiowas*. Norman: University of Oklahoma Press, 1962.

———. *Plains Indian Raiders: The Final Phases of Warfare from the Arkansas to the Red River. With Original Photographs by William S. Soule*. Norman: University of Oklahoma Press, 1968.

Ollman, Arthur. *Persona*. San Diego: Museum of Photographic Arts, 1992.

Olney, James. "Autobiography: An Anatomy and a Taxonomy." *Neohelicon* 13.1 (1986): 57–82.

———. *Metaphors of Self: The Meaning of Autobiography*. Princeton: Princeton University Press, 1972.

———, ed. *Autobiography: Essays Theoretical and Critical*. Princeton: Princeton University Press, 1980.

———, ed. *Studies in Autobiography*. New York: Oxford University Press, 1988.

Ondaatje, Christopher. *The Man-Eater of Punanai: A Journey of Discovery to the Jungles of Old Ceylon*. Toronto: HarperCollins, 1992.

Ondaatje, Michael. *The Collected Works of Billy the Kid: Left Handed Poems*. 1970. Reprint, New York: Penguin, 1984.

———. *Coming through Slaughter*. West Concord, Ontario: Anansi, 1976.

———. *Running in the Family*. New York: Penguin, 1982.

———. *There's a Trick with a Knife I'm Learning to Do: Poems, 1963–1978*. Toronto: McClelland & Stewart, 1992.

Orvell, Miles. *The Real Thing: Imitation and Authenticity in American Culture, 1880–1940*. Chapel Hill: University of North Carolina Press, 1989.

———. "The Typology of Late Nineteenth-Century Photography." In Younger, *Multiple Views*, 139–67.

Owens, Judith. " 'I Send You a Picture': Ondaatje's Portrait of Billy the Kid." *Studies in Canadian Literature* 8.1 (1983): 117–39.

Partridge, Elizabeth, ed. *Dorothea Lange: A Visual Life*. Washington: Smithsonian Institution Press, 1994.

Paulson, Ronald. "Hogarth's Self-Representations." In Folkenflik, *Culture of Autobiography*, 188–214.

Peirce, C. S. *Collected Papers*. Edited by Charles Hartshorne and Paul Weiss. 8 vols. Cambridge: Harvard University Press, 1958.

Petty, Jane Reid. "The Town and the Writer: An Interview with Eudora Welty." In Prenshaw, *Conversations with Eudora Welty*, 200–210.

Pfaff, Timothy. "Talk with Mrs. Kingston." *New York Times Book Review*, June 15, 1980, 1.

Phillips, Sandra S. "Words and Pictures." In Phillips and Szarkowski, *Wright Morris*, 23–32.

Phillips, Sandra S., and John Szarkowski, eds. *Wright Morris: Origin of a Species*. San Francisco: San Francisco Museum of Modern Art, 1992.

Pitts, Terence, ed. "A Portrait Is Not a Likeness." *The Archive* 29. Tucson: Center for Creative Photography, 1991.

Polk, Noel. "Plate Changes in *One Writer's Beginnings*." *Eudora Welty Newsletter* 12.2 (Summer 1988): 7.

Pollack, Harriet. "Photographic Convention and Story Composition: Eudora Welty's Uses of Detail, Plot, Genre, and Expectation from 'A Worn Path' through *The Bride of the Innisfallen*." *South Central Review* 14.2 (Summer 1997): 1–16.

Poniatowska, Elena. *Tinisima*. Translated by Katherine Silver. New York: Penguin, 1998.

Popkin, Jeremy D. "Autobiography versus Postmodernism: Alice Kaplan and Elisabeth Roudinesco." *a/b: Auto/Biography Studies* 12.2 (Fall 1997): 225–42.

Powers, Richard. *Three Farmers on Their Way to a Dance*. New York: McGraw-Hill, 1985.

Prenshaw, Peggy Whitman, ed. *Conversations with Eudora Welty*. Jackson: University Press of Mississippi, 1984.

——, ed. *Eudora Welty, Critical Essays*. Jackson: University Press of Mississippi, 1979.

——, ed. *More Conversations with Eudora Welty*. Jackson: University Press of Mississippi, 1996.

Price, Mary. *The Photograph: A Strange, Confined Space*. Stanford: Stanford University Press, 1994.

Price, Reynolds. *Clear Pictures: First Loves, First Guides*. New York: Ballantine, 1989.

——. *Collected Stories*. New York: Atheneum, 1993.

——. "For the Family." Afterword to Sally Mann, *Immediate Family*. New York: Aperture, 1992.

——. "Four Abrahams, Four Isaacs by Rembrandt." In his *Things Themselves*, 260–69. New York: Atheneum, 1972.

——. "Grounds to Stand On." Foreword to Caroline Vaughan, *Borrowed Time*. Durham, N.C.: Duke University Press, 1996.

———. "The Only News." Foreword to Eudora Welty, *Photographs*. Jackson: University Press of Mississippi, 1989.

———. *Permanent Errors*. New York: Atheneum, 1970.

———. *A Whole New Life: An Illness and a Healing*. New York: Atheneum, 1994.

Quinby, Lee. "The Subject of Memoirs: *The Woman Warrior's* Technology of Ideographic Selfhood." In *De/Colonizing the Subject: The Politics of Gender in Women's Autobiography*, edited by Sidonie Smith and Julia Watson, 297–320. Minneapolis: University of Minnesota Press, 1992.

Rabb, Jane M. *The Short Story and Photography, 1880s–1980s*. Albuquerque: University of New Mexico Press, 1998.

———, ed. *Literature and Photography: Interactions, 1840–1990*. Albuquerque: University of New Mexico Press, 1995.

Rabinowitz, Paula. "Eccentric Memories: A Conversation with Maxine Hong Kingston." *Michigan Quarterly Review* 26 (Winter 1987): 177–87.

Rainwater, Catherine. "Planes, Lines, Shapes, and Shadows: N. Scott Momaday's Iconological Imagination." *Texas Studies In Literature and Language* 37.4 (Winter 1995): 376–93.

Rich, Adrienne. "Diving into the Wreck." In *Adrienne Rich's Poetry*, selected and edited by Barbara Charlesworth Gelpi and Albert Gelpi, 65–68. New York: Norton, 1975.

Rival, André. *Self-Images: One Hundred Women*. Zurich: Edition Stemmle, 1995.

Rivera, Diego. "Edward Weston and Tina Modotti." Translated by Amy Conger. In Newhall and Conger, *Edward Weston*, 21–22.

Robbins, David. "Richard Prince, an Interview." *Aperture* 100 (Fall 1985): 67–13.

Roberts, Nancy. *Recognitions: Images of a Woman Artist*. Cambridge, Mass.: Zoland Books, 1989.

Robinson, Henry Peach. "Oscar Gustav Rejlander." In *Photography: Essays and Images*, edited by Beaumont Newhall, 105–7. New York: Museum of Modern Art, 1980.

Roegiers, Patrick. "Bellocq." *Cimaise* 35 (November–December 1988): 25–44.

Rogers, Malcolm, ed. *Camera Portraits: Photographs from the National Portrait Gallery, London, 1839–1989*. New York: Oxford University Press, 1990.

Rosenberg, Harold. "Portraits: A Meditation on Likeness." Introduction to Richard Avedon, *Portraits*. New York: Farrar, Straus, Giroux, 1976.

Rosenblum, Naomi. *A World History of Photography*. Rev. ed. New York: Abbeville Press, 1984.

Roskill, Mark, and David Carrier, *Truth and Falsehood in Visual Images*. Amherst: University of Massachusetts Press, 1983.

Rubin, Louis D., Jr. "Growing Up in the Deep South: A Conversation with

Eudora Welty, Shelby Foote, and Louis D. Rubin, Jr." In Prenshaw, *More Conversations with Eudora Welty*, 31–53.

Rugg, Linda Haverty. *Picturing Ourselves: Photography and Autobiography*. Chicago: University of Chicago Press, 1997.

Russell, John. "Travel Memoir as Nonfiction Novel: Michael Ondaatje's *Running in the Family*." *Ariel* 22.2 (April 1991): 23–40.

Sacks, Oliver. *The Man Who Mistook His Wife for a Hat*. New York: Summit, 1985.

Saldivar, Ramon. *Chicano Narrative: The Dialectics of Difference*. Madison: University of Wisconsin Press, 1990.

Samaras, Lucas. *Samaras Album*. New York: Whitney Museum of American Art and Pace Editions, 1971.

Sapir, Michal. "The Impossible Photograph: Hippolyte Bayard's *Self-Portrait as a Drowned Man*." *Modern Fiction Studies* 40.3 (Fall 1994): 619–29.

Savedoff, Barbara E. "Transforming Images: Photographs of Representations." *Journal of Aesthetics and Art Criticism* 50.2 (Spring 1992): 93–105.

Sayer, Chloë, ed. *Mexico: The Day of the Dead*. Boston: Shambhala Redstone Editions, 1993.

Sayre, Robert F. *American Lives: An Anthology of Autobiographical Writing*. Madison: University of Wisconsin Press, 1994.

Schafer, William J. "Thoughts on Jazz Historiography: 'Buddy Bolden's Blues' vs. 'Buddy Bottley's Balloon.'" *Journal of Jazz Studies* 2 (1974): 3–14.

Schubnell, Matthias. *N. Scott Momaday: The Cultural and Literary Background*. Norman: University of Oklahoma Press, 1985.

——, ed. *Conversations with N. Scott Momaday*. Jackson: University Press of Mississippi, 1997.

Scobie, Stephen. "*Coming Through Slaughter*: Fictional Magnets and Spider's Webbs." *Essays on Canadian Writing* 12 (Fall 1978): 5–22.

——. "Two Authors in Search of a Character." *Canadian Literature* 54 (Autumn 1972): 37–55.

Scruton, Roger. "Photography and Representation." *Critical Inquiry* 7.3 (Spring 1981): 577–603.

Sedofsky, Lauren. "Time Exposure." In Heron and Williams, *Illuminations*, 295–99.

Seed, Suzanne. "The Viewless Womb: A Hidden Agenda." In Younger, *Multiple Views*, 388–406.

Sekula, Allan. "The Body and the Archive." In *The Contest of Meaning*, edited by Richard Bolton, 343–89. Cambridge: MIT Press, 1989.

Seymour, Daniel. *A Loud Song*. New York: Lustrum Press, 1971.

Shaw, George Bernard. "On the London Exhibitions." In Goldberg, *Photography in Print*, 223–31.

Shawcross, Nancy M. *Roland Barthes on Photography: The Critical Tradition in Perspective*. Gainesville: University Press of Florida, 1997.

Shields, Carol. *The Stone Diaries*. New York: Penguin, 1993.

Shloss, Carol. *In Visible Light: Photography and the American Writer, 1840–1940*. New York: Oxford University Press, 1987.

Silk, Gerald. "All by Myself: Piero Manzoni's Autobiographical Use of His Body, Its Parts, and Its Products." In Couser and Fichtelberg, *True Relations*, 37–158.

Sischy, Ingrid. "Self-Portraits in Photography." In *Reading into Photography: Selected Essays, 1959–1980*, edited by Thomas F. Barrow, Shelley Armitage, and William E. Tydeman, 237–45. Albuquerque: University of New Mexico Press, 1982.

Skaggs, Merrill Maguire. "Eudora Welty's 'I' of Memory." In Turner and Harding, *Critical Essays on Eudora Welty* 153–65.

Smith, Henry Holmes. "Color on the Cusp, 1975–1984." In his *Henry Holmes Smith: Collected Writings, 1935–1985*, edited by James Enyeart and Nancy Solomon, 116–17. Tucson: Center for Creative Photography, 1986.

Smith, Sidonie. *A Poetics of Women's Autobiography: Marginality and the Fictions of Self-Representation*. Bloomington: Indiana University Press, 1987.

Smith, Sidonie, and Julia Watson, eds. *Getting a Life: Everyday Uses of Autobiography*. Minneapolis: University of Minnesota Press, 1996.

Snyder, Joel. "Picturing Vision." In Mitchell, *Languages of Images*, 219–46.

Snyder, Joel, and Neil Walsh Allen. "Photography, Vision, and Representation." *Critical Inquiry* 2.1 (Autumn 1975): 143–69.

Solecki, Sam. "Making and Destroying: Michael Ondaatje's *Coming Through Slaughter and Extremist Art*." *Essays on Canadian Writing* 12 (Fall 1978): 24–47.

Solomon-Godeau, Abigail. *Photography at the Dock: Essays on Photographic History, Institutions, and Practices*. Minneapolis: University of Minnesota Press, 1991.

Sontag, Susan. *On Photography*. New York: Farrar, Straus, Giroux, 1977.

Spacks, Patricia. *Imagining a Self: Autobiography and Novel in Eighteenth-Century England*. Cambridge: Harvard University Press, 1976.

Sprinker, Michael. "Fictions of the Self: The End of Autobiography." In Olney, *Autobiography: Essays Theoretical and Critical*, 321–42.

Stanley, Liz. "Enter the Author: The Auto/biographical I: Autobiography, Photography, and the Common Reader." In her *The Auto/Biographical I: The Theory and Practice of Feminist Auto/Biography*, 20–55. Manchester: Manchester University Press, 1992.

Stark, Amy, ed. *Edward Weston Papers*. Guide Series Number Thirteen. Tucson: University of Arizona, Center For Creative Photography, 1986.

——, ed. *The Letters from Tina Modotti to Edward Weston*. Tucson: *The Archive: Center for Creative Photography* Research Series 22, January 1986.

Stebbins, Theodore E., Jr., ed. *Weston's Westons: Portraits and Nudes*. Boston: Museum of Fine Arts, 1989.

Steichen, Edward. *A Life in Photography*. Garden City, N.Y.: Doubleday, 1963.

Steiner, Wendy. *Exact Resemblance to Exact Resemblance: The Literary Portraiture of Gertrude Stein*. New Haven: Yale University Press, 1978.

——. "Postmodernist Portraits." *Art Journal* 46.3 (Fall 1987): 173–77.

——. "The Semiotics of a Genre: Portraiture in Literature and Painting." *Semiotica* 21.1/2 (1977): 111–19.

Stetsenko, Ekaterina. "Eudora Welty and Autobiography." *Southern Quarterly* 32.1 (Fall 1993): 16–20.

Stoekl, Allan. "Cartier-Bresson: Between Autobiography and Image." *Modern Fiction Studies* 40.3 (Fall 1994): 631–41.

Stott, William. *Documentary Expression and Thirties America*. Chicago: University of Chicago Press, 1986.

Swann, Brian, and Arnold Krupat, eds. *I Tell You Now: Autobiographical Essays by Native American Writers*. Lincoln: University of Nebraska Press, 1987.

Sweet, Timothy. "Photography and the Museum of Rome in Hawthorne's *The Marble Faun*." In Bryant, *Photo-Textualities*, 25–42.

——. *Traces of War: Photography and the Crisis of the Union*. Baltimore: Johns Hopkins University Press, 1990.

Szarkowski, John, ed. *E. J. Bellocq: Storyville Portraits: Photographs from the New Orleans Red-Light District, circa 1912*. New York: Museum of Modern Art, 1970. Reprint, *Bellocq: Photographs from Storyville, the Red-Light District of New Orleans*. New York: Random House, 1996.

——. *Looking at Photographs: One Hundred Pictures from the Collection of the Museum of Modern Art*. New York: Museum of Modern Art, 1973.

——. *Photography until Now*. New York: Museum of Modern Art, 1989.

——. "Wright Morris the Photographer." In Phillips and Szarkowski, *Wright Morris*, 9–21.

Taft, Robert. *Photography and the American Scene: A Social History, 1839–1889*. New York: Macmillan, 1938. Reprint, New York: Dover, 1964.

Takaki, Ronald T. *Iron Cages: Race and Culture in Nineteenth-Century America*. New York: Oxford University Press, 1990.

Taylor, Sandra Ortiz. "The Art of Sandra Ortiz Taylor." San Franciso Gate Web site http://www.sfgate.com/foundry/sandra.html.

Taylor, Sheila Ortiz. *Coachella*. Albuquerque: University of New Mexico Press, 1998.

———. *Faultline*. Tallahassee: Naiad Press, 1982.

———. *Slow Dancing at Miss Polly's*. Tallahassee: Naiad Press, 1989.

Taylor, Sheila Ortiz, and Sandra Ortiz Taylor. *Imaginary Parents: A Family Autobiography*. Albuquerque: University of New Mexico Press, 1996.

Tedford, Barbara. "West Virginia Touches in Eudora Welty's Fiction." *Southern Literary Journal* 18.2 (Spring 1986): 40–52.

Tiegreen, Helen Hurt. "Mothers, Daughters, and One Writer's Revisions." *Mississippi Quarterly* 39.4 (Fall 1986): 605–26.

Trachtenberg, Alan. *Reading American Photographs: Images as History, Mathew Brady to Walker Evans*. New York: Hill and Wang, 1989.

———, ed. *Classic Essays on Photography*. New Haven, Conn.: Leete's Island Books, 1980.

Turner, Frederick. *Remembering Song: Encounters with the New Orleans Jazz Tradition*. New York: Viking, 1982.

Turner, W. Craig, and Lee Emling Harding, eds. *Critical Essays on Eudora Welty*. Boston: G. K. Hall, 1989.

Tuska, Jon. *Billy the Kid: A Bio-Bibliography*. Westport, Conn.: Greenwood Press, 1983.

Updike, John. *Midpoint and Other Poems*. New York: Alfred A. Knopf, 1969.

Vande Kieft, Ruth M. *Eudora Welty*. New York: Twayne Publishers, 1962.

Varsava, Jerry. "History and/or His Story? A Study of Two Canadian Biographical Fictions." In *History and Post-War Writing*, edited by Theo D'haen and Hans Bertens, 205–25. Amsterdam: Rodopi, 1990.

Vinitzky-Seroussi, Vered. *After Pomp and Circumstance: High School Reunions as Autobiographical Occasion*. Chicago: University of Chicago Press, 1998.

Wallen, Jeffrey. "Between Text and Image: The Literary Portrait." *a/b: Auto/Biography Studies* 10.1 (Spring 1995): 50–65.

Walton, Kendall L. "Transparent Pictures: On the Nature of Photographic Realism." *Critical Inquiry* 11.2 (December 1984): 246–77.

Warburton, Nigel. "Seeing through 'Seeing through Photographs.'" *Ratio*, new ser., 1 (June 1988): 64–74.

Wareheim, Marja. "Photography, Time, and the Surrealist Sensibility." In Bryant, *Photo-Textualities*, 43–56.

"The War of the Roses." *Print Collector's Newsletter* 22 (July/August, 1991): 91.

Weiler, Dagmar. "N. Scott Momaday: Storyteller." In Schubnell, *Conversations with N. Scott Momaday*, 168–77.

Welty, Eudora. *Delta Wedding*. 1946. Reprint, New York: Harcourt Brace & Co., 1974.

———. *The Eye of the Story: Selected Essays and Reviews*. New York: Random House, 1979.

——. "Ida M'Toy." In her *Eye of the Story*, 336–48.

——. *In Black and White: Photographs of the Thirties and Forties*. Northridge, Calif.: Lord John Press, 1985.

——. Introduction to *One Time, One Place: Mississippi in the Depression: A Snapshot Album*. Jackson: University Press of Mississippi, 1996.

——. "Literature and the Lens." *Vogue* 104 (August 1, 1944): 102–3.

——. *Losing Battles*. 1970. Reprint, New York: Vintage International, 1990.

——. "Moon Lake." 1949. Reprint, *The Collected Stories of Eudora Welty*, 342–74. New York: Harcourt Brace Jovanovich, 1980.

——. *One Time, One Place: Mississippi in the Depression: A Snapshot Album*. 1971. Reprint, Jackson: University Press of Mississippi, 1996.

——. *One Writer's Beginnings*. Cambridge: Harvard University Press, 1984.

——. *The Optimist's Daughter*. 1972. Reprint, New York: Vintage International, 1990.

——. *Photographs*. Jackson: University Press of Mississippi, 1989.

——. "Place in Fiction." In her *Eye of the Story*, 116–33.

——. *The Ponder Heart*. 1954. Reprint, New York: Harcourt Brace & Co., 1981.

——. *Twenty Photographs*. Winston-Salem, N.C.: Palaemon Press, 1980.

Wendorf, Richard. *The Elements of Life: Biography and Portrait-Painting in Stuart and Georgian England*. New York: Oxford University Press, 1990.

Westerbeck, Colin L., Jr. "American Graphic: The Photography and Fiction of Wright Morris." In Younger, *Multiple Views*, 271–302.

Westling, Louise. "The Loving Observer of *One Time, One Place*." *Mississippi Quarterly* 39 (Fall 1986): 587–604.

Weston, Charis Wilson, and Edward Weston, eds. *California and the West*. Millerton, N.Y.: Aperture, 1978.

Weston, Edward. *The Daybooks of Edward Weston*. Edited by Nancy Newhall. New York: Aperture, 1990.

——. "Light vs. Lighting." In Bunnell, *Edward Weston on Photography*, 97–102.

——. "Portrait Photography." In Bunnell, *Edward Weston on Photography*, 135–39.

——. "Random Notes on Photography." In Bunnell, *Edward Weston on Photography*, 26–32.

——. "Seeing Photographically." In Bunnell, *Edward Weston on Photography*, 140–44.

——. "Thirty-five Years of Portraiture." In Bunnell, *Edward Weston on Photography*, 103–13.

——. "What Is a Purist?" In Bunnell, *Edward Weston on Photography*, 83–87.

——. "What Is Photographic Beauty?" In Bunnell, *Edward Weston on Photography*, 152–55.

Weston, Ruth. "Images of the Depression in the Fiction of Eudora Welty." *Southern Quarterly* 32.1 (Fall 1993): 80–91.

White, Minor. "The Daybooks of Edward Weston." In Newhall and Conger, *Edward Weston*, 112–13.

White, William, ed. *Walt Whitman: Daybooks and Notebooks, 1877–1881*. 2 vols. New York: New York University Press, 1978.

Wilkes, Andrew, ed. "Edward Weston Portraits." *Aperture* 140 (Summer 1995).

Willard, Barbara, ed. *"I" . . . An Anthology of Diarists*. London: Chatto and Windus, 1972.

Williams, Martin. *Jazz Masters of New Orleans*. New York: Macmillan, 1976.

Williams, Susan S. *Confounding Images: Photography and Portraiture in Antebellum American Fiction*. Philadelphia: University of Pennsylvania Press, 1997.

Willis, Deborah. "Clarissa Sligh." *Aperture* 138 (Winter 1995): 11.

Wilson, Charis, with Wendy Madar. *Through Another Lens: My Years with Edward Weston*. San Francisco: North Point Press, 1998.

Wilson, Christine. "Looking into the Past: Davis School." In Prenshaw, *More Conversations with Eudora Welty*, 287–95.

Witkiewicz, Stanislaw. "Multipart Self-Portrait." In Lingwood, *Staging the Self*, 86.

Wolff, Sally. "Eudora Welty's Autobiographical Duet: *The Optimist's Daughter* and *One Writer's Beginnings*." In *Located Lives: Place and Idea in Southern Autobiography*, edited by Bill Berry, 78–92. Athens: University of Georgia Press, 1990.

———, ed. "Some Talk about Autobiography: An Interview with Eudora Welty." In Prenshaw, *More Conversations with Eudora Welty*, 158–66.

Wolin, Jeffrey. *Written in Memory: Portraits of the Holocaust*. San Francisco: Chronicle Books, 1997.

Wollen, Peter. "Fire and Ice." In *Other than Itself: Writing Photography*, edited by John X. Berger and Olivier Richon, n.p. Manchester: Cornerhouse Publications, 1986.

Wong, Hertha. *Sending My Heart Back across the Years: Tradition and Innovation in Native American Autobiography*. New York: Oxford University Press, 1992.

Woodard, Charles L., ed. *Ancestral Voice: Conversations with N. Scott Momaday*. Lincoln: University of Nebraska Press, 1989.

Woolf, Virginia. *Moments of Being*. Edited by Jeanne Schulkind. 2d ed. New York: Harcourt Brace Jovanovich, 1985.

Wydeven, Joseph J. "Consciousness Refracted: Photography and the Imagination in the Works of Wright Morris." *Midamerica: The Yearbook of the Society for the Study of Midwestern Literature* 8 (1981): 92–114.

Yates, Gayle Graham. "My Visit with Eudora Welty." In Prenshaw, *More Conversations with Eudora Welty*, 87–99.

Yates, Steve. *Betty Hahn: Photography or Maybe Not*. Albuquerque: University of New Mexico Press, 1995.

York, Lorraine M. *"The Other Side of Dailiness": Photography in the Works of Alice Munro, Timothy Findley, Michael Ondaatje, and Margaret Laurence*. Toronto: ECW Press, 1988.

Younger, Daniel P., ed. *Multiple Views: Logan Grant Essays on Photography 1983–89*. Albuquerque: University of New Mexico Press, 1991.

Zinsser, William. *Inventing the Truth: The Art and Craft of Memoir*. Boston: Houghton-Mifflin, 1987.

Index

—works: *The Collected Works of Billy the Kid*, xviii, 103–10, 117; *Running in the Family*, xviii, 108, 117–30; *Coming through Slaughter*, 29, 108, 110, 112–17; "Biography," 126; "Letters and Other Worlds," 126; "Signature," 130

Orozco, José Clemente, 208, 215

Oswald, Lee Harvey, 14

Painting, xviii, 4–6, 9, 10–11, 13, 42, 69, 84, 98–99, 113, 143, 152, 178, 207, 210, 226

Parks, Gordon, xx

Parmigianino (Girolamo Francesco Mario Mazzola), 226

Passport photographs. *See* Photographs: passport

Patterson, James, 256 (n. 15)

Paulson, Ronald, 226

Peirce, C. S., xv

Penn, Arthur, 107

Penn, Irving, 152

Peterson, Roger Tory, 20

Phillips, Sandra, 191, 193

Photographic metaphors, 36, 40, 45, 99, 101–2, 109–10, 132

Photographs: family, xvi–xvii, xix, 15, 18, 21, 27, 29–30, 38, 40, 44, 47–49, 62, 84, 87, 89, 110, 132, 138, 142, 144, 146, 155, 169, 181, 184–86, 190, 199, 238–39; passport, 6, 7, 64; Van Dyke, 9; news, 10, 139, 205, 223

Photography: and representation, xv, xvi, 2–6, 20–21, 42–43, 77, 174, 182, 212, 230, 234, 244 (n. 11); as icon, xv, 3; as index, xv, 3, 5; digital, xvi, 11–13; trick, xvi, 21, 26, 30–31; and fiction, 2–3, 10–11, 17, 21, 45; and posing, 3, 5, 21, 31, 51, 109, 159, 169–70, 212, 228, 238; and truth, 4; and optics, 5; and aura, 5, 202–3; not physically reproduced, 18, 21, 26, 71, 104, 113, 236, 240; and surface, 21, 33, 37, 77, 136, 143–46, 185, 203, 240; not taken, 49, 204; and fashion, 152. *See also* Camera lucida; Camera obscura; Captions; Daguerreotype; Photographic metaphors; Photographs; Photo-texts; Portraiture; Polaroids; Self-portraiture; Snapshots

Photo-realist painting, 10–11

Photo-texts, xvii, 177–78, 187, 189

Pitts, Terence, 229

Pohd-lohk (Old Wolf), 85, 93–95, 102

Polaroids, 7, 11, 231

Poniatowska, Elena, 221

Portraiture, xviii, 4–6, 21, 26, 30–31, 35, 37, 84, 97–98, 101, 110, 120–22, 124, 132, 143–45, 164, 179, 200, 205–6, 212–42 passim; group, 33, 44, 121, 190. *See also* Self-portraiture

Powers, Richard, xvi, 55, 241

Prabakaran, Velupillai, 122

Price, Mary, 17, 39, 202, 205, 216

Price, Reynolds, xvii–xviii, 131–47, 157–58, 176; mother of, 132, 135, 137, 139, 141–43; father of, 132–43, 146

—works: *Clear Pictures*, xviii, 131–47; "For the Family," 132; *Collected Stories*, 135–36; *The Surface of the Earth*, 136; *Love and Work*, 143; *Permanent Errors*, 143; *A Whole New Life*, 146

Prince, Richard, 13

Punctum, 33, 34, 116

Quinby, Lee, 43, 52

Rainer, Arnulf, 10

Rainwater, Catherine, 101

Rankin, Tom, xx

Ray, James Earl, 14

Rejlander, Oscar, 230

Rembrandt, 226

Rich, Adrienne, 76

Richter, Gerhard, 10

Rios, Clara Ignacia, 72

Rival, André, 232

Rivera, Diago, 208, 213–15

Roberts, Holly, 10–11

Roberts, Nancy, 228

Robinson, Henry Peach, 230

Roche, Henri-Pierre, 31

Rockwell, Norman, 6